Women's Activism in South Africa

Working Across Divides

EDITED BY

HANNAH BRITTON, JENNIFER FISH AND SHEILA MEINTJES

UNIVERSITY OF KWAZULU-NATAL PRESS

Published in 2009 by
University of KwaZulu-Natal Press
Private Bag X01
Scottsville 3209
South Africa
E-mail: books@ukzn.ac.za
Website: www.ukznpress.co.za

ISBN: 978-1-86914-146-2

Managing editor: Sally Hines
Editor: Lisa Compton
Typesetter: Patricia Comrie
Indexer: Brenda Williams-Wynn
Cover designer: Flying Ant Designs

Printed and bound by Pinetown Printers

Contents

Abbreviations

AAWC	All African Women's Conference
ANC	African National Congress
ANCWL	African National Congress Women's League
ASA	Advertising Standards Authority
AZASO	Azanian Students Organisation
CBO	community-based organisation
CBU	Children's Budget Unit (within IDASA)
CDC	Centers for Disease Control
CEDAW	Convention on the Elimination of All Forms of Discrimination Against Women
CGE	Commission on Gender Equality
COSAS	Congress of South African Students
COSATU	Congress of South African Trade Unions
DICAG	Disabled Children's Action Group
DP	Democratic Party
FOSATU	Federation of South African Trade Unions
FRELIMO	Front for the Liberation of Mozambique
FSAW; FEDSAW	Federation of South African Women
GAPA	Grandmothers Against Poverty and AIDS
GEAR	Growth, Employment and Redistribution
GMAC-UIF	Gender Monitoring and Advocacy Coalition for the Unemployment Insurance Fund
HIV/AIDS	human immunodeficiency virus/acquired immune deficiency syndrome

HSRC	Human Sciences Research Council
IDASA	Institute for Democracy in South Africa
IFP	Inkatha Freedom Party
JCC	Junior City Council (city of Cape Town)
JMC	Joint Monitoring Committee
KZN	KwaZulu-Natal
LHR	Lawyers for Human Rights
MCC	Mennonite Central Committee
MK	Umkhonto we Sizwe
MP	member of parliament
NCHRE	National Center for Human Rights Education
NEC	National Executive Council
NGO	non-governmental organisation
NIH	National Institutes of Health
NP	National Party
NSA	Netball South Africa
NUSAS	National Union of South African Students
OSW	Office on the Status of Women
PWN	Positive Women's Network
RCCT	Rape Crisis Cape Town
RDP	Reconstruction and Development Programme
RWM	Rural Women's Movement
SACP	South African Communist Party
SADF	South African Defence Force
SADSAWU	South African Domestic Service and Allied Workers Union
SADWU	South African Domestic Workers' Union
SAFA	South African Football Association
SAHRC	South African Human Rights Commission
SAPS	South African Police Services
SAYCO	South African Youth Congress
SEWU	Self-Employed Women's Union
SISA	Sport Information and Science Agency
SWAA	Society for Women and AIDS in Africa

TAC	Treatment Action Campaign
TAP	Township AIDS Project
UCT	University of Cape Town
UDF	United Democratic Front
UIF	Unemployment Insurance Fund
UN	United Nations
UNHCR	United Nations High Commissioner on Refugees
URW	Union of Refugee Women
WASSA	Women and Sport South Africa
WHARP	Women's HIV/AIDS Resources Project
WNC	Women's National Coalition
YDP	Youth Development Programme (of Cape Town)

Engendering Civil Society in Democratic South Africa

HANNAH BRITTON AND JENNIFER FISH

SOUTH AFRICA'S NEGOTIATED transition and 1994 democratic elections promised significant gains for gender equality, as women acquired one-third of the seats in the national parliament, secured constitutional protection and began an extensive process of legislative reform. These significant transformations at the national governance level continue to characterise South Africa as one of the most lauded states in terms of women's access to public positions of power and the protection of social rights. Women composed 32 per cent of the national parliament by the third democratic election, while the new Constitution is recognised as having one of the broadest and most inclusive anti-discrimination clauses internationally. These victories extend from decades of women's activism in the struggle to end apartheid and assure gender rights in the creation of a new nation. In this process, a record number of women moved directly from the anti-apartheid struggle, political exile, labour movements or political imprisonment to positions of power within both parliament and the civil service. These macro-level changes, coupled with the experiences of activism shared by those entering public positions of power, placed enormous hope on the women who took national office. Characterised by the overarching climate of optimism central to the 1994 transition, the end of the apartheid struggle created new opportunities for women to rebuild South Africa by centralising gender rights in order to improve the quality of life and status for all women in the country.

1

The process of rebuilding society in the aftermath of violent conflict also affords vital opportunities to transform gender relations (see Meintjes 2001 and Powley 2003). Since the end of apartheid, South African women have continued to redefine leadership, feminism and power on their own terms and in their own cultural contexts. Yet for every significant gain women have made in the national political arena, there remains a parallel obstacle that is often most evident outside of the formal public structures of governance. Changing the nature of social relations and ameliorating the underpinning causes of gender inequality continue to constitute the most daunting challenges to assuring the protective rights central to South Africa's new democracy. As a result, even though women are in powerful positions in the public sphere, 'the struggle continues' in the movement to alleviate gender inequalities in prevailing systems that have not yet transformed in accordance with the public commitment to gender rights. In families, households, communities and social institutions, women continue to face extreme marginalisation, as evidenced by the severe forms of gender-based violence throughout South Africa. We suggest that in the existing context, the negotiation of these deep contradictions in gender rights takes place in civil society organisations, where women continue to confront pervasive gender inequalities on a daily basis, while at the same time acting as powerful individual and collective agents of social change.

This book explores these spaces where women are actively reconstituting society by engendering democracy in ways that are central to assuring the long-term transformation of South Africa. In this collection, we situate civil society organisations as our central lens in analysing gender progress in the context of South Africa's ongoing process of social change and democratisation. Through case studies drawn from a broad collection of women's organisations within South African society, each of the chapters evaluates how women in South Africa are navigating the contested terrains of ethnicity, social position and/or the national movement to democratisation. By exploring women's engagement within competitive sports, domestic-violence services, national unions, rights-based activism and political organisations, this collection expands the notion of political involvement and illustrates how South African women are constructing new forms of activism within the context of contemporary state structures that assure only a partial form of gender equality.

The cases in this text demonstrate the agency of and the obstacles for women within civil society in the face of patriarchal power relations and in relation to the post-apartheid state. This collection is intended to take part in the dialogue that assesses the complementarity as well as the potential conflicts between women's ability to advocate for gender rights through powerful roles in public positions of state governance and as agents of social change in civil society. First, a central theme of our collection is that the state is both an avenue for change for women and is hostile to women's activism at the same time. Several authors in this collection explore the potential of the state for improving the status of women, while others point out the limitations of the state for transforming social norms and patriarchal patterns. Second, the case studies in this text point to the dual impacts of women's roles in civil society. While some assessments show that civil society is an important avenue for women's activism, others demonstrate that this sphere may be more hostile to women than the state has been. The complexities of these analyses challenge the notion of 'gender victory' that has been central to South Africa's transition by illustrating that public measures to assure women's representation have not yet materialised in ways that change the daily life circumstances for the majority of South African women. Finally, a unique contribution of this collection is the specific organisational ethnographies that focus on a range of women's groups and networks. These ethnographies map the ongoing processes of navigating the intersections of gender, sexuality, race and geography in the continually changing landscape of post-1994 South Africa.

The contributors in this volume are an embodiment of a key goal of the text: working across divides. This collection is intended, both in content and process, to be a bridge not only between South African and international authors but also between social activists and academic scholars. Several of the contributors are activists and practitioners in civil society organisations dealing with the rights of women on a daily basis. Others are academics whose scholarly work has been linked to the intellectual and political projects of advancing the rights of women and challenging patriarchal norms and systems. In joining this project, each of the contributors recognises the value of engaging in a dialogue across methodologies, strategies, disciplines and fields. We situate these studies within a larger conversation on transnational solidarity in order to contribute to the broader assessment of the relationships among local, continental and global gender politics. As Mama (2005) states:

> [T]he experiences of women's networks show additional challenges arising from the uneven levels of development among women's movements across the continent. This has meant that pan-continental mobilisation has struggled to be properly and evenly representative across and within nations that have remained deeply divided between urban and rural locations, and socially stratified along class, ethnic and religious lines, as well as by gender inequalities. (3)

Drawing from the South African experience, the voices in this collection vividly illustrate these challenges and demonstrate the importance of building a global feminist conversation that advances support for women's activism within the context of neo-liberal globalisation. The transnational nature of the anti-apartheid struggle and the international women's movement created the networks and mechanisms through which we bring scholar-activists and activist-scholars into an international conversation about systems of oppression, opportunities for transformation and possibilities of connection. Through the wide diversity of experiences and methodologies included in this text, we invite the reader into this conversation as a starting point for understanding how women's organising is created, sustained and internationalised.

To set the context for the variety of gender case studies explored in each chapter of this text, we begin with an overview of women's collective organising during the apartheid era. Next, drawing from both the historical and contemporary contexts, this chapter explores the relationship between gender and civil society by focusing on how these theoretical fields would benefit from the development of shared conversations and analyses, rather than working in isolation from one another, as has been the case in these distinct bodies of enquiry. We foreground the case studies with a conceptual meaning of gender, followed by elaboration on the contested meaning of feminism in the South African context. Drawing from the contemporary dialogue on transformative feminist practice, we then posit a new situational analysis that synthesises the findings from this collection: *pragmatic feminism*. We offer these condensed theoretical and applied backgrounds to situate the foundation from which we analyse women's engagement in civil society in the post-1994 South African context. Our intent here is to provide a framing structure that will enhance readers' understanding of each of the diverse case studies in the

collection. In setting up these various conceptual pieces, however, we do not suggest that any of these condensed summaries of central historical movements or complex theoretical debates is comprehensive in its scope. Rather, we hope that the context we establish in this introduction grounds the readers in ways that enhance the main focus of this book: women's activism in South African civil society organisations.

Women's organising during apartheid

Because women are often not able to access membership in institutions of state power, historically, women have found that civil society is a primary locus for crafting policy agendas and mobilising for political change. As we will discuss below, drawing on feminist theory and social movement theory, we posit a dynamic understanding of civil society that rejects an artificial separation of a public sphere from a private sphere. While civil society occupies the space between the state and the household, it also overlaps with each of these spaces. Civil society encompasses the household, issue-based networks and organisations working to engage the state and influence change at the micro-level of social relations. This fluidity of boundaries is central to the potential that civil society holds for transforming social relations at the micro-, organisational and structural levels.

Within civil society, women have been able to gather the collective strength necessary to influence, cajole and even threaten state entities and political leaders to provide legislation and resources for the advancement of women's rights and status. Civil society is a location for an endless array of gender-based organisations and, at times, women have been much more successful in entering this level of the public space to demand their rights, work towards their common interests and create networks and associations for support. This was certainly the case in South Africa during the apartheid struggle, particularly because the state remained completely closed to the participation of the majority of South Africans. Yet, as Denise Walsh points out in Chapter 2 of this collection, this pattern has changed. The recent attention of South African feminists on state institutions and electoral politics has shifted the focus of women's movements in post-apartheid civil society, providing a valuable opportunity to explore the multiple layers of gender-based activism during periods of rapid social change.

Each chapter in this collection highlights the connections between women's activism during the liberation struggle and the meaning of collective agency in the ongoing process of democratisation. The legacy of women's social and political activism in South Africa cannot be separated from the history of apartheid and its requisite systems of racial, class and gender oppression. Women's organising during apartheid was marked by a tension between moments when women worked across racial divides and moments when power asymmetries sharply divided activists along race and class lines. One strategy some women used to organise across divides involved adopting traditional identities, such as the 'motherist' ideology, and using those identities to promote progressive change (Wells 1993; Britton 2005). Many women often worked in radical, even militant, ways to oppose racial or gender hierarchies of oppression, yet this militancy was ensconced in claims of preserving and upholding traditional gender roles. For example, women organised around a maternal identity and fought to save the nation 'for their children'; many women embraced the ideal of becoming the 'mothers of the nation' for nationalistic struggles in African and Afrikaner communities. While not the only form of women's activism present during the struggle, this 'motherist' approach and other conservative identities were double-edged swords. They enabled women to propel issues from the 'private' sphere into the highly visible 'public' sphere. Such approaches to activism also gave women a valorised and respected identity, which in turn afforded them legitimacy in the eyes of their male partners and leaders. Yet it also reinforced a gender hierarchy that essentialised maternal roles while maintaining women's subordination and secondary status (Walker 1982; Meintjes 1998; Geisler 2004). These contradictions capture the complexities of women's mobilisation in both the apartheid and post-1994 eras, as the authors take up throughout the collection.

Wells (1993) presents one example of this type of conservative militancy in her analysis of the pass laws protests. Women's protests against the pass laws comprised some of the first national mass-action campaigns, drawing women from all races to these protests and propelling women into the sphere of national politics. Publicly and strategically, women stated that they opposed the pass laws because they interfered with their domestic roles as mothers and wives and deterred black women's entry into the labour market as domestic workers in white homes. Through these protests, they were successful in

opposing the imposition of the pass laws for decades longer than black men were able to do. Wells asserts that by employing the strategy of protest from within traditional identities, women crafted a successful platform to foster change while maintaining a position of power within traditional identities.

This same pattern, combined with the lessons drawn from socialist ideology, shaped the consumer boycotts of the 1950s. Women used their traditional roles as household consumers to fight against multiple industries and oppose their labour practices. While the leaders of many consumer boycotts were men, those responsible for envisioning and implementing the boycotts were often women. By the 1980s, consumer boycotts had changed to much more oppositional and internationally visible forms. Men and women in the movement used their purchasing power in combination with mass-action and national protests to challenge apartheid where it was most vulnerable: at its economic foundation (Terborg-Penn 1990; Mangaliso 1997). In this way, women activists applied their collective agency by drawing upon traditional roles to implement mass action in the service of economically revolutionary goals.

Even women's roles as militants and soldiers were at times informed by this concept of revolutionary female consciousness. Cock's (1991) examination of gender and militancy underscores that women used their maternal identity to justify radical action and even the potential to enact revolutionary violence. Women were trained and acted as freedom fighters in order to 'save the nation for their children'. Goldblatt and Meintjes (1998) have found that women's roles as 'mothers in the struggle' gave them the legitimacy to challenge apartheid laws and state violence, even through their own potential enactment of violence.[1]

But it is important to remember that this strategy of conservative militancy could also work to reinforce the division among women. Even before the advent of formal apartheid, the white South African women's movement for suffrage also was marked by this idea of conservative militancy. As with most suffrage movements of the time, white South African women's actions did little to assist black women's quest for political recognition and in many ways harmed the movement for racial equality (Walker 1982; Hassim 2006). Even though white English-speaking women have been recognised to be at the front of the movement for white women's suffrage (Walker 1990), Afrikaner women were able to use Afrikaner ideology to convince National

Party (NP) leaders to expand voting rights to women along racial lines, at the expense of any limited voting rights that black South African men had achieved in the Cape area. Vincent (1999) asserts that Afrikaner women in the suffrage movement strategically expanded the idea of Afrikaner mother-hood (*volksmoeder*, or 'mother of the nation') to make their case for the vote. They claimed that it was important to the nation to have their voice politically reinforce Afrikaner ideals in order to minimise the political voice of the black population. In their campaign, they used the language of home-making and motherhood to justify their quest for enfranchisement.

Other ideologies guided women's activism in labour unions and opposition movements. In the labour sector, union activism by women started as early as the 1920s and 1930s, and gained significant traction in the 1950s (Berger 1983, 1987; Mangaliso 1997). Infused with socialist ideology, union organising during this period was nurtured by international networks and allies. Even though much of women's labour activity was restricted to certain industries, women received invaluable training in negotiation skills, mobilisation tech-niques and mass-action strategies through their work in the labour unions. This socialist ideology also worked within opposition movements that func-tioned in the country until the 1960s. Notably, the politics of protest – which focused not only on altering the political system but also on changing the entire economic structure – distinctly influenced these forms of women's activism. South African women also formed several notable national women's organisations during the apartheid period, many of which were racially inclusive. Keeping in mind the important, but limited, involvement of white South Africans in the liberation struggle, in general, white women were more active in the movement than white men (Cock 1991). The African National Congress Women's League (ANCWL) and the Federation of South African Women (originally FSAW and in the 1990s FEDSAW) emerged as two of the key organisations at the time. Hassim (2006) discusses how these organisations were invested in two defining and often competing ideologies: feminism and nationalism. While not wishing to subordinate the quest for women's rights, both of these organisations did acknowledge the immediacy, if not the primacy, of the struggle for national liberation. For example, the ANCWL presents a complex history of gender inclusion and activism. Originally, women were denied full membership in the African National Congress (ANC) and served only a supporting role to the male leadership through membership in the Bantu

Women's League (Geisler 2004). However, as women's roles in anti-apartheid protests expanded, the ANC was forced to incorporate a more independent and meaningful role for the League. The ANCWL was formally revitalised in the 1940s. Emerging at the same time as the ANC Youth League in 1943, it effectively became a new organisation (Walker 1982; Hassim 2006).

The FSAW symbolised the movement towards women's alignment across organisations to mobilise strategically in the anti-apartheid struggle. Formed out of the recognition that women needed more autonomy than they were given as auxiliary groups, the federation comprised a number of different organisations (Walker 1982; Geisler 2004). By engaging as women activists against racialised state oppression, FSAW members worked strategically to fight the discriminatory apartheid laws, such as the pass laws, the Group Areas Act, the Population Registration Act and the Bantu Education Act (Mompati 1991; Joseph 1991; Klugman 1994; Kemp et al. 1995). Although an autonomous organisation, the FSAW recognised the need to fight for the end of apartheid while working to convince male comrades of the importance of overcoming all forms of oppression, not just racial discrimination. Thus, FSAW captures the tension women activists faced in integrating gender as a site of collective mobilisation.

After the period of violent, hegemonic repression by the apartheid state in the 1960s, which banned opposition movements (Berger 1983), many activists were forced into exile to continue their international mobilisation, military education and political training. A dramatic impact on resistance politics inside South Africa characterised this period. While the ANC, the Pan-Africanist Congress (PAC) and socialist parties all faced government bans, FSAW was never banned, yet its members frequently faced banning. Following this invasive measure of state bans, it took a decade for the internal opposition to reorient itself and craft new ways of organising and alternative strategies of resistance. This period constituted a new and different phase for the internal opposition, which consisted of a new generation of activists in the struggle. While often in the background of these resistance groups, women's experiences were invaluable in creating the foundation for a larger women's movement and vital to the formative structures of other national and regional resistance coalitions (Walker 1982; Hassim 2006).

Union activism formed a central component of women's engagement and political resistance under the apartheid regime. In the 1970s, a new form of

assertive union activity emerged in Natal, under the umbrella organisation the Trade Union Advisory and Co-ordinating Council, which later became the basis of the Federation of South African Trade Unions (FOSATU). Women remained active in this federation, as well as in the General Union Movement. Regardless of sector, ideological orientation or region, women found avenues of participation and activism within their union identity. A strong continuum of women's involvement from the 1970s to the 1980s characterised this area of activism, as women gained regional and sometimes national recognition for their work in the union movement. The Congress of South African Trade Unions (COSATU), founded in 1985, coordinated mass action and remained at the forefront of the resistance movement. Working within the twin frameworks of nationalism and feminism, women in COSATU organised to address issues of sexual harassment, maternity leave and night shifts that would affect parents' ability to care for their families (Mangaliso 1997). As Walsh discusses in the next chapter, while women found effective means to mobilise through the socialist ideologies of COSATU, they also experienced severe internal marginalisation as a result of patriarchal leadership within the organisational structure of COSATU, which illustrates the striking contradictions that characterise women's experience in their efforts to access power and advocate for gender equality.

Internal resistance to apartheid in the 1980s took on new heights as the liberation movement, which had been forced underground in the 1960s, began more direct confrontation with the apartheid state. Following the massacre of students in Soweto in 1976 and the subsequent student uprisings across the country, youth organisations launched national protests and increased radical mass action. In the late 1970s and early 1980s, a new generation of youth leaders and coalition politics challenged the more conciliatory and reformist politics of previous generations. The South African Youth Congress (SAYCO), the Congress of South African Students (COSAS), the Azanian Students Organisation (AZASO) and the National Union of South African Students (NUSAS) constituted just a few of the main national coalitions that mobilised a generation of youth, which had been excluded from the educational system, faced high levels of unemployment and had been raised in a distinct overarching climate of protest politics. The youth movement set the stage for identity politics throughout South Africa's anti-apartheid struggle, which provided an ideological and pragmatic connection to the women's movement.

Opposition groups in the 1980s began coordinated national campaigns to overthrow apartheid. While this full-scale assault remained remarkably non-violent, the apartheid state met each protest with increasing violence. Consumer boycotts in the 1980s again began to shake the foundations of the economy and coalition politics thrived. The United Democratic Front (UDF), organised in 1983, initially brought together over 400 civic, religious, youth, women and labour organisations. The UDF drew nearly three million members by 1985, with 700 affiliated organisations by 1987 working simultaneously at the local, regional and national levels. The organisation challenged military conscription, organised consumer and rent boycotts and supported youth protests of schools. COSATU, the UDF and the youth organisations were just a few of the numerous resistance coalitions that brought the apartheid state to its knees.

Because of the dynamics of organisational politics during these tumultuous times, often women did not occupy political leadership during the 1970s and 1980s. Yet women in exile received advanced educational degrees, political training and military service that led them to top positions within the political parties. Inside South Africa, women sustained a deep involvement in resistance politics, through both women's associations as well as groups organising underground to topple apartheid. Nationally, women's organisations remained central to the success of the UDF and youth coalitions. On a local level, women worked within religious organisations, funeral societies, savings groups, social organisations and economic enterprises, and often used their involvement in these associations to further their anti-apartheid networking. In each of these sectors, women attained valuable networking skills, individual growth opportunities and often small-scale economic empowerment. Their work in these groups also instituted a framework from which to create positive change in their immediate lives and communities. This demonstrates the positions of power that women are able to establish within deeply patriarchal and racially discriminatory systems in order to actively alter their environment. As Seidman (1993) argues, the forces of urbanisation and capitalism destroyed the indigenous subsistence systems, and many women entered the labour force for the first time in the 1970s and 1980s. Women harnessed the power they achieved within these activities to challenge not only the apartheid state but also the pressures of capitalism.

National and regional women's organisations also radicalised during the 1980s. Infused with ideologies of black consciousness, socialism and radical feminism, women focused on local and indigenous processes of collective mobilisation. Kaplan (1996) marks a change in ideologies guiding women's activism during this period from one of a 'female consciousness' to one framed by larger, nationalist struggles organised around 'social citizenship' and linking women's rights to the human rights discourse of economic and social justice. The Black Sash, for example, moved from working primarily on voting rights and human rights to work on forced resettlement and legal assistance for the families of political prisoners. While initially using the white leadership of the organisation as a challenge to the apartheid government's claim that all whites supported their policies, the Sash shifted its composition to include black and coloured South Africans. This ideological shift in Sash politics began in the 1960s and was solidly in place by the 1980s (Klugman 1994). During this same span of critical activism, organisations such as the Black Women's Federation (formed in 1975), Rape Crisis (1976), the United Women's Organisation (1980), the Natal Organisation of Women (1983) and Women Against Repression (1986) are but a handful of the examples of the ways in which women in this time period worked collectively through organisations to challenge the broader hierarchies of class, race and gender inequality. These organisations infused collective action in a broad scope of gender issues: to secure women's access to clean water and health care, to ensure freedom from state and gender-based violence, and to fight the oppression of women in the household and in the state. They also challenged the androcentric norms and values within the UDF – refusing to be seen as caterers and demanding respect as political equals.

Outside of South Africa in the 1980s, resistance to apartheid had become a transnational movement. The apartheid system created the context for political exile, which in many cases strengthened the capacity for women's mobilisation against the system of injustice. Exile gave women in the ANC the opportunity to form international networks and learn from women in other countries key lessons about the challenges and opportunities for organising in a post-conflict setting (Cock 1991). As apartheid drew near to its close in the 1990s, the composition of all the formal political structures and processes was under negotiation. In theory, the national agenda created space to discuss women's rights; however, women had to force their way into

the negotiating process. These critical negotiations created a context for returning women exiles to ally with women activists in the country, enter the process of democratic nation building and solidify alliances in support of race and gender justice.

Women leaders from within South Africa worked with women returning from exile to create the umbrella organisation of the Women's National Coalition (WNC). Drawing from the rich experience of coalition politics in the 1980s, the WNC brought together more than 90 women's organisations, women's branches of political parties, religious organisations, civic organisations and youth organisations in 1992. The WNC's main goals were to pressure for constitutional mandates for gender equality and measures to advance women into political office. As well as bringing in the full range of women's organisational foundations, the WNC straddled deep political and religious divides, prevailing cultural and ethnic fractures, and pronounced rural-urban divisions. Women leaders seized this unique moment, recognising that the end of apartheid created a rare and pivotal opportunity to move issues of gender onto the national agenda.

As Hassim (2006) argues, throughout the apartheid era, women's organisations and movement politics continually faced ideologies of nationalism and feminism that were at times both competing and complementary. Some women utilised conservative, traditional identities to push militantly for societal transformation. As a result, women's historic activism in South Africa remains marked by uneven periods of coalition building and activism: 'Many of their protests have been sporadic, varied in content, and characterised by an upsurge of political mobilisation around a specific campaign, followed by a decline' (Hassim 2006, 21). Furthermore, as we see throughout the struggle to end apartheid, women often faced a conflict of allegiances in terms of their efforts to end severe racial injustice and their competing investment in advocating for gender equality. Predominantly, however, women's mobilisation centred on a notion that the system of apartheid needed to be dismantled before fully addressing gender injustice, yet the call for women's rights was never abandoned. Furthermore, much like national liberation struggles throughout the global context, such circumstances placed gender priorities as secondary (Beckwith 2000). In the South African case, women continually confronted the dilemma of 'choosing' between race and gender justice. Yet, even as early as the 1950s, a clear agenda of promoting the

public role of women through the use of a 'gendered' discourse characterised organisational politics. This could be seen as a form of feminist activism, since women were making demands to meet women's needs and interests and to provide equal rights.

These qualities of women's mobilisation continue to resurface in gender activism within the post-apartheid context. As our collection repeatedly illustrates through each distinct chapter, the struggle among race, class and gender priorities turns up again and again in the ongoing process of nation building. Yet the transformation of state structures also provides new opportunities to draw from the foundation of women's activism during the struggle to end apartheid. The case studies throughout this text elucidate these paradoxical relationships within civil society – where women are both confined by former systems of power and actively drawing from the strength of historical activism to respond to new demands in the rebuilding of a democratic South Africa.

By the end of the first decade of democracy, most of the legislative aspects of apartheid were formally defeated. Yet pressing issues continue to burden women disproportionately and threaten their health, safety and welfare. From HIV infection rates to epidemic levels of gender-based violence, the legacy of apartheid continues to leave its mark on persisting systems of gender, class and racial inequality. In the rebuilding of South Africa, we contend that civil society organisations are situated in central positions to move the country into the next level of development. Women's roles within these organisations emerge from nearly fifty years of struggle, defined by the tension between advocacy for racial parity and for gender equality. Even though women have now attained important victories in government leadership, new forms of civil society organisation struggle to achieve congruence between South Africa's representation of gender rights at the public level and the realities of everyday social relations, where historical systems of inequality, culture and tradition continue to marginalise women. Analysis of this interplay between gender priorities at the governance level and the daily gender inequalities that prevail across divides provides an important framework for understanding the complexities of democratisation in South Africa. In capturing this particular moment in South African women's activism, we see a shared structure–agency dialectic that emerges in each of the case studies within this collection. Drawing from the experiences of women across a wide variety of sectors,

this text illustrates both significant progress realised by civil society organisations and the ongoing barriers to accessing the promises of democracy for women who remain severely marginalised by systems of intersecting inequalities of gender, race, class and geographic location.

Engendering a theory of civil society

Scholarship and theorising about the intersections between civil society and gender remain limited. Howell (2005) posits that this limitation stems from the fact that scholars interested in civil society are not likely to consider gender theory and often exclude the private sphere of the family. Studies of civil society focus primarily on examinations of organisational activity in the public realm, which excludes an analysis of gender relations, sexual practices and familial arrangements. Such frameworks reinforce pervasive notions of a public/private division between the state (public) and non-state (private) activities. This division more often emphasises public life, which is visible and external to personal relationships, and therefore devalues the private sphere, which would include family life, social networks and gender relations (Sapiro 1995).

Feminist theorists have established a long tradition of critiquing these power asymmetries suggested by the inherent division between a 'public' sphere and a 'private' sphere created in the foundations of Western political thought and sustained through contemporary formations of political life (Elshtain 1974; Okin 1979, 1991; Pateman 1988; Phillips 1991; Runyan 1992; Brennan and Pateman 1979). According to Howell (2005), this conceptual weakness is found also in more contemporary political theorists, including Adam Ferguson, Alexis de Tocqueville, Friedrich Hegel and Karl Marx, who 'in turn discursively reinforced the separation of the political economy . . . from the household economy, thereby masking the structural interrelations between the domestic sphere, civil society and capitalist economy' (4). These theories and ideas structure much of contemporary political life and, regrettably, continue to influence social and public norms. Howell (2005) asserts that such intellectual blinders have limited the explanatory potential of civil society theorists:

> [T]he silence on gender and civil society suggests a more pervasive hegemonic framing that acquiesces rather than challenges the gendered relations of civil

society. Civil society is discussed as though gender is irrelevant. Such a perspective implicitly reinforces the notion that the public is the natural domain of the male and the family that of the female . . . Had civil society theorists engaged more with the feminist problematisation of the public/private divide, they might have been better equipped conceptually to explore how the family shapes norms and practices in the sphere of civil society, and how gendered power relations pervade the spheres of state, market, civil society and family. (4)

If gender theory is successful in exploding the artificial boundary between the so-called public and private spheres, then we can use that process and knowledge to see that there are diverse interconnections among the state, civil society, social relations and gendered practices. Given the limitations placed on studies of civil society, it is often challenging for scholars to examine the layers of identities that may influence organisational behaviour and agendas.

It is these very layers that most often enliven feminist research. An understanding of sexuality, race, ethnicity, gender, ability and nationality guide many feminist scholars to examine how organisations operate and negotiate structures of power and control. Blurring this binary construction of the private/public spheres provides the opportunity to look at the inter-connections between multiple layers of society. As Ling (2002) posits, political spheres embody an inherent mutuality such that 'what pertains within the individual/household/nation contributes to the community/state/world, just as what happens in the world/state/community affects us as a nation/household/individual' (67). Drawing on this central notion of the mutuality of spheres, analysis of civil society organisations provides a more nuanced understanding of the particular nature of the interconnected levels of South Africa's broader political transition.

While civil society theorists have often ignored the role of gender, the rich body of social movement scholarship has consistently used the lens of gender for understanding women's political mobilisation. Through its exploration of how women organise for their rights and engage in mass-based action, social movement theory elucidates important aspects of understanding the politics *within* civil society. We draw on the notion of mutuality to suggest that the framework provided in social movement scholarship be applied to multiple forms of political life in ways that prioritise gender as a central

component of analysis. In doing so, we integrate civil society as a vital social sphere, rather than an isolated context that bears little impact on the state, household relations or national political transitions. While this collection focuses on civil society organisations and issue-based networks, we believe in the elasticity of social movement politics and civil society organising within the larger movement for women's equality in South Africa. Our intent is to provide a collection that focuses on the South African case to map how issues and ideas cut across institutional levels – from the state, to society, to a wide variety of societal institutions that shape the context of gender relations (Howell and Mulligan 2005).

One of the central features of the civil society debate in South Africa, and in the broader African continent, focuses on the unfulfilled promise of civil society activism and the inadequacies of gender machineries. As Mama (2005) states:

> Feminists have often preferred to work outside state bureaucracies and party machines, concentrating their efforts at community level. This accumulated experience of community activism has left us with few illusions about civil society, rural transformations, or traditional systems of governance. African women's ongoing experience in all these spheres has been, at the very least, cautionary. We have witnessed first-hand the deep conservatism of many of Africa's local cultures and production systems, and the deeply pervasive impact of capitalist development at even the most peripheral of locations. (4)

It is precisely because of the obstacles faced in civil society that South African gender activists and feminist theorists have turned towards a new type of agenda that blurs the lines between civil society and the state, between the public and the private, and instead fosters a new form of activism that works within the state and outside the state simultaneously. Even as these new alliances face the challenges of global neo-liberal constraints, this type of civil society activism has been fostered by the post-apartheid context, where former friends and allies have entered the halls of parliament and opened the possibility for interaction in the ongoing development of South Africa's democracy.

Within this collection, we focus on women's organisations in civil society that defy a public/private split. As Walsh makes clear in the next chapter, the

selection of cases illustrates our conceptualisation of civil society as inclusive of organisations, movements, trade unions, civics, parties and associations that hold a transformative agenda. These groups have come together with the intent of bringing about change in the public realm, in the state, in institutions and in private social norms and practices. The selections in this book represent contemporary examples of these boundary-crossing categories. Through these cases, we see both the power of women's collective organising to rebuild South Africa in the aftermath of apartheid and the prevailing barriers to realising democracy in everyday life.

The policing of women's personal lives and the boundaries of human rights are still seen throughout much of civil society, including within the private sphere. Sadly, the new catchphrase 'Democracy stops at my front door' demonstrates the outer limits of the South African transformation. This is yet another geographic limitation to public political rights, which have not yet extended to the spheres of the household, familial relations and sexuality. Helen Moffett's discussion in Chapter 6 acutely reminds us that sexual violence continues to be used as a horrifically effective tool of social control, which both shames women and works to limit their freedom of movement, their physical safety and their full empowerment. The epidemic levels of sexual violence and domestic abuse in South Africa impose a sharp warning to women that even though they have attained a place in national politics, they tread dangerous waters in seeking equitable positions of power in their personal, private and even familial roles. This pattern shows an ironic inversion of the public/private divide in South Africa. Publicly, women have obtained equality in their political rights and increasingly within political office. However, in the private realm, women's lives are confined within systems of patriarchy that are often reinforced by both physical and structural violence.

Jennifer Fish's (2006) work with domestic workers also examines the limitations of public political rights. The heavy footprint of economic and geographic apartheid is perhaps at its most visible in South Africa's domestic labour sector, which continues to be the largest sector of working black women in the waged economy. The position of contemporary domestic workers remains marked by racialised and class-based asymmetries of power between women employers and employees. Many domestic workers continue to live in geographic separation from their own homes and families, and from one another. This geographic isolation severely limits their mobilisation and ability

to transcend former apartheid structures. Despite obstacles to collective action, Fish demonstrates in Chapter 5 of this collection that domestic workers have realised victories in crafting public policy rights that regulate and standardise the private domain inhabited by domestic workers. For example, the South African Domestic Service and Allied Workers Union (SADSAWU) realised success in securing domestic workers' access to critical social security rights through the national Unemployment Insurance Fund (UIF). Yet this was only a first step in protecting one of the most vulnerable sectors of the working women's population – and it again shows that if change was going to be realised, it would most likely need to come from domestic workers themselves, rather than from the top-down levels of government. The domestic workers' sector will perhaps become the litmus test for how authentic South African's public rights discourse truly is, for until public political rights are realised for domestic workers, the rhetoric of transformation will remain hollow.

A continuum of women's activism and definitions of feminism

As is the case in most countries, in South Africa the term 'feminism' has incited deep divides and fractious debates. In the particular contexts of both apartheid and democratic nation building, feminism remains a hotly contested term for important ideological and political reasons. Steyn (1998) outlines the criticism of feminism within South Africa as part of cultural imperialism, imported from the West, and often in direct competition to the goals of the liberation struggle: 'Those women who have called themselves feminist have been, for the most part, white middle-class, left-wing intellectuals . . . and their tendency to speak on behalf of Black women has been resented' (43). Ginwala (1991) and Hendricks and Lewis (1994) outline the ethnocentric and imperialistic problems with a singularly focused feminism to the exclusion of an intersectional approach that centres issues of women's power within hierarchies of race, ethnicity, social position, class, sexuality and nationality. While broadly, the term feminism could be synonymous with women's strategic and practical needs, it became associated with a fracturing politics of placing gender above race or class identities in the strategies of the liberation struggle. Given the hegemonic power of apartheid, it is clear that race could not come second to gender in South Africa's liberation movement. At times, feminism was seen as divisive to the liberation struggle, and women would often voluntarily place gender equality second to issues of ending apartheid.

This collection explores first-hand accounts, scholarly research and organisational ethnographies that depict these debates within the broad continuum of women's activism in this particular phase of South Africa's transition. We encouraged each of the authors to frame their chapters within their own understanding of gender, feminism and womanist politics to depict these central diversities of experiences. As a collection, these chapters give substance to these national debates. While some authors are uncomfortable with the terms feminism or womanist politics, a unifying theme of this book is that the authors are exploring how organisations are working to improve the quality of life and status of women. In this way, the authors are investigating the full range of 'feminism' and the continuum of women's activism within South Africa. We situate this collection within the vibrant contemporary discourse that theorises the original forms of women's activism emerging from the very landscape of South Africa's rapidly shifting terrain.

Through her extensive analysis of gender and civil society organisations, Hassim (2005) posits two main forms of feminist activism in women's organisations after 1990: inclusionary and transformational feminism. The strand of inclusionary feminism is focused on gaining access to state structures and expanding representation within decision-making bodies, similar to what is also known as liberal feminism, state feminism or equality feminism. The idea is that by gaining *access* to institutions of power and influence, women will be able to bring about larger social or cultural change. Transformational feminism, on the other hand, is focused on women's strategic power and attempts to redress former power asymmetries in women's status and social position within all aspects of society. This includes policing and transforming the private sphere where male power predominates. Salo (2005) has critiqued Hassim's separation by arguing: 'The distinction that Hassim makes between inclusionary and transformational feminist strategies fails to take fully into account the complex and multiple terrains of gendered struggles, as well as the diversity of gendered movements in present-day post-apartheid South Africa' (1).

Drawing from the rich evidence within this collection, we propose that women's organisations are integrally involved in complex, multi-layered activities, sometimes engaging the state and sometimes opposing it. Furthermore, South Africa represents the dynamic interplay between collective action and the shifting nature of social structures. As we see in the changing

landscape of activism throughout apartheid, the negotiated transition and the post-1994 democratisation processes, periodisation and context are central to analysing activism and civil society organisations. What can be said of women's mobilisation in the early 1990s no longer holds, as gender organisations are now dealing with a completely different state structure. The collection of cases in this text underscores the importance of understanding how the South African context has changed, and as a result civil society organisations are continually responding to and placing new demands on state structures. Thus, we support the analyses of gender politics posited by both Salo and Hassim. Our intention is to enliven these debates by providing rich case studies that illustrate the complexities of women's activism within civil society organisations at this critical juncture in South Africa's ongoing political and social transition. What we hope to represent through this text is that South African women's organisations are not mere ventriloquists of the feminist agendas of liberal or radical feminism. Instead, the cases in this collection show that South African women's organisations are actively crafting strategies that are simultaneously and necessarily inclusionary and transformative, and this is part of the working for change in a post-liberation context.

Pragmatic feminism in the post-apartheid era

During the transition period in the 1990s, the entire legislative structure was under negotiation, and a diverse group of civil society organisations became active and powerful voices in crafting the Constitution, the electoral system and the structure of parliamentary life (Adler and Webster 1995; Eades 1999; Britton 2002; Croucher 2002). The initial goals of the women's movements in post-apartheid South Africa focused on state structures for women's participation in public and political life through the creation of the national machinery for gender equality, in line with Hassim's notion of inclusionary feminism. This approach centred on putting institutions in place first, to create access points for civil society groups and citizens and to begin to work within the democratic government – in order to replace a climate of fear with a culture of trust. While prioritising the top-down structures of change, the intention was that these institutions would be places for activists and organisations in civil society to articulate their needs and interests. By creating actual institutions for political change, this strategy – it was hoped – assured the added benefit that gender structures would outlast individual women

leaders. Thus, once created, these institutions were intended to ensure a lasting change. Ironically, then, women's post-apartheid activism focused on state structures and attention shifted away from civil society – the place where historically, South African women had been most active and the sphere in which most women live and work.

The artificiality of boundaries between the state and civil society became apparent at the negotiation table, and many hoped that there would be continued exchange, dialogue and collaboration within the new dispensation. Historically, parliament had assumed a predominant role as merely a rubber-stamp body, implementing the discriminatory and draconian policies of apartheid leaders. When members of unions and the anti-apartheid struggle moved into the halls of parliament after the 1994 election, they brought with them the possibility that the state would be an ally of citizens and perhaps an extension of the needs and interests of civil society. While the apartheid era saw leaders attempting to implement racial, gender and class hierarchies from the top down, the new era promised to demonstrate that social and political identities flowed across spheres of society and that structures of power were not bounded by institutional norms.

Because of this particular context, nearly ten years after the formal transition to democracy, women's groups in South Africa were still able to utilise strategically what was perhaps a limited moment within which to pursue both transformative and inclusionary strategies for change. This attempt to capitalise upon the existing elasticity in the relationship between the state and civil society was not a symptom of naivety on the part of women activists who harboured false beliefs in the transformative potential of the state; rather, it reflected a conscious, pragmatic attempt to utilise the old friendships, alliances and radical rhetoric of many political parties to pressure for change:

> [T]he South African state cannot be conceptualised as monolithic. We are only a decade into our transition, and the bonds of friendship and allegiance forged in anti-apartheid women's movements still hold between some women activists and women parliamentarians. These links are able to mitigate the socio-economic divides to a degree. So while women's organisations may apparently be engaging in inclusionary rather than transformational feminist strategies, women's shared identities as erstwhile comrades, their consciousness of the transformations required to make radical changes in ordinary women's lives, as well as the geopolitical location of the South African state as part of

the indebted group of nations, all mean that action that began as inclusionary feminist strategy may also come to contain elements of transformational strategy. (Salo 2005, 4)

Salo points to the possibility that women activists utilised a particular path for change that combined both inclusionary and transformational feminisms. The time period for taking this path may be brief, because the longer women are in office the more assimilated into parliamentary life they will become. This was certainly the case in other democratic transitions in eastern Europe and Latin America (Waylen 1994). Yet in the South African case, we posit a third organisational strategy that complements the particular period of transition. Stemming from the grounded analyses within this text, this third path reflects what we see as a form of *pragmatic feminism* on the part of South African women activists, who have worked across the transformative/inclusionary boundary to utilise all possible means of securing positive change in women's private and public lives. As the euphoria of the 1994 transition faded to South Africa's integration in global systems of power, we suggest that women's activism took on a particular pragmatic form that overcame the divisions of transformative and inclusionary gender politics to maximise the possibility of engendering long-term change within the shifting broader contexts. This pragmatic feminist approach engages effectively within the rapidly changing landscape of social and political life, drawing on both the victories of women's public representation and the grounded history of women's activism in civil society.

The chapters in this collection elucidate this pragmatic feminism, building on the elasticity between the state and civil society. What the cases demonstrate is that while the state itself may not be a panacea, it still represents a key source of power and the primary locus of vital resources, including the rights of citizenship, access to basic needs and the promise of protection from gender-based violence. Yet our authors are all keenly aware of the limitations of the state for social transformation, and many have come face to face with the problems of maintaining the momentum for a progressive feminist agenda once it becomes institutionalised in parliament or in national machinery. Accordingly, many of the authors in this text echo the limits of inclusionary feminism found by Tamale (1999, 2000) in Uganda, Mama (2000) in Ghana, and Gouws (2004) and Seidman (2003) in South Africa.

Walsh examines the juxtaposition of state and civil society as a foreground to the collection. The laudable attention on state institutions for feminist change was necessary and important in the post-apartheid era. Yet, as the women's movement progressed into the halls of parliament and government, it left civil society to 'return to politics as usual', with continued gender subordination and inequality stretching across women's lives. Walsh therefore calls on feminists to develop a new theory of civil society – one that ensures women's access to decision making and influence in these non-state spaces of power. Interestingly, Walsh asserts that feminists must demand that the South African state be responsible for ensuring democratic spaces for women's participation in civil society – reversing the usual direction of social movements calling for change within the state. If feminists are able to re-envision the boundaries between the state and civil society, the state can be used to challenge existing discrimination in the private sphere and to promote women's agency within civil society. Democracy must be a broader lived experience, not merely an electoral system or a group of state agencies.

One such state institution designed to bridge the boundary between state and civil society is the Commission on Gender Equality (CGE). Sheila Meintjes, a former member of the CGE, evaluates the role of this critical component of South Africa's 'gender machinery' in making public policy align with the gender priorities central to the rights-based approach to democratisation. Often cited as a model of centralising gender concerns within top levels of public governance, the CGE maintains a powerful position with both national and provincial offices that create national and regional gender programmes, monitor government and private sector operations and promote change in social and cultural practices. Meintjes's analysis is guided by a central question that interrogates the extent to which an independent statutory body can make a difference in a highly patriarchal and tradition-bound society. As the CGE was one of the key institutions designed to bring gender issues to the front of the national agenda, Meintjes's findings demonstrate the potential pitfalls of relying on public agencies for societal transformation, herein extending the work by Gouws (2004) and Seidman (2003). Many feminist consultants advised creating such institutions first, believing changes in social norms would follow. However, Meintjes notes that the institution itself is limited in its scope and its activist potential because it continues to operate within a society governed by norms, parties and rulers that have not actualised a

commitment to gender equality. Meintjes explores the very problems associated with focusing primarily on an inclusionary feminist agenda, in place of or prior to a transformational feminist agenda. Granted, most saw this machinery and state feminism as a step towards a more radical change in gender relations. Yet, as Meintjes shows, once women had the strategic power of decision making, the institutionalisation of a women's movement into state structures inherently limited or diluted the radical and transformational aspects of their agenda. So, while inclusion in institutions of state power often appears to be a necessary first step, it may also become an obstacle in and of itself.

Thus, both Walsh and Meintjes note the current limitations of pursuing inclusionary feminism in isolation, and both embrace the idea of simultaneously pursuing a transformative agenda within this inclusionary strategy of state feminism. As Mama (2005) asserts:

> [W]hile women are right to be deeply sceptical of the extent to which the patriarchal nation-state can support the liberation of women, feminists are nonetheless continually engaging with the state, demanding rights as citizens in ways that continuously push for redefinitions of the political, and of citizenship, and of culture ... they are also challenging the manifestations of patriarchal power relations in all aspects of our lives and social institutions. (4)

Both Walsh and Meintjes call on feminists to focus on the larger structural inequalities that persist in society as a whole and affect the institutions of the state, family and civic life. These structural inequalities are in fact residuals of the apartheid system. The footprint of the political economy of apartheid continues to mar South Africa through pervasive class, race and gender hierarchies. As the cases in this volume demonstrate, civil society organisations continue to organise against these structures, all the while existing within them.

Residual apartheid

As several of the cases in this text demonstrate, women's organisations are often a mirror for the limits of transformation in South Africa. Specifically, the new levels of political openness have not been matched by transformation of the geography or economy of apartheid. Political democracy has created new spaces for gender-based organising. Between 1994 and 2004, South Africa

experienced a virtual explosion in the number of non-governmental organisations (NGOs) and community-based organisations (CBOs). Each group had its own specific agenda or cause, and most groups were identified as issue-based rather than ascriptive. For example, issue-based groups mobilised around a specific women's issue – such as women and health, ending gender-based violence or developing women's economic potential. The ascriptive-based groups organised women as women, and attacked a broad range of women's issues or the inherent gender structure of society. These ascriptive groups were often short-lived because of the divisions within the membership along class or racial lines. Even though these groups often demonstrated effective means of working across race and class divides, many of the groups that had been vital during the transition, such as the WNC, either ceased to exist or faced enormous challenges to their viability following the 1994 transition (Britton 2005).

Merely opening the political space for all of these organisations to exist did not require a shift in economic power structures – just as we have seen in the larger South African society. Women's groups have mirrored the latent economic and geographic inequalities of the broader post-apartheid society. The work of Benita Moolman of Rape Crisis Cape Town (RCCT) clearly illustrates this point within one of the most dynamic sectors of civil society organisations. In Chapter 7 of this collection, Moolman explores how the political leadership and decision-making structures of the RCCT have changed, while a steady fight resists altering the persistent structures of economic and geographic apartheid within the organisation. Prior to 1994, the RCCT established their main offices in the white areas of Rondebosch, Rosebank and eventually Observatory. Women who did not live in the white areas, which would have included over 90 per cent of the women in the Cape Town region, had to travel great distances and at substantial costs to receive the RCCT's services. Following the end of apartheid, the RCCT opened branches in the former black township of Khayelitsha (1993) and in Heideveld (1997) on the Cape Flats, demonstrating progress in terms of the shifting political ideology of the organisation. Yet latent economic inequalities continue to pose formidable barriers to women's ability to access these vital services, as is strikingly evident in the physical structures and embedded organisational practices. So, while the availability of services expands geographically to respond to a much wider population of women, in some ways this

organisational growth has also reproduced the prevailing idea of the second- and third-class citizenship of today's politically free, but economically disadvantaged, black and coloured townships. In many ways, the RCCT represents a microcosm of the limits of political transformation. This economic and geographic inequality remains the vulnerable underbelly of South Africa's lingering 'social apartheid'. As we see throughout this collection, women pay a particular price for these incomplete transitions.

Within the context of women's sports, Cynthia Fabrizio Pelak reveals in Chapter 4 a similar disjuncture between the political liberation of post-apartheid South Africa and the economic and racial limits of civil society transformation. As a symbol of identity and power, the politics of sports were always important in the apartheid struggle, both nationally and globally. International exclusion of South Africa from sporting competitions, such as the Olympics, starting in 1964, served as yet another way to demonstrate condemnation of racial oppression and to isolate the racist apartheid government from the global community. Since the advent of democracy, sports have continued to mark a central location of struggle, yet in the post-1994 context, the identities being negotiated present distinctly gendered as well as racially charged meanings. Through an innovative contrast between two competitive women's sports, netball and soccer, Fabrizio Pelak reveals how these sports function as important spaces in civil society for women to operate as political actors. Netball, a sport closely related to basketball, was historically constructed as a women-only sport and was controlled in South Africa by white Afrikaans-speaking women. Soccer was historically constructed as a men-only sport and was dominated by black men in South Africa. On netball courts and soccer fields today, women are now able to challenge, on the one hand, male domination in sports and, on the other hand, racial domination within women's sports.

Since the transition, these hierarchies have been disrupted, but not without a price. Women's quest for leadership within male-dominated soccer led to instances of personal intimidation, sexual harassment and even physical violence. Similarly, within the historically white-controlled sport of netball, government intervention was necessary to mediate the intense racial conflicts in the sport. As Fabrizio Pelak demonstrates, remarkable change has taken place in both sports, but some inequalities remain. For example, all women were welcome to serve in administrative positions; however, white women

often had more time and more resources to participate as unpaid volunteer administrators. With the shifting political landscape of South African sports, however, new resources have been secured to assist women in transportation to the meetings, in recognition of the continued economic apartheid that limits many women's full participation in civic life. Here again we see that the patrolling of the racial, class and gendered limits of South Africa's ongoing transformation is located deep within everyday social practices that take place in civil society, extending even to soccer fields and netball courts.

South African women's activism within the global political economy

The South African case must also be situated within a broader continental movement in which the continual restructuring of post-colonial African states is integrally linked to gender (Mama 2005). This promise of the transformation of civil society through the use of state institutions is a pattern for women's organisations in Africa in general. Increasingly, there is an expectation of mutual collaboration and dependency between civil society groups and members of the state – a mutuality that was not seen in apartheid South Africa. Prior to the 1990s, women's groups in Africa were most frequently associated with development activities or with an affiliation to a male-dominated political party (Tripp 2005). The diversity and autonomy of women's organisations were quite low during this period, and the groups were used 'to contain women's political activity within these designated women's organisations, which meant that few women ever worked outside the bounds of these organisations to involve themselves in the actual [political] parties' (Tripp 2005, 82). Even if women had been involved in military struggles, they were more often than not re-subordinated following the end of the conflict, as seen in Mozambique (Sheldon 1994), Zimbabwe (Ranchod-Nilsson 1994) and Angola (Scott 1994).

In the 1990s, African women's activism and methods of organising began to shift rapidly, both across the continent and within South Africa, as Walsh discusses in the next chapter. International conferences, new communication technologies and increased economic linkages have further stimulated regional and continent-wide women's organisations that are able to support and foster national strategies for change (as seen in South Africa, as discussed in Meintjes's chapter in this volume as well as in the previous research of Seidman (1999)

and Britton (2005); in Eritrea by Connell (1997) and Hale (2001); and in Uganda by Byanyima (1992) and Tripp (2000)). Through this international networking, African women's groups started to cultivate new spaces created within post-conflict environments, where the gender rules and social norms had been disrupted, creating new possibilities for networks. During war and conflict, women often occupy traditionally male roles of leadership in the labour sector, as heads of households, and as soldiers during the conflict. In the 1990s, the training, education and experiences these women received during the conflicts have afforded women in Africa more broadly the ability to make claims of their legitimacy as political leaders at the end of conflicts (Cock 1991; Meintjes 2001; Hale 2001). The advent of multi-party political systems and the move away from military-ruled governments produced more opportunities for autonomous women's organisations within African countries, as women's political groups were no longer restricted to their position as branches of male-dominated parties. Additionally, donor agencies' new emphasis on women's rights, not just women's socio-economic development, has also fostered diversity in the nature and direction of women's groups throughout the continent (Tripp 2005).

It is here that our collection again coincides with the work of Salo's (2005) delineation of the multiple layers of women's activism occurring at the local, national and global levels. Increasingly, in the context of globalisation, women's groups in post-apartheid South Africa struggle to meet women's needs in their private lives, to face the challenges of national democratic consolidation and to fulfil the demands of international donors and global feminist networks:

> More importantly, the re-insertion of South Africa into the global arena has meant that women's organisations have had to take account of local, national and international power relations. In grappling with issues of donor funding or resisting the corrosive effects of economic globalisation, we have had to consider forging alliances with both local and international organisations. The organisational work required at multiple coalfaces, both at home and abroad, calls for inclusionary and transformational feminist strategies to be deployed both simultaneously and serially. (Salo 2005, 1)

As Salo argues, women's activism in civil society can no longer be assessed without consideration of the transnational processes that shape organisations,

as well as the populations they serve. The vast and dangerously persistent socio-economic inequalities that are found within South Africa are both part of the residual nature of apartheid and a result of the dictates of the international development regime and the global political economy. The civil society organisations in this collection certainly face these challenges of navigating the demands of local populations, while working within the context of global funding agendas that often prioritise donor agendas. This corresponds to the curtailment of feminist organising and progressive agendas across the continent following donor demands and the post-9/11 political climate (Lazreg 2004).

Reinforcing Ling's theory of the mutuality of spheres, this pattern is evident throughout the continent. Pereira (2002) found that women's activism in Nigeria has by necessity occurred at the local, national and international levels. Because of the impact of structural adjustment policies on the economic priorities of local and national governments, women in Nigeria have had to combine their strategies to secure basic rights, freedom from violence and access to social welfare with a struggle against the international development regime, transnational corporations and oil-extractive industries. Nigerian women's strategies include creating alternative economies and social networks that delink from the economy, as well as expanding human rights discourse and definitions of development to be more inclusive of women's needs.

Bahati Kuumba's contribution to this collection (see Chapter 10) provides an analysis of this impact of transnational networking and demonstrates that women's groups and women's networks in South Africa have had to be both inclusionary and transformative, working to make change using state structures while at the same time advocating for radical change within social norms and society at large. Kuumba demonstrates that the activities and organisations within South Africa cannot, and ought not to, be seen in isolation from the larger, continent-wide movement for women's rights and gender activism, extending the ideas of Salo (2005) discussed above. By exploring historical foundations for African and intercontinental linkages, Kuumba illustrates how new patterns of relationships are available within the context of globalisation that provide particular spaces where women are able to align around specific issues of concern, such as women's health. In this chapter, we see how African diasporic women of Cape Town and Atlanta mobilised around their shared

experiences with HIV/AIDS activism, creating powerful linkages in the fight against this global pandemic. As Kuumba's chapter summarises, a recurrent theme through-out this text depicts how the historical processes morph into contemporary events that reinforce the possibility and meaning of trans-national feminist networks. The shared legacy of fighting colonialism and imperialism, the growing linkages created within global capitalist structures and the recent trends towards regional organisations, such as the African Union, all create a framework for moving beyond national struggles and towards African women's networks that support continent-wide action and foster transnational identities.

The timing of the South African transition created an ironic tension between pushing for women's inclusion in the state while at the same time constraining women's socio-economic progress through a neo-liberal agenda (Basu 2005). While many networks and organisations have to work (in an inclusionary fashion) with the state to meet women's basic needs, they must simultaneously struggle (in a transformative fashion) to challenge an inter-national neo-liberal economic system that deprioritises state involvement in land rights, health and safety and general welfare. As Salo (2005) states:

> [T]he dictates of global institutions such as the World Trade Organization, the World Bank and the International Monetary Fund have constrained the state's ability to deliver more substantive socio-economic rights to all its citizens, even as it granted them formal political rights. As these current global power relations impact the local context, the socio-economic divide between rich and poor has deepened, and is reflected in the fragmentary, diverse nature of the South African women's movement today. (2)

South Africa is not alone in this multi-level struggle. There are calls to develop alternatives to the current trends of privatisation and liberalisation throughout Africa. Lazreg (2004) asks African countries and activist networks in general to delink from donor-driven development initiatives and develop a 'gender fund' through private contributions and a percentage of revenues from natural resources. This gender fund could provide autonomous, self-sustaining re-sources for change. Feminist scholars and activists in this collection are calling for precisely this type of alternative thinking to confront the power of state and transnational structures that continue to embed pervasive asymmetries of gender power.

One of the most vibrant grassroots networks in South Africa that demonstrates this local–international combination is seen in the social movements challenging neo-liberal globalisation and simultaneously organising for socio-economic rights domestically. For example, Miraftab's (2006) analysis of the anti-eviction campaign in South Africa demonstrates how movements have strategically challenged the binary of *invited* spaces and *invented* spaces of citizenship, where invited spaces are sanctioned and governed by the state and international donor agencies and invented spaces of resistance and change that expand notions of citizenship are criminalised. Since many of the invited spaces have not included the priorities and basic needs of many in South Africa, grassroots movements and issue-based networks are now inventing spaces and expanding the boundaries of what has been prioritised by a state constricted by the global push towards neo-liberalism. The work of the anti-eviction campaigners expands definitions of what constitutes civil society in South Africa, and indeed globally, by challenging limitations imposed by invited spaces and by crafting alternative visions of 'inclusive citizenship and just cities' (Miraftab and Wills 2005, 200).

The post-apartheid state has fallen far short of the promises of the Reconstruction and Development Programme (RDP) for widespread land reform, access to housing and a secure social safety net, in part because of the donor-driven shift towards the market-based national Growth, Employment and Redistribution (GEAR) plan that offloaded much of the obligation for social welfare and development into the private sphere of the household. This in turn has further disadvantaged women, who continue to be responsible for the maintenance of their families' social well-being. Furthermore, with the enormous burden of HIV/AIDS in South Africa, women carry an extraordinary portion of the labour of caretaking and family survival given the absence of state support for such expenditures and limited international donor funds. Civil society organisations, such as Cape Town's Grandmothers Against Poverty and AIDS (GAPA), are again stepping in to fill the notable gap between needs and services. Social movements and grassroots networks including the anti-eviction campaign, the landless movement and the movement against neo-liberal globalisation have fostered new forms of insurgent citizenship that challenge global restructuring as 'an ideology that claims to equalise through the promotion of formal political and civil rights yet, through its privatization of life spaces, criminalized citizens based on their consumption abilities' (Miraftab and Wills 2005, 202).

This body of work highlights the collective activism of new groups within civil society that were not immediately obvious for inclusion in the newly democratic South Africa, and demonstrates how emerging social groups must invent innovative and expanded notions of citizenship and justice (Miraftab 2006). For example, Christina Nomdo and Shaamela Cassiem's work with girl children (see Chapter 8) and Janine Hicks's work with immigrant women (Chapter 9) demonstrate that South Africa's democratisation has led to the creation of barriers in terms of accessing citizenship status. Both of these groups have struggled as a result of their pervasive marginalisation within the public rights discourse, which has in cases rendered the rights of the girl child and immigrant women invisible in key debates. The inability of certain groups of women to access protective measures encapsulates the material implications of the intersections of social inequality – where young/vulnerable and 'other' women face distinct forms of discrimination on the basis of the simultaneous interactions of race, class, gender, nationality, age and citizenship status. Such prevailing systems of domination create sharp divides among women who experience gender oppression in very different forms. Yet in both examples, the new fissures created by South Africa's transition to democracy have enabled these groups to demand a place for their collective voice, thereby mandating a broader conceptualisation of gender rights and citizenship in the context of South Africa's emerging democracy.

Nomdo and Cassiem have worked with girls in South Africa to develop a public voice so that they may be better able to pressure government agencies for their inclusion in protective rights. Working within the NGO sector, Nomdo and Cassiem have seen how the democratisation process in South Africa has primarily focused on the needs and issues of adult citizens, thereby silencing and often ignoring the very real and uniquely situated needs of children, especially girl children. Through the creation of the Children's Budget, these children have learnt how to monitor government spending and set goals for meaningful and resourced priorities. While it is evident that gender priorities shift over a lifespan, Nomdo and Cassiem advocate that age should inform a more complex understanding of gender and citizenship and demonstrate that challenging patriarchal norms must begin at the earliest stages of girls' socialisation and identity formation. If girl children are to become equal citizens, they must have access to education, health care and decision making during their time as 'child citizens'. Nomdo and Cassiem's work underscores

the importance of recognising democratisation as a long-term project. While the Constitution, electoral system and political institutions were a necessary first step, achieving sustainable democracy requires that girl children also see themselves as political actors and learn about the key ingredients of civic life, including participation, advocacy, budget analysis and leadership. As civil society organisations take up this work focusing on the needs of the girl child, they engage in both inclusive and transformative gender politics: training girls to work within a structured government system and simultaneously instilling the capacity to mobilise and resist through fostering girls' abilities to claim their democratic rights and collectively realise long-term transformation.

Similarly, Hicks's work centres on the quest for rights by refugee women, a group that does not qualify for the category of 'citizen', yet is increasingly in need of support from and recognition by the South African government. Organising through the Union of Refugee Women (URW), activists have aligned across ethnic and national identities to create survival strategies and support networks while they attempt to make themselves visible to policy makers and other civil society organisations. Arriving in South Africa after fleeing political violence or poverty in other countries, refugees hold expectations that South Africa is a place of democracy and opportunity on the continent. Most often, refugee women come face to face with the realities of the new progressive government, a government that is overwhelmed by the demands and expectations of its own citizens, that often chooses to exclude refugees from assistance and rights and that reifies national boundaries in an attempt to prioritise domestic development. Most striking in the context of everyday life, however, refugee woman must negotiate the extreme manifestations of xenophobic ideologies that limit day-to-day movement and pose severe risks of violence, displacement and even death, as we have seen in the 2008 wave of attacks on so-called foreigners living in South Africa.

The context of globalisation is characterised by more permeable boundaries and transnational linkages that lessen the role of the nation state (Marchand and Runyan 2002; Sassen 1998). In sub-Saharan Africa, such cross-border flows are often motivated by political strife and severely limiting economic conditions, rather than the oft-lauded flexibility of people and capital central to the contemporary nature of globalisation. Within the increasingly hostile climate of xenophobia and anti-immigration in South Africa, the quest of

refugee women to access the state or national resources is not only criminalised but also vilified and demonised – and the women themselves deported. Yet refugee women continue to work within invited spaces of citizenship through the court system to make radical demands for their inclusion and access to public rights beyond the limited space that has been given them. The response of the government to this group of women raises provocative questions about the depth and meaning of claims of transnational sisterhood and international solidarity. The clear limits to the possibility of *democracy* crossing borders are delineated with particular focus by Hicks in Chapter 9. Yet Kuumba asserts in the final chapter of this volume that if South African women return to their legacy of organising networks and coalitions, they may be able to transgress these boundaries and perhaps create a more fully democratic civil society. In the work of Kuumba and Hicks, we see most vividly the intimate nature of globalisation, as it takes form in defining everyday life and women's ability to access protective rights assured by both the state and the ideological notion of universal human rights.

An introduction to the collection

The grounded analyses in this book illustrate important parallels between women's agency in both public structures of government and civil society organisations. As each chapter portrays, in the aftermath of apartheid, women's organisations in civil society continue to struggle to redefine their mission, secure effective leadership and utilise new methods of activism. The national transition that shifted women's leadership from activists to public officials created distinct complexities. For example, while being comfortable with direct confrontation with the former apartheid regime, many of these women's groups are now struggling to work with the democratic government while simultaneously monitoring and challenging it. In addition, groups with long historical roots in the anti-apartheid movement are currently trying to build a mandate, attract a new membership and recreate feminist priorities in the ongoing process of nation building. In surveying the broad range of case studies within this text, we find that the shifting landscape of post-1994 democratisation creates new patterns of affiliations, challenges and possibilities for women as they work within former structures and simultaneously carve out innovative spaces to carry forward the gender priorities of South Africa's massive political transition.

One of the key tensions facing South Africa's commitment to gender equality is the struggle between the broad public sphere, which was valorised in the first ten years of democracy for the advancement of women, and the private sphere, which continues to be marked by high levels of gender-based inequality as a result of the lingering vestiges of patriarchal power and marginalisation. The continuation of South Africa's gender progress must now move beyond the public sphere to the greater challenge to reshape gender relations in everyday social life. Many civil society organisations are focused on the idea of democratising everyday social relations in a broad variety of 'spaces', such as netball courts, private houses, rape clinics, refugee networks and health centres. This collection takes us into the everyday lives of organisations that are actively reshaping South Africa as a direct result of women's activism. The select cases in this book examine the ways in which democracy may be extended through the use of public institutions, organisational mobilisation and transnational activism. As new strategies are formed to continue the progress of South Africa's gender rights campaign, we find that civil society organisations are working within these margins – using both inclusive and transformative gender politics to form a new pragmatic feminism to mobilise across divides.

The process of national transformation has created new fissures, and within these fissures we find emerging spaces for new participants in the democratic process. For example, many organisations have welcomed (or have been forced to include) multiple women's voices in their decision making and in their membership. One outcome of this new abundance of women's perspectives has been a shifting vision of feminism and of masculinity. For example, in Moolman's work with the RCCT, the inclusion of black and coloured South African women's voices has meant that the organisation can no longer operate with limited visions of masculinity. Because of the shared history of struggle against apartheid held by black men and women, the inclusion of black women's voices in the movement to end gender-based violence disrupts the idea of all men as perpetrators, and especially disrupts racist stereotypes linking black masculinity with violence and danger. In her rich discussion of the prevailing ideologies that fuel South Africa's escalating rates of gender-based violence, Moffett similarly advocates for a disruption in the extreme monolithic constructions of rapists as predominantly black men. By expanding the visions of masculinity to include men as comrades, partners and activists,

these two chapters illustrate how the negotiated terrains of political activism are creating new spaces for men in the fight to end gender-based violence.

In this collection, we intend to move beyond static notions of a monolithic state towards Gouws' (2004) vision that the 'state is a locale where women participate in the construction of citizenship for women through being involved in discursive struggles surrounding legislation and policy. Accepting this moves us from citizenship as a right to the inclusion of the relations between structures, discourse and agency' (2). We envision that the most meaningful contributions of this collection will emerge at this intersection of structure, discourse and agency. Each chapter depicts distinct relational processes that define the diverse forms of women's activism nearly fifteen years after the political transformation of state structures. The chapters demonstrate the internal struggles of women to challenge the residual apartheid within their organisations, while at the same time assuring the continued advancement of gender rights in the long-term project of democratising social institutions and everyday relations.

The organisations, cases and issues we have chosen for this collection depict key aspects of the transition and are representative of the broader national patterns of civil society–state relations in the consolidation of democracy in South Africa. These cases are not meant to be an exhaustive account of the wide variety of women's groups in South Africa. Rather, the networks and institutions reflected in this text are emblematic of the boundary crossings from public to private spheres, where important examples of the multiple intersections of gender and civil society can and do occur. As women activists transcend divides at the juncture of transformative and inclusionary activism, we suggest that they are forming a new and distinctly South African form of pragmatic feminist politics. This book features the diverse representation of spaces where women are acting as individual and collective agents through civil society organisations. It is our hope that this collection encourages a continued dialogue that includes key sectoral spaces outside the scope of this collection – such as HIV/AIDS organising, gay and lesbian activism, land movements and the collective action surrounding post-apartheid forgiveness and reconciliation.

We bring together the voices of South African women who explain in their own words how they achieved or continue to fight for their particular strategic needs or practical gender issues in efforts to contribute to the long-

term attainment of the vision of a 'new South Africa' held so closely in the transitional period of the early 1990s. The perspectives contained in this volume embody the ideology of transnational scholar-activism because the contributors are diversely situated in relation to South Africa's process of democratisation. As scholar-activists working within South Africa, we carry an ideological commitment to supporting the fullest possible realisation of the democracy envisioned by the generations of activists who assured the 'miracle' of a new nation. Transformation is broader than the borders between academics and activists, between civil society groups and government institutions and between South Africa and the world. We hope that the voices in this text capture and celebrate this unique period of women's activism, as the spaces portrayed in this collection illustrate the centrality of gender within the landscape of South Africa's emerging democracy.

Note

1. While women were active in the resistance forces of Umkhonto we Sizwe (MK) and were members of the white government's South African Defence Force (SADF), their numbers were small. Cock (1991) reported that in 1989, women made up only 14 per cent of the SADF and only 20 per cent of MK.

References

Adler, G. and E. Webster. 1995. 'Challenging Transition Theory: The Labour Movement, Radical Reform, and Transition to Democracy in South Africa'. *Politics and Society* 23 (1): 75–106.

Basu, A. 2005. 'Transnational Feminism Revisited'. *Feminist Africa.* Issue 5. www.feministafrica.org/index.php?page=issue_five. (Accessed on 15 December 2007.)

Beckwith, K. 2000. 'Beyond Compare? Women's Movements in Comparative Perspective'. *European Journal of Political Research* 37: 431–68.

Berger, I. 1983. 'Sources of Class Consciousness: South African Women in Recent Labour Struggles'. *International Journal of African Historical Studies* 16 (1): 49–66.

———. 1987. 'Solidarity Fragmented: Garment Workers of the Transvaal, 1930–1960'. In *The Politics of Race, Class, and Nationalism in Twentieth-Century South Africa,* edited by S. Marks and S. Trapido. London: Longman.

Brennan, T. and C. Pateman. 1979. '"Mere Auxiliaries to the Commonwealth": Women and the Origins of Liberalism'. *Philosophical Quarterly* 27 (2): 183–200.

Britton, H.E. 2002. 'Coalition Building, Election Rules, and Party Politics: South African Women's Path to Parliament'. *Africa Today* 4 (49): 33–68.

———. 2005. *Women in the South African Parliament: From Resistance to Governance*. Champaign: University of Illinois Press.

Byanyima, W. 1992. 'Women in the Political Struggle in Uganda'. In *Women Transforming Politics: Worldwide Strategies for Empowerment*, edited by J. Bystydzienski. Bloomington: Indiana University Press.

Cock, J. 1991. *Colonels and Cadres: War and Gender in South Africa*. Cape Town: Oxford University Press.

Connell, D. 1997. *Against All Odds: A Chronicle of the Eritrean Revolution*. Lawrenceville, NJ: Red Sea Press.

Croucher, S. 2002. 'South Africa's Democratisation and the Politics of Gay Liberation'. *Journal of Southern African Studies* 28 (2): 315–30.

Eades, L.M. 1999. *The End of Apartheid in South Africa*. Westport, CT: Greenwood Press.

Elshtain, J.B. 1974. 'Moral Woman and Immoral Man: A Consideration of the Public–Private Split and Its Political Ramifications'. *Politics and Society* 4: 453–74.

Fish, J.N. 2006. *Domestic Democracy: At Home in South Africa*. New York: Routledge.

Geisler, G. 2004. *Women and the Remaking of Politics in Southern Africa: Negotiating Autonomy, Incorporation and Representation*. Uppsala: Nordiska Afrikainstitutet.

Ginwala, F. 1991. 'Women and the Elephant: The Need to Redress Gender Oppression'. In *Putting Women on the Agenda*, edited by S. Bazilli. Johannesburg: Ravan Press.

Goldblatt, B. and S. Meintjes. 1998. 'South African Women Demand the Truth'. In *What Women Do in Wartime: Gender and Conflict in Africa*, edited by M. Turshen and C. Twagiramariya. London: Zed Books.

Gouws, A. 2004. 'The Politics of State Structures: Citizenship and the National Machinery for Women in South Africa'. *Feminist Africa*. Issue 3. www.feministafrica.org/index.php?page= issue_three. (Accessed on 17 December 2007.)

Hale, S. 2001. 'The Solider and the State: Post-Liberation Women: The Case of Eritrea'. In *Frontline Feminisms: Women, War, and Resistance*, edited by M.R. Waller and J. Rycenga. New York: Garland Publishing.

Hassim, S. 2005. 'Terms of Engagement: South African Challenges'. In *Feminist Africa*. Issue 4. www.feministafrica.org/index.php?page=issue_four. (Accessed on 17 December 2007.)

———. 2006. *Women's Organisations and Democracy in South Africa: Contesting Authority*. Madison: University of Wisconsin Press.

Hendricks, C. and D. Lewis. 1994. 'Voices from the Margins'. *Agenda* 20: 61–75.

Howell, J. 2005. 'Introduction'. In *Gender and Civil Society: Transcending Boundaries*, edited by J. Howell and D. Mulligan. London: Routledge.

Howell, J. and D. Mulligan, eds. 2005. *Gender and Civil Society: Transcending Boundaries*. London: Routledge.

Joseph, H. 1991. 'The National Federation of Women'. In *Lives of Courage: Women for a New South Africa*, edited by D.E.H. Russell. Oakland, CA: Basic Books.

Kaplan, T. 1996. *Crazy for Democracy: Women in Grassroots Movements*. New York: Routledge.

Kemp, A., N. Madlala, A. Moodley and E. Salo. 1995. 'The Dawn of a New Day: Redefining South African Feminism'. In *The Challenge of Local Feminisms: Women's Movements in a Global Perspective*, edited by A. Basu. Boulder, CO: Westview Press.

Klugman, B. 1994. 'South Africa: Women in Politics under Apartheid: A Challenge to the New South Africa'. In *Women and Politics Worldwide*, edited by B.J. Nelson and N. Chowdhury. New Haven: Yale University Press.

Lazreg, M. 2004. 'Beijing Plus Ten, or Feminism at the Crossroads?' *Feminist Africa*. Issue 3. www.feministafrica.org/index.php?page=issue_three. (Accessed on 3 December 2007.)

Ling, L.H.M. 2002. *Postcolonial International Relations: Conquest and Desire between Asia and the West*. London: Palgrave Macmillan.

Mama, A. 2000. *National Machinery for Women in Africa: Towards an Analysis*. Ghana: Third World Network – Africa.

———. 2005. 'Editorial'. In *Feminist Africa*. Issue 4. www.feministafrica.org/index.php?page=issue_four. (Accessed on 29 November 2007.)

Mangaliso, Z. 1997. 'Gender and Nation-Building in South Africa'. In *Feminist Nationalism*, edited by L. West. New York: Routledge.

Marchand, M.H. and A.S. Runyan. 2000. *Gender and Global Restructuring: Sightings, Sites and Resistances*. New York: Routledge.

Meintjes, S. 1998. 'Gender, Nationalism, and Transformation: Differences and Communality in South Africa's Past and Present'. In *Women, Ethnicity, and Nationalism: The Politics of Transition*, edited by R. Wilford and R.L. Miller. New York: Routledge.

———. 2001. 'War and Post-War Shifts in Gender Relations'. In *The Aftermath: Women in Post-Conflict Transformation*, edited by S. Meintjes, A. Pillay and M. Turshen. London: Zed Books.

Miraftab, F. 2006. 'Feminist Praxis, Citizenship and Informal Politics: Reflections on South Africa's Anti-eviction Campaign'. *International Feminist Journal of Politics* 8 (2): 194–218.

Miraftab, F. and S. Wills. 2005. 'Insurgency and Spaces of Active Citizenship: The Story of the Western Cape Anti-eviction Campaign in South Africa'. In *Journal of Planning Education and Research* 25 (2): 200–17.

Mompati, R. 1991. 'The Most Powerful Woman in the African National Congress'. In *Lives of Courage: Women for a New South Africa*, edited by D.E.H. Russell. Oakland, CA: Basic Books.

Okin, S.M. 1979. *Women in Western Political Thought*. Princeton, NJ: Princeton University Press.

———. 1991. 'Gender, the Public, and the Private'. In *Political Theory Today*, edited by D. Held. Palo Alto, CA: Stanford University Press.

Pateman, C. 1988. 'The Fraternal Social Contract'. In *Civil Society and the State: New European Perspectives*, edited by J.B. Keane. London: Verso.

Pereira, C. 2002. 'Configuring "Global", "National", and "Local" in Governance Agendas and Women's Struggles in Nigeria'. *Social Research* 69 (3): 781–804.

Phillips, A. 1991. *Engendering Democracy*. University Park: Pennsylvania State University Press.

Powley, E. 2003. 'Strengthening Governance: The Role of Women in Rwanda's Transition'. Hunt Alternatives Fund, Washington, DC. www.huntalternatives.org/download/10_strengthening_governance_the_role_of_women_in_rwanda_s_transition.pdf. (Accessed on 3 February 2007.)

Ranchod-Nilsson, S. 1994. '"This Too Is a Way of Fighting": Rural Women's Participation in Zimbabwe's Liberation War'. In *Women and Revolution in Africa, Asia, and the New World*, edited by M.A. Tetreault. Columbia: University of South Carolina Press.

Runyan, A.S. 1992. 'The "State" of Nature: A Garden Unfit for Women and Other Living Things'. In *Gendered States: Feminist (Re)Visions of International Relations Theory*, edited by V.S. Peterson. Boulder, CO: Lynne Rienner Publishers.

Salo, E. 2005. 'Multiple Targets, Mixing Strategies: Complicating Feminist Analysis of Contemporary South African Women's Movements'. In *Feminist Africa*. Issue 4. www.feministafrica.org/index.php?page=issue_four. (Accessed on 2 January 2008.)

Sapiro, V. 1995. 'Feminist Studies and Political Science – and Vice Versa'. In *Feminisms in the Academy*, edited by D. Stanton and A. Stewart. Ann Arbor: University of Michigan Press.

Sassen, S. 1998. *Globalisation and Its Discontents*. New York: New Press.

Scott, C. 1994. '"Men in Our Country Behave Like Chiefs": Women and the Angolan Revolution'. In *Women and Revolution in Africa, Asia, and the New World*, edited by M.A. Tetreault. Columbia: University of South Carolina Press.

Seidman, G.W. 1993. '"No Freedom Without the Women": Mobilization and Gender in South Africa, 1970–1991'. *Signs* 18: 291–320.

———. 1999. 'Gendered Citizenship: South Africa's Democratic Transition and the Construction of a Gendered State'. *Gender and Society* 13 (3): 287–307.

———. 2003. 'Institutional Dilemmas: Representation versus Mobilization in the South African Gender Commission'. *Feminist Studies* 29: 3.

Sheldon, K. 1994. 'Women and Revolution in Mozambique: A Luta Continua'. In *Women and Revolution in Africa, Asia, and the New World*, edited by M.A. Tetreault. Columbia: University of South Carolina Press.

Steyn, M. 1998. 'A New Agenda: Restructuring Feminism in South Africa'. *Women's Studies International Forum* 21 (1): 41–52.

Tamale, S. 1999. *When Hens Begin to Crow: Gender and Parliamentary Politics in Uganda*. Boulder, CO: Westview Press.

———. 2000. 'Point of Order, Mr. Speaker: African Women Claiming Their Space in Parliament'. *Gender and Development* 8 (3): 8–15.

Terborg-Penn, R. 1990. 'Black Women Freedom Fighters in South Africa and in the United States: A Comparative Analysis'. *Dialectic Anthropology* 15: 151–7.

Tripp, A.M. 2000. *Women and Politics in Uganda*. Madison: University of Wisconsin Press.

———. 2005. 'Women in Movement: Transformations in African Political Landscapes'. In *Gender and Civil Society: Transcending Boundaries*, edited by J. Howell and D. Mulligan. London: Routledge.

Vincent, L. 1999. 'A Cake of Soap: The *Volksmoeder* Ideology and Afrikaner Women's Campaign for the Vote'. *International Journal of African Historical Studies* 32 (1): 1–17.

Walker, C. 1982. *Women and Resistance in South Africa*, 2nd edition. Cape Town: David Philip.

———. 1990. 'The Women's Suffrage Campaign'. In *Women and Gender in Southern Africa to 1945*, edited by C. Walker. Cape Town: David Philip.

Waylen, G. 1994. 'Women and Democratization: Conceptualizing Gender Relations in Transition Politics'. *World Politics* 46: 327–54.

Wells, J. 1993. *We Now Demand: The History of Women's Resistance to Pass Laws in South Africa.* Johannesburg: Witwatersrand University Press.

CHAPTER TWO

Citizenship, Gender and Civil Society in South Africa

DENISE WALSH

CIVIL SOCIETY IS a celebrated arena for democratic politics. Its value is recognised across the globe and the political spectrum: from eastern Europe to Latin America and Africa, neo-liberals, liberals, socialists and radicals have embraced participation in voluntary associations, organisations and social movements. They argue that participation strengthens democracy by offering citizens the opportunity to build social capital, develop social trust and enhance state accountability, thereby enabling citizens to contribute to the collective life of a community. Through civil society, citizens discover, define and express their interests; discuss what ought to be done; publicly criticise existing practices and institutions; and influence public opinion and state policy (Young 2000, 164). These activities define full citizenship and are clearly central to democracy.

Feminists, however, have long noted that the ability to participate in civil society is not equally shared. Indeed, civil society has historically been defined by women's absence (Pateman 1988; Landes 1988).[1] Women, morality, particularism, the body and reproductive labour have defined the character and concerns of the private sphere, while the public sphere – comprising civil society and the state – has been idealised as a realm of reason, law and productivity run by a fraternal order of 'universal' men. As a result, women's power in modern public life has been indirect, ignored, associated with social constructions of femininity or realised selectively through private associations, such as kinship ties. Women have thus been constituted as a marginalised

group in civic and political life. Furthermore, as the chapters throughout this collection depict, differences among women, such as race, class, sexuality, nation, language and religion, distinctly shape and often intensify the particular nature of women's marginalisation.

A number of feminist scholars investigating the division of the public and the private have established that a gendered division of labour persists in contemporary civil society (Weldon 2005; Molyneux 2001; Tripp 1994). Women tend to congregate in associations that target survival and social interests, while civic and political associations pursuing public interests are frequently claimed as the domain of men. Civic and political associations operate according to fraternal norms in established liberal democracies, while patriarchal norms flourish in 'traditional' African communities (Tripp 2005; Tripp 1994), creating a dual barrier to women's participation in the public sphere.[2] In short, men dominate civic affairs and political decision making. So it is no surprise that South African civil society and the state have been highly segregated not only by race and class but also by sex.

Yet, South African democratisation during the 1990s did not follow the typical pattern of women's relegation to the private sphere. Indeed, feminists and women made impressive advances in the 1990s.[3] First, they extracted commitments of non-sexism from the African National Congress (ANC). Then, prying open the transition negotiations, women and feminists secured a gender equality clause in the Constitution and a tri-levelled gender machinery in the state. Finally, women gained impressive numbers in parliament and helped secure a series of legislative victories, including the 1996 Choice of Termination of Pregnancy Act and the 2000 Promotion of Equality and Prevention of Unfair Discrimination Act.

This large representation of women in politics and their unusual accomplishments in advancing gender equity offer feminist scholars a unique opportunity to investigate anew classic controversies over the importance of civil society, its boundaries and women's uneven marginalisation in the public sphere. In the first section of this chapter, I offer a transformative feminist approach to civil society, explaining the purpose of civil society for women; the relation of civil society to the state, market and family; and the relative 'friendliness' of civil society as opposed to the state. That approach embraces full citizenship, insists on open and inclusive communication in sectors that directly inform public opinion and policy making, and, in cases where state

institutions are more friendly and accessible to women than mainstream civil society organisations, harnesses inclusion to promote greater openness and access for all women in civil society.

Next, I offer a framework for assessing women's power and influence in civil society, attending to class, racial and geographic differences among women.[4] While South Africans are familiar with quotas and state-mandated strategies increasing women's presence, I go beyond such tactics. Like many inclusionary feminists, I believe that women must participate not only in the state but also in civil society.[5] However, all political engagement at this level is not equal. Women's participation in private associations, such as burial societies and grocery clubs, is not critical for achieving full citizenship, although these organisations do enhance members' ability to survive and develop social networks, which can lead to public activism. Civic and political associations, however, are explicitly oriented towards formulating interests and expressing them in public with the aim of shaping public opinion and political decision making. They are also vehicles for publicly confirming one's community membership and for defining that community. If all women are to have the opportunity to be full citizens and exercise these forms of public power and influence, they require access, voice and the capacity for contestation through-out civil society. Thus, I advocate an institutionalisation of participatory norms to transform power relations within civic and political society.

The second half of the chapter assesses women's agency in South African civil society from 1990 to 2005. The evidence presented here confirms that feminists have been right to focus attention on the interdependence of the public and private spheres and, more significantly, that despite an array of South African women's counter-publics and women's significant numerical presence in parliament, women's power and influence in civic and political civil society has remained quite limited, with poor, rural black women experiencing the deepest forms of marginalisation.[6] I conclude with a brief discussion of how the South African state might have promoted more open and inclusive public debate in civil society.

Theorising gender and civil society

While feminist critiques of the public and private spheres have been wide-ranging and influential, less work has been done to theorise gender and civil

society.[7] This is not to suggest that feminists have ignored women in civil society. On the contrary, a classic feminist strategy is to build a constituency of women who can mobilise in civil society. Such accounts of feminist civil society and historical women's movements dominate the field (Arneil 2006; Weldon 2005; Beckwith 2005b). Feminists have also analysed how women (or feminists) in civil society can work with women (or feminists) in the state to advance their mutual goals (Hassim 2005; Goetz and Hassim 2003; Htun 2003; Weldon 2002). While this has led feminist scholars to critique inequality in civil society, identify its threats to women's autonomy, and analyse the resistance of political parties and mainstream civil society to women's participation (Goetz and Hassim 2003; Phillips 2002; Molyneux 1998), feminist work on civil society continues to be dominated by a desire to enhance women's influence on public policy, revealing a relatively narrow, statist, instrumentalist approach to citizenship.[8]

A focus on women's movements and policy advocacy neglects other forms of public debate and opinion formation in civil society that may not be directed towards the state nor emanate from women's organisations or social movements.[9] Few feminist scholars treat civil society (which is more comprehensive than women's movements and organisations) as a significant 'organising category', valuing it because it enables participants to exercise full citizenship (Dean as cited in Phillips 2002, 72; Howell 2005).[10] As a result, feminist analyses of civil society and gender are incomplete. Given the limited influence of feminist scholarship on mainstream social science, it is not surprising that theorists of civil society (including those in South Africa) have often neglected gender.[11] Hence theorising on gender and civil society is underdeveloped.

A transformative feminist approach to civil society looks for ways to enhance women's full citizenship. I argue that women's inclusion in civic and political associations is insufficient to achieve this goal. All members must also have the opportunity to exercise power and influence in those associations. This necessitates attentiveness to the ways in which social constructions of gender inequality, particularly the sexual division of labour, limit women's agency in select sectors of civil society. Overcoming such barriers may entail state action to promote women's access, voice and capacity for contestation throughout civil society.

The most direct routes to full citizenship in civil society are through civic and political groups. Molyneux (2001) convincingly makes this point in her

study of women's mobilisation in Nicaragua, when she argues that some women's organisations, associations and social movements pursue practical interests, while others pursue strategic interests. Although the difference has been overdrawn, and pursuit of both in poor women's organisations is common, Molyneux distinguishes practical gender interests (the necessities women must supply for daily survival) from strategic interests (those that directly challenge gender subordination).[12]

Molyneux's analysis focuses on the *activities* and *objectives* of associations and organisations, and thus shares an affinity with the functionalist theory of civil society provided by Young (2000). Young identifies three different levels of associational activity and objectives: private associations (groups that address 'basic matters of life, death, need, and pleasure'); civic associations (groups directed towards serving the community); and political associations (focused on 'what is to be done'), such as a political party (2000, 160–3).

The first level is a form of social activity, such as a *stokvel* (informal savings association), that creates a select social network of friends and companions, and addresses practical interests. Neighbourhood associations are an example of the second level. They also provide social networks, but are more inclusive in membership and aim to enhance community life. Young's first and second levels of association are thus where women's practical interests dominate. Young's third level refers to organisations such as political parties. Like the first two, this level enhances social networks. It may also support second-level associations. Its primary aim, however, is to engage in discussion and debate about the common good, shaping popular opinion and public policy. Young's third level of associations, like women pursuing their strategic interests, offers far greater and direct opportunities for public influence and power than does a *stokvel* or neighbourhood association.[13] The insights of Molyneux and Young suggest that participating in political associations, organisations and social movements offers the most direct means to public power, with civic membership offering those opportunities only occasionally and private associations potentially undermining civic engagement.[14]

Feminist analyses of poor women's survivalist organising have underscored the potential of these efforts to promote strategic gender interests and political transformation (Rowbotham and Linkogle 2001; Tripp 2000). However, data on South African civil society support Young's distinction. While women

were active members in a number of organisations throughout the transition and post-apartheid eras – such as church groups, burial societies and grocery clubs that provided opportunities to enhance survival options and social networks – few of these groups pursued a public agenda.

In post-apartheid South Africa, analysts found that political associations, such as political parties and unions, most significantly increased members' trust in government, political interest, intention to vote and readiness to act and participate in collective action (Klandermans, Roefs and Olivier 2001, 126). Civic associations, such as neighbourhood committees, ranked close behind.[15] Church organisations, burial societies and *stokvels* had the lowest effects on members' political involvement. As the South African case dovetails with the claims of Young and Molyneux, in this chapter I use the term 'civil society' to refer to publicly oriented women's movements and organisations, mainstream civic associations, trade unions, political parties and social movements.[16]

Because the full exercise of democratic citizenship includes the capacity to define and express one's interests, discuss what ought to be done, publicly criticise existing practices and institutions, and influence public opinion and state policy, all citizens must have power and influence across publicly oriented civic and political associations. This requires open and inclusive communication.

As I have argued elsewhere, ensuring women's agency in the public sphere requires three things: access, voice and the capacity for contestation (Walsh 2006). Access means that diverse women are present across and within the full spectrum of civil society. While women's access is crucial, it is not, however, sufficient. Voice is also required. Access without voice suggests the worst kind of tokenism: woman as audience, not participant. By voice, I mean that a wide range of women at all levels of the group must be able to convey their interests through a variety of communicative styles.[17] Voice is a necessary condition because it ensures that 'assumptions that were previously exempt from contestation will have to be publicly argued out' (Fraser 1996, 124). Together, access and voice establish presence and a wide-ranging agenda, ensuring that a variety of women can introduce marginalised and repressed ideas.

Beyond voice, women must also have the ability to contest and successfully challenge the exclusionary rules of the game – for example, practices about

professionalisation, outreach, programme content, assessment, accountability and promotion. Not only should all women be able to make challenges to these practices, sometimes those challenges should succeed, indicating that women's voices are being heard and that institutions are being transformed. If civil society is open and inclusive, we will know it: a diverse range of women will be present at all levels and will speak with a variety of communicative styles, freely discussing and shaping objectives, questioning the way 'things are usually done'.

Widespread access, voice and contestation extended to all women in civil society are formidable ideals. But endorsing presence without attention to voice and contestation will sustain inequalities among women, as those who gain access to the upper echelons of power have little incentive to challenge the system. 'Getting women in' may promote a friendlier environment with less overt sexism, but is unlikely to generate resistance towards inequitable forms of assimilation. Voice and contestation, however, are not without risks. Not all women will support feminist goals, so demanding that each be offered voice and the capacity for contestation could thwart feminist objectives. But this offers more opportunity than risk, as voice and contestation require the space for all citizens to make counter-arguments. As feminists rarely have an equitable hearing and are frequently stigmatised and misrepresented, just debate is not a threat, but a real chance to advocate gender justice. This model thus goes beyond inclusionary feminism, insisting on voice and contestation as a means to transform power relations within existing civil society.

Access, voice and contestation serve as signposts for assessing women's transformative power and influence, as Figure 2.1 illustrates.

Figure 2.1 Evaluating women's agency.

The box in the centre highlights the criteria for evaluating women's agency. The box on the right illustrates that their agency is rated on a spectrum from limited to excellent. A limited ranking indicates that women are present, but likely to be observers and followers rather than leaders. Women's presence will typically be symbolic (for example, tokenism), functional (for example, serving tea) or supportive (for example, as assistants to others), and their physical presence and voice will conform to ritualised responses; segregation is common. Women's aspirations for enhanced power and influence will most often be expressed indirectly, discreetly.

A ranking of good means that women are not only physically present, but have an active, unscripted role and are actors. They are becoming integrated as equals across sectors and positions, participate in debate, raise new issues of concern and are no longer merely offering their tacit consent. Indeed, many will be protagonists, shape decision making, challenge the status quo and demand more power. Finally, an excellent rating reflects a diversity of women speaking with a variety of communicative styles. Deliberating freely on all issues, they question the rules of the game and have the confidence that their challenges will be heard, seriously considered and sometimes successful. This framework thus demands much more than presence and never conflates numbers with agency. Instead, the focus is on women's role as political actors with interests, providing feminists with high standards for measuring women's influence and power.

Where will the enforcement and institutionalisation of these participatory norms come from? Theorists of civil society have entertained the idea that the state might promote marginalised groups in civil society, although they posit different strategies about how to do so (Chambers and Kymlicka 2002).[18] Social democrats hope that state exhortations of affirmation for weak groups, along with liberal and substantive rights, will foster inclusion and equality. Walzer, in his discussion of this approach, argues this is how the state can maximise full citizenship (2002, 45). Speaking on behalf of critical theorists, Chambers also endorses liberal and substantive rights, but advocates new institutions for democratic debate so that associations, organisations and social movements might speak more effectively for themselves, as opposed to having the state speak for them (2002, 103–5). She thus pursues a more inclusive civil society, and also hopes to enhance its capacity for voice and contestation.

Inclusionary feminists, such as Phillips, agree with social democrats that the state is a potential ally in the struggle to protect and extend individual equality (2002, 81). However, inclusionary feminists marginally favour civil society over the state, assuming civil society is more accessible and contestable, providing a base for women's and feminist movements, consciousness-raising and a venue for shaping public opinion (78–9). Social democrats and inclusionary feminists are more willing to use the state than critical theorists, but like critical theorists, inclusionary feminists believe the limits of contemporary civil society are more likely to be resolved – and will be resolved better – by civil society, not the state.

The feminist claim about the relative friendliness of civil society, and critical theory's insistence that organisations must speak for themselves, appear democratic and logical, given women's historical marginalisation in the state and the impressive history of women's movements. Feminists' modestly successful targeting of the state legislatures and new bureaucratic institutions since the 1990s, however, presents the possibility that an unwavering privileging of civil society is imprudent. Is it still appropriate to claim that civil society's wide-ranging, diffuse array of groups is 'friendlier' – more accessible, contestable and transformable – than the contained, hierarchical and rule-bound state? Must state intervention distort the communicative capacity of civil society? The next section of the chapter suggests that theorists have overstated the friendliness of civil society and the intransigence of all state institutions. The South African case reveals the potential of constitutional principles and legislatures to improve women's access, voice and contestation *within* existing civil society.

Assessing South African civil society

To evaluate women's agency in civic and political society in South Africa from 1990 to 2005, I begin with women's counter-publics: the Women's National Coalition (WNC) and women's strategic organisations.[19] Undoubtedly, the WNC catapulted a wide array of women's interests to national attention during the transition negotiations. That it managed to be internally open and inclusive, and also successful at broadening public debate, denotes a unique accomplishment. Women's strategic organisations also had relatively good internal debate conditions, with modest capacity to shape public opinion and public policy. Next, I turn to an evaluation of women's access, voice and

contestation in civics (neighbourhood associations), unions and political parties. Activism in these three types of associations offered the strongest link to active citizenship in post-apartheid South Africa; each was also highly segregated by sex, and thus had limited debate conditions.

Women's access, voice and contestation in civil society during the early, tumultuous years of the democratic transition coalesced under the leadership of the WNC.[20] This coalition exemplified how open and inclusive conditions of deliberation can be achieved even during a democratic transition, highlighting why feminists and critical theorists have privileged this sector. It made efforts to transcend the limits of family and market that hinder women's participation in civil society, actively canvassing a remarkably diverse range of women by conducting public awareness and education campaigns, workshops, rallies and conferences at grocery stores, malls, churches and community centres across the country (WNC 1994b, 25–7 and 30–1).[21]

The WNC not only provided a broad range of two-million-plus South African women access to their organisation, but also demonstrated the capacity to listen to and project their voices into mainstream public debate. The WNC encouraged women to articulate their interests and make demands of the new democratic dispensation. A wide array of voices expressing diverse interests resulted in the inclusion of both women's practical and strategic interests as organisational goals.[22] Throughout its campaign, the WNC continuously debated the objectives and methods of the organisation (Hassim 2003). WNC leaders also projected those goals into the transition negotiations, the media and parliament. The WNC thus afforded women from across the country the ability to discover, define and express their interests; discuss what ought to be done; criticise practices and institutions; and influence the transition negotiations and public policy.

Diverse women's power and influence in and through the WNC was striking, but it did not last. After the first non-racial elections, the Coalition broke its link to political parties, and ruled that women members of parliament (MPs) could not hold an official position in the organisation. The result was a loss in leadership and political leverage that fragmented the nascent women's movement: the most talented leaders left civil society for parliament, and single-issue grassroots organisations mushroomed over the next decade. The unintended and immediate result of greater opportunities in the state was thus the demobilisation of the women's movement.

As the WNC declined, women's strategic organisations grew, providing women with space to articulate their interests and challenge the status quo. Organisations in urban areas improved women's access to public power, piercing the predominantly white, male, middle-class hegemony of civil society. Most urban women's organisations were internally open and inclusive. Many were young organisations, decentralised works-in-progress, member-driven and highly participatory. Issue-specific women's groups, such as the New Women's Movement and the Victoria Mxenge Housing Development Association, encouraged its predominantly black and coloured members to express their needs and interests and challenge patriarchal assumptions about women's subordination in public life (Ismail 1998; Edwards 1997).[23]

However, women's strategic organisations throughout this fifteen-year period had difficulty including poor, urban women as equals, and rarely integrated poor, black, rural women. Indicative of the pervasive divides among women's experiences, coloured and black women in institutionalised organisations reported feeling disempowered. Although women's national advocacy groups were acutely aware of the need to include rural women, logistical obstacles, limited funding and the timetables of government partners hobbled their efforts.[24] Rural women who participated in workshops and conferences remained isolated, bussed occasionally to urban sites for special events. One early and notable exception was the Rural Women's Movement (RWM), which led protests against local authorities and urged members to attend and speak out in community forums.[25] But the dynamism of this movement did not last long after the transition, as its most talented leaders moved into parliament. The majority of women's strategic organisations remained clustered in urban South Africa, and privileged women retained a disproportionate influence.

Moreover, groups led by white or coloured women tended to have higher degrees of institutionalisation, the closest links to government and the greatest access to funds. Collaborative relationships between these organisations, state gender institutions and feminists in the state emerged during the early years of democracy. An elite, feminist 'issue network' projected a variety of women's interests into state proceedings through hearings, petitions and reports (Van Donk and Maceba 1999; CASE 1998).[26] Working with conventional government agencies and departments, issue networks successfully secured an impressive array of legislative reform in areas such as customary marriage, violence against women and employment anti-discrimination.

The efficacy of this elite issue-network diminished after the second election in 1999, as the ANC intensified its efforts at centralisation. The ANC not only replaced and disciplined dynamic feminist MPs, but also insisted that NGOs 'be in line with government policy to get funding'.[27] Simultaneously, it increased the institutionalisation of state–society relations, creating bureau-cratic obstacles to the disbursement of government funds. Women's and feminist NGOs increasingly struggled to build a collaborative relationship with government that would not undermine their autonomy (Britton 2006). As international funding dwindled, ANC influence over organisational agendas increased. Remarking on the ANC pipeline of funds and policy prescriptions, Democratic Alliance MP Sandra Botha quipped that the entire NGO sector was 'an ANC jamboree'.[28] One activist bluntly confirmed that projects were 'driven by ANC politics'.[29] The line between collaboration and co-optation had dangerously deteriorated. By 1999, state-dominated funding, a smaller feminist cadre in the state and ANC determination to direct civil society undermined the ability of these organisations to speak out and challenge the status quo.

Even at their pinnacle of influence during the early years of the new democracy, women's issue networks and organisations were far less influential than civics, trade unions and political parties in shaping public opinion, public policy, the terms of community membership and strategic goals. Worse, South African women's access, voice and capacity for contestation in these main-stream organisations were quite limited.

Membership in mainstream civic and political society in South Africa was notably segregated by sex, race, class and geographic location. Fewer women than men were members. Even where women's membership was proportionally significant, their access to leadership positions remained quite low. Women's rank did advance slightly over the period. In some cases, this was a result of established male leadership moving into the state; in political parties, it was the ANC's adoption of a quota for the party list that increased women's advancement. Rural women, however, were often denied membership in community associations and in trade unions, and were marginalised in political parties. All of mainstream civil society remained thoroughly male dominated in 2005.

Civic organisations, and in particular civics, were vital centres of local urban politics in South Africa before and after the unbanning of the ANC,

particularly in black townships.[30] Unfortunately, no national studies assessing participation by sex in civic associations have been undertaken.[31] It is risky to generalise across all civic associations in South Africa, as they varied tremendously by locale, purpose and local power relations.[32] Yet anecdotal evidence indicates women's access in civics modestly increased with the transition, and then stalled during consolidation.

During the early years of the transition, women represented the majority of members in civics. Although it was common for professional men to ascend to leadership roles, women were prevented from doing so (Glaser 1997; Mayekiso 1996).[33] As the political influence of the civics peaked in 1994 and their most talented leaders became local councillors, some women made advances up the ladder of power, achieving numbers as high as 30 per cent of leadership positions in the Johannesburg area (Heller 2003, 165). Unfortunately, it soon became evident that this impressive advance was a one-time event. Civics remained notable for their large female membership and male leadership into the twenty-first century.[34]

Women's access to leadership positions in trade unions, arguably the most politically significant and vibrant area of civil society over the period of this study, followed a similar pattern. The majority of women in the Congress of South African Trade Unions (COSATU) were black and faced substantial pay and occupational discrimination. In 1993, Connie September became the first woman to be elected as a COSATU national office-bearer.[35] In 1995, when women constituted 36 per cent of the membership, they held 8 of 83 top-ranking positions.[36] As one female union member dryly remarked: 'A democratic union gives all members a right to a say in the way a union works, yet the higher up the union you go the less women you will find taking part in decision making.'[37] COSATU made intermittent efforts to target women for promotion, but they were often impromptu afterthoughts: as the 'women were not readily available' at the time of the decision, the men would have to go 'fetch them from home' to confirm the appointments.[38] Shadowed by the prevailing social constructions surrounding male leadership and women's roles in the household, such efforts generated a trend of only small improvements in women's ranking across affiliates.

While formal commitments to women's greater inclusion in union leadership were increasing and more women were organising and becoming union members, by the year 2000, female trade union employees were the

lowest-paid workers and continued to be excluded from educational opportunities and most management positions. By 2005, two women had been integrated into the select group of six national office-bearers. However, COSATU continued to reject quotas for women at all levels, and women's leadership numbers crested between 20 and 30 per cent across affiliates.

Women outside the formal economy were excluded not only from leadership positions but also, until 2005, from membership in COSATU altogether. In the mid-1990s, black women comprised approximately 60 per cent of the informal labour market and were concentrated in the less lucrative sectors, such as crafts and shop work. Black women from Durban formed the Self-Employed Women's Union (SEWU) in 1994 and actively pressed for membership into COSATU to secure international funding. Yet SEWU members were not eligible to join COSATU, because, as self-employed workers, they could not negotiate wages and benefits with an employer. Hence, SEWU women were not 'workers'.[39] This case draws a parallel to the struggles faced by domestic workers in efforts to gain recognition within the ranks of COSATU, as Fish discusses in Chapter 5 of this collection. Women's subordinate position in the economy thus reinforced their exclusion from the trade unions. Urban women in the formal labour market with leadership skills, education or experience were able to join civics and unions, but in most cases that was the extent of their access: the rank and file.

Women's most notable success in accessing leadership positions took place in the ANC, which also influenced opposition parties. In 1990, the ANC Women's League (ANCWL) won the right to be included in decision-making forums and attended the ANC Consultative Conference. The League then spearheaded a highly divisive and ultimately unsuccessful attempt to win a 30 per cent quota for women in the National Executive Council (NEC). That battle revealed the limited commitment to women's participation within the party. As one ANC woman leader noted, it served as a wake-up call to women that 'even when you are promised support from senior leadership, it doesn't mean that you will get it' (Baleka Kgositsile as quoted in Hassim 2006, 127). Despite the quota defeat, the number of women in the NEC increased to 30 per cent by 1999. But by 2002, the number of women in the NEC had dropped to a little less than 20 per cent.

Other political parties echoed this pattern. In the Democratic Party (DP), women constituted nearly 30 per cent of the Federal Council in 1999. In

2005, that number dropped to only 16 per cent. Women gained access to parliament, but the balance of power did not correspondingly shift in the parties. As Inkatha Freedom Party (IFP) MP Suzanne Vos emphatically insisted, men run South African political parties: 'Because we have a patriarchal society, women depend on men for patronage in terms of their places, because . . . the men are the bosses of the parties.'[40] Within the parties women were not mobilised to promote women's strategic interests. The IFP's large, vibrant Women's Brigade provided women with space for public action, but only as mothers under male guidance and on behalf of male leaders: women's role in the family was understood to 'naturally' complement men's role as public leaders. The ANCWL, despite promising early attempts to become a power base for women, put little energy into organising women at the grassroots or providing them with leadership opportunities, and it returned to its historic role as a women's auxiliary organisation to the party (Hassim 2005, 98).

Like women's access, women's ability to speak their minds and be heard in community organisations, unions and political parties increased modestly mid-decade and then stagnated. Resistance to black women's voices in rural community organisations was acute: ideally, women were to be seen and not heard. But by mid-decade that position was under attack. Walker (1996) recounts an exchange during a meeting in the Natal Midlands prompted by an NGO worker's suggestion to elect women to a committee:

> A woman's voice came out of the crowd and said, 'But we are not allowed to speak' . . . An old man said, 'It has always been said that men are better than women, but I know there are some women here who can do things better than some men.' There was much clapping of hands by the women. A man stood up and said, 'A woman will not be over me as long as I live.' There was much noise after this. Another man then got up and said, 'OK, it's all right now for women to take over, because the tough fight with the government for land is now over.' At this an older woman responded that he was being unfair since women had also fought the battle for more land. (146–7)

While women's public speech was controversial and its value publicly questioned, it was not impossible for women to make themselves heard. NGOs in the immediate post-apartheid period challenged women's limited voice in

rural areas, hoping to provide a platform for them to be heard. Unfortunately, NGOs were as susceptible to sexism as were other institutions. NGO researcher Clare Hansmann noted: 'Project workers will talk to the men on the water committees because they want to get things done quickly and they know that men will be able to take decisions.'[41] Rural women reported being dis-empowered by NGO project consultants who spoke English, used jargon and 'called meetings at short notice and wanted the women to deal with many "complicated questions" in a short space of time' (Motala 2000, 20–1). NGOs in rural and urban areas ignored the impact of women's domestic responsibil-ities on their availability, their lack of experience in community decision making and their limited education. Surface efforts at inclusion worsened women's marginalisation, producing alienated bystanders instead of empowered citizens.

While unions made some efforts to listen to women's voices, they also found ways to edit the conversation. Women's conferences in the late 1980s were spaces for union women to gather and formulate demands, from equitable taxation to shared domestic responsibilities. But the male leadership defined the majority of the women's programmes as 'community issues' outside their purview and refused endorsement. The interdependence of civil society and the family was denied. By the early 1990s, leadership appeared more flexible and agreed to women's institutions within the union, ostensibly to enhance their voice in shaping union policy. COSATU established a women's coordinator and gender forums in a few cities. The forums functioned as internal counter-publics, providing members with space to discuss sexual harassment and build skills and confidence.

By 1994, COSATU established a women's forum in all its regions. But men in the regions attacked women's forums as divisive and criticised women's cooperative leadership styles as weak and ineffective. Male domination permeated all regional union meetings – even women's meetings. As Fiona Dove reported, 'You'd find men at a women workers' conference as leaders of a delegation. They said the women needed their help' (Telela 1994, 15). Women's coordination between regions was generally poor, and female leaders were overextended. Financial support was available only at the national level. The few successful women's forums experienced isolation and enjoyed little power. Judy Mulqueeny insists that gender consciousness within the trade unions had stalled by 1996, noting that while some men within the unions 'are very advanced in gender theory . . . practically they don't implement it'.[42]

As we see throughout this collection, striking divisions between ideology and practice emerge in each of the case studies across a wide span of organisations. In line with these findings, a 2005 survey found that women were less likely to participate in union activities and felt they had less influence with their shop stewards than did men (NALEDI 2006, 32). Instead of women's voices being silenced, as they had been before democratisation, they were redirected, co-opted and ignored.

Political parties did a bit better in instituting measures to support women's leadership, particularly the ANC. Yet women in the ANC criticised their party for limiting women's ability to speak and be heard. 'Does representation mean participation? We feel no,' insisted Mohau Pheko, leader of the WNC. 'We still have a situation where men stand at the feast table while women [can only] smell the hors d'oeuvres.'[43] As the ANC tightened party control, women's dependency on the male-dominated party leadership increased. Within the organisation, women's presence was becoming more symbolic, as party elites pursued centralisation, encouraging women to be grateful and dependent supplicants, not vocal members.

The elections in 1999 exemplified the ways in which political parties limited women's voices. Registration and opinion polls suggested that a space for women's agency within the parties was possible. Women exceeded men in their voter registration level and their support for female candidates. By 1999, a gender gap had emerged in election issues, with more women than men approving gender quotas in political parties and participation in decision making. Yet a research report and survey conducted by the Commission on Gender Equality (CGE) in 1999 found that candidates were not targeting women as an interest group, that the campaigns were male dominated and that women running on party lists were not promoted by the parties, leading to their 'virtual invisibility as political leaders or candidates' (CGE 1999). Women rarely served as party spokespersons, and no party demanded better media representation for their female candidates. A CGE meeting for political parties to explain their policies on women was poorly attended and this was interpreted as a lack of commitment to gender equality. Not surprisingly, South African gender analysts concluded that 'women have not received the recognition they deserve' by party leaders.[44] Against their better interests, political parties ignored women's issues and their own women politicians.

The limited opportunities for women to voice their interests in civics, unions and political parties did not stop them from challenging the status

quo. Indeed, gender issues were on the agenda of many organisations, and efforts at improving women's descriptive representation were frequent. However, while women's challenges occasionally met with success, too often their victories were short-circuited.

Sometimes persistent male dominance backfired, leading women to successfully retaliate. In one community organisation, women managed to formally marginalise their minority male membership, upending the patriarchal rules of the game. A woman in the organisation explained: 'Men are quite dominating, so the women have taken a decision that men can attend and make verbal inputs, but they cannot make important decisions' (as quoted in White 1998, 16). In this case, majority rule trumped patriarchal privilege. Such a direct, successful assault was atypical.

The unpopularity of direct confrontation was clearly evident in the struggle over women's leadership in COSATU. In 1997, the organisation's only female national officer, Connie September, concluded an eighteen-month investigation by recommending a gender quota of 50 per cent by the year 2000 to increase women's presence in union leadership positions. The Report to the September Commission noted that the union's support for affirmative action 'applies to everyone except COSATU'. At its sixth congress, COSATU was thus expected to approve a quota without opposition.

Yet, despite the support for a quota by the ANCWL, the South African Communist Party (SACP) and the COSATU general secretary, the COSATU unions rejected the quota, instead supporting a gender training programme to promote women in the ranks and a declaration of union solidarity on gender equality. Opponents argued that quotas imposed from the top down would undermine democratic accountability and smacked of tokenism. Nevertheless, COSATU endorsed quotas for blacks (males) in the workplace. Although the September Commission challenged male hegemony and successfully inserted the issue of women's representation into union debates and policy making, COSATU's gender imbalance persisted.[45] As Joyce Pekane pointedly noted, even when a handful of women advanced to the NEC, 'the men who don't want the quota still maintain the status quo' (Meer 2002, 7). A 2005 survey of priorities for change within COSATU ranked gender and the empowerment of women at the very bottom.

Women's challenges to the status quo that were pursued through backroom channels appeared more successful, but were dependent on elite favouritism.

In the ANC, contestation over the women's quota on the party lists was not won through popular debate, but was handled with discretion. Instead of publicly exposing sexism and inequality within the party and demanding their rights, women had to achieve inclusion behind closed doors, leaving inequality safely under the control of party leaders. While winning the quota enabled women to challenge business as usual in parliament and momentarily establish good conditions of debate, the sexist organisational procedures within the ANC went largely uncontested, limiting the potential of women's greater presence on the party lists to undermine patriarchal norms in the party hierarchy.

Clearly, women in civil society were not passively in acceptance of male domination. Their strategies for coping with the problem varied. Most chose to maximise their autonomy through membership in private associations such as church organisations, burial societies and *stokvels*, pursuing essential practical needs. This was also the path of least resistance, confirming women's limited access, voice and contestation within mainstream civic and political associations. Yet a large number of women did become members of civics, unions and political parties, and a few challenged their marginalisation: they spoke their minds, demanding quotas and policy reform. Those challenges, like women's access to leadership and voice, became increasingly rare after 1998.

An analysis of women's agency in South African civil society substantiates feminist claims that the public and the private are mutually constitutive – that the market, family and state deeply shape agency in civil society. Women repeatedly complained that sexist attitudes and the sexual division of labour limited their time and energy to devote to civic and political organisations. Women activists, union members and party stalwarts noted resistance from family members, the double burden, lack of safe transport and inconvenient hours for meetings. They recognised their limited experience and skills and the lack of institutional support, and were aware that they had internalised patriarchal norms and were susceptible to intimidation and sexual harassment. A wide range of women insisted their male colleagues gave them little respect, taking more notice of their physical appearance than of what they said. The South African case thus underscores the validity of the claim that civil society, market and family intersect in ways that negatively reinforce women's subordination.

Evidence of the interdependence of the public and the private is not surprising. The role of the democratising state in shaping women's agency in civil society is more noteworthy. In South Africa, the post-apartheid state affected public debate conditions in several ways. First, as Dryzek (2000) has theorised, the inclusion of marginalised groups in the state depleted the ranks and resources of civil society. While the vast majority of civil society found the transition difficult to navigate, the WNC was eviscerated. Second, as theorists of democracy have long warned, the state can co-opt civil society (Dryzek 2000; Habermas 1984). In South Africa, ANC consolidation eroded the independence of civil society and took an additional toll on women's agency. Women who were independent-minded activists demanding more than the party leadership was willing to deliver became inconvenient and expendable.

But the state also had positive effects, as feminist scholars of public policy have long recognised. Parliament provided space for inspired feminist leadership and good debate conditions, offering women's groups in civil society powerful collaborators. While cooperation was contingent on the interests of elite ANC leaders, it nevertheless produced impressive legislative reform. Clearly, scholars and activists are right to be wary of state threats to the autonomy of civil society, but in South Africa the instrumental benefits of women's cooperation with the state were substantial. Moreover, effective cooperation offered women new opportunities to become engaged, active citizens. Women's experience in South Africa confirms that, at times, some state institutions can be more welcoming than mainstream civil society, and may be an undervalued resource for pursuing greater openness and inclusiveness in public life.

Conclusions

The South African case makes it clear that feminists need a better appreciation for access, voice and contestation throughout civil society to analyse women's ability to achieve full citizenship. The instrumentalist attitude of many feminists towards civil society has meant that they have under-theorised the importance of democratic participation. Many have also under-theorised its scope, locating citizenship in the voting booth, the state and counter-publics, but not in powerful, publicly oriented civil society. Both are a mistake. Full citizenship means more than influencing legislation. Power and influence in

civil society are critical for publicly expressing one's belonging in the community, for discovering and continuously reformulating the terms of one's membership, and for recreating and transforming that community. To do this requires agency in and across civic and political associations.

A number of factors limit women's access, voice and contestation in South African civil society. Indeed, the South African case illuminates the ways the family, market and state shape women's agency in civil society. Women continued to be the majority of the unemployed and the poor, charged with the heaviest load of domestic responsibilities, while being socialised to accept those inequalities. Family and market forces were readily identified by South African women as impediments to their progress, but the role of the state was less evident and more complex.

Although the state ultimately proved a threat to women's organisations, women in parliament and select state institutions also inspired and collaborated with them. The state was both friend and foe. Legislatures where talented feminist leadership was concentrated during the early years of the South African democratic transition and judiciaries that upheld constitutional principles of gender equality became important allies.[46] Moreover, the discursive political opportunity structure that endorsed substantive citizenship would likely have favoured women's demands for greater agency in civil society (Hassim 2005, 160–1). However, during the transition, feminist attention focused on how to make the state accountable to civil society (not on how to make civil society accountable to the state) and endorsed principles of non-sexism and non-racism. Nevertheless, South Africa offers a situation in which select state institutions and the WNC, coupled with the dominant political discourse of citizenship, might have put demands for an open and inclusive civil society on the public agenda.

Theorists of civil society are aware that the state might promote marginalised groups in civil society. They have argued that state support for equality in civil society is essential. Whether that support entails advocacy of the weakest associations (Walzer 2002), liberal rights that provide 'essential preconditions' for communication (Chambers 2002, 97) or anti-discrimination legislation (Phillips 2002), they envision the state in a supportive role, with civil society in the lead. Yet an analysis of women's agency in South Africa suggests that a supportive state role may need to be more extensive than these theorists envision.

In South Africa, basic liberal rights offer insufficient 'preconditions' for equitable communication. The most powerful organisations in civil society – political parties and labour unions – have unremittingly resisted women's advancement in leadership and have consistently deflected women's policy demands and challenges to the institutional status quo. South African civil society's institutional decentralisation and feminist activists' focus on the state have made the task of securing equality in civil society even more difficult. The capacity of women's organisations and social movements to promote a civil society that is resistant to the distorting effects of money and power, or to counter sexist inequality, is thus quite low.

The ANC certainly raised the expectations of women in civil society, advocated support for gender equality, inspired many women leaders and advanced important legislation, but it did little to directly promote women's power and influence in civil society. This is unfortunate, as moving towards this goal would have constructed women as full citizens. As South Africa continues the process of democratic nation building, the legacies of the women's movement and the continuing dynamism of women's organisations constitute a basis for pride and optimism. The future can be worthy of the past if women's power and influence are established throughout civil society so that all South Africans might claim the rich public life they deserve.

Notes

This chapter draws on the author's doctoral dissertation, *Just Debate: Culture and Gender Justice in the New South Africa*, New School for Social Research, 2006. The University of Virginia, the Department of Political Science at the University of the Witwatersrand and the Transregional Centre for Democratic Studies in Cape Town provided field-research support. Participants at the African Studies Association Conference in November 2006 offered insights on an earlier draft. In addition to helpful comments from the editors, three anonymous reviewers provided invaluable suggestions.

1. This is true even when middle-class women moved into civil society during the nineteenth century. Their presence in voluntary associations dedicated to the moral improvement of the poor was characterised not as public activism but as private charity.

2. For an early and in-depth discussion of the applicability of the concept 'civil society' to Africa, see Harbeson, Rothchild and Chazan (1994). For a more recent analysis of civil society in Africa, see Gyimah-Boyadi (2004).

3. Not all women involved in these efforts were feminists, and some men were feminists. In

this chapter, the term 'feminists' indicates those who oppose inequitable power relations on the basis of sex. I follow Hassim (2005, 2006) in conceptualising feminists along a continuum from inclusionary to transformative. At one end are inclusionary feminists, who aim to improve women's political representation. At the other end are radical transformative feminists, those who attack all forms of economic, social and political forms of oppression, domination and exploitation.

4. Black, coloured (meaning 'mixed-race') and white racial designations inherited from the apartheid era continue to change in meaning but remained salient categories throughout the period examined here.

5. This is not to suggest that civil society is the only terrain for exercising full citizenship, but that it is a vital arena of the public sphere that must not be neglected. For a feminist critique of the overvaluing of civil society, see Jaggar (2005).

6. I use this formulation to expose the differential and multiple forms of domination, exploitation and oppression specific women in South Africa experience, not to assign this group of women the symbolic status of disempowered victims. I would like to thank Linzi Manicom for insisting on this clarification.

7. In this chapter, 'gender' refers to the processes that create, sustain and reproduce oppression, domination and exploitation on the basis of sex. For a discussion of gender as a process, see the dialogue in *Politics and Gender* by Beckwith (2005a), Hawkesworth (2005) and Htun (2005).

8. Feminist analysts working on eastern Europe are an interesting deviation from this pattern. See Einhorn and Sever (2005).

9. Goetz and Hassim are an exception on this latter point. Albertyn (2003) has recognised the importance of targeting society and culture, arguing that the South African women's movement has directed too much of its attention towards the state, to the detriment of the politics of the personal. Contemporary feminist scholars interested in challenging gendered cultural and social practices often focus on performativity (e.g. Butler 1990).

10. Phillips's explanations for this failure are unsatisfactory (2002). The state, much like civil society, is part of 'the public', is interdependent with the private, has instrumental value for advocates of gender justice and is clearly gendered. Yet feminists have not refrained from theorising gender and the state.

11. South African feminists and feminist scholars have long grappled with this issue, however, and attention to gender in civil society is increasingly integrated in empirical analyses. See note 34 for recent examples.

12. Feminist scholars of women's survivalist organisations have criticised Molyneux's distinction, arguing that strategic gender interests are often central in the formation of poor women's survivalist groups (Tripp 2000; Tamale 2001). However, these categories are useful for identifying agendas and groups that directly and publicly aim to challenge gender, class and other forms of subordination.

13. Civics (neighbourhood associations) and political parties in South Africa are not as distinct as Young's typology suggests. Civics engaged directly in political protest in the early 1990s and competed with local councillors for influence and resources after the transition. However, they were much less successful in providing members with political opportunities to influence state policy (Heller 2003; Cherry, Jones and Seekings 2000). Another exception to Young's

typology is the family, which in some societies reaches across all three of Young's levels and is also the primary unit of economic production.

14. Young argues that private associations can be 'depoliticising or brazenly self-regarding' (Young 2000, 162). However, individual women may gain public stature and prestige through membership in some types of private association, such as kinship groups. Weldon also sees positive potential in private associations, such as solidarity and consciousness-raising. Nevertheless, her analysis of feminist civil society in the United States confirms that civic and political associations have a *'greater direct effect on policy processes than more inwardly-oriented activities'* (Weldon 2005, 204; her italics).

15. Non-governmental organisations (NGOs) do not appear on the list, perhaps because most NGOs in South Africa do not have a membership base but are sustained by international donors.

16. Women's groups that are survivalist but engage in civic and political activities are included. A wide range of social movements have emerged in South Africa since the transition to democracy. They aim to shape public opinion and state policy (some, such as the Treatment Action Campaign, explicitly work to enhance active citizenship) and should be included in my analysis. Unfortunately, data on women's participation in these organisations are insufficient, so these movements are only intermittently integrated into the chapter.

17. Young (2000) suggests a wide range, from articulate speech making, to passionate disruption and dissent, to storytelling, ceremony and public acknowledgement. The capacity to develop these skills and an awareness of one's interests requires counter-publics, or what Weldon (2005, 2006) refers to as 'separate organizations for disadvantaged social groups', such as 'feminist civil society'.

18. The Chambers and Kymlicka book is particularly useful here because the editors asked each contributor to become a representative of a specific tradition and to respond to their set of questions about civil society (2002, 3). I refer to Phillips's approach as 'inclusionary', as she focuses on the exclusion of women from civil society and how to challenge it.

19. This discussion is an expanded version of my analysis of women's participation in civil society during the liberal moment (Walsh 2006).

20. The WNC was an umbrella organisation of more than 70 women's groups from across the racial, class and political spectrum. Some of the organisations in the WNC were feminist, but not most. The WNC produced a Women's Charter, itemising women's strategic and practical concerns culled from a country-wide consciousness-raising campaign. The WNC's charter is available at www.anc.org.za/ancdocs/policy/womchart.htm.

21. While efforts were made to involve all the regions, security concerns, funding problems, lack of transport and disorganisation within the upper echelon of the organisation caused problems throughout the campaign, particularly in the Natal region (WNC 1994a, 7–8).

22. The WNC has been described by some outsiders as dominated by middle-class women who were not active in the liberation struggle. Yet highly politicised ANC women from widely varying backgrounds led the organisation. They also had different political agendas that nearly incapacitated the coalition.

23. The Victoria Mxenge Association is an excellent example of a private association that effectively promoted women's practical and strategic interests in civic and public life. For additional

examples, see Hanna Mhlongo, 'KZN Women's Organisations Make Proposals to Gender Policy', *Natal Witness*, 14 August 1997; Doris Ravenhill, 'Her Votes Count', *Sowetan*, 8 March 1999; Saint P. Molakeng, '"Women Musn't Mimic Men"', *Sowetan*, 3 August 1998; 'Women Demand a Say in Traditional Courts', *Agenda* 43 (2000), p. 73.

24. This pattern was particularly evident in the debate over customary marriage reform (Goldblatt and Mbatha 1999; Likhapa Mbatha, researcher, Gender Research Project, interviewed by the author, Johannesburg, 9 July 2003).

25. RWM members experienced dramatic change: 'Where I live, it is not like before when the chiefs, *kgotla's* [community meeting], or the government used to tell us what to do. Women no longer accept anything until they have met and discussed things' (activist Yvonne Padi from Modderfontein as quoted in *Speak* 1994, 27).

26. Charity Bhengu, 'Women Look to Equal Say in Polls', *Sowetan*, 18 November 1998; Pamela Dube, 'SA Women "Not Treated Equally"', *Sowetan*, 23 October 1998. 'Issue networks' are associations of activists, bureaucrats, lawyers, elected representatives and other specialists who work behind the scenes to pass legislative reform (Htun 2003, 5). 'Issue networks' are associations of activists, bureaucrats, lawyers, elected representatives and other specialists who work behind the scenes to pass legislative reform (Htun 2003, 5).

27. Michelle Festus, gender coordinator, National Land Committee. Interviewed by the author, Johannesburg, 29 July 2003.

28. Sandra Botha, MP for the Democratic Alliance. Interviewed by the author, Cape Town, 25 July 2003.

29. Festus interview.

30. Civics are strongest in black African townships and have been studied extensively (see, for example, Cherry, Jones and Seekings 2000; Seekings 1998; Adler and Steinberg 2000; Van Kessel 2000).

31. The Johns Hopkins 2002 study catalogued women's considerable presence in the non-profit sector, but failed to distinguish between public and private associations (Russell and Swilling 2002). Smaller, 'snapshot' studies of women's participation in civil society are available. For one example, see Hirschmann (1994).

32. This last point I owe to Elke Zuern, private communication.

33. For an exception, see Cullinan (1992).

34. That pattern was replicated in many of the new social movements, such as the Soweto Electricity Crisis Committee and Anti-Privatisation Forum of Gauteng. Members are predominantly 'grannies', but the movements are led by men (Egan and Wafer 2006; Buhlungu 2006; Paley as cited in Hassim 2005, 258). Women's leadership in the Concerned Citizens Forum and Bayview Flat Residents Association are exceptions (Dwyer 2006; Benjamin 2007). The Landless People's Movement has been depicted as sexist, limiting women's voice and access by ignoring the sexual division of labour (Greenberg 2006). Not surprisingly, the new social movements tend to ignore women's strategic interests (Hassim 2005).

35. In 1993, estimated COSATU membership was 1.2 million, making it the largest trade union federation in South Africa. By 2001 its membership had increased, and included 40 per cent of the waged labour force (Lodge 2001, 170).

36. Women did hold some upper-level positions at the regional and local levels, although most often as treasurers.

37. As quoted in M. Naidoo, 'Union Women Adopt "Charter"', *Teaser*, 29 September 1995.
38. Mummy Japhta, gender coordinator, COSATU. Interviewed by the author, Johannesburg, 30 July 2003.
39. Regional COSATU offices did, however, offer office support to SEWU (Devenish and Skinner 2006, 264).
40. Suzanne Vos, MP for the Inkatha Freedom Party. Interviewed by the author with Julie Ballington, Cape Town, 23 July 2003.
41. Kate Skinner, 'Making Sure Water Works', *Sowetan*, 30 July 1998.
42. Judy Mulqueeny, former SACP Central Committee member. Telephone interview by the author, 27 July 2003.
43. Judith Matloff, 'For South Africa's Women Hopes Still Remain Thwarted', *Christian Science Monitor*, 89 (172): 31 July 1997.
44. The analysts were Shireen Hassim, Sheila Meintjes, Julie Ballington, Rebecca Holmes and Shireen Motara.
45. In 2000, women constituted 94 per cent of the administrative staff and 12 per cent of organisers (*Shopsteward* 2000). Strategies to provide women with access to union positions remained voluntary, and gender committees and coordinators were marginalised throughout the period.
46. Cathi Albertyn (2003, 608) has argued that equality principles in the Constitution can legitimise women's rights in the private sphere. I am suggesting a similar strategy can be used to promote women's full citizenship.

References

Adler, G. and J. Steinberg, eds. 2000. *From Comrades to Citizens: The South African Civics Movement and the Transition to Democracy*. Basingstoke: Macmillan Press; New York: St. Martin's Press.

Albertyn, C. 2003. 'Contesting Democracy: HIV/AIDS and the Achievement of Gender Equality in South Africa'. *Feminist Studies* 29 (3): 595–615.

Arneil, B. 2006. *Diverse Communities: The Problem with Social Capital*. Cambridge: Cambridge University Press.

Beckwith, K. 2005a. 'A Common Language of Gender?' *Politics and Gender* 1 (1): 128–36.

———. 2005b. 'The Comparative Politics of Women's Movements: Teaching Comparatively, Learning Democracy'. *Perspectives on Politics* 3 (3): 583–96.

Benjamin, S. 2007. 'The Feminization of Poverty in Post-apartheid South Africa'. *Journal of Developing Societies* 23 (1–2): 175–206.

Britton, H.E. 2006. 'Organising against Gender Violence in South Africa'. *Journal of Southern African Studies* 32 (1): 145–63.

Buhlungu, S. 2006. 'Upstarts or Bearers of Tradition? The Anti-privatisation Forum of Gauteng'. In *Voices of Protest: Social Movements in Post-apartheid South Africa*, edited by R. Ballard, A. Habib and I. Valodia. Pietermaritzburg: University of KwaZulu-Natal Press.

Butler, J. 1990. *Gender Trouble: Feminism and the Subversion of Identity*. London: Routledge.

Chambers, S. 2002. 'A Critical Theory of Civil Society'. In *Alternative Conceptions of Civil Society*, edited by S. Chambers and W. Kymlicka. Princeton, NJ: Princeton University Press.

Chambers, S. and W. Kymlicka, eds. 2002. *Alternative Conceptions of Civil Society*. Princeton, NJ: Princeton University Press.

Cherry, J., K. Jones and J. Seekings. 2000. 'Democratization and Politics in South African Townships'. *International Journal of Urban and Regional Research* 24 (1): 889–905.

Commission on Gender Equality (CGE). 1999. 'Review of the 1999 Gender Elections – a Gender Perspective'. Braamfontein: Commission on Gender Equality.

Community Agency for Social Enquiry (CASE). 1998. 'The State of Civil Society in South Africa: Past Legacies, Present Realities and Future Prospects'. Johannesburg: Community Agency for Social Enquiry.

Cullinan, K. 1992. 'Building a Non-Sexist Civic'. *Reconstruct* 6 (October): 9.

Devenish, A. and C. Skinner. 2006. 'Collective Action in the Informal Economy: The Case of the Self-Employed Women's Union, 1994–2000'. In *Voices of Protest: Social Movements in Post-apartheid South Africa*, edited by R. Ballard, A. Habib and I. Valodia. Pietermaritzburg: University of KwaZulu-Natal Press.

Dryzek, J.S. 2000. *Deliberative Democracy and Beyond: Liberals, Critics, Contestations*. Oxford: Oxford University Press.

Dwyer, P. 2006. 'The Concerned Citizens Forum: A Fight within a Fight'. In *Voices of Protest: Social Movements in Post-apartheid South Africa*, edited by R. Ballard, A. Habib and I. Valodia. Pietermaritzburg: University of KwaZulu-Natal Press.

Edwards, R. 1997. 'New Women's Movement: Pap and Bread Are Not Enough'. *Agenda* 33: 33–6.

Egan, A. and A. Wafer. 2006. 'Dynamics of a "Mini Mass Movement": Origins, Identity and Ideological Pluralism in the Soweto Electricity Crisis Committee'. In *Voices of Protest: Social Movements in Post-apartheid South Africa*, edited by R. Ballard, A. Habib and I. Valodia. Pietermaritzburg: University of KwaZulu-Natal Press.

Einhorn, B. and C. Sever. 2005. 'Gender, Civil Society and Women's Movements in Central and Eastern Europe'. In *Gender and Civil Society: Transcending Boundaries*, edited by J. Howell and D. Mulligan. London and New York: Routledge.

Fraser, N. 1996. 'Rethinking the Public Sphere'. In *Habermas and the Public Sphere*, edited by C. Calhoun. Cambridge, MA: MIT Press.

Glaser, D. 1997. 'South Africa and the Limits of Civil Society'. *Journal of Southern African Studies* 23 (1): 5–25.

Goetz, A.M. and S. Hassim, eds. 2003. *No Shortcuts to Power*. London and New York: Zed Books; Cape Town: David Philip.

Goldblatt, B. and L. Mbatha. 1999. 'Gender, Culture and Equality: Reforming Customary Law'. In *Engendering the Political Agenda: A South African Case Study*, edited by C. Albertyn. Johannesburg: Centre for Applied Legal Studies.

Greenberg, S. 2006. 'The Landless People's Movement and the Failure of Post-apartheid Land Reform'. In *Voices of Protest: Social Movements in Post-apartheid South Africa*, edited by R. Ballard, A. Habib and I. Valodia. Pietermaritzburg: University of KwaZulu-Natal Press.

Gyimah-Boadi, E., ed. 2004. *Democratic Reform in Africa: The Quality of Progress.* Boulder, CO: Lynne Rienner Publishers.

Habermas, J. 1984. *The Theory of Communicative Action I: Reason and the Rationalization of Society.* Boston: Beacon Press.

Harbeson, J.W., D. Rothchild and N. Chazan, eds. 1994. *Civil Society and the State in Africa.* Boulder, CO and London: Lynne Rienner Publishers.

Hassim, S. 2003. 'Representation, Participation and Democratic Effectiveness: Feminist Challenges to Representative Democracy in South Africa'. In *No Shortcuts to Power,* edited by A.M. Goetz and S. Hassim. London and New York: Zed Books; Cape Town: David Philip.

———. 2005. *Women's Organizations and Democracy in South Africa: Contesting Authority.* Madison: University of Wisconsin Press.

———. 2006. 'The Virtuous Circle of Representation: Women in African Parliaments'. In *Women in African Politics,* edited by G. Bauer and H. Britton. Boulder, CO: Lynne Rienner Publishers.

Hawkesworth, M. 2005. 'Engendering Political Science: An Immodest Proposal'. *Politics and Gender* 1 (1): 141–56.

Heller, P. 2003. 'Reclaiming Democratic Spaces: Civics and Politics in Post-transition Johannesburg'. In *Emerging Johannesburg: Perspectives on the Post-apartheid City,* edited by R. Tomlinson, R.A. Beauregard, L. Bremner and X. Mangcu. New York: Routledge.

Hirschmann, D. 1994. *Urban Women and Civil Society in the Eastern Cape.* Grahamstown: Institute of Social and Economic Research, Rhodes University.

Howell, J. 2005. 'Introduction'. In *Gender and Civil Society: Transcending Boundaries,* edited by J. Howell and D. Mulligan. London and New York: Routledge.

Htun, M. 2003. *Sex and the State: Abortion, Divorce, and the Family under Latin American Dictatorships and Democracies.* Cambridge: Cambridge University Press.

———. 2005. 'What It Means to Study Gender and the State'. *Politics and Gender* 1 (1): 157–66.

Ismail, S. 1998. 'When Women Take Control – Building Houses, People and Communities!' *Agenda* 38: 51–62.

Jaggar, A. 2005. 'Civil Society, State and the Global Order'. *International Feminist Journal of Politics* 7 (1): 3–25.

Klandermans, B., M. Roefs and J. Olivier, eds. 2001. *The State of the People: Citizens, Civil Society and Governance in South Africa, 1994–2000.* Pretoria: Human Sciences Research Council.

Landes, J. 1988. *Women and the Public Sphere in the Age of the French Revolution.* Ithaca and London: Cornell University Press.

Lodge, T. 2001. *Politics in South Africa: From Mandela to Mbeki.* Oxford and Cape Town: James Currey and David Philip.

Mayekiso, M. 1996. *Township Politics: Civic Struggles for a New South Africa.* New York: Monthly Review Press.

Meer, S. 2002. 'Women in Leadership'. *Naledi Policy Bulletin.* March 6–7. www.naledi.org.za/pubs/2002/meer1.pdf. (Accessed on 1 August 2007.)

Molyneux, M. 1998. 'Analysing Women's Movements'. *Development and Change* 29 (1): 219–45.

———. 2001. *Women's Movements in International Perspective: Latin America and Beyond.* New York: Palgrave.

Motala, S. 2000. 'Rural Women Demand Meaningful Representation in Local Government'. *Agenda* 45: 14–19.

National Labour and Economic Institute (NALEDI). 2006. 'The State of COSATU'. August. www.naledi.org.za/pubs/2006/The_state_of_COSATU_Report.pdf. (Accessed on 1 August 2007.)

Pateman, C. 1988. 'The Fraternal Social Contract'. In *Civil Society and the State*, edited by J. Keane. London: Verso.

Phillips, A. 2002. 'Does Feminism Need a Conception of Civil Society?' In *Alternative Conceptions of Civil Society*, edited by S. Chambers and W. Kymlicka. Princeton, NJ: Princeton University Press.

Rowbotham, S. and S. Linkogle, eds. 2001. *Women Resist Globalization: Mobilizing for Livelihood and Rights*. London and New York: Zed Books.

Russell, B. and M. Swilling. 2002. 'The Size and Scope of the Non-profit Sector in South Africa'. Johannesburg and Durban: School of Public and Development Management and the Centre for Civil Society.

Seekings, J. 1998. 'Civic Organisations During South Africa's Transition to Democracy, 1990–1996'. In *The Post-colonial Condition: Contemporary Politics in Africa*, edited by D.P. Ahluwalia and P. Nursey-Bray. New York: Nova Social Science.

The Shopsteward. 2000. 'Gender Policy'. 9 (3) September. www.cosatu.org.za/shop/shop0903/shop0903-04.htm. (Accessed on 6 May 2008.)

Speak. 1994. 'This Land is Our Land'. May: 27.

Tamale, S. 2001. 'Between a Rock and a Hard Place: Women's Self-Mobilization to Overcome Poverty in Uganda.' In *Women Resist Globalization: Mobilizing for Livelihood and Rights*, edited by S. Rowbotham and S. Linkogle. London and New York: Zed Books.

Telela, R. 1994. 'Women Make Their Voices Heard'. *Speak*, November: 19.

Tripp, A.M. 1994. 'Rethinking Civil Society: Gender Implications in Contemporary Tanzania'. In *Civil Society and the State in Africa*, edited by J.W. Harbeson, D. Rothchild and N. Chazan. Boulder, CO and London: Lynne Rienner Publishers.

———. 2000. *Women and Politics in Uganda*. Oxford: James Currey.

———. 2005. 'Women in Movement: Transformations in African Political Landscapes'. In *Gender and Civil Society: Transcending Boundaries*, edited by J. Howell and D. Mulligan. London and New York: Routledge.

Van Donk, M. and M. Maceba. 1999. 'Women at the Crossroads: Women in Governance'. *Agenda* 40: 18–22.

Van Kessel, I. 2000. *'Beyond our Wildest Dreams': The United Democratic Front and the Transformation of South Africa*. Charlottesville: University of Virginia Press.

Walker, C. 1996. 'Reconstructing Tradition: Women and Land Reform'. In *Reaction and Renewal in South Africa*, edited by P.B. Rich. Basingstoke: Macmillan Press.

Walsh, D. 2006. 'The Liberal Moment: Women and Just Debate in South Africa'. *Journal of Southern African Studies* 32 (1): 85–106.

Walzer, M. 2002. 'Equality and Civil Society'. In *Alternative Conceptions of Civil Society*, edited by S. Chambers and W. Kymlicka. Princeton, NJ: Princeton University Press.

Weldon, S.L. 2002. *Protest, Policy, and the Problem of Violence against Women: A Cross-National Comparison*. Pittsburgh: University of Pittsburgh Press.

———. 2005. 'The Dimensions and Policy Impact of Feminist Civil Society: Democratic Policy-Making on Violence against Women in the Fifty US States'. In *Gender and Civil Society:*

Transcending Boundaries, edited by J. Howell and D. Mulligan. London and New York: Routledge.

———. 2006. 'Inclusion, Solidarity and Social Movements: The Global Movement Against Gender Violence'. *Perspectives on Politics* 4 (1): 55–74.

White, C. 1998. 'Democratic Societies? Voluntary Association and Democratic Culture in a South African Township'. *Transformation* 36: 1–36.

Women's National Coalition General Secretariat Report (WNC). 1994a. 'The Women's National Coalition, National Conference, Kempton Park, World Trade Centre'. Johannesburg, 25–27 February.

———. 1994b. *The Origins, History and Process of the Women's National Coalition: Summary Report of the Women's National Coalition Research*. Marshall Town: Women's National Coalition.

Young, I.M. 2000. *Inclusion and Democracy*. Oxford: Oxford University Press.

Gender Equality by Design

The Case of the Commission on Gender Equality

SHEILA MEINTJES

WHILE SOUTH AFRICA'S democratic project after 1994 sought to reshape the way in which South Africans would participate in creating a new non-racial national consciousness, it was not uncontested. However, the national debate about a new constitutional dispensation had initially excluded any reference to women's issues or to the notion of gender equality. This gave rise to a coordinated and unusual coalition of a diversity of women's pressure groups and organisations to ensure that these issues became part of the democratic discourse. A Women's National Coalition (WNC) was formed in 1992 across the divides of race, class and ideology. The coalition's objective was to inject a gender perspective into the discussions and negotiations about South Africa's Constitution and the country's future and to influence the shape of the institutions that would oversee the creation of a democratic state and society. Fifteen years later, the question of how effective these institutions had been in promoting gender equality was debated by feminists and gender activists alike.

The outcome of the post-apartheid settlement saw the development of a broadly agreed-upon strategy among members of the WNC to create a clutch of institutional mechanisms to promote gender equality in South Africa, exemplifying a form of inclusionary feminism driven by, and perhaps at the expense of, a more transformational feminist agenda (Albertyn 1995; Hassim 2005a). A progressive Constitution drew together both liberal and social democratic rights, formal and substantive, that promised both a political and a social transformation in the country. Through the Constitution, a range of

bodies to promote and protect democratic rights was established (in Chapter 9 of the Constitution). The Commission on Gender Equality (CGE) was one of these bodies. Its specific mandate was to monitor the progress of gender equality and to promote and protect gender rights in the state and in society. This was one strand of the institutional strategy. Another was to ensure that feminists in parliament create a mechanism to monitor legislation and to ensure that the gender implications were well understood – thus the establishment of the Joint Monitoring Committee (JMC) on the Quality of Life and Status of Women. A third strategic site of state institutional development was the Office on the Status of Women (OSW) in the administration – to be situated preferably at the highest level of the state, the presidency. Civil society and the women's movement tended to think about their relationship with these organisations as one of accountability: these bodies were the creatures of civic virtue and civic action and should be accountable to the women's movement broadly conceived. How that accountability would operate was less clear.

Because gender norms shape sex and gender relations in society, the struggle for full gender equality challenged identities in ways that racial equality did not (which is not to suggest that the latter is not contested, as Goldberg's work shows (1993, 2001)). In South Africa, the discourse around gender in most institutional environments located it as a 'women's issue' and thus the responsibility of women. In practice, the effect was that many non-feminists were able to work within the gender sector without having to deal with the more challenging aspects of the 'transformation' of gender relations and gender norms. Gender mainstreaming became the focus of the institutional strategy in promoting gender equality after 1994, which in effect took the form of demanding the presence of women in a 'critical mass', established internationally as 30 per cent (Baker and Van Doorne-Huiskes 1999).

The translation of gender mainstreaming into institutional practice, however, varied in different countries that signed the UN protocols after the Beijing Women's Conference in 1995. In South Africa, the purpose of the gender machinery, particularly the OSW, was to interface with government departments to ensure that gender mainstreaming became a key aspect of policy. Here, the strategy focused on the development of a national gender policy that would ensure that women were provided equal opportunities with men for promotion, training and participation in decision making. The JMC

would monitor the way legislation dealt with gender equity and gender equality. And intersecting with civil society would be an independent constitutional body, the CGE, whose responsibility would be to promote and protect gender equality and democracy, underscoring the dominance of the constitutional prescripts of the Bill of Rights. The growing focus on women meant that a 'women empowerment' model began to emerge as the central approach in the process of promoting gender equity and gender equality in South African state institutions.

Government for transformation

The literature on South Africa's transition has been somewhat triumphalist about the change from apartheid to democracy. Political democratisation and economic restructuring and liberalisation seemed to flow easily within the process of 'elite pacting' in the period of negotiations between liberation and apartheid forces. Although the contest was not without bloodshed, a civil war did not unfold. Feminists, however, have tended to focus on different aspects of the transition – particularly the way in which diverse women's organisations strove to develop gender as a significant variable in the construction of a woman-friendly state and post-apartheid society (Hassim 2005b; Gouws 2005; Fick, Meintjes and Simons 2002; Murray 1994). The WNC drove a women's agenda that saw a remarkable increase in women's political representation after the first democratic election in 1994.

The change from apartheid to democracy instilled a dramatic shift in the balance of race and gender appointments in the transforming state. In the new South African democracy, transforming apartheid-based institutions or building new post-apartheid institutions meant developing them from the artefacts of the struggle for democracy – the vision, values, principles and practices that drove the change in the first place (Albertyn 1994; Hassim 2005a; Meintjes 1998). For gender transformation in the state, the influence of the WNC and its constituents, including the African National Congress Women's League (ANCWL), was significant.

Manicom (2005) argues that the discourse around women, gender and citizenship in South Africa is somewhat 'ambiguous or porous' and 'multivalent'. She suggests that one of the consequences of the constructions given to 'women' as a category in the South African debates was to induce a 'particular hegemonic representation of the relationship between the category

in question . . . and other forms of difference' (Manicom 2005, 28), thus abstracting both gender and women from lived social relations. These other forms of difference referred to race, ethnicity and, above all, class. Manicom's insight is particularly relevant to the way in which *the state* used the concepts of women and gender. However, the WNC was a coalition that placed difference at its centre, and the descriptive category of 'women' was not intended to essentialise women's experience or their identities. It was the state's appropriation of the women's agenda that tended to create a discourse that reproduced gender 'as binary and heteronormative' (Manicom 2005, 28). Manicom is right that in the policy discourse and even in some academic discourse, 'the term "gender" often stands in for "women" as the subject of gender politics' (Manicom 2005, 29). She argues:

> The 'women' of the politics of transition represented a gendered construction that was integral to the building of an emergent discourse of socio-economic and legal equality and rights-bearing citizenship, one that simultaneously worked to marginalize or down-play identities based on race, class, region and nation. That strong emphasis on 'women' expressed the politics of democracy and non-racialism (as actively espoused by the African National Congress) against other contending constructions of women-citizens in relation to ethno-nationalist or communal identities. (Manicom 2005, 31)

Manicom might even have emphasised gender identity more strongly in her argument. The question would then be how far the discourse of gender-as-women shaped an agenda that limited the nature and possibilities for gender transformation. The subsumption of women as gender meant that other than heteronormative relations and identities were excluded: gay, lesbian, transgendered and intersexed people were theoretically and in practice out of the loop – and, of course, so were men.

The effect of the 'women's' coalition politics of the transition, however, was to open spaces for women's participation in the public sphere in the context of a particular configuration of androcentric (male-centred), heteronormative, gendered power that did not lead to a more inclusive transformation of gender power relations in society. Gay and lesbian organisations were certainly part of the WNC, but the particularities of their concerns were somewhat muted. Their concerns were part of a coalition politics that organised separately in a National Coalition for Gay and Lesbian Equality.

Manicom does not pursue why the ANC downplayed the politics of non-sexism. Indeed, she glosses over the implications of the use of the term 'non-sexist'. Yet its significance was that it might have opened spaces around which gender activism directed towards a change in gender relations could occur. In the context of the struggle against apartheid, however, South African gender activists in the transition to democracy were more concerned about women's representation than about confronting the nature of 'patriarchy' and the androcentric, male-determined social norms and values that created different forms of secondary status for women in society. Indeed, the focus on representation in democratic institutions and the creation of new institutions to protect and promote gender equality in the years immediately after the first democratic election essentially shaped and limited the possibilities for gender transformation for years to come. By not confronting the deeper issues of patriarchal cultures and the idea that women are inferior to men, which is a deeply held belief in the traditional ethnic and linguistic groups to which many South Africans belong, women would continue to be conceived as secondary subjects.

This shortcoming in the campaign to assure gender rights as central priorities in South Africa's emerging democracy became even more urgent after the mid-2006 rape trial of Jacob Zuma, who was then deputy president of the ANC and later elected president of the ANC in December 2007. The Zuma rape trial brought to the surface the extraordinary depths of belief that women are 'at the service' of men, particularly in sexual terms, as Moffett vividly depicts in Chapter 6 of this collection. If women wear revealing clothes, they are 'asking for' sex, and saying 'no' is simply another way of saying 'yes'. For feminist activists, it became alarmingly clear that the previous twelve years of democracy had not shifted people's beliefs about women. Clearly a 'new front' needed to be opened, where the discourse about gender equality and the objectives of activism needed to confront deeply held cultural beliefs about 'good' women and 'bad' women (see Motsei 2007). These views are pervasive in society, across the divides of race, ethnicity and gender. Growing conservativism and reaction to gender discourses and gender equality bode ill for any social change.

Manicom emphasises that the way women were defined during the earlier transition period, both in the WNC's Charter for Effective Equality and by the ANC, could be construed in two ways: first, where women were constructed

as substantively 'equal citizens' to men, and second, where women were constructed in a more limited sense, as maternal citizens, mothers of the nation (Manicom 2005). The latter resonates strongly with the roles that women play in the home. In the national liberation movement and in the ANC in particular, this idea remained dominant, although not uncontested. Hassim (2006) has shown how women in the ANC challenged this identity from at least the mid-1980s and strove for equality. This was clearly evident in the leading role that the feminists in the ANCWL played in mobilising a wider constituency of women to influence the gender content of the negotiations for a new constitutional democracy. The strategic choices made by the broad coalition of organisations they drew together – including the feminist policy analysts and gender activists – during the transitional period were to have a significant effect on the ways in which the new democratic state took up what it called 'gender transformation'.

Would a more concerted emphasis on non-sexism by the women's movement have altered the politics of the transition in any significant way, heralding a different kind of struggle for substantive citizenship? The effect of the way in which the arguments unfolded was to differentiate the 'women-as-women' struggles from those of others, such as the gay and lesbian movement. But it also limited the debate to one that did not significantly demand gender transformation. The opportunities for a broader, united approach to gender transformation were effectively curtailed by the terms of the debate. It also enabled a silence around cultural practice that subordinated women and gay people.

The Constitution supports two rather ambiguous sets of equality rights in the Bill of Rights (Chapter 2, section 9, subsection 3): those of gender, sex and sexual orientation and those of cultural practices. While these could support women in traditional relationships to secure their rights and entitlements, they could also define new divisions between different social categories: unemployed 'dependent citizens' in contrast to an educated, skilled and employed middle class of 'independent citizens'. In this context, some citizens are more equal than others.

It is important, however, that we understand that the use of the term 'women' should not be read in an essentialist fashion. Nussbaum's (2000) philosophical approach to women's urgent needs and interests in developing nations provides a thought-provoking antidote to the idea that the category

'women' merely universalises women's diversity. In her view, 'real women's lives . . . help us to see the salient problems and how they bear on one another' (Nussbaum 2000, 11). Her account of the situation of women in India points to the significance of cross-cutting factors such as caste, geographic location, educational opportunities, child labour and general economic opportunities in shaping the gender outcomes of life chances. Accordingly, women in India experience high levels of sexual assault and abuse. The poverty gap for women, including those in the higher castes, is much greater than among men. Yet in principle, India's Constitution is 'woman-friendly' and outlaws discrimination on the basis of sex. The Indian Constitution also abolished the category of 'untouchable' and the practice of child marriage (Nussbaum 2000, 24–33). Yet neither of these has come to an end in India. Comparatively, then, the woman-friendly nature of South Africa's Constitution should not blind us to the enormous difficulties entailed in changing society's norms, values and behaviours around gender relations. As this collection surveys the landscape of predominant spaces where gender inequalities persist despite the enormous progress in centralising gender in constitutional protections as well as state institutions, we see in each case a parallel to the Indian context, where such public victories have failed to transform gender relations.

While the Constitution and the setting up of the gender machinery provided the first building blocks for the promotion of gender equality in South Africa, these institutions also promoted notions of substantive democracy that linked gender rights to women's needs and interests. Gender-mainstreaming critics elsewhere have shown that in the shift to 'woman-focused' policy and practice, the idea of gender transformation was completely subverted (Kabeer 1994). Any understanding of how gender power and authority operates is then replaced by a focus on woman empowerment or on the integration of women in development and into decision-making positions, including as public representatives. The relational aspect of women's social subordination is thus not addressed. The focus on women then allows for the co-option of an elite cadre of women to the detriment of real social transformation. Concessions can be made to women's needs and interests without upsetting conventional political, social or economic power and control (Sainsbury 1996).

In the last decade or so, there has been a spate of feminist studies that argue for the political representation of women in the state as 'a necessary

first step to the institutional transformation that is required if "substantive" representation is to be achieved' (Goetz and Hassim 2003, 5; see also Fick, Meintjes and Simons 2002; Gatens and Mackinnon 1998). In this instance, substantive representation is realised when (1) women actually effectively represent and are accountable to women's real interests, and (2) the system is both gender-sensitive and accountable in order to assure that 'sanctions against public sector actors who have abused women's rights' are enforced (Goetz and Hassim 2003, 6). Goetz and Hassim argue that women's access to public engagement through consultation and dialogue – and even representation – is not enough to ensure accountability to women. They suggest that appropriate means of holding decision makers to account need to be established. This is more difficult to achieve. In South Africa, the practical outcome of the debate was to establish the 'national gender machinery', which comprised the OSW, the JMC and the CGE. The fourth leg of this institutional set-up was to be the 'women's movement', which, in the 1990s, comprised civil society organisations including non-governmental organisations (NGOs) and community-based organisations (CBOs). If the three state bodies could be made to promote and even represent the needs and interests of women and hold the state to account, then the issue of accountability might be dealt with in a novel way. Parliament itself would then have to account to the national gender machinery and the women's movement.

Bringing women into the public arena in ways that do not confront men's traditional political role or patriarchal systems of power (as in the Ugandan model of local government, where special seats for women councillors are added on) would not be satisfactory, for it merely made women representatives 'lesser politicians' (Goetz and Hassim 2003, 7). Indeed, globally, the main focus of integration of women has been into bureaucracies – not in terms of numbers alone, but also in the establishment of specialised bureaucratic structures dedicated to improving gender representation in the state. This follows the UN prescriptions about gender mainstreaming. Thus, a critical aspect of women's integration relates to the terms of their public engagement. Affirmative action policies and specialised gender machinery were the chosen mechanisms of states to ensure women's participation in policy making.

Some feminists have argued that the effect of the bureaucratic route to integrating women's concerns has been to depoliticise their needs and interests (Gouws 1996, 2004). Indeed, Goetz and Hassim suggest a somewhat more

active 'anti-political' effect of what they call the 'discourse of inclusion'. They argue that 'the stress is on avoiding politics and competition, except perhaps within a more narrowly defined field of contestants: women, and particularly urban and privileged women' (Goetz and Hassim 2003, 12). Although the focus of their argument relates particularly to political-party involvement, the difficulty for gender activists and feminists is to weigh up the risks of co-option with the risks of marginalisation in the choices made in either engaging the state through establishing gender machinery (inclusionary feminism), or pursuing a feminist agenda in civil society through social movement activism (transformational feminism) (Hassim 2005a; Salo 2005). The following section explores these arguments through a narrative analysis of the establishment of the independent constitutional body of the CGE and the two associated sister institutions, the parliamentary JMC and the OSW in the bureaucracy.

Gender machinery in South Africa: Institutional design

The new Interim Constitution that was agreed upon before the first democratic elections in 1994 grew out of a dialogue, negotiations and compromises between very diverse parties, but the main contenders were the white-Afrikaner-dominated National Party (NP) and the broader-based, though predominantly black African, African National Congress (ANC). The constitution makers were mindful that apartheid had underpinned the huge social and economic disparities between different racial groups and had oppressed the majority of the people of South Africa. The foundation principles of the Constitution Act of 1996 included two unusual concepts: non-racialism and non-sexism. The Constitution was based on the idea of promoting a national human rights culture, while also acknowledging that the state would have to provide a bridge for the creation and protection of new socio-economic rights for previously excluded and disadvantaged sections of society. The legal regime was thus one that melded a rights and welfare approach and one that brought together two quite different philosophical and democratic paradigms, the one liberal and the other socialist. In trying to balance the universal rights of citizens with particular interests of specified groups, the Constitution had to address ways of promoting equality for all without tampering with the rights of particular groups.

The rights recognised in the Constitution in the Bill of Rights (Chapter 2) emerged from the acknowledgement of demands made by 'the people' over

the previous thirty years and sought to promote equity, or the provision of resources to previously disadvantaged and excluded groups, as much as to promote democracy and political equality. Socio-economic rights complemented rights to substantive equality based on race, gender, sex, pregnancy, marital status, ethnic or social origin, colour, sexual orientation, age, disability, religion, conscience, belief, culture, language and birth. The Bill of Rights also enumerated a host of material rights: to trade; to labour; to a clean environment; to property; to housing; to health care, food, water and social security; and to education – among other cultural and legal rights. These were not abstract rights, but were embedded in earlier and contemporary demands made by ordinary people in their everyday struggles against apartheid – demands for land and housing, and for adequate education, health and welfare provision. Behind the different substantive clauses of the new Constitution lay assumptions about justice and equity which appear in the Preamble.

The compact between the negotiating parties included a combined process of institutional design and affirmative action for previously excluded citizens in the development of racial and gender equity as the way in which South Africa might overcome its divided past. While the new democratic state would try to reform existing government departments and institutions to embrace norms and values of democratic civil service, it also set about providing new institutions in order to protect and promote South Africa's new democracy and to create a new citizenship for all South Africans, especially for those previously excluded or marginalised.

The Constitution enjoined a range of different bodies to protect democracy in various ways. In Chapter 9 (sections 181–94) six bodies were established to promote and protect democracy: the Public Protector; a Human Rights Commission; the Auditor General; the Electoral Commission; the Commission for the Promotion and Protection of the Rights of Cultural, Religious and Linguistic Communities; and the CGE. In other sections of the Constitution, other constitutional bodies that protect citizens either directly or indirectly included the Constitutional Court (section 167, subsection 1), the High Courts and Magistrates' Courts, the Judicial Service Commission, the Public Service Commission, the Finance and Fiscal Commission, the National Directorate of Public Prosecutions (section 179, subsection 1) and an independent complaints police body (section 206, subsection 6) that was later set up as the Independent Complaints Directorate. Collectively, these institutions

instilled tangible processes that connected the social democratic ideologies of the post-apartheid transformation with the pressing need to redress severe inequalities.

Gender activism had determined that the new democratic state should establish the national gender machinery, in effect a cluster or 'package' of institutions designed to promote gender equality. At an international conference convened by the WNC in Johannesburg in May 1993, a range of international feminist scholars and 'femocrats' debated the advantages of different models. The idea of a package crystallised at this meeting, although at this stage, there was no discussion of what became the constitutional CGE, which would intercede in the relationship between civil society and the state and monitor the progress of gender equality. The CGE would have specific powers allocated to it to undertake its work.

There was a strong belief that these institutions would be only as effective as their relationship with a vibrant and organised civil society actively involved in policy planning and implementation. Underpinning the dominant thinking about the institutional mechanisms and their effectiveness was a particular unspoken vision of participatory democracy. In the new democratic order, there was both recognition and concern that the patriarchal nature of political parties and the liberation movements would subsume the needs and interests of women. At the same time, women's independent initiatives were not integrated into the broader political consensus developing around the negotiations. Autonomy held its own dangers. Some of the rationale for women's separate organisation was never publicly debated; it was simply part of a pacting process within the constitution-making process and the ANC.

The legislation setting up the CGE was developed after that of the Public Protector and the South African Human Rights Commission (SAHRC) in 1996. The former was the direct heir of an earlier structure set up under apartheid, which dealt with citizen complaints about the service of different state departments and statutory bodies, while the latter was established in order to protect citizens' social and economic rights. The SAHRC was given specific powers to conduct litigation on behalf of its 'clients', authority that was not specifically provided for in the CGE Act. However, the Commission on Gender Equality Act gave considerable powers of investigation to the CGE, and gave the Commission all the rights that would enable it to act as a 'juristic person'.

The CGE was able to take up any constitutional matters that it deemed necessary to promote and protect gender equality, which in effect gave it the power both to litigate and conduct constitutional court cases. In terms of the Constitution, the CGE and other Chapter 9 bodies were independent, subject only to the Constitution and the law. These constitutional bodies would be impartial and perform their functions 'without fear, favour or prejudice'. Other institutions of state must support and protect the independence, impartiality, dignity and effectiveness of these bodies. No organ of state can interfere in the functioning of these institutions, but they are accountable to the National Assembly and must report on their activities once a year.

The Commission on Gender Equality Act 1996 specified that those appointed to the Commission, no fewer than seven and no more than eleven, should be South African citizens, 'fit and proper persons', with a record of commitment to and knowledge about gender equality. A significant proviso of the Act was that appointments had to reflect the broad race and gender composition of South Africa. The functioning of the CGE was specified in the Act through its mandate: to protect and promote gender equality, to conduct research and investigate complaints and to provide public education and information. It had to monitor South Africa's international agreements around gender equality. This mandate provided the basis for the organisational form and scope of the activities of the Commission. One important clause was that the CGE had to develop relationships and partnerships with 'like-minded organisations'. These were to be civil society organisations working on gender as well as other human rights bodies, such as the SAHRC.

The second important body to be established as part of the gender machinery was the OSW. This institution was part of the civil service and was set up by means of a cabinet memorandum. Its mandate was to develop public gender policy and promote gender mainstreaming in government. The OSW was first located in the Office of the Deputy President (Thabo Mbeki at the time) in the Mandela government. From the outset, there was little understanding of how complex this task would be. Each department had its discrete role, and the principle of non-interference by ministries in another's activities and functions was important for good governance. Thus the task of the OSW to ensure that government departments at national, provincial and local levels mainstreamed gender into their functions was fraught with

difficulty. There was little understanding about gender budgeting outside of feminist academe. The essentially hierarchical and functionally distinct ministerial and sectoral system of responsibility and authority did not change with the democratic order. So while issues of gender cross-cut every aspect of policy, the implementation of gender mainstreaming would become a real site of struggle. In particular, while the new state committed itself to gender equality and gender equity, it did not make any budgeting arrangements for implementation. Moreover, departments had no line-function accountability to the OSW. All appointments to government and provincial departments were made from within, including those for the gender focal points. The latter appointments were not bound in any way to the authority of the OSW.

The above difficulties were compounded by an understandable sensitivity of the OSW to the monitoring of its activities by the JMC and the CGE. It felt that the three organisations should work in tandem to challenge the reluctance of national government departments and provincial governments and their line departments to do more than pay lip-service to the idea of gender mainstreaming. It is no surprise that gender focal-point appointments were 'add-ons' to the work that officials were appointed to do. After the 1999 general election, when Thabo Mbeki became president, the OSW moved into the presidency, into a new ministry whose portfolio was to promote the interests of special categories – women, youth and the disabled. It appeared as if the state would take the concerns of women seriously. However, the issue of cross-cutting responsibilities was never satisfactorily resolved and in many respects the OSW remained something of a lame duck.

The third institution involved in promoting gender equality was the parliamentary JMC. This committee was at first an ad hoc committee without a budget, but after three years was made into a fully budgeted joint standing committee (including members of the House of Assembly and the National Council of Provinces). Its chair, initially Pregs Govender, was always drawn from the House of Assembly and initially drove the process of maintaining oversight over government legislation, ensuring that each piece of legislation was analysed for its gender implications. The chair of the committee played a significant role in promoting the idea of a women's budget, an analysis of the national budget that probed the gender implications and outcomes of the process nationally. During 1998 and 1999, in fact, the minister of finance paid rather more than lip-service to this initiative and departments were

enjoined to add gender instruments to their evaluation. But this was not pursued after 2000, and the gains made during the first period of democracy to promote the interests of women were subsequently lost. The JMC's effectiveness weakened in subsequent years, especially after Govender resigned from parliament after voting against the arms deal, a R50 billion plan to purchase arms and refurbish the armed forces, rather than use these resources to address the needs of the poor. During the third term of the ANC, the JMC has hardly met, and its leadership did not challenge parliament or the cabinet on its gender-equality strategies or outcomes on such significant issues as HIV/AIDS.

One of the critical aspects in the establishment of the gender machinery was the problem of duplication in the functions and activities of the three bodies. Role clarification remained an ongoing difficulty between the three institutions, with each jealously guarding what it conceived to be its territory. Yet each institution at times ran parallel research and monitoring programmes. The problem of overlap and coordination dogged the activities of all three bodies since their establishment.

The CGE's mandate was much broader than that of the OSW: to oversee the promotion and protection of gender equality in state and society. Its powers were quasi-judicial, with monitoring and investigations key components of its mandate, combined with powers that far exceeded those of the OSW. Through its public education and information dissemination, the CGE should theoretically have been able to mobilise communities around specific gender issues such as HIV/AIDS, gender-based violence and other aspects of people's lives that limited their access and thus their enjoyment of full human rights. In reality, this was not without its ironies. One commissioner recounted to the new commissioners in 2001 how, in KwaZulu-Natal, women had marched to the provincial parliament to protest that gender equality infringed their rights to test young girls to see whether they were virgins (Meintjes, personal papers). The CGE, on the other hand, took up the issue of virginity testing as a violation of human rights.

A complex range of activities was coordinated within the CGE: gender information workshops; gender dialogues; campaigns; and the dissemination of information through pamphlets, posters, comics, exhibitions at conferences and a periodical newsletter. Initially, the CGE produced a considerable amount of information and literature. However, the organisation became embroiled

in internal conflicts that were compounded by weak and ineffective leadership. Tensions between commissioners and staff dogged its internal relations from its inception.

The first appointments to the CGE were particularly important in framing the organisation's institutional values, meanings and discourses. Where were appointees drawn from and how did they shape repertoires of action, activities and expectations to create the identity of the CGE? How were the relationships between commissioners and the secretariat defined and given substance? Gender activists, who might not have professional expertise, were nominated and appointed for five-year terms. Some were appointed to act full-time, while others were part-time. Members of women's organisations, trade unions and religious and cultural organisations, as well as academics and researchers, were appointed. Four were academics: a male Muslim cleric, a woman priest and two white women lawyers. A fifth was a woman Indian lawyer and the five others were black women, two of whom were strong feminist activists with a history in the struggle, one a teacher and trade unionist, one a recently disabled nurse and the other a former nurse and student of law. (Although a white man was also appointed, he never served a term.) The final appointment was of the chairperson, a staunch member of the South African Communist Party (SACP) and the ANC. Of the appointees, most understood gender as 'women's issues', while the feminists saw a more complex set of issues at stake. These ideological differences were never resolved.

The first few years of the CGE's existence were critical in shaping its institutional culture. The influence of the first chairperson, Thenjiwe Mtintso, and the first chief executive officer, Colleen Lowe Morna, was significant. Mtintso's strategy was to consult as widely as possible to develop a collective identity within the organisation. Mtintso's life experience shaped her approach. She came from a poor background, where an early awareness of the effects of class as much as race shaped her guiding ideas. She had joined the Black Consciousness Movement and was severely tortured in the 1970s. She went into exile, became an Umkhonto we Sizwe (MK) commander and later represented the ANC in Uganda. On her return from exile in the early 1990s, she completed a degree in sociology and political studies as a mature student, and undertook a master's in public administration and development. She had played an important role in the SACP in promoting gender equity and during the transition was part of the party's delegation to the WNC's inaugural

conference in April 1992. She then became a member of parliament in 1994 (Reid and Walker 2003, 15–21).

Mtintso was a highly principled and independent-minded democrat, fearless in voicing her opinion but open to debate and discussion. She was also a loyal member of the SACP and the ANC. Independence and loyalty were, however, sometimes at odds with one another. She had undoubted leadership qualities. She was a popular choice as the first CGE chairperson in 1996. Her appointment was for a five-year term, but she served for only one year. At the end of 1997, at the ANC's congress, she agreed to stand for, and was elected to, the post of deputy secretary-general of the ANC at the behest of the SACP.

Mtintso's move to the ANC head office pointed to two significant issues for the future of the CGE. The first was the importance of independent, authoritative and appropriate leadership for the success of an independent constitutional body. The second was the extent to which the governing party influenced appointments to these independent bodies. Mtintso's election to a political post was indicative of the manner in which party political loyalty and commitment could override the needs and interests of society more generally and this new constitutional body in particular. Indeed, the ANC treated the CGE as 'a bit on the side'.[1] Overall, it was a disappointing start to the life of what was a unique experiment in the institutional design of gender machineries worldwide.

In the process of setting up the CGE, the Commonwealth Secretariat provided advice on institutional development and institution building. The consultant was Colleen Lowe Morna, an experienced Zimbabwean gender activist and journalist, and in 1992, the chief programme officer for the Commonwealth Observer Mission to South Africa. From 1994 to 1997, Lowe Morna was employed by the Commonwealth Fund for Technical Cooperation.[2] When the post for a CEO was advertised, Lowe Morna applied and became the first CEO in August 1997. The post continued to be subsidised by the Commonwealth Fund for Technical Cooperation until March 1998. Lowe Morna's move into the new post seemed a seamless one. However, subsequent events were to raise questions about the transfer of consultants into bureaucratic posts.

Lowe Morna drew up the original concept document for the CGE after a study tour of Australia and Uganda. She consulted with experts on different

mechanisms to promote women's human rights in other parts of the world
and in South Africa. Among those who influenced the process were advocate
Mojanku Gumbi (an adviser to Deputy President Mbeki), Geraldine Fraser
Moleketi (minister of welfare) and Dr Cathi Albertyn (a driving force in the
WNC, who had written about possible models to promote gender equality in
South Africa).[3] Lowe Morna was a dynamic and tireless innovator, with an
energy that often left others, particularly commissioners, behind. She had a
very good relationship with the chairperson, but was sometimes at odds with
others in the CGE. This was to become a source of tension after Mtintso left
the CGE.

In the ensuing four years, the CGE tore itself apart in conflict between
different factions. In an attempt to sack Lowe Morna, the CGE dragged itself
into a long and expensive court case. When the second round of commissioners
was appointed in April 2001, they found a dysfunctional organisation: the
court case was not settled, despite the CGE losing an appeal; morale was very
low after more than 27 staff members had resigned; and yet another consultant
had been appointed as CEO, a clear case of not learning from past mistakes.
The new commissioners were inducted only at the end of May, a gap of
months in which little work was undertaken. Mutual suspicion between the
new commissioners and those reappointed by parliament did not help matters.
It would take several years for the CGE to recover its balance and even longer,
if at all, for it to regain the confidence of civil society stakeholders. The
second round of the CGE reflected a similar make-up to the first. Of the
twelve commissioners, seven were academics and educationists (a musicologist,
two sociologists, a political scientist (myself), a religious scholar who was
also a priest, a lawyer and a gender researcher) and two had been administrators
(one in government and another from the trade unions). Two others were
reappointed from the previous CGE, both of whom had been nurses, but
were pursuing further studies in law and sociology. Almost all had been active
in earlier women's struggles at different times and in different ways. Although
politics was never formally discussed, several held official positions in political
parties. The second CGE would be no less fractious and influenced by politics
than the first.

The most serious differences in the CGE related to the strategic direction
of the organisation. In particular, the balance between the practical needs of

people living in poverty and advocacy on their behalf (which some commissioners pursued) and more strategic, politically focused issues that would challenge cultural and gender power more broadly continued to divide the institution. This had significant implications and consequences for gender transformation. Commissioners could not agree on priorities. Some simply continued to act as NGO advocates, an approach that tended to confirm in the minds of civil society that the CGE was in fact no different from an NGO. Others concentrated on constitutional challenges that would redefine gender relations. But the issues of gender power relations in the broader context of South Africa's transition culture were not strategically addressed.

In its organisational development, the CGE never properly confronted the dilemmas posed by the difference in strategy required to pursue gender equality as opposed to meeting the particular practical needs of poor rural women. To some extent, this failure reflected the unwillingness of the CGE to confront state policy, where real transformational gender interests were at stake. But its unwillingness to confront the state was compounded by the way in which it conducted its work. Both the lack of a coherent and long-term national plan and the internal institutional framework that allowed for disparate activities by commissioners blocked any potential for effective strategic intervention. Yet despite the limitations in the understanding of gender equality adopted by the CGE and the institutional blockages, it did support a number of significant challenges to gender discrimination in the course of the work it undertook in the first seven years of its existence.

The tensions in the CGE prevented it from gaining the confidence of civil society organisations or interacting boldly with the other two national gender machinery institutions. Despite undertaking important research into a range of critical issues such as sex work, gender-based violence, traditional leadership, the budget, unemployment insurance and social security, with many submissions to the relevant parliamentary portfolio committees, the CGE made little real public impact after an initial burst of enthusiastic consultation with government departments and NGOs.

Seidman (2003) sees the limitations of the impact of the CGE in its inability to fully decide on what its role should be: a policy-making body or an organisation tasked with building the women's movement. Feminist analysis elsewhere in the world had pointed to the dilemmas faced by gender activists in promoting engagement with the state. It very often meant a growing distance

between an elite of 'bureaucratic' feminists with professional and legal expertise and grassroots activists who dealt with the real problems faced on a day-to-day basis by women in society. Such divisions within the CGE created new intersections of social power and difference among women who shared a certain level of access to the state and political change processes. As we see throughout the cases in this book and in the broader feminist analyses of intersections of social power, recognising difference among women is critical, particularly in the South African context. At the same time, however, such differences challenged the possibility of establishing a coherent agenda of action within the CGE. This might be said of all three organisations that drove the gender agenda in the state in South Africa.

All three organisations faced tensions between the ideology of promoting gender equality and their existence as bodies within the hierarchy of the state. All three organisations also tried to overcome some of the divisions by working together on strategic priorities. In 2001 a 'Gender Summit' was held with civil society organisations at which agreements were made that they would work together with civil society to confront the limits to change. Poverty, gender-based violence and HIV/AIDS were identified as the three most challenging issues to a sustainable democracy in South Africa. Critics had also pointed to the need to develop stronger relations with trade unions and critically engage the state over its policies of combating poverty and HIV/AIDS. These would be the priorities towards which all would work in as coherent a way as possible. The OSW agreed to convene quarterly national gender machinery meetings to discuss strategies and progress, hoping that this would lead to greater coordination. But the processes of decision making, along with the strategies, goals and organisational culture that developed, grew in the context of continuing significant differences and tensions. Educational and racial differences alongside deep ideological divisions also played a divisive role. To hold these differences together required insight, legitimacy and leadership skill – and the capacity to rise above the differences to keep the wider objectives of the agreements in sight.

Conclusions

While the Constitution provided a new set of rules to regulate and reconstitute the political, social and normative rights framework for South Africa, including those of gender relations, the lived reality of South African society existed in

sometimes sharp and ironic contrast to the substantive equality of the Bill of Rights and the foundation values and principles of non-sexism and non-racism. Both of these principles reflected an acknowledgement of the struggles for freedom from racist and sexist oppression. Yet in the years to come, the gender struggle would prove to be the more contested. Formed in the cusp between state and society, the gender machinery was to mediate and implement the objectives of the Constitution itself. In the first years, this process occurred in the context of contested understandings of gender and with very limited resources.

The importance of the combination of leadership and organisational structure and development in the success of any organisation cannot be underestimated. In the case of the gender machinery, the issue of feminism, too, cannot be ignored. The agenda of transformation was lost in the process of the institutional integration of women's issues into the policy process. In part, this was because 'femocratisation' embraced a woman-oriented approach, as distinct from a gender approach. This tended to subvert the transformation agenda (Hassim 2005b). Does this mean that institutionalisation merely bolsters the existing androcentric norms and values of society?

Feminist activists and scholars have debated the importance of the diversity of position, identity, heterogeneity – in effect the sheer complexity – of state–society constructions of gendered subjects. They have sought to understand the link between different kinds of politics and the subordination of women in South Africa. The important point is that a focus on 'women empowerment' does not necessarily address the issue of men's power in a hierarchical society; the objectives are to provide women with the requisite tools to elbow their way into male-dominated contexts with appropriate skills and confidence. The CGE did not adequately engage with these ideas in establishing its modus operandi. However, the very idea of gender equality constituted a challenge to conventional gender power relations in South Africa. The CGE faced these dilemmas from the beginning with an agenda that seemed to speak to transformation. Yet at the same time, it lacked the political understanding, and perhaps even the political will, to go beyond consciousness-raising through its education and information activities and women-empowerment training.

One could argue that a feminist agenda was never able to take root in the organisation from the beginning. The CGE was so concerned to get the

structures and structural relationships – its roles and functions – right that it failed to get the ideology and politics right. The struggle for gender equality is not just about empowering women but also about changing gender power relations in society; it is about providing space for women, but it is also about changing ideas about who should make decisions and the roles traditionally assigned to women and men. It is here that the opportunity for a new form of pragmatic feminism, as defined in the introduction to this collection, is salient. By grafting Hassim's (2005a) transformational feminism onto inclusionary feminism, we see pragmatic feminism emerging in ways that embrace both agendas. Institutional culture and discourse is as important as the structural aspects of institutional development. Had the CGE taken more time to identify what gender transformation really meant and then developed a long-term plan of action to promote it, it may have avoided some of the debilitating conflict that ensued. This failure opened the CGE to interference and criticism from outside – especially from the dominant ANCWL, who saw many of its members in the CGE as accountable to the party rather than to a constituency of women. This need not necessarily have been detrimental had it been part of a broader strategy for gender transformation, rather than a narrower route for political reward and mobility for individuals into a political career.

We end, perhaps, where we started: to suggest that while the CGE was an original concept, its capacity to influence the course of change was severely limited by its inability to grasp the nature and needs of gender transformation. Meeting the needs of poor women will not achieve the desired results. A much broader and deeper understanding of gender constructions and gender power relations is required if the CGE is to promote gender equality.

Notes

This chapter is a revised version of an earlier article published as 'Gender Equality by Design: The Case of South Africa's Commission on Gender Equality' in *Politikon* 32 (3) (2005).

The author lectures in political studies at the University of the Witwatersrand. Both an activist and an academic, she was involved in opposing apartheid and, in the 1970s and 1980s, participated in internal women's organisations linked to the liberation struggle in the Western Cape, Natal and the Transvaal. In the 1990s, she was a member of the Women's National Coalition and was a member of the research supervisory group that oversaw the development of the Women's Charter for Effective Equality. She was a member of the Charter drafting committee.

In May 2001 she was appointed to the Commission on Gender Equality as a full-time commissioner for five years. She agreed to serve for a three-year term and resigned in March 2004. This chapter draws on both her activist and her academic experience.

1. This phrase is the title of an article written by a group of feminist scholars during the apartheid era: Hassim, Metelerkamp and Todes (1985).

2. Colleen Lowe Morna. Interviewed by the author, Johannesburg, 12 May 2004.

3. Colleen Lowe Morna. Interviewed by the author, Johannesburg, 12 May 2004.

References

Albertyn, C. 1994. 'Women and the Transition to Democracy in South Africa'. In *Gender and the New South African Legal Order*, edited by C. Murray. Cape Town: Juta.

———. 1995. 'National Gender Machinery for Ensuring Gender Equality'. In *The Constitution of South Africa from a Gender Perspective*, edited by S. Liebenberg. Cape Town: David Philip.

Baker, S. and A. van Doorne-Huiskes. 1999. *Women and Public Policy: The Shifting Boundaries between the Public and Private Spheres*. Aldershot: Ashgate.

Fick, G., S. Meintjes and M. Simons. 2002. *One Woman, One Vote: The Gender Politics of South African Elections*. Johannesburg: Electoral Institute of Southern Africa.

Gatens, M. and A. Mackinnon. 1998. *Gender and Institutions: Welfare, Work and Citizenship*. Cambridge: Cambridge University Press.

Goetz, A.M. and S. Hassim. 2003. *No Shortcuts to Power: African Women in Politics and Policy Making*. London: Zed Books.

Goldberg, D.T. 1993. *Racist Culture: Philosophy and Politics of Meaning*. Oxford: Blackwell.

———. 2001. *The Racial State*. Oxford: Blackwell.

Gouws, A. 1996. 'The Rise of the Femocrat?' *Agenda* 30: 31–43.

———. 2004. 'The Politics of State Structures: Citizenship and the National Machinery for Women in South Africa'. *Feminist Africa*. Issue 3. www.feministafrica.org/index.php?page=issue_three. (Accessed on 3 January 2008.)

———. 2005. 'Shaping Women's Citizenship: Contesting the Boundaries of State and Discourse'. In *(Un)thinking Citizenship: Feminist Debates in Contemporary South Africa*, edited by A. Gouws. Aldershot: Ashgate.

Hassim, S. 2003. 'The Gender Pact and Democratic Consolidation: Institutionalizing Gender Equality in the South African State'. *Feminist Studies* 29 (3): 505–28.

———. 2005a. 'Nationalism Displaced: Citizenship Discourses in the Transition'. In *(Un)thinking Citizenship: Feminist Debates in Contemporary South Africa*, edited by A. Gouws. Aldershot: Ashgate.

———. 2005b. 'Terms of Engagement: South African Challenges'. In *Feminist Africa*. Issue 4. www.feministafrica.org/index.php?page=issue_four. (Accessed on 12 January 2008.)

———. 2006. *Women's Organizations and Democracy in South Africa: Contesting Authority*. Madison: University of Wisconsin Press.

Hassim, S., J. Metelerkamp and A. Todes. 1985. 'A Bit on the Side: Gender Struggles in the Politics of Transformation'. *Transformation* 5: 3–32.

Kabeer, N. 1994. *Reversed Realities*. London: Verso.

Manicom, L. 2005. 'Constituting "Women" as Citizens: Ambiguities in the Making of Gendered Political Subjects in Post-apartheid South Africa'. In *(Un)thinking Citizenship: Feminist Debates in Contemporary South Africa*, edited by A. Gouws. Aldershot: Ashgate.

Meintjes, S. 1998. 'Gender, Nationalism and Transformation: Difference and Commonality in South Africa's Past and Present'. In *Women, Ethnicity and Nationalism: The Politics of Transition*, edited by R. Wilford and R.L. Miller. London: Routledge.

———. Personal papers, Women's National Coalition.

Motsei, M. 2007. *The Kanga and the Kangaroo Court: Reflections on the Rape Trial of Jacob Zuma*. Johannesburg: Jacana.

Murray, C. 1994. *Gender and the New South African Legal Order*. Cape Town: Juta.

Nussbaum, M.C. 2000. *Women and Human Development: The Capabilities Approach*. Cambridge: Cambridge University Press.

Reid, G. and L. Walker. 2003. 'The CGE in Context'. Unpublished manuscript, Commission on Gender Equality.

Republic of South Africa. 1996. Constitution of the Republic of South Africa (Act No. 108 of 1996).

Sainsbury, D. 1996. *Gender Equality and Welfare States*. Cambridge: Cambridge University Press.

Salo, E. 2005. 'Multiple Targets, Mixing Strategies: Complicating Feminist Analysis of Contemporary South African Women's Movements'. In *Feminist Africa*. Issue 4. www.feministafrica.org/index.php?page=issue_four. (Accessed on 7 December 2007.)

Seidman, G. 1999. 'Gendered Citizenship: South Africa's Democratic Transition and the Construction of a Gendered State'. *Gender and Society* 13: 287–307.

———. 2003. 'Institutional Dilemmas: Representation versus Mobilization in the South African Gender Commission'. *Feminist Studies* 29 (3): 541–63.

CHAPTER FOUR

Women's Sport as a Site for Challenging Racial and Gender Inequalities in Post-apartheid South Africa

CYNTHIA FABRIZIO PELAK

THE NON-RACIAL SPORTS movement in South Africa that emerged in the late 1950s and expanded through the 1980s played a critical role in the anti-apartheid struggle. Some argue that 'the movement was, perhaps, the most successful at bringing international action against apartheid structures in South African society' (Nauright 1997, 156). Those calling for an international sports boycott against South Africa appreciated the symbolic significance of challenging exclusionary practices within sports. They knew that despite sport's reputation for being 'outside of politics', institutionalised sports contribute symbolically and materially to the reproduction of dominant racial ideologies and inequalities. The anti-apartheid sports movement and changes in the sporting realm since 1994 serve as powerful examples of how sports can be a site both for reproducing and challenging dominant ideologies and practices.

Scholarship on race, sport, and nation building within South Africa is growing (Booth 1998; Nauright 1997; Alegi 2004). This body of research, however, focuses almost exclusively on the world of elite male sports and on highly visible leaders of the non-racial sports movement. Experiences of athletes and coaches as change makers at the grassroots level within sports dominated and controlled by women are given very little attention. In this chapter, I broaden the existing literature by focusing on how women athletes and sport administrators are using sports, particularly netball and soccer, to challenge and transform dominant race and gender relations in post-apartheid

South Africa. Moreover, through this analysis, I hope to suggest that historically grounded research on gender/race/class hierarchies within sports can be useful for theorising more broadly issues of gender relations and democratisation, such as gender-based violence and women's bodily autonomy, in South Africa. The centrality of bodies in sports and the use of sport to naturalise gender differences make the sporting realm a particularly useful context for grappling with patriarchal imperatives in South Africa and the limits of women's political equality.

The two sports examined here – netball[1] and soccer – were chosen because of their popularity and specific historical configuration along race and gender divisions in South Africa. Netball, a sport closely related to basketball, was historically constructed as a women-only sport and controlled by white Afrikaans-speaking women in South Africa. Soccer, on the other hand, was historically constructed as a men-only sport and dominated by black[2] men. Within each of these sports, I aim to demonstrate how women (and some men) have actively and collectively challenged the historical legacies of colonial, apartheid and patriarchal relations. The differing race and gender histories of netball and soccer offer appealing contrasts for understanding intersecting power relations and democratising practices in post-apartheid South Africa. Before presenting the case studies, I briefly review relevant theoretical insights and the methodological tools that shape this analysis.

Theoretical considerations

By conceptualising South African women athletes and administrators as *political actors* and examining the process of collective change within two popular sports, this study expands conventional notions of the political and sheds light on important contributions to struggles of democratisation of South African society that largely go unnamed and unrecognised. Principally, this analysis grapples with the question of how the dismantling of apartheid created space for women athletes, especially black women athletes, to challenge racialised and gendered structures in male-dominated and white-controlled sports. I rely on theoretical insights from the sociology of sports and social movements literatures to develop an analytical framework to elucidate how sports can be an effective site for social change. I also draw on theoretical insights from studies of intersecting race/class/gender relations to understand how multiple and cross-cutting hierarchies shape South African women's experiences in sports (Collins 2000).

Scholars adopting a critical approach to theorising sports view sports as social practice embedded within specific historical and cultural contexts, structured by material power relations and legitimated by dominant ideology (Carrington and McDonald 2001; Gruneau 1983/1999; Hargreaves 1994). Consistent with this view, sports are understood as human social inventions rather than predetermined sets of structures and practices. I adopt these conceptualisations along with Gruneau's (1983/1999) assertion that '[d]epending upon their association with divergent material interests, the meanings of sports, like all cultural creations, have the capacity to be either reproductive or oppositional, repressive or liberating' (17).

In South Africa, modern sport, which emerged in connection to European colonialism, has played an important role in supporting the status quo of white, affluent, male colonial rule. Although South Africa is popularly considered a 'sports-crazed' society, mass participation in sports is limited and contested. During colonialism and apartheid, sporting facilities and resources were distributed according to a rigid racial hierarchy (Archer and Bouillon 1982; Booth 1998; Nauright 1997). These racialised disparities were also simultaneously influenced by gender and class status, as well as by whether someone lived in an urban or rural setting (Hargreaves 2000; Jones 2001; Roberts 1992). Rugby, for example, has been closely linked with the construction of white masculine power and Afrikaner nationalism (Grundlingh 1995). Soccer, on the other hand, has served as the ideological cornerstone for constructing black masculinity and asserting black men's power and leadership within black communities and families (Alegi 2004). Through the historical exclusion of women, rugby and soccer have been marked as men's/ boys' territory and have been sites of 'rigid expressions of chauvinist masculinity' (Hargreaves 2000, 30). The historical construction of netball, on the other hand, has been based on middle-class notions of femininity espoused by white Afrikaans-speaking women in South Africa. The racial and gender specificity of netball suggests that the sport contributed to the colonial and apartheid projects of the imagined communities of white South Africans (Pelak 2005a). Like rugby and soccer, it is netball's embeddedness in dominant social hierarchies of gender, race and colonial orders that creates distinct limitations and possibilities for change in South Africa.

Scholars of sports have documented how the institution is highly gendered, such that gender differences shape and constrain who participates in sports,

the organisation and structures of sporting activities and the social and cultural meanings attached to sports. Scholars generally agree that dominant structures and practices within sports reflect and facilitate boys' and men's social, political and economic advantage over women (Messner and Sabo 1990). The rigid distinctions between so-called male sports and female sports illustrate the process by which sports highlight and construct gender differences and justify gender hierarchies. Scholars argue that masculine flagship sports sustain hegemonic models of masculinity through rituals of conformity, social isolation from women and deference to male authority (Sabo and Panepinto 1990); naturalise men's privileged status by linking maleness with highly valued and visible skills; and positively sanction the use of aggression/force/violence (Bryson 1990). Writing from within South Africa, Roberts (1992) argues that the gendered division of household labour, which burdens women and privileges men, is a critical factor in limiting South African women's access to sports.

Women share a long history of challenging gender boundaries within sports (Birrell and Cole 1994; Lenskyj 1986). One way that women have gained access into the male-dominated realm of competitive sports is to construct sporting practices that emphasise their femininity. Netball is the quintessential feminine sport that opened up sporting activities to large numbers of South African women. Theoretically, netball, a non-contact, women-only sport, does not radically challenge gender-appropriate behaviours or dominant constructions of gender, because it is constructed as naturally suited for women. Even the standard uniform of a blouse and skirt emphasises its feminine gender construction. Netball is thus constructed as a 'women's sport' in opposition to 'real' sports that men play. Nonetheless, women-dominated sports do afford women the often rare opportunity to control top decision-making positions within sports.

Another way to challenge masculine dominance in sports is for women to take up male-typed sports, such as soccer. The masculine construction of soccer means that women who take up the sport wage a formidable challenge to dominant gender constructions and exclusionary gendered practices (Pelak 2005b). The resistance and backlash women experience when they seek to participate in a so-called male sport can be read as evidence of the challenge to the dominant gender order. This challenge is limited, however, in the area of organisational control because women are constructed as outsiders within

a sport such as soccer and typically are not considered as 'real' soccer players/ administrators.

Employing a fluid conception of social movements, Staggenborg (1998, 182) uses the notion of social movement communities 'to encompass all actors who share and advance the goals of a social movement, regardless of the site and form of their resistance'. It is through the conception of multiple and fluid forms of social movements that I come to think of female netball and soccer participants as part of the broader non-racist and non-sexist sports movement community in South Africa. Although netball and soccer players do not represent a formal social movement, nor do the players necessarily identify as political activists, they do intentionally mobilise to challenge the existing order in a symbolically important institution in civil society.

To demonstrate how netball and women's soccer participants can be agents of change, I utilise the insight of social movement scholars that posits two major prerequisites for the development of collective action: a degree of openness in the political order and a shared understanding of an injustice among a group of individuals. *Political opportunity theory* holds that collective mobilisation emerges and succeeds in contexts in which divisions among political elites and institutions are heightened and counter-mobilisation tactics by elites are weakened (Jenkins 1985; McAdam 1983). *Collective identity theory*, in contrast, suggests that individuals come together and translate their experiences of social injustices into social protest only when they construct, negotiate and maintain a collective identity of common interests, experiences and consciousness through ongoing interactions linking people (Taylor and Whittier 1992; Melucci 1996).

Data and methodological approach

The data for this analysis were collected during two three-month stays in South Africa during 1999 and 2000 and a one-month stay during 2003.[3] The data include interviews, surveys, documentary evidence and direct field observations. For the analysis of netball, I conducted semi-structured interviews with fourteen elite netball athletes and eight top-level administrators. The interviews with athletes were conducted at the 2000 national netball championships using a randomly drawn sample from players of the top ten most competitive teams.[4] The sample of interviews with the administrators was purposively drawn based on their position in the governance of netball.

Three administrators were board members of Netball South Africa (NSA), the governing body of netball; one was a provincial netball administrator; one was a national administrator for netball at the school level; and three were from the South African Sports Commission, the national umbrella organisation for sports.[5] The analysis of netball was also informed by completed surveys from 251 participants at the 2000 national netball championships.[6] Beyond the interviews and surveys, I use documentary evidence including newspaper articles, policy statements and tournament programmes to illuminate the struggles within netball.

For my analysis of women's soccer, I conducted semi-structured interviews with seven players and eleven administrators. The sample of interviewees was purposively drawn by first identifying the most central actors involved in women's soccer nationally and in the Western Province and then continuing to interview individuals as time and opportunity allowed. The content of an interview was determined by the institutional location and unique experiences of the respondent. Four of the seven soccer players interviewed had competed on the national soccer team, and the remaining three athletes competed at the regional level for varying lengths of time. Four of the administrators were from the Western Province South African Football Association, and seven worked at the national level with the South African Football Association (SAFA).[7] The analysis of soccer also relies on completed surveys from 84 athletes participating in the 2000 Western Province Women's Football League and direct observations of league matches during 2000.[8] My attendance at the games allowed me to observe interactions between players, coaches, administrators, umpires and fans; to build rapport with those whom I wanted to interview and survey; and to engage in casual conversations with people who made up the women's soccer community.[9] Throughout my analysis, I use pseudonyms to identify the respondents in order to ensure their anonymity. Finally, like the netball case, these findings also draw from documentary evidence such as newspapers, policy documents and tournament programmes to further my understanding of the context.

Overall, I ground these observations within an interpretive, anti-racist–feminist epistemological and methodological framework (Andersen 1994; Fonow and Cook 1991; Harding 1991). Drawing on feminist critiques of androcentric social science, I recognise the interplay between researcher and participants in producing knowledge. Although I lived and worked in sub-

Saharan Africa for several years in the past and conducted substantial fieldwork for this research, my identity as a white American academic limits and shapes my perspective. Rather than supplying definitive answers to my questions regarding the experiences of South African athletes, this analysis is one attempt, however limited and partial, to grapple with understanding those experiences.

The case of netball

Netball has its roots in basketball, which emerged during the late nineteenth century in the United States. The sport was developed in Britain by female physical educators and then spread globally when British colonialists imported their sporting practices as a means of establishing British culture in the colonies (Archer and Bouillon 1982). In South Africa, netball first emerged in English-speaking white schools in the late 1950s, but quickly became popular at Afrikaans-speaking white schools. By the 1960s, as one administrator remarked, 'Afrikaner women owned netball in South Africa'. It appears that netball offered Afrikaner women an acceptable 'ladylike' sport that contributed to the larger project of white nationalism while not challenging dominant norms of femininity and womanhood espoused within Afrikaner communities (Pelak 2005a).

The international sports boycott directly affected netball between 1970 and 1994. No international netball teams travelled to or from South Africa throughout this period. During the 1970s, in the context of mounting international pressure, the apartheid government instituted a number of so-called multinational sport reforms that encouraged the development of separate race-based sport federations, but left in place the broader structure of white dominance (Booth 1998). In response to these reforms, white netball administrators started training camps in black townships and lobbied black schools to offer netball for girls. According to a white netball administrator, the mission of the training camps was to 'spread the gospel of netball'. By the 1980s, although the sport was still dominated by white women, netball became the most popular sport among women of all racial and class backgrounds from rural and urban communities (SISA 1997). Netball, in fact, was the only sport regularly offered at schools regardless of their racial designation within the apartheid system.

With the dismantling of apartheid in the late 1980s, a period of intense racial conflict emerged within netball that ultimately led to substantial

transformation of the sport. As the political context shifted, formal talks to unify the four racially segregated netball associations began. The talks were extremely contentious and saturated with historical distrust and suspicion. It was not until 1994 that a racially inclusive national governing body was formed. The formation of the NSA marked a major change in the political opportunity structure within netball, and many seized the moment to articulate their grievances.

Challenging apartheid structures and practices
The vast political changes that followed the 1994 democratic election in South Africa sparked a series of challenges by black women in netball. Given their strong collective identity, black netballers were able to translate their grievances into collective action. At the first national netball competition after racial unification in 1994, black players protested at what they perceived as racial discrimination in the selection of national players (Motsei 1994). In 1995, dissent re-emerged around an all-white team travelling to the All Africa Games.[10] Amidst this conflict, the NSA president was pressured to resign, and shortly thereafter the executive committee was reconfigured. In 1996, black women again organised protests at the national championships and stopped the competition from proceeding. The protestors argued that racial trans-formation in netball was taking too long and that white leaders were not working hard enough to integrate black women into netball at all levels. The conflict became so intense that officials from the Ministry of Sport and the National Sports Council stepped in to arbitrate. Another shake-up happened at the 1999 national championships and the executive committee was again replaced. This time, an African woman was appointed president and a diverse executive committee was installed.

In response to black women's collective protests during the mid-1990s, netball leaders instituted a number of affirmative action policies to increase black women's participation and influence. The most controversial policy was that of racial quotas for provincial teams competing at national tournaments. As a starting point, in 1995, racial quotas were enforced at competitions of the under-19 age division. By 2000, quotas were enforced at the highest level of competition – the national championship tournament. Provincial teams lost points in the tournament if they did not have at least 40 per cent representation of blacks or whites on their player rosters. In addition,

the rules required that there be at least two players of the under-represented race playing on the court at all times. Tensions surrounding this policy at the championship tournament were palpable. As one would expect, the policy found more support among those identifying as black and/or African than among those identifying as white and/or Afrikaans.[11] The rewarding of racial integration and the penalising of racial segregation in determining points at an elite sports competition was a strong statement about the value of diversity within netball and a bold move that was unprecedented in South Africa.

Paradoxically, however, the use of binary racial categories in the quota policy reinforced the rigid racial boundaries that the policy aimed to dismantle. While the policy challenged racial inequalities, the designation of players as 'black' or 'white' simultaneously underscored racial divisions and contradicted the multiple racial/ethnic/cultural categories and fluid and situational nature of identities in South Africa (Jung 2000). Although netball administrators maintain that the term 'black' was inclusive of all 'non-white' South Africans, the meaning of the term varied widely among athletes, who come from all across South Africa, where regional differences are stark. Because of the controversy around the racial quota policy at the 2000 championships, the policy was modified for the 2001 championships. In place of racial quotas for teams and penalties for not meeting the quotas, racial targets were implemented to encourage, but not force, racial integration.

Many of the interviewed players talked about the loosening up of rigid racial divisions within netball. Assertions expressing the need for tolerance and acceptance of differences were common. Lynne, a 23-year-old Afrikaans-speaking woman, explains how netball itself serves as a site for bringing women together:

> If you put yourself in the team, then you must be there and you must accept the other players. It is not that you are white or black; you can't think that she is white and she is not. People are different in culture or colour, or whatever. But all of us are people; all of us are in the world and living together. Maybe tonight we sit down and have a talk. The white and the black differ very much. Because [of] our religion, we do this and this. In our culture, we believe in this and this. And then, you see the differences but you can do nothing about it. You must be accepting of one another and play the game.

Integrating geographically based netball teams has proven extremely difficult in the context of rigid spatial divisions. Although racial residential segregation decreased slightly in the 1990s, South Africa is still one of the most spatially segregated nations in the world (Christopher 2001). Movement across communities in the 'new South Africa' is constrained by structural inequalities, high costs of transportation and perceptions of crime and safety. In general, white women's fear of crime constrains their visiting historically black townships to play netball, and black women's lack of financial resources limits their travelling to historically white-dominated central cities, where most of the sporting facilities are found. Moreover, the rise in the level of gender-based violence in South Africa since 1994 surely constrains all women's and girls' movement through public space (Moffett 2002). Divergent experiences of travelling to team practices and matches build resentments and work against constructing a unified 'we' within diverse teams. While the racial quota policy demands integration, spatial segregation, whites' fear of black neighbourhoods and contrasting material realities among South Africans hinder the integration of teams. This contradiction presents a parallel to other cases where prevailing structural social inequality presents the sharpest barriers to the actualisation of democracy.

Limitations of a fragmented collective identity
It is no secret to even the most casual observer that women's sports take a back seat to men's sports in South Africa. Given the rigid gender segregation within sports and the visibility of men's opportunities and rewards, women athletes commonly develop a keen awareness of structural gender inequalities within sports. Through accumulated experiences of the trivialisation of their athleticism and the lack of material support compared to men athletes of their own racial/ethnic and class backgrounds, women netball athletes have developed a collective consciousness about structural gender inequalities. However, not all South African women have understood and experienced gender inequalities within sports in the same way (Hargreaves 1997, 2000; Jones 2001; Roberts 1992).

The varying levels of race and class privilege among netballers mediate their experiences of gender inequalities and thus influence the development of a shared consciousness of intersecting systems of inequality. While most netballers invoked a structural framework to explain gender imbalances, when

it came to understanding race and class inequalities many athletes relied on individually based frameworks. In the following quote, Sheila, a 22-year-old who identified as white, talks about how an individual's desire and 'heart' can overcome her financial difficulties:

> It is difficult for some of them [blacks] and it is difficult for some of us [whites]. That is the people that I see. I want the best coaching, but to get the best coaching I must drive 50 kilometres to the court and 50 kilometres home. You understand. But it is my choice because I want to have the best coaching because I want to have my colours, my national colours [to get on the national team]. But, OK, they have transport problems sometimes, I can understand that. But if you really, really want to do something, put your heart to it, there must be a way. Sometimes I feel that they [blacks] just take it for granted.

Although Sheila recognises transportation difficulties facing some players, she believes it is ultimately the individual's choice and effort that secure access to quality coaching. Contrasting explanations for why black women frequently drop out of teams are another illustration of the fragmented group conscious-ness of race/class disadvantages among netball participants. I asked Danielle, who identified as white and Afrikaans, why she thought black women drop out of netball. She responded:

> Well, it depends. Um, I don't know. It all depends on let's say if they can't keep up with the training, or can't keep up with the techniques, that can be a problem. I don't think money is a problem. That I don't think. So it all depends on what they can do, or want to do. If the want is there, I think they'll probably stay there.

When I asked Nomsa, who identified as black, the same question, she said:

> They normally drop out because of financial problems. And it's heartbreaking really, heartbreaking . . . This thing of black women not wanting to play netball, it's not like that. I'm 36 years old and I'm still playing today. So, these women are not playing because it's costly.

The assessment offered by Danielle is based on a framework of individual skills and desires, while Nomsa interprets the problem as one of financial hardship. Without suggesting that racial/ethnic identity directly determines race/class consciousness, the observed differences in the interpretive frameworks employed by athletes suggest a fragmented group consciousness of intersecting inequalities. Collective identity theory suggests that the lack of a shared consciousness among netballers constrains the emergence of collective action against race/gender/class inequalities facing netballers.

Transforming the image of netball
Despite the limitations of a fragmented collective identity among netballers, by the end of the 1990s, netball was in a new place. The following quote from a high-level administrator at the South African Sports Commission describes the unique struggle within netball:

> I think netball is much more advanced than, say, cricket in dealing with [racial] transformation issues. They have been through the painful process longer. Netball is still going to have problems, but its problems will not be transformation-related. I think it is because they have not taken short cuts. They have seen through all the pitfalls that were there. You can see the pitfalls with rugby, with cricket and hockey; you can name most of the sports. You can sort it by the grumbles. It is still there, the stomach is still grumbling, you know. Now and again, you will get the outbursts [within netball], but look at the national team. The top seven netball players, four or three of them are black . . . They have become more sensitive and more innovative in dealing with [racial] transformation than other sports.

Many have left netball to avoid the pain of change, but those who have remained or have recently joined are dealing with the 'grumbling in their stomachs', those gut-wrenching feelings that accompany challenges to beliefs and practices that have been reproduced for centuries. The sports administrator's comment about the inclusion of black players on the national team is a common litmus test used by South Africans to measure racial transformation. Based on this criterion, netball has made measurable gains towards racial transformation.

Like the racial diversity of the national team, the appointment of the first African president of the NSA serves as a salient symbol of racial trans-

formation within netball. The following quote from a black woman adminis-
trator conveys the symbolic importance of the new president for transforming
the image of netball from a conservative 'white sport' of the past to a racially
inclusive sport of the future:

> Netball was just not well accepted by most South Africans . . . whatever
> people would say about netball it was very negative. We had to change. I
> think the image of netball is no longer one of being white. People can start
> seeing more racial integration because it's now headed by a black woman. It
> is the first time in the country that netball has a black woman as president.
> And I think that has brought a lot of acceptance of netball. Even if we're not
> yet there, I think the process is there. We are moving.

Despite the unfinished transformation of netball, many within netball argue
that the process and mechanisms of change are present. Indeed, women
netballers are renegotiating historical practices and structures of power and
engaging in the construction of a new collective identity. As Mohanty (1991,
58) argues, a shared collective identity among women of diverse racial and
class backgrounds can only be forged through concrete historical practices,
such as those on the netball court.

The case of soccer

Although men have historically dominated as both participants and adminis-
trators of soccer in South Africa (Couzens 1983; Thabe 1983), women have
at least a 30-year history of participating in organised soccer. Oral histories
offered by members of the women's soccer community suggest that individual
women participated in soccer before the early 1970s, but that it was not until
then that formal teams and leagues were organised in major urban settings
such as Cape Town, Durban and Johannesburg. Starting in 1975, the South
African Women's Football Association sponsored an annual interprovincial
tournament at which players for a national squad were selected. However,
given South Africa's isolation due to the sports boycott, no international
matches were played until the late 1980s (Booth 1998). The first international
competition played by a national squad was during a five-week 'rebel' tour in
Italy during 1989. To participate in the Italian tour, the South African squad
had to covertly leave the country disguised as an anonymous soccer club

(thus making it a 'rebel' tour). The first official international match played by South Africa was against Swaziland in 1993, which took place in Johannesburg (Hawkey 1993).

Since the dismantling of apartheid and the readmittance of South Africa into the international sporting community, the popularity of soccer among South African women has grown exponentially (Egunjobi 2000). The growth of women's football during the 1990s is reflected in the steady increase in the number of teams competing in the Cape Town women's league. According to league documents, there were approximately 6 teams competing in 1990, 10 teams in 1994, 13 teams in 1996, 16 teams in 1998 and 22 teams at the beginning of the 2000 season. This represents a 267 per cent increase over a ten-year period. A 1997 national representative survey of women's sport participation in South Africa estimated that 65 000 women participated in recreational and competitive soccer (SISA 1997). SAFA administrators, however, criticise the methodology of the survey and claim that some 200 000 South African women and girls currently participate in soccer. According to the national survey, soccer is the eleventh most popular sport among South African women, well behind netball, the most popular sport, with over 700 000 participants (SISA 1997).

Despite men's soccer being popularly defined as an 'African' game, women of European descent were the first women to take up organised soccer in South Africa. Paralleling the growth of women's soccer in many parts of the industrialised world (Hong and Mangan 2004; Scraton et al. 1999), it was white, English-speaking, middle-class women who dominated women's soccer in South Africa during the 1970s and 1980s. In the late 1970s, token black women – first coloured, then African women – started to join teams. Although some black women played during this early period, the harsh material inequalities structured by apartheid and the legacies of colonialism meant that very few black women enjoyed opportunities in sport. For the vast majority of African women, especially those in rural areas, sport participation was irrelevant to their lives (Hargreaves 2000; Roberts 1992). Without school-based soccer opportunities for girls/women like those available to boys/men, the development of women's soccer in South Africa was limited.

Changing racial demographics
According to several interviewees, racial integration of women's soccer teams in the apartheid context was not a problem because the sport was so insigni-

ficant and hardly noticed by most people. Although women of diverse racial/ ethnic identities came together on the soccer field, apartheid and white privilege still shaped race relations in the sport. For example, on 16 September 1978, the *Cape Herald* published a short editorial on women's soccer titled 'White Selfishness Must Cease'. I quote the article in its entirety because it reveals the racialised context of women's soccer in the Western Province during this period:

> It is to the credit of Western Province women's soccer that its team for the recently-completed interprovincial tournament was chosen 'on merit', that it was not an all-White team. It is a pity, though, that they allowed their good non-racial intentions to be outweighed by attending a racial celebration. Surely, good manners dictated that, if some of their party were disqualified from any activity surrounding the tournament, they should all disqualify themselves as well. In other words, the White members of the team should have declined to attend a dance from which their Black teammates were excluded. One understands it is difficult for Whites to appreciate the social humiliation (among other humiliations) which Blacks have to suffer. But one believes that, at a time when South Africa is supposedly changing, Whites should make an effort to learn. That they are learning is evident, but it is also evident that they refuse to learn when it is at the expense of their own comfort or their privileged position. White selfishness must cease, and soon, for a proper solution to our problems.

This editorial recognises the 'good non-racial intentions' within women's soccer, but highlights how social relations within the sport were not insulated from white privilege and the socio-political mandates of apartheid.

Paradoxically, in the post-apartheid context, women's soccer became more racially segregated. As political opportunity structures shifted with democratisation, black women seized the moment to forge new sporting identities and challenge gender-exclusionary practices in soccer. Black women started to join existing teams and form new teams in increasing numbers. In 1993, the first women's team based in an African township was organised in the Western Province and became a model for other teams (Keim and Qhuma 1998). As more African and coloured women joined soccer, more league games were

played in black townships, places where white South African women rarely travelled. As a result, 'white women started to disappear', as one interview respondent remarked. Given the constraints of racialised spatial arrangements in South Africa, many white women started to play indoor soccer, which is played primarily in white-dominated neighbourhoods, where such sporting facilities are available. By the mid-1990s, indoor soccer became dominated by white women and outdoor soccer became dominated by black women, although there are token white and black women involved within each context.

The shift in racial demographics of women's soccer athletes is also reflected in the changing composition of provincial teams participating in the annual interprovincial tournaments between 1987 and 1994. By examining team photographs and player names printed in tournament programme guides from 1987, 1988 and 1989, I estimated that black women made up 15 per cent, 18 per cent and 13 per cent of the teams' membership in each respective year. Later, in 1990, 1992 and 1994, team photographs and player names suggest that black women made up, respectively, 21 per cent, 41 per cent and 39 per cent of the teams' membership. According to the 1997 national survey mentioned above, 86.8 per cent of the women soccer participants identified as black/African, 5.9 per cent as white, 4.8 per cent as coloured and 2.5 per cent as Indian/Asian (SISA 1997). Comparing these estimates with census data (Statistics South Africa 1999), it appears that Africans are over-represented in women's soccer, whites and coloureds are under-represented and Indians/Asians are proportionately represented. Generally speaking, participants do not view the decrease in white women's participation in soccer as problematic – first, because white women do not represent a large part of the South African population, and second, because white women's material advantages suggest that they could participate if they desire to do so.

Negotiating gender structures within soccer
The tremendous increase in the number of women taking up the masculine flagship sport of soccer during the 1990s must be understood in the context of the changing public discourse around gender equality within and beyond sports. The following comment from Oliver, an assistant coach with the national women's soccer team, speaks to the changing ideas and opportunities:

> Before it was sort of a tough move for a woman to play football [soccer], but now it is not that difficult. We are living in a democratic country where you can do whatever you want.

As the new South Africa was consolidating in the late 1980s and early 1990s, a wave of gender activism emerged around the goal of recognising gender equality as an autonomous aspect of the new democracy (Lemon 2001; McFadden 1992; Meintjes 1998; Nnaemeka 1998; Seidman 1999). As part of this emerging women's movement, new sport structures and a new national discourse on gender equity in sports developed. In 1992, a Women's Desk was established at the National Sport Council, the leading sport organisation associated with the African National Congress, and in 1994 an independent advocacy organisation, the Women's Sports Foundation, was formed. Later, in 1996, the umbrella organisation Women and Sport South Africa (WASSA) was launched (Hargreaves and Jones 2001; WASSA 1997). The stated mission of WASSA is to

> develop a culture where all girls and women will have equal opportunities, equal access and equal support in sport and recreation at all levels and in all capacities as decision-makers, administrators, coaches, technical officials as well as participants. In doing this, it ensures that women and girls may develop and achieve their full potential and enjoy the benefits that sport and recreation have to offer. (WASSA 1997, 7)

While gender equity is now a part of the official rhetoric of state-supported sports organisations (Department of Sport and Recreation 1998/9), in practice the transformation of patriarchal structures within sport has been limited. National sport leaders have prioritised racial integration of big-time men's sports, such as rugby and cricket, and the hosting of mega global sports events over mainstreaming gender equity in sports. In general, sexism in sports is conceptualised by national male administrators as secondary and unconnected to racism within sports. The following quote from a top administrator from the South African Sports Commission illustrates how intersections of race and gender inequalities are often overlooked. In the context of talking about gender and race within sport, the administrator remarked:

> We are still dealing with the first stage of transformation. What are we doing with the black population? Before you even get to the subsections of the broader problem . . . Our focus is at the first level. We are still focusing at the main problem, racial transformation. So gender becomes the next focus. If you have not solved the first focus, you are not going to start focusing more on the second focus.

The clear separation of race and gender structures articulated by this administrator renders black women's experiences in sport invisible. Such conceptualisation constructs black men's experiences as the standard and women's experiences, which are not understood as racialised, as secondary. Black men stand in for 'the black population'. The prioritising of racial transformation over gender transformation means that the inequalities facing black women, who are the majority of the South African population, are subordinated to the inequalities facing black men. The dynamic of ignoring intersecting social inequalities and subordinating concerns of gender inequality to those of racial inequality is not unique to sports. It is, however, clearly visible in the new government's financial and symbolic investment in using big-time male sports as a mechanism for nation building in the post-1994 context. The use of a male-dominated social realm to build a collective identity among all South Africans was not questioned. Given the symbolic importance of sports in the public discourse on democratisation, one must wonder how the strategy of using male-dominated sports to unify the nation actually undercut the emerging public discourse on the importance of eradicating sexism in the new South Africa.

Despite the lack of recognition of the intersections of racism and sexism in sports and the androcentric priorities of male sports administrators, the political context and discourse have shifted such that concerns about gender inequalities in sports have become legitimate and politically salient. Democratisation has, using Mikell's (1995) language, opened up 'dialogue spaces' to grapple with issues of gender inequality and challenge gender-normative practices in sports. Even within masculine flagship sports, such as soccer, sport leaders can no longer ignore the issue of sexism.

Conflict over the control of women's soccer
As one would expect, as more women showed up at soccer pitches, more overt power struggles between women and men emerged. Some men reacted

with violence and sexual harassment, while others have been more accepting and have embraced women as part of the broader soccer community. Up until 1994, women's soccer was organised autonomously, separate from any men's soccer governing body. In 1994, the unification of the various racially based soccer organisations and the formation of SAFA led to women's soccer becoming associated with, although still independent of, the male-dominated association. In the context of the growing popularity of women's soccer in South Africa and an influx of monies for women's soccer during the 1990s, problems erupted in one of the women's leagues in the Johannesburg area. Allegations of sexual harassment and mismanagement of funds were raised against several men who were owners and managers of various local women's soccer teams (Rulashe 1997). After the problems persisted for several years and written requests for SAFA to intervene went unanswered, the minister of sport and the national government got involved. The Office of the President of South Africa convened a judicial commission headed by Judge Pickard to investigate the women's complaints along with other conflicts within the organisation. The following quote from a women's soccer administrator describes the nature of the gendered conflict, the judicial commission and structural consequences for women's soccer:

> The sport [women's soccer] grew very rapidly and in 1994 we started having a lot of problems with men. They saw women's sports growing and they wanted to come and start running it. We had huge troubles in those years – 1994, 1995 and 1996. It was really a tormented time for all of us. A lot of the women were threatened by these men and their kids intimidated. It led to the police being involved and all sorts of mess. And unfortunately, the men who were trying to take over the running of women's football had connections with the federation [SAFA] and the federation supported them instead of the women. The people in charge of the men did not take us [women administrators] seriously. We had to go to the minister of sports. And there was a huge [judicial] commission for men and women in soccer and it took about three years to complete. It resulted in women being rendered powerless. It resulted in the federation disbanding women's soccer as a separate entity and incorporating it into the men's structure. Of course, it is not a men's structure but a football structure. But unfortunately, it doesn't work like that.

The emergence of physical violence, intimidation and sexual harassment suggests the real and profound challenge that women in soccer posed and the deep sense of entitlement to control the sport that some men felt. The Pickard Commission found that SAFA was extremely dilatory and negligent in giving attention to the problems, and advised SAFA to increase resources for women's football and create structures to develop the women's game (Pickard Commission 1997). After intense public negotiations, a decision was made to change the organisational relationship between women's soccer and SAFA. Specifically, women's soccer was to become a subcommittee of SAFA rather than simply affiliated with the organisation. As a subcommittee, the larger male-led governing body would have total control over and fiscal responsibility for women's soccer.

Most within the women's soccer community welcomed this change, but some leaders and players voiced concerns. The vast majority of Western Province soccer players that I surveyed thought that joining SAFA would be beneficial because it would bring in more monetary resources for women's soccer, especially from corporate sponsors.[12] Others, such as the administrator quoted above, articulated concerns about women losing decision-making power. As with women's soccer in other countries (Hong and Mangan 2004), men have been an integral part of women's soccer in South Africa, serving as team sponsors, coaches, managers, referees, administrators and fans. Given women's limited access and experience within soccer, South African women's soccer is dependent on men's expertise and resources. Despite concerns about losing organisational control and the hostilities from some men, the women's soccer community did not seek to exclude men's participation. Rather, it was a question about the extent of men's involvement, the lack of women in leadership roles and the marginalisation of women leaders.

While most national SAFA administrators rhetorically supported increasing women's leadership capacities, the process of dismantling male dominance within soccer has yet to be fully embraced and institutionalised at all levels. The following quote from a high-level SAFA manager highlights the challenges of mainstreaming gender equality within the sport. Responding to a question about gender transformation, he said:

> On the executive level there is recognition that women's football has to be treated a whole lot more seriously than had been in the past. But how to

translate that into real action is another matter. Whilst there is a commitment, the commitment on a philosophical level that it needs to change, how to do that practically... becomes another matter. Because, you know, we are not quite sure if everyone is as committed to that as they say they are on paper.

The difficulty of translating commitment to gender equality into policy and practice has become as clear to the women's soccer community as it has to those in other social and political sectors in South Africa (Friedman 1999). Nonetheless, the democratic transition afforded South African women new resources, including an emergent national discourse on gender equity, governmental support and more opportunities to challenge beliefs and practices that construct them as outsiders within soccer. As elite women sport administrators were advocating for change at the highest levels of sports administration, women at the grassroots were challenging barriers on the soccer fields. Soccer players, particularly young black women, were putting into practice what national sports leaders were putting in writing. Rather than simply benefiting from new opportunities, women/girls in soccer can be considered agents of change in the new South Africa. By escaping the trappings of daily domestic labour and dominant gender ideology and showing up at the soccer fields, they contribute to the process of democratisation. Furthermore, through their engagement in everyday social spaces, these women and girls are crafting new dimensions of civil society that provide opportunities to organise across divides.

Conclusions

The findings of this study contribute to our understanding of the potential role athletes and sport administrators play in social-change projects and nation-building processes in the new South Africa. Although women's netball and women's soccer may not constitute formal social movement organisations, the waves of collective action against racism within netball and the challenges to male dominance in soccer are illustrative of how grassroots activities within civil society can contribute to everyday democratisation. Rather than women athletes simply being the beneficiaries of anti-racist or feminist organising within South Africa, these observations suggest that women athletes are an integral part of that collective organising against racial and gender inequalities.

Borrowing from social movement theories, I conceptualise netball and soccer athletes and administrators as political actors who formed collective

identities and engaged in collective resistance against race/gender hierarchies within sport. Although these efforts are not widely recognised in this politicised form, they do suggest the continuation and expansion of the earlier non-racial sports movement in South Africa. Consistent with political opportunity theory, these data show that the democratic transition within South Africa undercut state support for the status quo within netball and soccer, and weakened the power of white female leaders in netball and black male leaders in soccer to exclude black women from full and equal participation in their respective sports.

Within netball in recent years, it appears that athletes and administrators are building on the positive changes of the 1990s by turning their attention to economic privileges and disparities among netballers and South African women more generally. During my 2003 field research in South Africa, netball administrators reported that they were making strides in developing a group consciousness of structural inequalities. It appears that the increase in racial integration and the lessening of racial tensions have created space for netballers to disentangle race and class barriers facing South African women and move forward in building a new collective identity. For example, the financial costs incurred by netball administrators, who are largely volunteers, became more visible in recent years and this led to administrators grappling with how economic differences discourage black women's leadership within the sport. As a result, new policies of reimbursing expenses of administrators were adopted. As Meintjes (1998) argues, it is the recognition of the 'yawning gulfs' of material differences among South African women that makes it possible for them to collectively challenge their shared subordination. Future research on the development of a collective identity within netball and the role of netball in the democratisation of civil society is warranted.

The case of the masculine flagship sport of soccer also shows how past traditions are being reworked by women (and some men) and new 'traditions' and meanings are being created (Hargreaves 1994). The growth of women's soccer in South Africa during the 1990s signals a significant challenge to gender-exclusionary practices in the sport. South African women, particularly black women, are actively negotiating dominant gender ideologies, the realities of poverty and the burdens of domestic labour (Roberts 1992) to enjoy the physical pleasures of competitive soccer. Challenges to male dominance in soccer, however, have not gone unchecked. Some men within soccer have

resisted strongly the growing presence of women. Sexual harassment and intimidation have been used to keep women in their place and helped men to gain organisational control of women's soccer. Nonetheless, women have found successes in tapping into the new national discourse on gender equity and have gained new opportunities that were not imagined just a short time ago.

The shifts in racial demographics within women's soccer also demonstrate that South African women do not form a homogeneous unified group whose members experience gender inequalities in sports in the same way. White women had access to soccer before black women, but as the number of black women in soccer grew during the 1990s, many white women left the sport. Shifting and contentious race relations among women within soccer and netball demonstrate how a shared gender status among women is not sufficient for mobilising against inequalities.

Overall, these data lend support to African feminists' assertion that African women are not tradition-bound and interested only in issues of survival (Salo and Mama 2001). South African women athletes are not simply victims of sexist, racist and colonialist relations, but are active agents in negotiating structural inequalities and ideological constraints to build new subjectivities and opportunities. Despite the difficulties inherent in negotiating the legacies of colonialism, apartheid and male supremacy, this analysis suggests that women athletes have made significant changes whereas other popular men's sports have not. Although national political and economic elites may not recognise or celebrate women athletes' contributions to nation building, scholars should not ignore the contributions of women athletes and the importance of sports in limiting and facilitating gender change in South Africa. Given the centrality of bodies in sports and nation building, sports are an ideal and important site for understanding how dominant race/gender/class hierarchies are constructed and maintained. Considering the growing popularity of competitive sports among African women, continued research on their experiences within sports promises to produce insights into African feminisms and the processes by which patriarchal relations within civil society are being challenged and transformed. Questions regarding how South African women's sport participation is connected to participants' sense of bodily integrity and confidence, as well as their experiences of gender-based violence, are ripe for investigation. The uncontested use of male-dominated sports to

build a unified South Africa also ignores the issue of the gendered nature of the state and the limitations that current political strategies pose for South African women to translate their newly gained political rights into freedom and autonomy in civil society.

Notes

1. Netball is typically played on a hard-surface court measuring 100 feet by 50 feet and divided into thirds with goalposts at opposite ends. The seven players on a team are restricted to certain areas of the court depending on their position. The aim of the game is to score goals by throwing the ball through the hoop at the top of the goalposts. Players may not run with the ball, kick it, hold it for more than three seconds nor touch another player (International Federation of Netball Associations 2001).

2. Drawing on the convention of the Black Consciousness Movement, I use the term 'black' to refer to South Africans of African, Asian, and coloured racialised identities.

3. The primary sites of my fieldwork were Johannesburg, Pretoria and Cape Town. Johannesburg and Pretoria were chosen because the national headquarters of women's soccer and netball are located in these cities. Cape Town was chosen because it is considered the most developed location for women's soccer in South Africa and was the site of the 2000 national netball championships, a week-long tournament involving over 600 athletes from throughout South Africa. See Pelak (2005a and 2005b) for additional descriptions of data and methodological approach employed in this research.

4. The interviews focused on the participants' sporting histories; the personal, structural and organisational changes taking place within netball; and the athletes' attitudes and thoughts about gender, race and class relations within sports. The ages of the athletes ranged from 20 to 36 years and averaged 25 years. The racial/ethnic/cultural backgrounds of interviewees approximate their relative representation within competitive netball. According to a representative survey I conducted at the championship tournament, 47.2 per cent of netball participants identified as white and/or Afrikaner, 43.1 per cent as black and/or African, 5.2 per cent as coloured, 3.2 per cent as Indian and 1.2 per cent as having mixed racial/ethnic/cultural heritage.

5. The South African Sports Commission was formed in 1999 out of the amalgamation of part of the Department of Sport and Recreation and the National Sports Council, but was disbanded in 2005.

6. The survey was designed to assess the demographic background of participants, the structural barriers they experience in competitive sport and their attitudes regarding racial transformation in netball. Self-administered survey forms were distributed to members of 30 of the top 40 regional teams participating in the tournament. Twenty-four teams returned completed surveys for a team response rate of 80 per cent. Of the estimated 382 individuals who made up the 30 teams sampled, 251 usable surveys were collected for an individual response rate of 68 per cent.

7. Of the soccer interviewees, 58.8 per cent are women and 41.2 per cent are men. The average ages of the athletes and administrators interviewed were 27 and 44 years old, respectively. Because racial identities and categories in South Africa continue to be highly contentious, variable and context-specific, respondents were asked to self-identify (Jung 2000). About 53 per cent identified as coloured/black, 29 per cent as African/black, 12 per cent as white and 6 per cent as Indian.

8. The self-administered survey forms were distributed to all but four teams participating in the league and included questions regarding players' demographic characteristics, experiences playing competitive soccer, opinions of the status of women's sports in South Africa and views on gender transformation in soccer. Completed surveys were returned by nine of the eighteen teams for a team response rate of 50 per cent.

9. Notes were taken during informal conversations when possible, and more extensive notes were written directly after leaving the matches. I also took photographs during my field observations, which was an effective way to introduce myself and explain the purpose of my research. At the end of my fieldwork, I used the photographs to construct a league yearbook and I distributed the yearbook as part of my 'giving back' to the research participants.

10. 'Stop NSC Meddling, Appeals SA Netball Executive', *Citizen*, 7 September 1995.

11. According to the representative survey conducted at the tournament, 42.3 per cent said the quota policy was positive, 46 per cent said it was negative and 11.7 per cent said that the policy was neither positive nor negative. Respectively, 65 per cent and 62 per cent of blacks/Africans and Indians said the policy was positive. Only 19 per cent of white/Afrikaner respondents said the policy was positive.

12. Of the 84 women soccer athletes surveyed, 87.5 per cent said that joining the men's organisation will help women's football, 2.5 per cent said it will hurt women's football and 10 per cent said that joining SAFA would neither help nor hurt. In a follow-up open-ended question, respondents were asked why they thought joining SAFA would help or hurt. The modal response of those supporting the change said that joining SAFA would increase financial resources.

References

Alegi, P. 2004. *Laduma! Soccer, Politics and Society in South Africa*. Pietermaritzburg: University of KwaZulu-Natal Press.

Andersen, M.L. 1994. 'Studying across Difference: Race, Class, and Gender in Qualitative Research'. In *Race and Ethnicity in Research Methods*, edited by J.H. Standfield II and R.M. Dennis. Newbury Park: Sage Publications.

Archer, R. and A. Bouillon. 1982. *The South African Game: Sport and Racism*. London: Zed Press.

Birrell, S. and C. Cole. 1994. *Women, Sport, and Culture*. Champaign, IL: Human Kinetics Books.

Booth, D. 1998. *The Race Game: Sports and Politics in South Africa*. London: Frank Cass.

Bryson, L. 1990. 'Challenges to Male Hegemony in Sport'. In *Sport, Men, and the Gender Order: Critical Feminist Perspectives*, edited by M. Messner and D. Sabo. Champaign, IL: Human Kinetics Books.

Carrington, B. and I. McDonald. 2001. *'Race', Sport and British Society*. London: Routledge.

Christopher, A.J. 2001. 'First Steps in the Desegregation of South African Towns and Cities, 1991–6'. *Development Southern Africa* 18: 457–69.

Collins, P.H. 2000. *Black Feminist Thought: Knowledge, Consciousness, and the Politics of Empowerment*, 2nd edition. New York: Routledge.

Couzens, T. 1983. 'An Introduction to the History of Football in South Africa'. In *Town and Countryside in the Transvaal: Capitalist Penetration and Popular Response*, edited by B. Bozzoli. Johannesburg: Ravan Press.

Department of Sport and Recreation. 1998/9. 'Annual Report of the Department of Sport and Recreation'. Johannesburg: Department of Sport and Recreation.

Egunjobi, S. 2000. 'Now Women Get Chance of Glory: Nations Cup Opens Window of Opportunity for African Stars'. *Sunday Times*, 12 November.

Fonow, M. and J. Cook. 1991. *Beyond Methodology: Feminist Scholarship as Lived Research*. Bloomington: University of Indiana Press.

Friedman, M. 1999. 'Effecting Equality: Translating Commitment into Policy and Practice'. In *Agenda: Empowering Women for Gender Equity*, 2–17. Monograph in collaboration with the African Gender Institute. Durban, South Africa.

Grundlingh, A. 1995. 'Playing for Power: Rugby, Afrikaner Nationalism and Masculinity in South Africa'. In *Beyond the Tryline: Rugby and South African Society*, edited by A. Grundlingh, A. Odendaal and B. Spies. Johannesburg: Ravan Press.

Gruneau, R.S. 1983/1999. *Class, Sport, and Social Development*. Amherst: University of Massachusetts Press.

Harding, S. 1991. *Whose Science? Whose Knowledge?: Thinking from Women's Lives*. Ithaca: Cornell University Press.

Hargreaves, J. 1994. *Sporting Females: Critical Issues in the History and Sociology of Women's Sports*. London: Routledge.

———. 1997. 'Women's Sport, Development, and Cultural Diversity: The South African Experience'. *Women's Studies International Forum* 20: 191–209.

———. 2000. *Heroines of Sport: The Politics of Difference and Identity*. London: Routledge.

Hargreaves, J. and D. Jones. 2001. 'South Africa'. In *International Encyclopedia of Women and Sports*, edited by K. Christensen, A. Guttman and G. Pfister. New York: Macmillan Reference USA.

Hawkey, I. 1993. 'Paine's Dames Net a First Goal across Sport's Gender Line'. *Sunday Times*, 30 May.

Hong, F. and J.A. Mangan. 2004. *Soccer, Women, Sexual Liberation*. London: Frank Cass.

International Federation of Netball Associations. 2001. 'About netball'. www.netball.org/thesport.htm. (Accessed on 22 December 2007.)

Jenkins, J.C. 1985. *The Politics of Insurgency*. New York: Columbia University Press.

Jones, D. 2001. 'In Pursuit of Empowerment: Sensei Nellie Kleinsmidt, Race and Gender Challenges in South Africa'. In *Freeing the Female Body: Inspirational Icons*, edited by J.A. Mangan. London: Frank Cass.

Jung, C. 2000. *Then I Was Black: South African Political Identities in Transition*. New Haven: Yale University Press.

Keim, M. and W. Qhuma. 1998. 'Winnie's Ladies Soccer Team: Goals for the Gugulethu Home-side'. *Agenda* 31: 81–5.

Lemon, J. 2001. 'Reflections on the Woman's Movement in South Africa: Historical and Theoretical Perspectives'. *Safundi: The Journal of South African and American Comparative Studies* 3(2): 1–14.

Lenskyj, H. 1986. *Out of Bounds: Women, Sport and Sexuality*. Toronto: Women's Press.

McAdam, D. 1983. *Political Process and the Development of Black Insurgency, 1930–1970*. Chicago: University of Chicago Press.

McFadden, P. 1992. 'Nationalism and Gender Issues in South Africa'. *Journal of Gender Studies* 1 (4): 510–20.

Meintjes, S. 1998. 'Gender, Nationalism and Transformation: Difference and Commonality in South Africa's Past and Present'. In *Women, Ethnicity and Nationalism: The Politics of Transition*, edited by R. Wilford and R. Miller. London: Routledge.

Melucci, A. 1996. *Challenging Codes: Collective Action in the Information Age*. Cambridge: Cambridge University Press.

Messner, M. and D. Sabo. 1990. *Sport, Men, and the Gender Order: Critical Feminist Perspectives*. Champaign, IL: Human Kinetics Books.

Mikell, G. 1995. 'African Feminism: Toward a New Politics of Representation'. *Feminist Studies* 21: 405–24.

Moffett, H. 2002. 'Entering the Labyrinth: Coming to Grips with Gender Warzones, using South Africa as a Case Study'. In *Partners in Change: Working with Men to End Gender-based Violence*. Santo Domingo: United Nations, INSTRAW.

Mohanty, C. 1991. 'Under Western Eyes: Feminist Scholarship and Colonial Discourses'. In *Third World Women and the Politics of Feminism*, edited by C. Mohanty, A. Russo and L. Torres. Bloomington: Indiana University Press.

Motsei, J. 1994. 'Controversy over Netball Selections'. *Sowetan*, 15 August.

Nauright, J. 1997. *Sport, Cultures and Identities in South Africa*. London: Leicester University Press.

Nnaemeka, O. 1998. 'Introduction: Reading the Rainbow'. In *Sisterhood, Feminisms, and Power: From Africa to the Diaspora*, edited by O. Nnaemeka. Trenton, NJ: African World Press.

Pelak, C.F. 2005a. 'Athletes as Agents of Change: An Examination of Shifting Race Relations within Women's Netball in Post-apartheid South Africa'. *Sociology of Sport Journal* 21: 59–77.

———. 2005b. 'Negotiating Gender/Race/Class Constraints in the New South Africa: A Case Study of Women's Football'. *International Review for the Sociology of Sport* 40 (1): 53–70.

Pickard Commission. 1997. Report of the Pickard Commission of Enquiry into the South African Football Association and the National Soccer League. Johannesburg.

Roberts, C. 1992. *Against the Grain: Women and Sport in South Africa*. Cape Town: Township Publishing Cooperative.

Rulashe, L. 1997. 'Sex Claim: "We are Innocent"'. *City Press* (Johannesburg), 20 March.

Sabo, D.F. and J. Panepinto. 1990. 'Football Ritual and the Social Reproduction of Masculinity'. In *Sport, Men, and the Gender Order*, edited by M. Messner and D. Sabo. Champaign, IL: Human Kinetics Books.

Salo, E. and A. Mama. 2001. 'Talking about Feminisms in Africa'. *Agenda* 50: 58–63.

Scraton, S., K. Fasting, G. Pfister and A. Bunuel. 1999. 'It's Still a Man's Game? The Experiences

of Top-Level European Women Footballers'. *International Review for the Sociology of Sport* 34: 99–111.

Seidman, G. 1999. 'Gendered Citizenship: South Africa's Democratic Transition and the Construction of a Gendered State'. *Gender and Society* 13: 287–307.

SISA (Sport Information and Science Agency). 1997. 'Participation of Women in Sport in South Africa'. Conducted by BMI, Sport Info (Pty) Ltd. Johannesburg: Sport Information and Science Agency.

Staggenborg, S. 1998. 'Social Movement Communities and Cycles of Protest: The Emergence and Maintenance of a Local Women's Movement'. *Social Problems* 45: 180–204.

Statistics South Africa. 1999. 'Primary Tables, Western Province'. In *The People of South Africa: Population Census, 1996*. Johannesburg: Statistics South Africa.

Taylor, V. and N. Whittier. 1992. 'Collective Identity in Social Movement Communities: Lesbian Feminist Mobilization'. In *Frontiers in Social Movement Theory*, edited by A.D. Morris and C. Mueller. New Haven: Yale University Press.

Thabe, G.A.L. 1983. *It's a Goal! 50 Years of Sweat, Tears and Drama in Black Soccer*. Johannesburg: Skotaville Publishers.

WASSA (Women and Sport South Africa). 1997. 'History of WASSA'. Unpublished manuscript. Johannesburg: Women and Sport South Africa.

CHAPTER FIVE

Organising from Private Spaces

Domestic Labour in South African Civil Society

JENNIFER FISH

PAID DOMESTIC WORK institutionalises the deeply embedded historical processes that relegated black women's labour to relations of servitude within the private households of South African society. At a structural level, paid household labour continues to comprise the largest sector of work for black women in South Africa.[1] Often characterised as the 'last bastion of apartheid',[2] domestic labour symbolises a critical disjuncture between the public emphasis on gender rights in the transitional democracy and the everyday processes that maintain sharp asymmetries of power between those who employ household workers and those who perform such labour. Moreover, paid domestic work remains distinctly racialised and feminised, which places formidable socio-economic barriers in the daily lives of women employed in this sector. As a result of these distinctly instilled power relations established during apartheid, domestic labour remains a central social institution fourteen years after the democratic transition. A close look at this institution clearly reveals the extreme challenges to actualising human rights for all in democratic South Africa.

Although the daily lives of domestic workers continue to be structured by ongoing and severe socio-economic inequalities, in the post-1994 context of macro-societal changes, this sector is also gradually shifting as a result of women's activism and organising within civil society. Domestic workers continue to enact both individual and collective agency to demand that the gender rights of South Africa's new democracy are accessible to the largest

sector of working women, namely by building on union organisation and alignment with central gender rights initiatives. This chapter[3] explores the successes of women's organising from some of the most severely marginalised positions within South African society. I draw on seven years of longitudinal field research to explore how women have formed vibrant sites of organisation within civil society that are actively reconstituting South Africa's new democracy.

Theoretical framework

To understand the particular space that domestic labour holds in post-1994 South Africa, I ground my work in former analyses of the role of this sector as a manifestation of broader systems of power within the apartheid era. In South Africa's history, domestic labour reinforced the overarching ideology of apartheid throughout daily interactions in the private household sphere. Gaitskell et al. (1984) analysed how this institution of servitude specifically situated black women's labour as a 'product of the complex operation of class, race and gender divisions over time' (107). Cock (1989) similarly depicted the relationship between 'maids and madams' as a site of intimate racial socialisation that served to reinforce systemic social practices central to apartheid rule:

> The role of the domestic worker is important in socialisation in the dominant ideological order. Often it is the only significant interracial contact whites experience, and they experience this relationship in extremely asymmetrical terms. Many white South African children learn the attitudes of racial domination from domestic relationships with servants and 'nannies'. The converse is also equally true in that blacks presumably learn the attitudes of submission (or at least the semblance thereof) that apartheid requires, and also the resentment it generates through some experience of domestic service. (8–9)

As Cock suggests, these often intimate social interactions within the private household are integrally connected to governing public ideologies, which reproduced systems of severe race, class and gender inequality at the structural level.

Institutionalised paid household labour served a particular function in South Africa's apartheid context. The system demanded women's labour in

the private household in order to reinforce the privileges of the dominant minority as well as relations of servitude across the colour line. Throughout these racialised processes, gender socialisation simultaneously connected black women to paid labour in the private household spaces of the white minority population. This social arrangement constructed distinct experiences for domestic workers, whose lives were shaped by the demands of physical, emotional and psychological labour. Central to the nature of this work, women were required to migrate from their own homes in order to provide services in the residentially delineated spaces of privilege in South African society. Domestic workers were most often 'live-in' help, which created a particular form of entrapment and posed serious challenges to workers' autonomy, privacy and ability to mobilise collectively. These central characteristics of paid domestic labour, therefore, created a distinct duality in workers' lives as they negotiated the day-to-day realities of their experience in employers' private homes while maintaining financial, emotional and psychological relationships with their families and communities of origin. Workers' bifurcated experiences further heightened the power of employers while reinforcing the geographic divides that dominated the apartheid system.

As is evident throughout the global growth of transnational paid household labour (Romero 1992; Perreñas 2001; Hondagneu-Sotelo 2001; Chang 2000; Pettman 1996; Enloe 1989), this institutionalised socio-economic arrangement illustrates that women's experience of gender oppression is extremely variant, based on the interconnected nature of race and class positions. In my analysis, I employ the theoretical perspectives of *intersectionality* and post-colonial feminism that reject a monolithic construction of womanhood (Mohanty, Russo and Torres 1991) and assert that gender inequality must be understood through its interconnected relationship with race, class and nation.[4] In South Africa, black domestic workers remain extremely disadvantaged as a result of what Collins (1990) describes as a 'matrix of domination', in which race, class and gender marginalisation operate simultaneously. In contrast to this 'triple oppression' (Cock 1989), women positioned as employers are often able to draw from race and class privilege in ways that dilute their experience of gender oppression.[5] Through the practice of paid household labour, we see how privileged women also participate in gender discrimination by reinforcing the devalued nature of household labour in the private sphere, which ultimately socially reproduces the privileged position of men through their placement in the public labour arena.

The institution of domestic labour complicates the presumed division between public and private spheres that repeatedly devalues the feminised household space.[6] Recent political theorists have eschewed this public–private dichotomy in gendered analyses of citizenship, the state and globalisation. For example, in her discussion of the 'interactive mutuality' of spheres, Ling offers a feminist perspective on the inherent interconnectedness between the public and the private realms by positing, 'What pertains within the individual/household/nation contributes to the community/state/world, just as what happens in the world/state/community affects us as a nation/household/individual' (2002, 174). The concept of *interactive mutuality* between the public and private realms is particularly useful in seeking to understand the institution of paid household labour in post-apartheid South Africa – where state processes of democratisation are actively resisted in private spaces as a result of ongoing gender, race and class power structures. By connecting the theory of interactive mutuality with an intersectional framework of inequality, we see how the social reproduction of domestic labour is reinforced in the household, state and global spheres through the pervasive race, class and gender inequalities that continue to constitute social relations in post-apartheid South Africa. This chapter explores the spaces in which women's collective mobilisation has infused the potential for social change in the face of imposing structural obstacles.

Research methodology

To illustrate the relevance of these theories, I draw on narrative data collected over a seven-year period during the early phase of South Africa's transition to democracy. Field research conducted in Cape Town initially in 2000–2001 yielded 85 semi-structured interviews among a wide cross-section of individuals and organisations throughout South African society, including domestic workers, employers of domestic workers, local experts, parliamentarians and union leaders.[7] Extensive participant observations within South African households employing domestic workers yielded exceptionally valuable content for further analysis. These combined data are enhanced through longitudinal follow-up of interviews and participant observations over the course of five subsequent field-research site visits from 2004 to 2007.

Because of the highly particular and shifting complexities of race and class relations in Cape Town since 1994, the data gathered for this study

represent the perspectives of both black and coloured domestic workers as well as a range of employers, including the 'newly elite' coloured and black parliamentary employers and the more traditional white 'madams'.[8] For domestic workers, union membership was over-sampled to gather the perspectives of women actively involved in restructuring this sector. The sample of domestic workers was also equally divided between those who live where they work and those who live in their own homes and commute to work each day, in order to account for the substantial impact of residential location on the nature of paid domestic labour.[9] The race of the employer was purposively sampled within the domestic worker population to include shifting patterns in the post-1994 context. Of the domestic workers who were formally interviewed, 20 per cent worked for 'new employers' at some point in their careers.[10]

Employer participants were purposively sampled to address the study's overarching emphasis on change within the institution of domestic work since the inception of the democratic state. In line with a predominant emergent discourse about South Africa's 'new madams', black, coloured and Indian employers accounted for 13 of the 20 formal employer interviewees. Of the 7 white employers, 4 were considered 'non-traditional' because of their role in key human rights groups or their identity as strong feminists.[11] Also, within the overall group of 13 coloured, Indian and black employers, 8 were identified as either feminists or highly professional women, or both. The employer sample therefore draws much more heavily on emergent groups that have not previously been represented in the literature on domestic work in South Africa.

In addition to the formal semi-structured interviews, I conducted focus groups, substantial archival research and an additional 30 in-depth interviews with particular experts across a wide variety of sectors (including government leaders, NGO members, gender activists, legal experts and policy makers) to acquire a comprehensive set of perspectives on the institution of domestic labour in South Africa's post-apartheid context. Extensive participatory research with the central national organising body of domestic workers – the South African Domestic Service and Allied Workers Union (SADSAWU) – and the governmental Commission for Gender Equality (CGE) provided central content throughout the fieldwork.[12] Within the group of experts and the organisational leaders, follow-up longitudinal interviews were conducted in 2004, 2005, 2006 and 2007. The following analyses explore women's

collective organising around the case of domestic labour by drawing on data gathered from a variety of sources in this longitudinal study. As a scholar-activist, my intent throughout this process is to document the voices of women at this particular juncture in South Africa's history while providing analyses that situate these narratives within a broader trajectory of post-apartheid democratisation.

Domestic labour and collective organising

To contextualise this research, I begin with an abbreviated overview of women's mobilisation within domestic labour during South Africa's apartheid era. Throughout this period of severe social inequality, domestic workers repeatedly organised to challenge collectively the extreme marginalisation of this sector. Domestic workers' unionisation emphasised the central need to transform conditions of labour where systematic injustices distinctly enforced the relegation of black women to this particularly marginalised work sector.[13] Although working-class, predominantly black, unions were banned during much of the apartheid era, the broader labour movement served as a key site of resistance and collective action. The Federation of South African Trade Unions (FOSATU) and the Congress of South African Trade Unions (COSATU) provided national structures that supported the unionisation of domestic workers and the eventual formation of the South African Domestic Workers' Union (SADWU) in 1986. Within the context of heightened enforcement of apartheid, SADWU afforded a space to organise workers and advocate for basic labour benefits within the household employment site. Unionised domestic workers also aligned with the broader anti-apartheid struggle for social and economic justice through the elimination of racialised governance.[14]

Non-union organisational efforts to train domestic workers throughout the apartheid era also provided spaces where workers met on a regular basis and shared opportunities to align in their common struggles. The Domestic Workers Association of Cape Town, for example, offered educational services for workers' children while serving as an advocate organisation to meet the diverse needs of women employed in this sector. Such organisations simultaneously created venues where larger NGOs and women's rights organisations, such as the Black Sash, invested in increasing the protection of domestic workers. In such organisational alignments, collaboration around domestic workers' rights represented a particular complexity between public

advocacy and everyday social arrangements in private household spaces. Women with access to social power in the apartheid system served as advocates for domestic workers' rights while at the same time often employing domestic workers in their own homes. Similarly, some women's groups were invested in serving as networking organisations between workers and potential employers, which more often reinforced women's relations across racial lines within the context of paid domestic labour, rather than advancing a movement for political transformation of the sector.[15] These historical examples of domestic workers' organising during apartheid illustrate how the asymmetric power relations between women, structured through the institution of paid household labour, stand in sharp contradistinction to the broader ideology of social equality central to the anti-apartheid struggle. In this regard, women's activism around the rights of domestic workers in their private household employment contexts also repeatedly confronted the overarching race, class and gender power relations embedded in apartheid society.

Domestic labour and democratisation

As we explore social change in the contemporary post-1994 South African context, the collective action of domestic worker unions and gender-rights-centred NGOs elucidates the potential for women to utilise organisations as a central space to mobilise civil society in ways that move South Africa into the next phase of democratisation. This research illustrates that women's political engagement surrounding this sector has resulted in tangible policy changes that assure protective citizenship rights to domestic workers for the first time in South Africa. Furthermore, domestic workers' collective organisation continues to provide a policy basis that is beginning to impose standards of accountability among employers within the private household sphere. As a result, protective policies that recognise domestic workers as both citizens and a vital workforce provide a partial conduit for shifting power relations within the private sphere to promote access to the promises of gender rights for all women.

Participants in this research continually suggested that the organisation of domestic workers affords the most effective strategy for democratising this distinct apartheid icon. The asymmetrical power relations and persistent socio-economic inequalities that exist within this institution gradually lose their power as individual workers align with a broader movement for both

gender rights and the formalised protection of domestic workers. This research illustrates that working through unions and NGO networks has been beneficial to realising domestic workers' inclusion in protective policies. The most challenging aspect of social change, however, remains centred on shifting asymmetrical power relations between workers and employers in the private household such that policies 'have teeth'. Given the substantial barriers to social change within this 'last bastion of apartheid', democratising social relations hinges on both effective policy protections and domestic workers' organisation to counter the structural inequalities embedded within this pervasive and normalised institution of paid household labour. To explore the impact of collective action within this particular sector, let us next turn to a case-study analysis of domestic workers' union activism that illustrates how spaces within civil society provide important opportunities for women to organise across social divides and advocate for the protection of this highly vulnerable labour sector.

Organising across divides: Domestic workers and civil society

The resistance to democratic transition in South Africa's private household labour spaces motivated a gender-rights movement built on the notion that 'Women won't be free until domestic workers are free'.[16] By working with and through the gender machinery of South Africa's new democracy, along with a series of human-rights-based NGOs, SADSAWU successfully amended a central social security policy to include domestic workers in unemployment insurance for the first time.[17] This case illustrates how women's mobilisation through civil society organisations has facilitated the inclusion of domestic workers in central protective social policies, thereby formalising women's household labour in ways that complement the social protections central to the guiding ideologies of democracy in South Africa.

The launch of SADSAWU in April 2000 built on pre-existing leadership alliances within SADWU to emerge as a new organisation within the context of the transition to a national democracy. Although SADWU established the first formal unionisation of domestic workers, it disbanded ten years later in the early phases of democratic transition, ironically the same year that the national Labour Relations Act was passed to legalise domestic worker unionisation. The central articulation of gender priorities in the post-1994 process of nation building provided a powerful platform to overcome this

sectoral void in unionisation through the launch of SADSAWU. In the early inception of this organisation, leaders emphasised domestic workers' limited access to improved social and economic conditions. As SADSAWU national office-bearer Hester Stephens stated: 'It is our interest now in the union to build this union because we are quite aware that the struggle is still continuing; whatever is the new South Africa, nothing has changed.'[18]

Throughout my longitudinal study among all members of the executive body, SADSAWU leaders repeatedly expressed this motivation to build the national union of domestic workers in accordance with the new democracy and its particular emphasis on gender rights. In this regard, women's organising through unionisation provided a space to begin to advocate for the inclusion of domestic workers in formal public policies central to the building of a democratic nation.

SADSAWU's national leadership is supported by the local Cape Town office of COSATU, an alignment that provides substantial support through operational resources as well as an ideological commitment to the prioritisation of domestic workers in the broader labour campaigns. However, according to leaders in both organisations in 2006, at the national level, SADSAWU and COSATU have not yet aligned for reasons of historical conflict over the 'viability' of domestic worker unions in the broader initiatives of labour in South Africa. In this respect, the relationship between SADSAWU and COSATU at the national level is parallel to the disjuncture between South Africa's broader commitment to gender rights and the ongoing institutionalisation of domestic labour. As a result, echoing Walsh's analysis in Chapter 2 of this collection, 'the struggle continues' in prioritising domestic labour within the national union movement.

Notwithstanding these organisational challenges in relation to COSATU, within the first year after its launch, SADSAWU demonstrated the effective organisation of women within civil society by opening six regional offices and establishing an enrolment base of approximately 11 000 members by June 2001.[19] At this same time, Department of Labour officials estimated that over one million women were employed in domestic service.[20] As this low overall enrolment rate suggests, the primary organisational goal for SADSAWU during its first year focused on membership recruitment, as reflected in the overarching national priority of membership growth. One of the strongest barriers to enrolment in this early phase stemmed from social power dynamics maintained within the households of employers, which, in many

cases, scrutinised workers' union affiliation, as well as the long-term implications of domestic workers' labour empowerment. Domestic worker participants, for example, repeatedly conveyed that open union membership within the household work space created a serious threat to their employment conditions, making it difficult to attend meetings and align with other women organisationally. One respondent in this study described how her employer reacted to her SADSAWU campaign T-shirt by saying, 'Never, never, never wear that T-shirt in my house again!'

These barriers to individual membership were of concern to union leadership for two primary reasons. First, without a central employer where union dues could be easily collected, weak financial viability remained a serious hindrance to organisational growth. Second, in addition to membership campaigns, SADSAWU's main focus remained centred on policy change to include domestic workers in labour and social security legislation. Yet without a stronger membership base, SADSAWU's organisational strength as a lobbying agent was quite constrained in these early phases of growth and development. Moreover, each of SADSAWU's national office-bearers, with the exception of one leader, worked in domestic labour, creating a structure where substantial responsibilities rested on the shoulders of a few officers who also assumed full-time and often live-in roles as domestic workers.

Despite these pervasive challenges, the commitment of individual SADSAWU leaders has resulted in continual growth in the organisation's membership and capacity. Domestic worker participants in this study who enacted personal agency through joining SADSAWU repeatedly expressed the sense of empowerment in their individual employment contexts. The following interview response captures the felt benefits of union membership for one domestic worker:

> I'm only involved in the union and then I also like to go to different meetings, like the NGOs and that kind of meetings, and it's also empowering me as a worker, and not sitting here in the room and do nothing for yourself. (Domestic worker interview, Khayelitsha, February 2001)

Part of the strategy of increasing union enrolment among domestic workers emphasised a broader awareness of the personal empowerment potential

available through organisational affiliation. Another domestic worker linked her felt sense of individual empowerment with a broader political struggle to realise the 'new South Africa':

> Yes, it [unionisation] is part of the struggle, and to make other workers aware of it, that I can talk to them about the union, because I find the union like a security for myself, you know, if I got a problem, I can go there. So I also want them to be part of that union. (Domestic worker interview, Gugulethu, March 2001)

These statements illustrate how union membership fosters worker agency at the individual level. Yet the role of unionisation also involves a collective level of participation in political processes of nation building. Through domestic workers' engagement with the organisational capacity of the national union, they also gained direct access to a broader gender rights movement in South Africa as a result of the necessary alignment of SADSAWU with other civil society and human rights organisations.

Organising within the gender machinery

Union leaders, SADSAWU members, parliamentary and NGO participants in this study repeatedly asserted that even though domestic workers realised marked success in collective organisation, the severe forms of inequality within this labour sector necessitated a need for alignment with other gender rights organisations. Accordingly, one year after its inception, SADSAWU established an organisational alliance that continues to position domestic workers more centrally within South Africa's broader gender rights movement. Initiatives resulting from the collective activism of this alliance pushed forward a public discourse that began to challenge the inherent contradictions of domestic workers' limited rights in the context of South Africa's public gender priorities. I move now to an analysis of the process of organising that led to the inclusion of domestic workers in unemployment insurance. The victory that was achieved elucidates one of the most viable avenues to utilising women's collective mobilisation from a variety of social locations throughout civil society. This case study thus reveals an effective approach to organising across socio-economic divides to advocate for the protection of domestic workers within South Africa's democratic dispensation.

In 2001, SADSAWU's first major policy initiative involved securing domestic workers' access to the national Unemployment Insurance Fund (UIF) intended to provide a critical safety net for workers during periods of unemployment. Since 1994, the UIF policy has been widely viewed as one of the most important social security initiatives within the new democracy, particularly because of the estimated 40 per cent unemployment rate in South Africa. Yet within government structures, the inclusion of domestic workers in UIF benefits remained under investigation from 1991 until 2001 because of the particular implementation challenges inherent in legislating the private household sphere.[21] Government policy makers interviewed for the present research shared a particular scepticism about including domestic workers in the UIF because of the criticism they would receive in relation to ensuring compliance among employers, particularly in this case where the labour site is also the private household. In addition to the power dynamics at play, the extensive deliberations over domestic workers' protection within the UIF illustrate the symbolic importance of this first measure to include domestic workers in social security benefits, thereby instilling measures to formalise women's labour in the private sphere.

Ally (2007) provides a critical analysis of the state's relationship to domestic workers by centralising the repeated constructions of this sector as 'vulnerable' in state discourse and policy construction. In Ally's argument, such 'democratic statecraft' reproduces the severely marginalised positions of workers while enhancing state power as a result of the particular subjectivity framing this sector. '"Vulnerability" as a mode of entry into citizenship-rights for domestic workers presumed, in particular, a victimised subject with compromised capacity' (7). As we examine the crafting of policy on the part of the state, the construction of domestic workers among allied gender and human rights organisations, and the response to such policies by domestic workers themselves, Ally's astute analysis shows how this repeated construction of 'vulnerable workers' creates a particular form of subject status that shapes the creation of policy as well as its later implementation. As we shall see, the discourse surrounding the inclusion of domestic workers in the UIF encapsulates Ally's analysis.

In March 2001, the Department of Labour presented a final draft of the Unemployment Insurance Fund Bill (B3-2001) to the Labour Portfolio Committee. This third draft specifically *excluded* domestic workers from

unemployment insurance coverage and identified a need for an additional eighteen months to investigate the administrative challenges involved with this sector. Refusing to accept this delay, SADSAWU joined a coalition organised by the CGE, a constitutional body established in 1997 under Chapter 9 of the Constitution to promote and protect gender equality. The collective became known as the Gender Monitoring and Advocacy Coalition for the Unemployment Insurance Fund (GMAC-UIF). This alliance consisted of four predominant NGOs (with both gender and human rights profiles) – including the Black Sash, the South African Council of Churches, Women on Farms Project and the Southern African Catholic Bishops' Conference – along with representation from the COSATU parliamentary office. The collective aligned by identifying shared concerns about the unconstitutional nature of the exclusion of the 'most vulnerable' sector of the labour population. This coalition represented the first collective organisational initiative to take on the case of domestic labour as a central gender priority since the 1994 transition to democracy.

In order to enhance participation in the newly open parliamentary process of public submissions on draft policy documents,[22] this collective representation of civil society centred its work on strengthening each individual submission by establishing a shared platform of gender justice within the context of social security rights. Organisational members of the GMAC-UIF aligned with SADSAWU and presented individual submissions on the case of domestic workers' protection, each of which clearly demonstrated the unconstitutional and discriminatory nature of the exclusion of domestic workers from unemployment insurance benefits prioritised in the new democracy. Furthermore, every submission repeatedly challenged government on the contradictory nature of its social security philosophy – to protect the 'poorest of the poor' – and its practice of excluding the most vulnerable sector of the working population from unemployment insurance benefits.

According to parliamentarians interviewed in this research, SADSAWU's opening statements during the UIF hearings made a central contribution to the reform of this policy. General Secretary Myrtle Witbooi challenged parliamentarians to acknowledge the multiple contributions domestic workers repeatedly make to the overall governmental and economic livelihood of the nation:

We ask you to think seriously about domestic workers. You know ever since this slavery started in this country, domestic workers were there. We have been doing the work for all of you, yet when it comes to laws, there is just no way it can be extended to domestic workers . . . We find it most problematic that the bill seeks to include the poor while overlooking the poorest of the poor, the domestic worker . . . We feel the unemployment insurance is discriminating against us as women . . . We see women that are working for twenty years. We see them walking in the streets because there is no unemployment benefits for them. There is no pension fund for them . . . I am asking you this morning, listen with your heart to the domestic worker . . . think of your mothers because many of you were raised by domestic workers working for you while you are here now . . . I am asking you this morning, please consider the domestic workers . . . if it were not for them in your houses, you would not have been here today, if it were not for domestic workers working for the people of Parliament, there would be no Parliament today.[23]

Witbooi's emotional plea draws on constructions of gender and the collective symbolic meaning of motherhood and domestic service in South African society. At the same time, the statement on the nation's ability to function as a result of domestic workers' labour, made within the formal chambers of parliament, struck a chord in a very public venue – one laden with historical symbolism – and instilled a serious challenge to denying workers protective rights. In this sense, the prominent position of SADSAWU within the GMAC-UIF initiative proved to be an effective tool of accountability and public presence during the parliamentary submission process.

Less than one week after these public submissions, government announced that the UIF would be extended to cover all domestic workers, acknowledging that they comprised the largest and 'most vulnerable' sector of working women in the country. Many NGO leaders and political analysts in this study suggested that this bold change in government policy resulted directly from the pressure exerted by civil society and specifically the GMAC-UIF public submissions. One parliamentarian stated that the public statement delivered by SADSAWU made the decision to extend coverage 'unavoidable'. Interestingly, while such policy change marks a monumental victory for domestic workers, we also see the co-optation of the discourse of vulnerability and the strategic use of essentialised gender constructions of motherhood and household labour as

pivotal in this inclusive amendment. Such competing analyses are evident in the work of the coalition organised to advocate for domestic workers' rights.

The CGE led the process of organisational networking from its particular position of power within the new democratic framework. As an independent monitoring body, the CGE assumes a central role in the structure established by the broader national gender machinery, captured by its mandate:

> The CGE exists because South Africans, when writing their Constitution, insisted that such an institution be established. But it is also there to ensure that gender issues are visible and integrated in the day-to-day policy and practice of state and non-state institutions. Until gender equality is a way of life in South Africa, the mandate of the Commission on Gender Equality remains.[24]

The CGE works with government structures to a certain degree, yet its primary role is as a monitoring body, holding the state as well as private institutions accountable to upholding gender equality as an integral part of democracy. Meintjes, analysing from her insider position on the CGE, demonstrates in Chapter 3 of this collection that this organisation, while holding the potential for powerful change, faced severe limitations in its ability to actualise change through the promising trilateral public structures of the gender machinery. Meintjes points to the moderate leanings of 'femocratisation' as a critical shortcoming of the CGE. Rather than advocating the transformation of gender relations through the simultaneous emphasis on women's empowerment and men's redistribution of power, the CGE more often emphasised advocating for women's rights within the existing structures of the state. In her words: 'The Commission was so concerned to get the structures and structural relationships right – its roles and functions – that it failed to get the ideology and politics right' (page 92–3, this volume).

I share with Meintjes this critique of the ideological shortcomings of the CGE that posed serious barriers to the potential for radical gender transformation through use of the gender machinery structures. At the same time, however, the focus on establishing the structural relationships served to leverage power within the context of the CGE's leadership of other NGOs in this strategic coalition. In the case of advocating for the rights of domestic workers, the CGE's work on the UIF campaign, in collaboration with SADSAWU and other well-positioned NGOs, afforded a space where organisations aligned

across divisions to establish a collective civil society voice and mobilise for policy change. From this platform, the CGE used its elevated position as a tool to lead NGOs and speak in alignment with those organisations positioned as 'most vulnerable', particularly the domestic workers' union. Ironically, even though both SADSAWU and the CGE share serious limitations in their organisational strength and operation, their alliance in the GMAC structure elevated the collective power of these organisations as aligned civil society voices for women's rights.[25]

Union leaders recognised the importance of the unemployment insurance policy to the domestic work sector because it could provide a sustainable income for women during periods of unemployment. Because of the vulnerable position of domestic workers in jobs that continue to be considered 'informal', the worker participants in this research identified the ability to secure such transitional resources as critical to assuring some sort of a 'safety net' in the context of severe socio-economic circumstances. Organisational submissions from the GMAC-UIF described this benefit as a central component of an overarching commitment to assure equitable access to democratic social security, rather than an isolated protection policy. This allowed for a wider participation of NGOs focused on gender rights as human rights.

The UIF policy reform process also established a new framework for the coalition model organised by the CGE. The integral membership of SADSAWU within the coalition afforded domestic workers a pivotal space to network with other NGOs who represented their cause. SADSAWU's presence as an equal party in the coalition in turn informed NGOs about the practical realities of policy decisions in ways otherwise unavailable without the representation of domestic workers' experiences at the decision-making table. In a personal interview, Fatima Seedat, director of the GMAC-UIF, described her perceptions of how the structure of the coalition informed her own understanding of the recipients of this critical policy change.[26] She said that this particular coalition allowed her to develop a heightened awareness of the daily realities of domestic workers in ways she had formerly not considered, even in her experience as a gender specialist. Other leaders in the GMAC-UIF process stated that their integral work with SADSAWU forced them to continually consider the question, 'Why are we here?', within the broader framework of gender rights. Thus, the public structure of South Africa's gender machinery constructed a successful platform for women to align across race and class

boundaries and, through the use of effective organisational mobilisation, advocate for the inclusion of domestic workers as a viable and central labour sector.

SADSAWU also benefited extensively from its involvement with GMAC-UIF. Primarily, its alignment with organisations with wider networks, extensive histories as human rights advocates, greater lobbying experience and larger resource bases positioned SADSAWU more powerfully when several other organisations backed its parliamentary submission with the same outlined concerns and suggestions for reform. This alignment of civil society organisations proved to be effective in the efforts to 'take domestic workers seriously' within the context of inclusion in policy rights. SADSAWU leaders embraced the GMAC-UIF model and associated it directly with the ultimate success of the policy reform.

Another critical component of the effectiveness of this collective model stemmed from a shared reference among GMAC-UIF members to the international conventions adopted by South Africa. In particular, the resolutions of the Convention on the Elimination of All Forms of Discrimination against Women (CEDAW)[27] became both a central reference point and a tool to hold the state accountable to the gender rights platform centralised in the nation's transition to democracy. By referencing international conventions such as CEDAW, members of the GMAC-UIF reinforced the state's obligation to the international community in ways that proved to be effective. Even though such references can often be more rhetorical than applied, in this case of instituting change in domestic labour policy, the strategic invoking of CEDAW standards connected the GMAC-UIF to a broader transnational gender rights movement. Drawing on international documents therefore illuminated the anomaly of the gender discrimination inherent in the exclusion of domestic workers from critical social-security legislation, in sharp contrast to commitments held by South Africa within the international community. Furthermore, because South Africa's own national policies surrounding gender rights are in many instances more progressive than CEDAW, pointing to the international standard underscored these sharp contradistinctions. As South Africa debated its first major social security protection for this sector, the combined influence of domestic workers, local NGOs, the CGE monitoring body and the international standards provided a powerful collective stance to usher in policy change.

Because state institutions hold substantial power in their ability to reconstitute the symbolic and material nature of domestic work, they cannot be ignored or discounted. However, state accountability is enhanced when it is demanded from aligned international organisations applying pressure from 'above', as well as from within civil society putting on pressure from 'below'. The Black Sash, historically a women's anti-apartheid organisation that remains involved in domestic worker rights, drew on the guiding principles of CEDAW to make the following submission on the UIF to the South African state:

> There has been a clear trend in recent years amongst international jurisdictions to bring casual workers and workers in the informal sectors within the ambit of more formal employment legislation. This trend has been brought about in recognition of the principle established under international law that to exclude them amounts to unfair discrimination. We submit that the exclusion of domestic workers from the UIF benefits is in clear contradiction of international law, is at odds with accepted international practice and for all of these reasons, as well as the reasons outlined above, is unfair discrimination.[28]

As members of the GMAC-UIF utilised these international documents, they participated in a broader global women's movement in two ways. First, drawing on CEDAW reinforced South Africa's role in formal institutions of global governance and its commitment to gender rights within the international community. Second, GMAC-UIF members strengthened informal international civil society networks by utilising alliances and strategic relations with global organisations to enhance their ability to hold states accountable both to their local populations and to the governing international standards. In this case, while the CGE's effectiveness in pushing forward a radical agenda for gender transformation remains truncated, its overt focus on building structures through relationships demonstrated success in this instance by connecting NGOs at the local level, strengthening the representation of less powerful organisations, such as SADSAWU, and strategically capitalising on its rhetorical power by aligning with the international women's standards articulated in CEDAW. The combination of these roles proved to be effective in instituting important policy change to protect domestic workers and connect this sector ideologically to a larger gender rights discourse.

The GMAC-UIF process illustrates that while the labour performed by domestic workers may remain in the private household, it is not in isolation from the public sphere at both the national and global levels. At the same time, the strengthening of both formal and informal civil societies shapes the nature of domestic work. As workers in private households are connected to a larger movement of gender rights through union membership, their power within the labour site is strengthened in both material and ideological ways. Workers acquire direct knowledge and skill sets from their union experience that enhance their ability to demand rights in the work setting in accordance with national protective labour legislation. At the same time, the domestic workers in this research articulated a feeling of internal empowerment through their knowledge of the context of domestic labour outside of South Africa and the 'solidarity' they experienced as a result of support for SADSAWU's campaign for protective rights in South Africa. Thus, through their membership in the national union, domestic workers both gain an increased awareness of rights and benefit from participation in a broader imagined international civil society. This union participation, which places their work in private households into the national public dialogue through organisational representation, is then connected to global levels of activism surrounding domestic labour.

While workers themselves do not often directly take part in transnational organising, their membership in the national union instils in them a broader awareness about the global nature of domestic work, and connects women in South Africa to international activists in ideological solidarity. As revealed through my interviews with union members, this identification with a broader labour movement provided a level of empowerment that strengthened workers' agency and countered the extreme vulnerability of isolation that is particular to this form of employment. For example, a domestic worker named Thelma stated that she discussed her knowledge of the domestic workers' union movement in Jamaica, the US and Brazil with her employer, suggesting that South Africa's standards of unionisation and protective legislation were not unrealistic given the progress of the sector in other global locations. This knowledge provided a level of agency within Thelma's work setting that stemmed directly from her informed power base. Furthermore, union members' knowledge of the investment of international organisations in their struggle provided a foundation of strength that advanced the organisational

capacity of the national union, and, in some instances, instilled a level of hope for workers about the potential to democratise the institution of domestic labour in South Africa.

The voice of domestic labour in state structures

Since the GMAC-UIF initiative, the case of domestic labour has moved to a more central position within the broader public dialogue on gender rights. In 2001, the Department of Labour initiated minimum-wage legislation for informal workers, and in this context domestic workers received wide coverage in public dialogue. In participant observations since the 2001 GMAC-UIF campaign, I noticed the domestic labour sector at times becoming a measure to assess the viability of gender rights or labour policy implementation. In daily discourse throughout field research evaluation, perceptions of domestic workers continue to be commonly connected to women who are among the 'poorest of the poor' in South Africa. Such constructions resonate with the overarching 'vulnerability' discourse generated by the state in relation to domestic workers. Because they make up the largest sector of working women, however, any measure of gender rights progress must be evaluated in relation to domestic workers' ability to *access* such rights. As one union leader put it: 'Women's rights mean little for this country unless domestic workers' lives improve.'

As we move beyond the legislative victory to explore the ways in which domestic workers are positioned within the broader discourse of gender and social rights in South Africa's new dispensation, Ally's (2007) theory of the state's contradictory role provides one of the most illustrative analyses of a striking and overarching relationship between domestic workers and the new democratic government. Even though the state eventually granted inclusion for domestic workers in the case of the UIF, it did so within a broader context of constructing this group as particularly 'vulnerable', thereby reifying the pervasive race, class and gender power asymmetries central to South Africa's apartheid system. As Ally acutely points out, 'In various forms, by posing the vulnerability of these workers as the basis for state regulation of the sector, the state constructed workers as lacking the capacity to effect change themselves, thereby extending the state's responsibility, and with it, its powers and reach' (7). Ally goes on to assert that such pervasive constructions of workers as 'vulnerable' simultaneously put forth a notion of their unionisation

efforts as weak and ineffective. Unlike other unions, in the eyes of the state, domestic workers are not positioned to enter into bargaining situations to assure protective legislation or minimum-wage standards. Accordingly, in the UIF campaign case, while assuring protective rights, the state maintained power in the doling out of such rights, thereby reconstructing this particular sector as vulnerable (read 'weak and ineffective') from the perspective of the state. As Ally argues, this allowed the state to act by proxy to determine the conditions of employment for domestic workers. Such analyses pose serious questions about the extent of actual social change instilled through the UIF policy victory, when it occurred within the context of an ongoing construction of women in this sector as distinctly vulnerable, weak and ineffective at unionisation.

As we see in Witbooi's parliamentary address on behalf of SADSAWU, union leaders also draw on these generalised constructions of vulnerability in their own discourse and interactions with state actors. I suggest that in doing so, they are both rhetorically reproducing their own marginalised position and enacting a particular form of agency within the distinct nature of South Africa's democratic transition. For example, the use of imagery surrounding motherhood, the phrase 'poorest of the poor', and the symbolic meaning of 'domestics' in South Africa emerge in the public discourse of SADSAWU leaders. Accordingly, Witbooi encouraged policy makers to 'think of your mothers' when considering the exclusion of domestic workers from the UIF. Such discourse both reproduces this notion of vulnerability and, as policy makers admitted, 'makes it very difficult to ignore domestic workers'.[29] Perhaps this use of the rhetoric of vulnerability is chosen strategically by domestic workers as a creative form of resistance distinct to this particular phase of South Africa's transition. I suggest that the way in which domestic workers respond to state constructions of the 'vulnerability' and the 'highly marginalised' position of women in this sector constitutes their own distinct form of pragmatic feminism.

The GMAC-UIF case paved a path for state recognition of domestic workers as a viable labour sector, as well as a central constituent of any protective gender measure. In line with Ally's critique, the positioning of 'vulnerability' as the central framework from which the state constructs its relationship to (and protection of) women in this sector reinforces a distinctly paternalistic power relation, whereby the state continues to allocate reform 'from above'.

Such relations hardly advance the progressive feminist vision of gender change or the redressing of gender, race and class divides central to South Africa's democratisation project. While these pervasive power asymmetries must continue to be actively challenged, the practical and felt victories of domestic workers surrounding the UIF campaign may also be held simultaneously. According to SADSAWU leaders, a shared perception that 'now we are on the map' symbolised a critical victory in the state's public recognition of this sector through tangible policy change. As a result, from the GMAC-UIF we see a new pattern in the intentional inclusion of domestic workers in state processes dealing with gender, social security, minimum-wage standards and labour rights.

As a critical example, the integration of domestic workers in state processes extended to the executive level in 2006, when President Thabo Mbeki's Working Group on Women invited SADSAWU leaders to join in a broader project of examining the state of women's conditions in South Africa. The scope of this initiative is defined as 'promoting and monitoring the implementation of government's policies on the empowerment of women' as a measure of 'advancing gender equality in the second decade'.[30] Delegates from women's organisations throughout South Africa participate in this Presidential Working Group, which is structured by an emphasis on 'social cohesion' and women's contribution to a 'second economy'. As we see in the GMAC-UIF case, international initiatives such as CEDAW and the Beijing Platform of Action[31] guide the work of evaluating gender progress within state processes. This presidential initiative draws from the gender machinery in place within South Africa and works directly with the Office on the Status of Women (OSW) and the CGE. Yet the formalisation of this initiative represents an added component of state processes focused on the analysis of gender equality following the first fourteen years of democracy.

Women's organisations are central to structuring the representation within the Presidential Working Group on Women. From the 53 women's organisations represented within the broader working group, President Mbeki selected a Coordinating Committee of 12 members based on initial presentations that outlined the specific gender concerns of organisational constituents. When SADSAWU leadership presented their interests to Mbeki, they stated: 'We are here to represent the women that clean your houses.' Here again, we see domestic worker union leaders evoking the imagery of

marginalisation and traditional gender roles in their efforts to attain solid representation within state-led structures. After these initial meetings in which leaders shared the lived experiences of women employed in domestic labour, SADSAWU succeeded in acquiring a central position as one of 12 members on the Coordinating Committee. This inclusion positions the national union of domestic workers in a direct line of visibility with the highest level of the executive structures, within a broader effort to evaluate the effectiveness of gender rights implementation throughout South Africa. Moreover, through this structure, the case of domestic labour holds a central position within the broader gender rights movement through women's collective mobilisation in civil society. SADSAWU's participation in the Presidential Working Group exemplifies how women's organisations provide a liaison between workers positioned in this severely disenfranchised location and state processes established to promote the advancement of gender rights. Ongoing analyses of SADSAWU's role in the Presidential Working Group's Coordinating Committee will afford the opportunity to evaluate the extent to which such formal inclusion impacts shifts in social relations that play out in the private household sphere, where women's labour remains a serious challenge to the ongoing actualisation of gender rights.

Assessing challenges

The victories associated with the organising of domestic workers have grounded the most vulnerable and largest sector of the working women's population in South Africa within the larger public discourse on gender rights. As the GMAC-UIF case represents, the protective legislative measures illustrate enormous progress in terms of formalising domestic labour as a bona fide sector of employment for the first time in South Africa's history. Women's use of civil society organisations and unionisation proved to be a pivotal component in realising these central protections. The domestic labour case depicts an innovative model of women's organising across NGOs, which fostered an increased collective strength for both SADSAWU and the CGE through this unique approach to mobilising for policy change. Such critical measures of progress hold the potential to actualise the gender equality goals central to South Africa's new democracy. Furthermore, the collective action of the GMAC coalition incited a gradual shift in the social norms that govern domestic labour. When the demand to protect domestic workers in

unemployment insurance is backed by a larger body of civil society organisations, domestic workers' rights have more clout in individual employment contexts. In this regard, the mobilisation of domestic worker unions demonstrates that civil society affords the opportunity to align more closely the private and public spheres of democratisation. While change in everyday social relations remains the sharpest challenge to implementing the progressive gender, labour and social security policies assured on paper, the GMAC-UIF victory represents an important initial step in that journey. As the other chapters in this collection also illustrate, civil society comprises the most vital space for women's collective organisation and political participation in the ongoing reconstruction of a democratic South Africa. Through organisations such as SADSAWU, women are supported in their pursuit of roles as political agents invested in reconstituting the terms of the emergent nation. These accounts of collective organising in South African civil society show how women emerge from marginalised positions to confront predominant structures of race, class and gender inequality that prevail in the post-apartheid context.

The impact of these victories, however, must ultimately be measured by the extent to which such policy changes have encouraged shifts in social relations within the private household sphere, where workers and employers maintain distinct power asymmetries as a result of pervasive socio-economic divides that persist fourteen years after the realisation of governmental democracy. Domestic workers in this study repeatedly asserted that 'our rights are only on paper'. Therefore, as we see in broader analyses of the progress of democratisation, accessing the social protections formalised in policy change remains one of the greatest obstacles to assuring democracy for all South Africans. The pervasive dominance of 'social apartheid' in many instances renders policy changes ineffective because of the power of ongoing structures of race, class and gender inequality. As a result, the GMAC-UIF victory must be placed within the broader and more complex project of infusing democratic policy in everyday social life.

In this research, examples of gradual shifts in social relations did surface in direct response to the policy protections realised through domestic workers' collective action. Employers, for example, expressed a heightened awareness about minimum-wage legislation for domestic workers and in some cases increased their pay scales. In some interviews, workers also expressed that

their awareness of new laws strengthened their employment situations. Thandi's knowledge of the protections supplied in the Basic Conditions of Employment Act, for example, allowed her to set boundaries within the work context, limiting her weekend hours and asserting her rights to appropriate leave time throughout the year. In instances such as these, the impact of civil society organisations' work does have a presence within the actual work setting, where the realities of social hierarchies persist and continue to constitute the most striking contradictions of the emergent South Africa. This level of change in social relations, however, remains the greatest challenge to South Africa's success in redressing apartheid and assuring that even the most severely marginalised sectors of the population are able to access social rights in their everyday lives. When domestic workers can do so, the notion that 'democracy stops at my front door' may gradually shift as the work of civil society organisations incites felt social change, particularly in relations across race and class divides. Furthermore, successes such as gaining access to the UIF place important examples of change in everyday discourse, which also holds the potential to change relations at the community, household and family levels. As the 74 000 domestic workers who have been able to access UIF benefits since 2003 interact within their communities, the impact of civil society organisations continues to expand. Cases such as these represent the integral connections among the mobilisation of women in civil society, the realisation of further legislative measures to assure gender rights, and the gradual transference of South Africa's rhetoric of social equality to material changes in everyday relations at the most private level of society.

Conclusions

Through an in-depth analysis of the case of domestic labour in South Africa, this chapter explored a sector that confronts some of the most formidable barriers to the full realisation of gender rights. Findings from this research repeatedly underscore how domestic labour holds a particular space in South African society, where the feminised household retains interconnected power asymmetries central to apartheid's structure of dominance (Fish 2006a). These severe inequalities present pervasive obstacles to women's organising that are particular to this sector, including power asymmetries among women, required migration and the perpetuation of racialised constructions of female servitude. The nature of domestic labour continues to be shaped by a complex

set of relations between women positioned as either employers or domestic workers. As this intimate relationship illustrates, any concept of gender rights must embrace an intersectional approach to consider the extremely disparate positions of women as a result of ongoing class and race divides that mediate access to protective legislation in South Africa's ongoing process of democratisation. The way in which domestic labour is situated in South African society therefore presents a very specific case of how women mobilise within and around this extremely challenging sector to assure wider access to gender protections within the new democracy.

Domestic workers' agency at a collective level has been most evident in the case of the national union, SADSAWU. Since its 2000 launch, this organisation has established a solid membership base, aligned with a series of gender and human rights NGOs, and positioned itself at the centre of the recently launched Presidential Working Group on Women. Notably, the alignment of SADSAWU through the GMAC-UIF established a context where gender rights organisations collectively took on the case of domestic labour, advocating for the union motto 'Women won't be free until domestic workers are free'. The victory realised in the UIF case illustrates how even the most severely marginalised women are able to utilise organisations to work through the embedded state structures of the gender machinery in ways that contribute to the ongoing processes of assuring democratic gender rights. As Meintjes (Chapter 3 of this book) and Ally (2007) point out, such state structures present striking limitations in advancing progressive gender change. The 'femocratic' emphasis on representation within state structures places distinct boundaries on the promises of the integrated gender machinery. At the same time, even though women hold over one-third of the parliamentary positions, the state discourse with its gendered, paternalistic constructions of domestic workers as 'vulnerable' renders this sector weak and unable to exercise agency. Overall, then, the domestic labour sector illustrates a very distinct case study of gender rights in relation to the state.

This research illustrates that civil society organisations provided a structure where the successful mobilisation of women across race and class divides resulted in tangible policy change to protect this extremely marginalised sector. I suggest that while at the organisational level women have united to include domestic labour as a central gender rights concern, the private household presents a case where women's alignment across divides remains most seriously challenged by the persistent relations of inequality between 'maids and

madams'. As Britton (2005) asserted in her research on South African women parliamentarians, the private sphere remains the most serious obstacle to realising the public victories of democracy. In Chapter 6 of this collection, Moffett contends that the prevalence of rape serves as a policing agent in South African society – where men retain power and dominance in the most private encounters with women. The private nature of domestic labour similarly affords those with power an opportunity to 'police' the extent to which the public discourse of gender rights infiltrates the private sphere, where social relations continue to be structured by a history of servitude, thereby reinforcing distinct race, class and gender divides. This policing of domestic worker rights in the private household in many cases renders policy changes insignificant, as employers maintain enough social power to retain former systems of power and dominance. Furthermore, the state's persistent reinforcement of domestic workers as 'weak' and 'vulnerable' reproduces the power of employers in relation to this sector of working women commonly constructed as 'the poorest of the poor'.

In this regard, we see another context in which women repeatedly asserted that democracy is most severely inaccessible in the realm of the private household. In the case of domestic workers, the duality of daily survival creates two distinct experiences of the limitations of gender rights within the private sphere. First, when the household becomes a site of paid labour, it is still not generally considered a formal work sector. Thus, this feminised and highly racialised institution presents a severe contradiction in relation to the public discourse of protection of gender rights, as the data throughout this chapter illustrate. Second, domestic workers return to their own homes and communities, both in rural areas on an annual basis and in township locations where economic structures continue to define the geographic inequalities central to residential location. Domestic workers similarly contended that the concept of gender rights had not yet been embraced within their own private homes, where their daily lives remained confined by gender inequalities. As one worker asserted, 'No matter what laws say we have gender rights, if a man wants to hit me, he will hit me.' This duality of existence therefore inflates the extent to which women employed as domestic workers must deal with the contradictions of the public and private spheres in their daily lives. For some workers in this study, living with this contradiction motivated their enrolment in the national union as a mechanism both to empower them personally and to build organisational strength as part of a collective workers' voice.

Domestic workers hold a particular material and symbolic space that links their day-to-day lives with the former system of apartheid through powerful ties to the embedded social conditions of servitude. Shifting the nature of domestic work requires substantial changes among those who continue to hold privilege, those 'formerly disenfranchised' who now employ domestic workers, and the state in its relationship to this particular sector. Given the overlapping obstacles central to the nature of domestic labour discussed throughout this chapter, collective mobilising at the organisation level is critical to advancing social change at both the private and public levels. The work of SADSAWU, in alignment with other NGOs, to assure the inclusion of domestic workers in the critical UIF social security protection marks a pivotal victory in the long-term pursuit of assuring 'domestic democracy'. The ongoing organising of women across divides through civil society organisations constitutes one of the most promising routes to engendering long-term social change in the shifting terrain of South Africa's democratic landscape.

Notes

1. While Statistics South Africa (2000) reports two other slightly larger occupational categories for women, the number of women in official estimates is severely under-reported because the employment context is the private household. Department of Labour officials in this research repeatedly referred to domestic labour as the 'largest sector of working women' in South Africa. Furthermore, disaggregation of the data by racial categories illustrates that domestic work remains the largest sector of labour for black women in South Africa.

2. This phrase was repeated by several participants in this study, with interview narrative data from 2001 capturing this description of domestic labour among participants who were domestic workers, employers of domestic workers, parliamentarians and non-governmental organisation leaders.

3. The research presented in this chapter builds on an earlier book (Fish 2006a) and journal article (Fish 2006b).

4. For further explanation of intersectionality and its connection to domestic labour, see Guillaumin (1995); Young and Dickerson (1994); Collins (1990); and Cock (1980).

5. Throughout this chapter, I refer to 'employers' as women. While I recognise that men also employ domestic workers, my work focuses specifically on the power relations among women in the private household labour context.

6. For analyses of this public/private division, see Pateman (1988) and Enloe (1989).

7. English was the primary language of communication in each of the individual interviews, although a translator was employed to interpret local meanings throughout the interview transcripts.

8. Critical to the ethics and confidentiality of this project, however, I did *not* interview any employers of workers, or workers of employers, in my sample.

9. All of the domestic workers in this sample worked for one employer on a full-time basis during the time of this study. Other aspects of the research, however, did take into account the shifting dynamics in this sector, with particular attention paid to the role of part-time domestic workers (or 'chars') who work for a number of different employers.

10. An additional set of interviews was conducted with five women recruited to work in coloured communities through domestic worker 'agencies'.

11. Because the term 'feminism' carries wide associations and meanings, in this study I define feminism as a social movement that seeks to emancipate women from the oppressive circumstances of structural inequality that continue to privilege men. Critical to this research, however, I also acknowledge the vast *difference* in women's experiences that leads to diverse perspectives on this term. In this research, when I label participants as 'feminists', I am referring to those who self-identify in this way as well as to those who espouse gender rights orientations, but may not have used the term 'feminist' to describe themselves.

12. I have maintained relationships and continual communication with key participants in this study for the past seven years. Several have reviewed and commented on the findings from this research.

13. For an extensive historical review of domestic work unionisation, see Gordon (1985).

14. I am grateful to Eunice Tholakele Dhladhla, Myrtle Witbooi, Hester Stephens and Maggie Shongwe for their detailed depiction of this complex history of union organisation over the past 35 years.

15. See, for example, the case of the 'Centres for Concern' depicted in Jacklyn Cock's 1989 film *Maids and Madams*.

16. SADSAWU motto, 2001.

17. By 'first time', I am referring to the first time since the establishment of the apartheid government. Domestic workers were not included in unemployment insurance throughout the apartheid era (from 1948 to 1994). This 2001 victory marked a critical step towards the formal recognition of this sector.

18. Hester Stephens, SADSAWU president, personal interview, Kenilworth, Cape Town, February 2001.

19. These data were acquired through review of SADSAWU's organisational membership database and union records as of 2001. Without national data on the exact number of women employed in this sector, the ratio of union membership cannot be precise; however, local estimates suggest that SADSAWU's membership remains at approximately 1 to 4 per cent of the total number of domestic workers in South Africa, illustrating the ongoing work of collective mobilisation.

20. This is according to interviews with three Department of Labour officials who consulted national records in 2001, as well as general estimates reported in the *Cape Times* newspaper from 2001.

21. For detailed accounts of this extensive investigation process, see the following South African government reports: the 1991 Manpower Commission Report on Domestic Workers, the 1993 Limbrick Report and the 1996 Task Team Report on domestic workers and the UIF.

22. In the South African parliamentary legislative process, policy drafts are initially written by the relevant government department. The portfolio committee (composed of members of parliament) then reviews and critiques the bill, holds public hearings to gather input from civil society and eventually approves the final legislative document, along with the national president and the relevant minister.
23. Myrtle Witbooi, SADSAWU general secretary, parliamentary public submission in Cape Town legislative chambers, March 2001.
24. From the 'Vision, Mission and Values Statement' of the CGE, internal organisational document, 2001.
25. I thank the anonymous reviewers of earlier versions of this chapter for this important analysis.
26. Fatima Seedat, personal interview, CGE Cape Town office, April 2001.
27. The Division on the Advancement of Women at the United Nations sponsored the Convention on the Elimination of All Forms of Discrimination Against Women (CEDAW), which was adopted in 1979 by the UN General Assembly. Accordingly, 'this document is often described as an international bill of rights for women. Consisting of a preamble and 30 articles, it defines what constitutes discrimination against women and sets up an agenda for national action to end such discrimination' (United Nations Division for the Advancement of Women, 2008; www.un.org/womenwatch/daw/cedaw).
28. Shehnaz Seria, parliamentary public submission in Cape Town legislative chambers, March 2001.
29. Drawn from interviews with government policy makers, March 2001.
30. The quotations are drawn from the mission defined by the Presidential Working Group, acquired as internal documents, June 2006.
31. Initiated in Beijing, China, in 1995, the Beijing Platform of Action is widely considered the largest international gathering focused on women's rights. From this United Nations conference, the Platform of Action established twelve critical areas of concern, which remain an active reference standard for the ongoing evaluation of gender rights at local and global levels (www.un.org/womenwatch/daw/beijing/platform/plat1.htm#statement).

References

Ally, S. 2007. '"Maid" Subject: Democratic Statecraft and Domestic Workers in Post-Apartheid South Africa'. Paper delivered at the Wits Institute for Social and Economic Research (WISER), 26 March 2007.

Britton, H. 2005. *From Resistance to Governance: Women in South African Parliament*. Urbana: University of Illinois Press.

Chang, G. 2000. *Disposable Domestics: Immigrant Women Workers in the Global Economy*. Cambridge: South End Press.

Cock, J. 1980. *Maids and Madams: A Study in the Politics of Exploitation*. Johannesburg: Ravan Press.

————. 1989. *Maids and Madams: Domestic Workers under Apartheid*. London: Women's Press.

Collins, P.H. 1990. *Black Feminist Thought*. Boston: Unwin Hyman.

Enloe, C. 1989. *Bananas, Beaches and Bases: Making Feminist Sense of International Politics*. Berkeley: University of California Press.

Fish, J. 2006a. *Domestic Democracy: At Home in South Africa*. New York: Routledge.

————. 2006b. 'Engendering Democracy: Domestic Labour and Coalition-Building in South Africa'. *Journal of Southern African Studies* 32 (1): 107–27.

Gaitskell, D., J. Kimble, M. Maconachie and E. Unterhalter. 1984. 'Class, Race and Gender: Domestic Workers in South Africa'. *Review of African Political Economy* 27: 86–108.

Gordon, S. 1985. *A Talent for Tomorrow: Life Stories of South African Servants*. Johannesburg: Ravan Press.

Guillaumin, C. 1995. *Racism, Sexism, Power and Ideology*. London: Routledge.

Hondagneu-Sotelo, P. 2001. *Doméstica: Immigrant Workers Cleaning and Caring in the Shadows of Affluence*. Berkeley: University of California Press.

Ling, L.H.M. 2002. *Postcolonial International Relations: Conquest and Desire between Asia and the West*. London: Palgrave.

Mohanty, C.T., A. Russo and L. Torres. 1991. *Third World Women and the Politics of Feminism*. Bloomington: Indiana University Press.

Nyman, R. 1997. 'The Death of SADWU: The Birth of a New Organisation?' *South African Labour Bulletin* 21 (2): 34–8.

Parreñas, R.S. 2001. *Servants of Globalization: Women, Migration and Domestic Work*. Stanford: Stanford University Press.

Pateman, C. 1988. *The Sexual Contract*. Stanford: Stanford University Press.

Pettman, J.J. 1996. *Worlding Women: A Feminist International Politics*. London: Routledge.

Romero, M. 1992. *Maid in the U.S.A*. New York: Routledge.

Statistics South Africa. 2000. 'October Household Survey'. Pretoria: Statistics South Africa.

Young, G. and B. Dickerson. 1994. *Color, Class, and Country: Experiences of Gender*. London: Zed Books.

CHAPTER SIX

Sexual Violence, Civil Society and the New Constitution

HELEN MOFFETT

SOUTH AFRICA HAS the worst known figures for gender-based violence for a country not at war. At least one in three South African women will be raped in their lifetime. These rates of sexual violence against women (as well as children and men), along with the signal failure of our criminal justice and health systems to curtail the crisis, suggest an unacknowledged gender civil war. Yet narratives about rape continue to be rewritten as stories about race, rather than gender. This stifles debate, demonises black men, hardens racial barriers, and greatly hampers both disclosure and educational efforts. As an alternative to racially inflected explanations, I argue that contemporary sexual violence in South Africa is fuelled by justificatory narratives rooted in apartheid practices that legitimised violence by the dominant group against the disempowered, not only in overtly political arenas, but also in social, informal and domestic spaces.

In South Africa, gender rankings are maintained and women regulated through rape, the most intimate form of violence. Thus in post-apartheid democratic South Africa, sexual violence has become a socially endorsed punitive project for the purpose of maintaining patriarchal order. One result has been to constrict and compromise women's experience of citizenship, as the promises of constitutional equality are countered by the fear of sexual violence. The 2006 rape trial of Jacob Zuma, now president of the ruling African National Congress (ANC), provided a clear demonstration of the shortfall between the rights women are guaranteed under the 1996 Constitution

and the cultural, political, judicial and social backlash women risk should they lay claim to these rights.

In this chapter,[1] I explore the ways in which sexual violence, the epidemic of rape in particular, undercuts the gender gains of the post-apartheid state almost as fast as they are made. However, while this conundrum is obvious to everyone able to read newspaper headlines, what is of particular interest here is how apartheid and colonial scripts concerning race and gender are intertwined and embedded in private spaces, where they remain apparently impervious to public efforts (by the state and civil society) to dismantle them. Worse still, as I aim to show, it seems that sexual violence has become a means of policing a society that, while egalitarian for the first time in public spaces, remains highly stratified, vertically organised and potentially violent in private, intimate and domestic spheres – a tension that does not bode well for the newly enfranchised women citizens of South Africa.

Sexual violence and the long shadow of apartheid

In the few years since South Africans queued to cast their votes in the country's first election based on universal adult franchise, the status of women in this fledging polity has come under increasingly troubled scrutiny. Sexual violence in particular has spiralled, with a vast array of research suggesting that South Africa has higher levels of rape of women and children than anywhere else in the world not at war or embroiled in civil conflict. This claim, and the statistics that support it, are often angrily contested, with the result that yet more data are collected and yet more quantitative analysis is undertaken by yet more reputable organisations and institutes. All emerge with the same grim findings, which are regularly reported in the mainstream media: at least one in three South African women can expect to be raped in her lifetime; and one in four will be beaten by her domestic partner.[2] These figures emanate from credible organisations, including parastatals, such as the Medical Research Council (Wood, Maforah and Jewkes 1996; Wood and Jewkes 1998; Mathews et al. 2004), the Human Sciences Research Council and Statistics South Africa; academic initiatives, such as the Centre for the Study of Violence and Reconciliation (Vetten 1997) and the Groote Schuur Hospital Rape Protocol Project (Denny et al. 2002); international monitoring groups, such as Human Rights Watch; and private institutions, such as the Population Council.[3] Findings from these studies, as well as the failure of South Africa's over-

burdened criminal justice and health systems to respond appropriately to the crisis, suggest an unacknowledged gender civil war. The high rate of rape in particular is also fuelling South Africa's HIV/AIDS pandemic, a major stumbling block to the functioning of the new state and a vibrant civil society. If we view South Africa's brave new democracy from the perspective of the millions traumatised by sexual violence, we cannot escape the staggering contradiction between the hard-won gender rights enshrined and even showcased in the public arena and women's everyday experiences of private violation.

Much of the research on sexual violence undertaken in the first ten years of South Africa's democracy has been quantitative (some examples have been cited above). Theoretical investigation has tended to fall within the ambit of masculinity studies or the field of social anthropology (see, for instance, Bhana 2005; Niehaus 2003; Morrell 2001; Vogelman 1990). There is a growing body of work on sexualities in Africa that adds useful context to local studies of sexual violence (Arne 2004).[4] While useful, Western aetiological models (Cahill 2001; Schwartz 1997; Scully 1994; MacKinnon 1989; Groth 1979; Brownmiller 1975) that highlight the anger, fear and inadequacy of individual men or the monstrosity of patriarchy as central to the 'story' of why men rape fail to provide sufficiently nuanced explanatory or analytical frameworks for the current South African experience of pervasive sexual violence. The present 'narratives of normalisation' surrounding sexual violence in South Africa and other developing societies are more wide-ranging and complex than those identified in Western feminist discourses of the 1970s and 1980s, which did not take fully into account the acute and complex forms of 'othering'[5] present in societies with a history of extreme racial/ethnic conflict. It needs to be established whether there is a theoretical relation between South Africa's apartheid narratives, which were based on vigorous, even frantic principles of 'othering', and our current climate of sexual violence.

Meanwhile, we might well find insights in sophisticated post-colonial analyses of gender violence that focus on the citing of women's bodies and sexuality as political and cultural capital whenever nationalist, religious and ethnic agendas are invoked in the process of political transformation (Green 1991; Mama 1997; Jayawardena and De Alwis 1996). While it is generally recognised that during times of war, civic unrest and open political turmoil, there is a rise in rates of sexual violence (Meintjes, Pillay and Turshen 2001),

little data have been collected on the correlation between incidences of sexual violence and more benign forms of political transformation – those accompanying national independence, the overthrow of repressive regimes, and so forth. Yet it seems that there is a case for arguing that during periods of overt nationalist fervour, political regeneration, emancipation and other arguably more laudable forms of political restructuring, the rates of sexual violence against women (and children) also rise alarmingly, often for reasons that have to do with the immediate past. This has certainly been the case in South Africa.

I believe the pernicious and overtly racially ranked hierarchies endorsed and enforced during South Africa's apartheid regime continue to have profound implications for women and their experience of gender-based and sexual violence, even after these forms of social stratification are apparently dismantled or transformed in line with rights-based principles. I suggest it is vital to investigate the complex relationship between South Africa's recent history of apartheid, with its emphasis on rigid stratification and abnormal social rankings along racial lines, and the disquieting rise in gender and sexual violence in the years since the institution of democracy.

Has the first flourish of democracy simply afforded South Africans the opportunity to observe an already entrenched problem? Unfortunately, while there is no doubt that sexual violence[6] has always been prevalent in South Africa, there is also no avoiding the fact that the first fourteen years of the new state saw a dramatic increase in sexual assaults on women, children and men. Many ask whether improved education on rights, the transformation of the courts and police force and increased reporting have not contributed to the spiralling of these figures, but while these factors may have been partly responsible for an initial jump post-1994, they do not explain the continuing steep increase. It is also worth noting that in spite of attempts to reform the overburdened and beleaguered criminal justice system, survivors of intimate violence still regularly experience discrimination and inefficiency at the hands of the courts and police, and rape in particular remains hugely under-reported.

I pose the theory that sexual violence in post-1994 South Africa is fuelled by justificatory narratives that are rooted in apartheid discourses. At the same time, discourses of race, including accusations of racism, have stifled open scrutiny of the function of rape as a source of patriarchal control. Under apartheid, the dominant group used methods of regulating blacks and

reminding them of their subordinate status that permeated not just public and political spaces, but also private and domestic ones. In post-apartheid South Africa, it is gender rankings that are maintained and women who are regulated. This is largely effected through sexual violence, in a national project that gives every indication that many men may indeed have bought into the notion that by enacting intimate violence on women, they are performing a necessary work of social stabilisation. In what follows, I will present various 'cameo' scenarios for scrutiny that point to the need to deconstruct our current narratives of both rape and race – a task that is vital if we are to translate gender equality from statutes into lived experience and if we are to survive as a viable democracy.

Rape narratives

There are numerous 'narratives' concerning rape in South Africa's public discourses. To begin with, I will focus on two cameo examples that demonstrate how demands for gender equality (and in particular, an end to male violence) are undermined, attacked or silenced either by accusations of racism, or by backlash from sectors of society that resist holding men responsible for rape.

In 1999, with the 'new' South Africa only five years old, several NGOs, together with corporate sponsors, put together two short educational broadcasts on gender-based violence, featuring the South African-born Hollywood actress Charlize Theron. These were shown on terrestrial television channels during advertisement breaks and also at some commercial cinemas. The first time I saw one, I was electrified by Theron's opening line, which ran: 'Hey, all you South African men, here's a question for you – have you ever raped a woman?' The two-minute 'ad' went on to deliver a straightforward message on date and acquaintance rape, but what impressed me was that it was the first time I had ever seen those responsible for the problem acknowledged, much less addressed, in a public information broadcast. Never before in the history of South African educational media campaigns had rapists or potential rapists been directly addressed.[7]

Clearly, I was not the only one struck by this: the short films caused a furore, and within a matter of weeks the Advertising Standards Authority (ASA) had banned them from airing, in response to consumer complaints. The reasons given were that they were offensive to South African men, stereotyping them as 'either being involved in rape or being complacent about it' (Johnson

2003, 14), and script changes were advised. The appeal process overturned the ASA ruling within weeks, but the broadcasts were not screened again.

The Theron broadcasts had all the markers of a South African society transformed not only in racial but also in gender terms, reflecting the constitutional enshrinement of equality for all. Those who scripted them assumed that this amounted to a socially endorsed and cohesive view that in such a society women should not be raped, and men should be held responsible for their acts of violence. However, in assuming that the newly democratic society could grapple with the issue of rape as a marker of gender inequality only, the makers of the ad were sadly mistaken. While responsive to the crisis of intimate violence plaguing the infant democracy,[8] they would have done well to attend the conference on Women in Post-War Reconstruction in Johannesburg in 1999, which signalled that something was terribly amiss with Africa's brand-new and most feted democracy. Activists and scholars noted that '[d]uring the transition from war to peace, or from military dictatorship to democracy, the rhetoric of equality and rights tends to mask the reconstruction of patriarchal power' (Meintjes, Pillay and Turshen 2001, 4). The new South African polity was proving to be no exception.

Five years later, against a backdrop of celebrations marking the country's first ten years of democracy, President Thabo Mbeki publicly attacked anti-rape campaigner Charlene Smith, herself a rape survivor, on the grounds that her efforts to educate South Africans about rape were racist.[9] His rationale for doing so was that Smith had described South Africa as having the worst figures for sexual violence in the world.[10] It was the second time he had publicly denounced her as a racist – for critically addressing the issue of rape – and this time it caused a public stir, as Smith's tireless and courageous efforts to educate the South African public on rape and its deadly relation to HIV/AIDS had earned her considerable public acclaim (Smith 2001). Mbeki never retracted any of these accusations, although he subsequently acknowledged that a quotation he had attributed to her (that she had described black men as 'rampant sexual beasts . . . unable to keep it in [their] pants') had in fact been authored by an American academic (Smith 2005).

Having established that efforts to critique rape lead to backlash, whether from civil society or the highest elected public official in the land, we begin to see how this might lead to paralysis, even as the problem escalates. Only weeks after the Mbeki–Smith clash (perhaps the starkest example of how a

critique of patriarchal violence can be hijacked by anxieties about racism), I attended a reading and discussion group at the home of Professor Njabulo Ndebele and his wife, Mpho. Vice-chancellor of the University of Cape Town, Ndebele is himself a celebrated writer and astute critic and social comment-ator. His most recent novel, *The Cry of Winnie Mandela*, had been lauded for its remarkable insight into the emotional and political terrain traversed by southern African women. Those present made up a fair representation of Cape Town's progressive intelligentsia, and included writers, activists, academics, publishers and even theologians. The guest of honour was well-known writer Sindiwe Magona,[11] recently returned to Cape Town after fifteen years of an exile of sorts in New York City.

Sindiwe spoke openly and eloquently of her grief and shock at returning home to discover that hers was now a society in which babies were raped on a regular basis. She was particularly outraged to discover nurses at her local clinic instructing mothers to bring in their daughters to receive contraceptive injections as soon as they began menstruating – given the extremely high likelihood that they would be repeatedly raped during their teenage years. She was appalled and bewildered by the fatalism of a society that simply accepted that it was women's lot to be raped, and saw this as a tragic cross to be endured, rather than an illegal and untenable act of violence, especially in the age of HIV/AIDS. The subsequent lively discussion focused on possible causes for this tide of sexual violence, with many of the speakers detailing the attack on masculinity conveyed by the degradation and humiliation of apartheid, the breakdown of the African family through the system of migrant labour, and so on. Sindiwe became angrier still, eventually crying out, 'I'm sick of hearing apartheid used as an excuse! There can be no excuse, no justification for this behaviour!'

Sindiwe's response is salutary, not least because it reveals the pitfalls of most discussions of rape in public and private forums that attempt to link it causally to South Africa's history of apartheid. First, they generate discourses that often begin to resemble a series of 'excuses'; second, in unproblematically detailing the degradation of masculine pride as the reason for the propensity to rape, such discourses offer no critique of patriarchal frameworks that shape such 'pride'; and third, they unwittingly lay the blame for sexual violence at the door of those who were discriminated against under apartheid. Every single contributor to the elite debate described above premised their remarks

on the unspoken assumption that rapists were black. Yet my years as a hotline counsellor in the latter half of the 1980s rapidly disabused me of the notion that domestic and sexual violence were the province of poor, black or ill-educated men. I received distress calls not only from women living in townships or ghettoes, but from the wives of professional men living in Cape Town's most exclusive suburbs. I listened to women who had been sexually assaulted or beaten not only by gangsters, illiterates, alcoholics and unemployed men, but also by ministers of religion, teetotallers, university professors, doctors and lawyers.[12] Counselling women of all races and religions and classes brought home to me the truisms of sexual violence: rape, like most crimes, is intra-communal (that is, it is usually committed by 'insiders', not 'outsiders'); women are far more likely than men to be raped; and women are invariably raped by men. In other words, sexual violence (outside of wars of 'ethnic cleansing' and genocide) is an instrument of gender domination and is rarely driven by a racial agenda. In brief, if we look at the Theron and Mbeki–Smith incidents and others like them as markers of the kinds of rape narratives tolerated or disrupted in the newly democratic South Africa, we begin to see that racial accusations and assumptions like these prevent the unmasking of patriarchal violence. It is clear that the makers of the Theron ads were naive in assuming that South African society could stomach any discourse on rape that located responsibility for sexual violence with the perpetrators: men. Five years later, luminaries from the president himself to the cream of South Africa's writers and academics assume all too readily that any discussion of rape is predicated on a rapist who is always black. Therefore, certainly according to Thabo Mbeki, any critical investigation or denunciation of rape is an attack on black men, which can be demonstrated by such talk of rape being racist. Obviously, this makes it very difficult to debate the aetiology or purpose of rape.[13]

These common discursive responses to rape reveal alarming trends about the post-apartheid South African society and its inability to discuss openly issues of gender: any discussion of rape is invariably subsumed in narratives about race or class, not gender; these assumptions concerning rape, race and class are held at the highest political and intellectual levels; and the aetiology of sexual violence, while a serious concern, is almost never directly addressed.

South Africans of all races, it seems, assume that perpetrators of sexual violence are black men, no doubt because of apartheid narratives they have internalised. This leaves us without an adequate framework for critique. The

truth is that the majority of rapists in South Africa are black only because the majority of the South African population is black. Ten years of transformation have nevertheless failed to deconstruct the old apartheid narratives of sexual violence that demonise black men as incontinent savages, lusting after forbidden white flesh, with the result that open discussion of a major problem is at a standstill. I have written elsewhere about how rape narratives inscribe the rapist as simultaneously black and monstrous, noting:

> It's clear that by using monster narratives that literally 'paint it black', the standard stories of rape in South Africa confirm everyone's worst fears. White women fear every man that does not belong within their community . . . white men buy guns to protect their families from the threat of the heart of darkness beyond the garden gate. Black men are outraged and humiliated at being categorised as violent, sex-crazed maniacs preying on white woman; black women are kept from reporting the violence they experience for fear of being disloyal.
>
> The irony is that as a result, the great majority of rapes (between peer members of the same community) can never be addressed or discussed, and so the real problem of sexual violence flourishes in the dark. Meanwhile, the worst kind of racial stereotyping is kept alive, and barriers between communities harden. (Moffett 2002, 60)

Neither is this new. Davis (1983) first laid out the way rape narratives can be used to inflame racial attitudes some 25 years ago. It is clear that in a newly democratic society, the 'racing of rape' serves as a counter-transformative narrative, one that maintains and nurtures fear and suspicion in communities that are already historically or culturally divided, or prompts a return to conservative values and traditions. Public and private responses to the 'story' of rape that features a depraved black perpetrator include gloomy prognostications of the eventual collapse of the state and failure of the democratic project under black majority rule.[14] They also include an array of prescriptive 'antidotes' that run counter to transformative values: re-embracing hierarchical family structures that locate men as 'heads of households' and advocate the subordination of women (a common response seen in some religious groupings), or the enthusiastic endorsement of cultural and 'tribal' rituals such as virginity testing – often couched in terms that are explicitly

sexist and homophobic. Moreover, as shown above, such anxieties and assumptions about race are both stifling open discussion of sexual violence and avoiding any confrontation with the perpetrators.

Although I have explained elsewhere that there are no logical barriers to women raping men,[15] rapists are invariably male, which places any discussion of rape squarely within discourses of violent gender and patriarchal domination. Nevertheless, South African men and women find this almost impossible to contemplate. In a society battling to shake off the legacy of institutionalised racism, it may seem a bridge too far to acknowledge that gender is at the heart of this acute social problem. Instead, one hears repeatedly that apartheid and its ills (such as the migrant labour system) 'emasculated' black men, left them 'impotent' and experiencing a 'crisis of masculinity';[16] and although these remarks are problematically embedded in unquestioned patriarchal discourses, they carry a grain of truth. But these explanations explicitly exclude white men, thus implying – however unwittingly – that they do not rape.

Even those who recognise that the assumption that all rapists are black is outrageous and offensive to black men nevertheless continue to insist that poverty and joblessness are key to the aetiology of sexual violence without acknowledging that such claims might also be degrading and offensive to the poor and unemployed (if only through the demonstrably false corollary that middle-class men in secure employment do not commit rape). Yet aetiological theories about substance abuse and alcohol, dysfunctional families, childhood traumas, conservative religious or cultural traditions, and so on, continue to proliferate. There is no doubt that factors such as alcohol and substance abuse, unemployment, entrenched poverty, lack of infrastructure in rural areas, the hopelessness born of lack of opportunity and joblessness, the threat of HIV/AIDS, prior history of abuse, post-traumatic stress syndrome, oppressive cultural and religious mores, gang membership, peer pressure and breakdown of the family and clan structures all exacerbate the problem of sexual violence – as they do almost any social ill.

Some of these factors are certainly more relevant than others in shaping the scourge of sexual violence in the South African context, and indeed their impact will differ within communities according to geographical, religious, ethnic, economic, linguistic or still more specific local factors: for example, young men in impoverished urban ghettoes 'learn how to be a man' from

crime lords and drug dealers, with group rape a common initiation ritual in gangs. As Elaine Salo explains, 'While all men are capable of rape, the reasons why they rape are diverse, and informed by whom they rape, as well their own and their victims' structural location in society.'[17]

Neither is it as easy to tease out the entangled categories of gender, race and class in South Africa as I have perhaps suggested, in the interests of clarity. Race, gender, class and sexuality continually inflect each other and are often subsumed into one another, as a result not just of apartheid (which merged the categories of race and class), but also of centuries of patriarchal colonialism that made strenuous efforts to monitor and control the category of gender along racial and ethnic lines. However, none of the factors listed above – all of which might amplify sexual violence – supply an authentic aetiology; none *cause* rape.[18] Neither do they fully explain the prevalence of sexual violence across every sector of South African society, including the wealthy, privileged, educated and employed classes. It would seem that it is more palatable, acceptable even, to ascribe the tide of sexual violence in post-apartheid South Africa to a discourse of apartheid 'emasculation' or poverty. To examine the gender ideologies and identities in which it is rooted would mean acknowledging that no matter how many women sit in parliament, the goal of gender equality remains out of reach, certainly in private spaces, where sexual violence defines relations of power; it would also mean facing up to the virulence of the overlapping patriarchies that threaten even those fragile gender rights that have been established. No wonder we flinch from such scrutiny.

Like most feminists, I believe the cause of sexual violence lies in the construction of dominant masculinities found in all patriarchal social systems.[19] Nevertheless, there is indeed a link between South Africa's recent history and the failure of its citizens under democracy to respect women's rights to bodily autonomy and integrity. I believe questions about the relation between apartheid's legacy and the current scenario of unchecked sexual violence must be framed – but in such a way that they do not focus exclusively on black men. This means that any discussion of the relation between the history of apartheid and the current crisis of gender-based violence requires the crafting of new paradigms that acknowledge that there are men in every stratum of South African society who enact sexual violence.

Rape and the anxiety inherited from apartheid

We have already established that the area of gender-based violence is fraught with racialised assumptions, in which rape narratives are endorsed and circulated when they feature a barbaric Other, invariably inscribed as 'darker' (literally, morally and figuratively) than the victim. Secondly, there is the problem that arises when women, rather being seen as the potential victims of a demonised Other, become the Other themselves. For over 50 years, South African society operated on the explicit principle that the Other was unstable, potentially extremely powerful and therefore dangerous, and needed to be kept in its place by regular and excessive shows of force.[20] Women – the current subclass – are also seen as having significant agency and therefore they pose a potential threat to the uncertain status quo. Today, as under apartheid, there is considerable social anxiety about a powerful, unstable subclass that *must be kept in its place*. In the words of sociologist John Moland: 'Both systems, the patriarchy and the race-caste system, rest upon a relationship in which the dominant or superordinate has made the dominated or subordinate "an instrument of the dominant's will and *refuses to recognize the subordinate's independent subjectivity*"' (1996, 404; my italics).

Many sexually violent men justify their behaviour in terms of the discourse that women 'ask for it'. However, closer scrutiny of the local context would suggest that this differs from Western constructions concerning supposedly provocative behaviour or dress, and is implicitly related to the project of not only refusing to 'recognise [women's] independent subjectivity', but actively punishing such 'independent subjectivity'.

A cameo that sheds revealing light on this issue was presented in a ground-breaking televised interview screened at about the same time that the Theron anti-rape broadcasts were banned. A taxi driver openly described how he and his friends would cruise around at weekends, looking for a likely victim to abduct and 'gang-bang'. His story was unselfconscious and undefended: he showed no awareness that he was describing rape, much less criminal behaviour. When the interviewer pointed out that his actions constituted rape, he was visibly astonished. What was most striking was his spontaneous and indignant response: 'But these women, they force us to rape them!' He followed this astonishing disavowal of male agency by explaining that he and his friends picked only those women who 'asked for it'. When asked to define

what this meant, he said: 'It's the cheeky ones – the ones that walk around like they own the place, and look you in the eye.'[21]

This reflects a disturbing pattern in which a woman is described as 'asking for it' because she has asserted her own will, answered back, moved around on her own, and so on. So it would appear that in some cases men are 'forced' to rape women because the latter dare to practise freedom of movement, adopt a confident posture or gait, make eye contact, speak out for themselves: in other words, when women visibly demonstrate a degree of autonomy or self-worth that men find unacceptable, they are perceived as sufficiently subversive and threatening as to compel men to 'discipline' them through sexual violence. What is more, if rape is believed to be deserved – if a woman is simply being 'corrected' or 'taught a lesson' – it is somehow not considered to be a criminal activity.

This rationale for rape – as a handy shorthand means of teaching a 'cheeky' woman a lesson – is deeply familiar to anyone who grew up under apartheid. This is the same script that was used during five decades of apartheid rule to justify everyday white-on-black violence as a socially approved and necessary means of 'showing the "darkies" their place'. This is not so much a script of flat-out racial or gender rejection, as one that is violently punitive towards those members of a subclass who reveal (through body language, visible signs of self-respect, freedom of movement) that they do not recognise or accept their subordinate status in society.

As a child growing up in a conservative farming area in the Western Cape, I heard again and again, 'I love the blacks, I get along fine with my workers, I'm like a father to them – but what I won't tolerate is the cheeky ones, the troublemakers'. Even as a very young child, I knew exactly how this 'cheekiness' was shown or 'performed' – very often in no more than a bold stare, an upright posture ('walking tall') or a refusal to demonstrate sufficiently grovelling gratitude for the weekly tot of wine – and how it was punished – usually with beatings, occasionally severe enough to result in serious injury or even death.

Such behaviours followed a social and political pattern of 'keeping the blacks in line', reminding them who was 'master'. 'Subversives' or 'agitators' were singled out for humiliating or brutal treatment as a means of threatening their peers, reminding them of the fate that awaited them should they step

out of line. These acts of violence were generally random and spontaneous, and sometimes fairly low-key, aimed not necessarily at causing life-threatening harm, but at shaming and humiliating the target. In other words, these acts, while not necessarily public spectacles, nevertheless served a useful didactic and warning function to others.[22] Such shows were necessary under an apartheid state that gave whites unparalleled power and relegated black citizens to a subordinate status because the latter were in the majority. Whenever a small group attempts to dominate a large group, fear becomes an important strategic weapon.

Here the parallels between blacks under apartheid and women in South Africa today become more compelling; women, in the well-known saying by Gloria Steinem, are 'a majority that are treated like a minority'. Although women's numerical majority is marginal, there is no doubt that as a group women are sufficiently numerous (compared to men) to make 'control' problematic. It could be argued that sexual violence in South Africa has thus become a form of 'witch ducking or burning' – an ordeal visited on women in order to keep them and their peers compliant with social 'norms' determined by hegemonic, powerful, yet threatened patriarchal structures.[23] The useful thing about this particular hypothesis is that it incorporates the fallout of apartheid across race groups.

Of course, this is not to suggest that women in pre-apartheid or even pre-colonial South Africa were not policed or controlled, or lived free of the fear of patriarchal violence. But the legacy of apartheid has contributed to two critical problems: our subsequent focus on race still tends to repress open scrutiny of gender issues; and the tendency of apartheid to drive violence into intimate and domestic spaces continues to fuel the epidemic of sexual violence.

In South Africa, then, some men believe that by resorting to sexual violence they are participating in a socially approved project to keep women within certain boundaries and categories (as well as a state of continuous but necessary fear). After all, the Other has historically been seen as powerful, subversive, potentially unstable, needing to be policed (even if this meant torture, detention and murder) not only 'for their own good', but also for the 'greater good' of society. This kind of hierarchical thinking (and anxiety about how to keep certain groups stable and bounded within socially prescribed and limited domains) does not disappear simply as the result of a democratic election.

This kind of 'rationalised' intimate violence is also often used as a 'control mechanism' when the group believed to be inferior is absolutely necessary to the continued comfort and survival of those in power, and an integral part of the latter's daily lives: when they are needed not only to provide conventional labour, but to carry out domestic chores and childcare as well. The vast majority of white South Africans who vocally and enthusiastically supported apartheid entrusted the cooking of their meals and the care of their children to black servants. These and similar domestic duties involve a considerable measure of trust and exposure, and point to the paradoxical vulnerability of the dominant class being serviced.[24]

Something else difficult to convey to those who have never lived in a society where unskilled domestic labour is cheap and plentiful is the degree of practical helplessness of many white and/or middle-class South Africans.[25] Similarly, it is entirely possible that a great many violent men in this country are genuinely unable to calculate a grocery budget, prepare a nourishing meal or do the laundry – and are therefore dependent on female partners or relatives to perform these chores for them. But this form of dependency generates anxiety and a need to regularly display authority to sustain the services of the oppressed, thus inflaming the propensity for violence, particularly in the intimate sphere. South Africans of all races remain familiar with social strategies that combine intimate and ongoing proximity with ongoing enactments of extreme repression.

Moreover, the complex blend of peer and societal pressures men experience regarding the need to 'police' feminine subversion exists against a backdrop that tells them that rape is a 'safe' crime to commit (and perhaps not a real crime after all); there are unlikely to be legal consequences; and that any shame attached to the act will adhere to the victim, not themselves. These socially accepted scripts concerning gender and violence were underlined by Vogelman's findings in his 1990 study of South African self-confessed rapists who had evaded the criminal justice system (they were often found 'not guilty' for technical reasons). Some of these subjects expressed indignation that an act as normative as rape should be criminalised. In short, many men rape not because they want to or are 'tempted', but because their social context suggests that they can (and in some cases, should) do so with impunity.

The parallels with low-level, continuous 'punishment' meted out by white South Africans to black South Africans under apartheid are compelling: for

instance, black workers who might be beaten by their white employers (or a black 'boss boy' authorised by his 'masters' to implement white social control) had little or no redress. While a range of violent behaviours, from assault to murder, were crimes according to apartheid statute books, there was once again a tacit social understanding that certain kinds of white-on-black violence were 'necessary' as a kind of oil that kept apartheid hierarchies running smoothly. It was certainly extremely difficult for blacks to institute criminal proceedings against whites (or the lackeys of the dominant group) who used violence against them. Both forms of violence – men's sexual attacks on women, and racist attacks shaped by apartheid ideology – reveal the anxiety of the perpetrator class about possible loss of dominance.

My interviews with local researchers investigating gender and the construction of identity (national, racial, ethnic, cultural and linguistic) are beginning to point to the possibility that South African women are policed and immobilised by fear of rape by the 'Other/Outsider'. At the same time, they are punished for attempts to break out of subordinate roles and rigidly enforced cultural or ethnic communities by covertly 'legitimised' sexual violence that takes place *within* recognised social structures: families, co-religionists, tribes, villages or neighbourhoods.[26] Acts of violence are therefore seen as necessary, not only to keep the unstable subclass of women in their ordained places, as discussed above, but to confirm and remind them of their membership in a specific community. As a tool of social control, sexual violence is especially effective, as it combines the literal pain and shock of physical violence with deep shame and self-blame on the part of the victim, which leads to self-punitive and self-monitoring behavioural changes by the victim (who is extremely unlikely to report her attacker or seek legal redress, particularly if he is part of her immediate circle, and who may instead become withdrawn, submissive, fearful or restricted in her movements). Such changes on the part of women, who might otherwise display autonomy, possibly serve orthodox and conservative community 'needs' in the short term. At the same time, women's entitlement to gender rights – particularly as citizens of a new democracy – is placed in jeopardy, if not destroyed, because of the power of sexual violence to circumscribe individual agency.

Rape and gender equality

Having established that appalling levels of sexual violence in South Africa are directly shaped by the legacy of apartheid, the question arises as to why,

in the post-1994 society, such violent forms of social control are still being imposed on South African women.

South Africa's new Constitution enshrined the rights of all groups in society. It had to. The spectre of apartheid – social structuring and discrimination on the grounds of the precise shade of one's skin, ancestry and so-called tribal identity, and the suffering this caused – haunted the 1996 Constitution. One of its chief aims, therefore, was to enshrine the right to equality for everyone. Like many 'peace treaties', it was driven by a sense of 'never again'. The recent history of legislated inequality was so abhorrent that rights were endorsed and guaranteed across the spectrum of race, gender, class, ethnicity, religion, language, level of ability, sexual orientation or preference. The battle for women's political rights in particular, which gathered momentum during the last two decades of the twentieth century, was especially visible, as were the efforts to enshrine the legal rights of lesbians and gays.[27]

The ruling ANC responded to these imperatives with an admirable programme of women's representation: what amounts to one of the world's most radical affirmative action programmes in favour of women, with a stated commitment to placing women in one-third of political spaces by 2009 (Mama 2004, 2–3). The path to what might seem an unusually bold strategy was smoothed by a liberation struggle that had co-opted and honoured women in roles beyond the usual undervalued and feminised ones of supplying food, shelter and nursing care (although women undertook these duties too); their contributions as political strategists, leaders and guerrilla fighters were acknowledged and at times encouraged.

Nevertheless, these rights were crafted in a country contending not only with a legacy of racism, but also one of manifest sexism, homophobia and xenophobia. In the areas of gender and sexuality, the emergent South African nation was arguably not ready for full equality; neither did it popularly endorse such equality. To paraphrase a conclusion from one of the gender-based violence surveys, 'Violence arises when a chauvinistic citizenry is in a relationship with a liberated Constitution.'[28]

It can thus be argued that political space (on all sides of the spectrum) for women in South Africa has invariably been carved out in ways that do not undermine the variety of interlocking patriarchies in society. In the process, the tension between validating women's rights to full citizenship and political participation without revising their social subordination has created a new

variation on the disjuncture between the private and the public realms typical of capitalist patriarchal systems. This theme is perhaps best illustrated anecdotally. Pregs Govender, former ANC MP, recounts the story of a senior male member of government who was extremely supportive of her work as chair of the Joint Standing Committee on the Improvement of Quality of Life and Status of Women, a body that made Herculean efforts to translate the equality principles of the Constitution into substantive legislation. He saw no contradiction between his enthusiastic endorsement of women's active participation in politics and his repeated insistence that at home he was the master: 'Democracy stops at my front door.'[29]

Even if this kind of splitting between the public and private realms is not typical of all South African men (or women), it is nevertheless openly and informally reflected in social interaction. It is perhaps best summed up in the near-identical phrase, taken from an interview with a married man, cited in the title of a report on domestic violence: 'I do not believe in democracy in the home.'[30] It is a requirement of participation in the new South African state that one should 'believe' in democracy 'outside the home'; with the exceptions of a few extremist fringe groups, no credible political grouping in South Africa is likely to call for the withdrawal of universal adult franchise or drive women out of political structures. However, the substantial divergence between the ways in which men and women are understood to inhabit public and private spaces means that the flattened and transparent structures associated with democratic practice are eschewed in the domestic and, even more so, the sexual realms.

So it would seem that it is important that South African women are frequently reminded that their equality in the public domain does not translate into equality in the private domain, an arena that remains highly stratified and hierarchically structured. Consequently, we witness the uneasy and convoluted relation between violence and rights wrought by more than a decade of democracy. The women's movement in South Africa had done much to position women on centre stage at the moment of transition to democracy, but it had arguably failed to deconstruct the multiple overlapping and entrenched forms of patriarchy that had flourished under apartheid. Given that much of this patriarchal heritage remains intact, the newly democratic South African state can be suspected of trying to site women as holding equality only some of the time and in certain spaces. So a devil's bargain has

been struck: women are widely accepted as having equal political status, even within structures such as parliament, as long they remain subordinate in the private and domestic realms.[31] It is entirely possible that rape covertly performs the function of *policing* this fault line.

Citizenship and the Zuma rape trial

Nowhere was this more clearly seen than in the 2006 rape trial of the ANC's then deputy president, Jacob Zuma, who was charged with raping a woman half his age while she was an overnight guest in his home. As the daughter of one of his valued struggle comrades, she was in the position of an honorary daughter to him; throughout the trial, she referred to him as 'uncle'. Zuma's claim was that the woman, who is openly HIV-positive and a lesbian, had approached him and aggressively insisted on sex, leaving him little choice but to comply. His bizarre explanation – that in his (Zulu) culture, it was necessary to satisfy an aroused woman, otherwise she would make a rape accusation – provoked perplexity and outrage, even though in the final analysis the white male judge accepted this explanation. Zuma did not use a condom, and infamously reported that he showered after the encounter to try to avoid HIV infection.

Zuma was entitled to a vigorous defence, and he received one. In the end, he was found not guilty: the judge determined that the sex had been 'consensual' and that 'Kwezi' (the accuser's nom de plume) had lied. Gallons of printer's ink have been spilt over the theatre of the trial itself – in which Zuma supporters chanted, danced, threatened women from anti-rape organisations, attacked and stoned a woman rumoured to be the accuser and burnt the accuser in effigy.

The inexplicable weakness of the prosecution, the inherent sexism of the judgment and its implications presented grave challenges to gender equality in social institutions and public processes. The fact that the accuser's sexual history (including her history of prior rapes as a child) was exhaustively uncovered and used to discredit her testimony dismayed many, as did Zuma's apparent lack of remorse at having (at the very least) acted recklessly and irresponsibly in having unprotected sex with a woman he knew to be HIV-positive, not to mention the impropriety of the sexual contact (even if consensual) itself. Zulu *izangoma* (diviners) and cultural commentators have observed that Zuma's behaviour constituted a form of social incest taboo in

the culture he vigorously appropriated to support his behaviour; indeed, if he was the '100% Zuluboy' he claimed to be during the trial, he was required to undergo cleansing rituals and pay damages.[32]

Space does not permit a full discussion of the fallout of the trial, or a detailed analysis of the discourse thereof. However, what is important for the purposes of my argument is that the Zuma trial blew wide open many debates at the heart of South Africa's plague of sexual violence. The kind of rape mythologies embedded in social and intimate relations mimicking the hierarchies of apartheid were overtly present in the 'text' and 'performance' of the trial – not only in the strategy of the defence and in the judgment issued by the judge, but even in the discourse of the prosecution. The latter was marked to an extraordinary degree by absence and silence. What follows is a list of questions the prosecutor, inexplicably, did *not* ask:

1. *If you were afraid, as you testified, to leave Kwezi in an aroused state, did you ensure that she had an orgasm?* Zuma's own orgasm was a matter of public record; the complainant's sexual satisfaction or lack thereof was never raised. Was Zuma in fact admitting to being a lousy lover?

2. *Can you supply independent medical proof that you are, as you claim, HIV-negative?* Much was made of Kwezi's apparent lack of compliance with a forensic psychologist or neurologist – as if every single rape complainant in South Africa needs to submit to nebulous tests to eliminate the possibilities of hallucination and mental disorder leading to confabulation – yet the one question the prosecution asked about Zuma's medical history remained unsupported by any objective or expert independent testimony. Zuma was asked if he knew his HIV status, and he replied that he did, and that he was HIV-negative. No questioning followed that asked, for instance, how he knew this; where and when he had been tested; or whether he could supply any supporting evidence, such as receipts or the test result itself. If medical evidence (in the form of a court-ordered and independently administered test for HIV) could have been provided that disproved his statement on the witness stand, it would have had a devastating impact on the case for the defence.

3. No questions were asked about Zuma's sexual history, even though he is a much-married and indeed polygamous man, with a well-known history of

multiple adulteries. While Kwezi's sexual history was minutely scrutinised and her traumatic past probed, no mention was made of the fact that one of Zuma's former wives had committed suicide, allegedly as a result of her husband's cruelty. Kwezi's history of unreliability in her relationships with men was exhaustively rehearsed; no corresponding elaboration of Zuma's exploitative relationships with women was undertaken.

4. The most glaring omission of all was the failure to ask Zuma, *Have you ever been accused of rape before? Have you ever faced disciplinary hearings within the ANC in exile for rape or sexual harassment?*

The prosecution was not the only party to be blinded by the paucity of rape narratives and models available to the criminal justice system in South Africa. Probably the most alarming of the judge's decisions in the course of the trial was his legal blurring together of the accuser's sexual history and her history of sexual violence. These were collapsed, with Kwezi's history as a survivor of child rape used to suggest that she was unstable, emotional and disturbed – and therefore could not be trusted. The hoary old stereotypes of hysteria and neurosis were flagrantly invoked. It was clear that Kwezi had suffered profound trauma in her youth, and this was not disputed by the defence – but it was used to emphasise the 'unreliability' of her testimony.

Given that millions of women following the progress of the trial were themselves rape survivors, this was chilling. Rape hotlines reported that they were inundated with calls from survivors re-traumatised by the case – and terribly afraid that, should they be raped again (unfortunately by no means an uncommon occurrence), this would be held against them in a court of law. Not only did the discourse and narrative of the trial underline the mental fragility of rape survivors; there was also an explicit element of 'once is unlucky, twice is careless – more than that, and you have to be lying'. Given that many women in this country experience multiple rapes, the implications are deeply disturbing.

I belong to an Africa-wide listserve that connects feminist and gender scholars and activists throughout the continent. The day after the not-guilty verdict, the tone of postings on the listserve was not one of indignation, but of fear bordering on terror. Black lesbians in particular felt that they had been marked out as 'fair game'. One woman spoke for many when she observed

piteously that the judgment seemed to have handed men a licence to rape any former rape survivor again and again.

It is possible (although in my opinion highly unlikely) that Kwezi and Jacob Zuma enjoyed consensual sex on the night in question; nevertheless, the shape of the trial made it quite clear that in order to be perceived and treated as a credible witness by the criminal justice system, any woman who lays a charge of rape in the 'new' South Africa must be articulate and preferably educated; if not virginal, then clearly morally beyond reproach;[33] and possessed of impeccable mental health (the trial transcripts clearly indicate that having sought counselling or experienced any kind of trauma renders a woman disturbed and unreliable for purposes of giving testimony).[34] Above all, this paragon needs not to have been raped before. This eliminates, for many women, the possibility of laying charges of rape, regardless of their constitutional rights to equality and dignity before the law.

The new South Africa has led many women to believe that they have the right to justice, a comprehensive justice that cannot be denied them on the basis of race, class, gender, sexuality, health status or history. But the Zuma trial showed the extent of the backlash: the full ire of civil society was invoked against an HIV-positive young lesbian who had dared to lay a charge against the second most powerful citizen in the country. Outside the court, a pro-Zuma supporter said to the television cameras, 'How dare she? Who does she think she is?' Whatever Kwezi's thinking, she clearly believed she was a citizen who was free to press charges – and she paid a high price for doing so. Commentators from elsewhere in the developing world have observed, correctly, that this trial would never even have been able to take place in most of the rest of the African continent;[35] and in that respect, South Africa's Constitution and judiciary still hold out the promise of equality before the law, even in matters of sexual violence. However, as the trial showed, although women's rights as equal citizens may be guaranteed by the letter of the law, powerful elements within civil society, political organisations, government institutions and the independent judiciary mitigate against gender equality in such cases.

Moreover, none of the trial revelations concerning Zuma's reckless and sexist behaviour slowed his rise to power. In December 2007, he was elected president of the ANC – a post that holds the promise of the presidency of the country in the next national election. The ANC Women's League was among

the powerful bodies that endorsed his candidacy. It would appear that the delegates who lobbied for Zuma at one of the country's most critical political crossroads consider gender rights to be of such little importance that the notion of a chauvinist president holds no fears for them.

Conclusions

This chapter does not prove my claims. Instead, it presents a framework that might explain why rape in the new democratic South Africa is so extraordinarily widespread. I believe this framework could be useful for future research on the causes and extent of rape in South Africa. As Moolman's contribution to this collection shows (Chapter 7), organisational responses to gender-based violence must address the troubling and pervasive divides between the promises of gender rights and the prevailing social scripts that render such rights inaccessible. Future research and practical applications that use this model will undoubtedly provide new insights into sexual violence in South Africa, as well as in the field of gender-based violence.

Like Sindiwe Magona, South African women are sick of hearing that apartheid is to blame for the brutality that men mete out to them. Nevertheless, we must examine how the legacy of apartheid intersects with justificatory narratives of rape and the use of sexual violence as a tool of social control and intimate terrorism. But in doing so, we must learn to confront and deconstruct the knee-jerk response that in scrutinising the sources and pur-poses of rape we are engaging in a racist project. Rape is about many things, including the toxic after-effects of apartheid; but it is probably one of the few burning social issues in South Africa that are fuelled not by narratives about race, but rather by vitriolic patriarchal imperatives.

There are already signs of change in civil society discourse. In the seven years since I began this project, there has been a shift in the popular tendency to pigeon-hole sexual violence as a 'woman's problem'. (The growing rate at which men and small children of both sexes are also becoming rape victims has helped jolt the public into taking a broader view of the problem.) In spite of the danger that efforts to scrutinise men as perpetrators will be deemed racist, there are shifts towards holding men accountable for what is, after all, a problem of their making. There have been energetic efforts by men, male-aligned NGOs, civil society organisations and social institutions to tackle the problem of male violence,[36] especially against women and children, as reflected

in Moolman's analysis of the organisational shift towards including men in confronting prevailing constructions of masculinity in the work of Rape Crisis Cape Town. Unfortunately, many are still wrestling with patriarchal baggage. Given that the nascent 'men's movement' has roots in faith-based organisations, it is disheartening, but not surprising, that the then Anglican Archbishop Njongonkulu Ndungane headed the Men's March on National Women's Day in 2003 in which men carried placards announcing 'Hands Off Our Women', or that he was quoted as saying, '. . . real men don't rape women and children . . . we want our women, our wives, sisters and daughters to walk freely in our streets'.[37] Apart from the entirely unproblematised identification of women as property, this kind of discourse reflects that South African men still posed mostly patriarchal solutions to the problem of their own violence: if they are not to be predators, they are urged to be protectors.

Meanwhile, the escalation of particularly brutal rapes, including the spate of baby rapes in recent years, has shamed the nation into asking, 'What is wrong with our men?' (Posel 2005; Pillay 2001, 43). But we cannot answer this question, or join hands in organising with men in combating the scourge of sexual violence until we have debunked the distracting and dangerous myths arising from our past that continue to hijack the debate on rape.

In the mammoth task that lies ahead – nothing less than the dismantling of patriarchies on a global scale – perhaps a helpful starting point is Albertyn's suggestion (2004) that freedom and autonomy might be more useful goals for women in South Africa's transformation process than political equality. Certainly, as the research in this chapter and throughout this collection repeatedly suggests across a number of cases, political equality alone is unfortunately insufficient to establish women as full, free and rights-bearing members of a democratic polity.

The last idealistic words belong to Kopane Ratele, a male lecturer at the University of the Western Cape, and are taken from a public letter in support of Charlene Smith, after she had written in the *Mail and Guardian* weekly newspaper about her experience of being raped:

> . . . if the liberation struggle was meant to free us from oppression, it must have been to free us all from all kinds of oppression. If the struggle was truly for liberation, it was for all kinds of liberation. Liberation has no plural. Being an indivisible whole, liberation cannot be partitioned. It is radical. To opt for anything else is to endanger it. (Smith 2001, 211)

This serves both as a prompt to broaden the scope of the liberatory project, and a reminder of how far the South African project of democratisation has yet to go. It is up to the men and women of this country to ensure that sexual violence does not continue to deny women the freedom enshrined in our brave new Constitution.[38]

Notes

1. This chapter is drawn from my more extensive writings on rape as a form of social control in post-apartheid South Africa, and is largely a revised and extended version of an earlier piece, previously published in 2006 as '"These Women, They Force Us to Rape Them": Rape as a Narrative of Social Control in Post-apartheid South Africa' in the *Journal of Southern African Studies* (special issue, 'Women and the Politics of Gender in Southern Africa') 32: 129–44.

2. These figures are supported by most of the sources cited below, but in this case are drawn from *Gender: The New Struggle*, a survey of 3 500 participants by the University of Cape Town's Unilever Institute of Strategic Marketing (November 2004).

3. Some studies have turned up even higher figures than those cited here. For example, a 1999 survey of more than 2 000 male Cape Town City Council workers revealed that 48 per cent of them had physically abused a domestic partner at least once. This figure was expected to be significantly lower than the estimated national average, given that the study population were in secure employment. See N. Abrahams, R. Jewkes and R. Laubsher, '"I Do Not Believe in Democracy in the Home": Men's Relationships with and Abuse of Women' (Tygerberg: Medical Research Council, 1999).

4. See also the special issues of *Feminist Africa* 5 ('Sexual Cultures'), December 2005, and *Feminist Africa* 6 ('Subaltern Sexualities'), September 2006.

5. By this I mean the ongoing, deliberate, politically and culturally endorsed creation of and emphasis of difference, with a dominant category and 'normative' of 'us', and the projection of qualities of 'strangeness' and 'otherness' onto a usually subordinate category – 'them'.

6. The area of gender-based violence (which might include domestic violence, spousal/partner abuse, abuse of the girl child, human trafficking, as well as attacks motivated by homophobia) is too broad to scrutinise for purposes of this discussion.

7. Official (police) anti-rape education strategies in South Africa prior to this date contained standard warnings on avoiding the perils of 'dark alleys' and 'short skirts'; these explicitly addressed potential victims only, not perpetrators.

8. As early as 1995, Human Rights Watch had published a damning report, *Violence against Women in South Africa: State Response to Domestic Violence and Rape*. See in particular Chapter 5, 'The Magnitude of the Problem', pp. 44–59.

9. At the same time, he denounced a senior UN office-bearer, Kathleen Cravero, claiming that her statement (relating to HIV/AIDS) that many African women were unable to negotiate

consent, much less condom use, stereotyped African men as 'violent sexual predators'. See 'Letter from President Thabo Mbeki', *ANC Today* 4 (39), 1–7 October 2004, available at www.anc.org.za/ancdocs/anctoday/2004/at39.htm, and Charlene Smith (2005).

10. Lisa Vetten of the Centre for the Study of Violence and Reconciliation, in a response in the *Mail and Guardian* (29 October 2004), argued that neither Smith nor Mbeki had cited the correct figures in enumerating the number of South African women who had been raped. (Mbeki, working naively on the assumption that all rapes were reported to the police, cited reported crime figures only, whereas Smith simply multiplied the number of reported rapes by a 'guesstimate' of 20.) Vetten nevertheless noted that even the most conservative of the professional surveys reflected exceptionally and disturbingly high figures for rape. Joan van Niekerk, the national coordinator of Childline South Africa, also issued an open letter to Mbeki in which she deplored the attack on Smith and debunked the watered-down statistics on rape and child abuse presented by the spokesperson for the National Commissioner of Police in the press. She went on to entreat the president and the police not to stifle efforts to discuss violence against women and children with misleading accusations of racism (posted on the GWS Africa listserve hosted by the African Gender Institute at the University of Cape Town on 11 October 2004).

11. Magona is perhaps best known abroad for her book *Mother to Mother* (Cape Town: David Philip, 1998), a fictional collection of letters between the mothers of murdered Fulbright scholar Amy Biehl and the young South African political activist who struck her down.

12. Data gleaned from crisis organisations are not usually statistically useful, given the cultural disparities and practical barriers that inform whether or not a woman is able to call a helpline. Such disparities doubtlessly explain why so many of my callers were middle-class educated women. Nevertheless, the point remains that they were not being abused or violated by impoverished strangers, but generally by their equally middle-class and educated partners.

13. This is not necessarily indicative of obtuseness; it reflects perhaps the anxieties found within a post-apartheid society facing not only the same endemic racial tensions that occur in any racially or ethnically diverse society, but also battling the demons of a recent past of institutionalised racism.

14. It is not only locally that I encounter the assumption that my work must necessarily highlight the 'barbarism' of black men. During a visit to the US in 2000, after I had assured an American academic at a respectable college that black South African men were not hell-bent on punitively raping white women (an impression he seemed to have gleaned from reading J.M. Coetzee's novel *Disgrace*), he responded, 'You mean they do this to their own kind?'

15. In 'Constructing Sexual Aggression and Vulnerability: Further Thoughts on the Body Politics of Rape', a paper I wrote for the British NGO, Womankind, I argue that rape is easily simulated: all that is required are the means of immobilising the intended victim and a penetrative or blunt instrument. It goes without saying that I do not advocate that anyone 'try this out at home'; rather, my intention is to separate the choreography of rape from the biology of penetrative sexual intercourse. Too many people assume that only those able to produce an erect penis are able to 'perform' rape, whereas a small but significant number of rape survivors report that their attackers could not sustain erections, and therefore resorted to using their hands or other instruments (see Smith 2001; Denny et al. 2002).

16. These are the very terms used in almost every public discussion of the topic, the Harold Wolpe Forum debate on 'Gender-based violence and sexuality in South Africa' being a case in point. (Summary notes of the discussion from the floor were kindly provided by Tracey Bailey of the Harold Wolpe Memorial Trust; www.wolpetrust.org.za.)

17. 'Gangs and Sexuality on the Cape Flats', *African Gender Institute Newsletter* 7 (December 2000). Available at web.uct.ac.za/org/agi/pubs/newsletters/vol7/elaine.htm.

18. In a nutshell, women who experience identical pressures and deprivations may respond in a multitude of maladaptive ways – but they do not resort to sexual violence.

19. The UCT Unilever study noted that 'conflict or violence happened mostly when a chauvinistic male was in a relationship with a woman with a liberated mind' (*Cape Times*, 15 November 2004).

20. And nearly five decades of apartheid rule were preceded by centuries of colonial rule and enslavement.

21. *Special Assignment* documentary, SABC 3, 2000.

22. It must be stressed that although the kinds of 'controlling' narratives of violence under scrutiny here were enacted by whites (or their representatives) upon blacks, they would have been internalised to varying degrees by all South Africans living under apartheid, regardless of race, class or gender.

23. Readers of my work who live outside South Africa have queried whether all South African women do indeed live in fear of rape. This is impossible to prove statistically, and of course, the degree of such fear is determined by the widely variant risks and resources presented to women (whether they travel to work by public transport or after dark, whether they can afford burglar bars and alarms, and so on). Nevertheless, visitors are often shocked by the extent to which many South African women self-regulate their movements and adopt guarded patterns of living. I regularly interact with visiting North American and European students, and am invariably struck by the untrammelled sense of freedom with which many of these young women move around and conduct themselves socially, in sharp contrast to the cautious demeanour of my female South African students. Simidele Dosekun of UCT's African Gender Institute is currently conducting research on the extent to which fear of rape dominates the social habits of young women who have not been raped.

24. Servants are of course privy to a great deal of sensitive and intimate information about their employers: digestive disorders, sexual habits, menstrual cycles, drinking problems, parenting difficulties, family conflicts, and so on. This is a well-trodden path within the field of Marxist feminism and slavery studies.

25. This 'learned helplessness' is being passed on to middle-class blacks, now the largest group in southern Africa employing domestic workers, cleaners, childminders and gardeners.

26. The relationship between construction of identity and sexual violence is an area that requires closer scrutiny than is possible here.

27. For a useful account of the way the women's movement has interacted with the state in the last 25 years, see S. Hassim's *Women's Organizations and Democracy in South Africa: Contesting Authority* (Madison: University of Wisconsin Press, 2005). N. Hoad, K. Martin and G. Reid (eds) chart the story of how sexual equality came to be included in the new Constitution in *Sex and Politics in South Africa* (Cape Town: Double Storey, 2005).

28. See note 19 above.
29. Personal communication to the author, July 2004.
30. See note 3 above.
31. When heterosexual women do enjoy equality in the family and other domestic spaces, the general perception is that they are 'permitted' to do so by a liberal partner, rather than entitled to do so.
32. See, for example, Nomboniso Gasa's presentation to the Centre for Conflict Resolution at the University of Cape Town immediately after the verdict. Gasa is a struggle veteran, academic and trained *isangoma* (traditional healer).
33. I've written elsewhere (Moffett 2002) about how standard rape 'scripts' in this country make it nearly impossible for most rapes to be acknowledged as such in South Africa. For example, rape survivors are considered credible only if their rapist is a stranger, or if the rape takes place during the commission of an additional crime (such as housebreaking or hijacking) or when severe physical violence over and above the rape itself occurs. Of course, the most credible rape victim is the one who is murdered by her assailants.
34. This sets up a classic catch-22 scenario: the chances of a South African woman escaping trauma during her lifetime are slim. But if she does experience trauma, her legal standing as a potential rape victim is permanently compromised.
35. Amina Mama, chair of UCT's African Gender Studies (who hails from Nigeria), and Rhoda Reddock, chair of Gender and Development Studies at the University of the West Indies, both made this point at the Centre for Conflict Resolution workshop immediately after the verdict.
36. For an overview of these efforts, see Robert Morrell's 'Men, Movements and Gender Transformation' in Ouzgane and Morrell (2005).
37. 'Real Men Don't Rape Women and Children', SAPA, 17 November 2003.
38. I am extremely grateful to Amina Mama, Jane Bennett, Brenda Martin, Joanne Henry, Elaine Salo and other members of the African Gender Institute at the University of Cape Town for infrastructural and collegial support provided during this research.

References

Albertyn, C. 2004. 'Gender Equality: Can It Still Work for Women in South Africa?' Unpublished project, Centre for Applied Legal Studies, University of the Witwatersrand, Johannesburg.

Arne, S. 2004. *Re-thinking Sexualities in Africa*. Uppsala: Nordic Africa Institute.

Bhana, D. 2005. 'Violence and the Gendered Negotiation of Masculinity among Young Black School Boys in South Africa'. In *African Masculinities*, edited by L. Ougzgane and R. Morrell. Pietermaritzburg: University of KwaZulu-Natal Press.

Brownmiller, S. 1975. *Against Our Will: Men, Women and Rape*. New York: Simon and Schuster.

Cahill, A.J. 2001. *Rethinking Rape*. Ithaca: Cornell University Press.

Davis, A. 1983. *Rape, Racism and the Myth of the Black Rapist*. New York: Vintage Books.

Denny, L., et al. 2002. 'Sexual Violence against Women: A Significant Health Problem'. Findings

of the Rape Protocol Project at Groote Schuur Hospital, Cape Town, presented at the South African Colleges of Medicine Annual Symposium on Violence.

Green, D. 1991. *Gender Violence in Africa*. New York: St Martin's Press.

Groth, A.N. 1979. *Men Who Rape: The Psychology of the Offender*. New York: Plenum Press.

Jayawardena, K. and M. de Alwis. 1996. *Embodied Violence: Communalising Women's Sexuality in South Asia*. London and Atlantic Highlands, NJ: Zed Books.

Johnson, W. 2003. 'Are Whites (and Men) Ready for Democracy?' Paper presented at the Centre for African Studies at the University of Cape Town.

MacKinnon, C. 1989. *Towards a Feminist Theory of the State*. Cambridge, MA: Harvard University Press.

Mama, A. 1997. 'Sheroes and Villains: Conceptualizing Colonial and Contemporary Violence Against Women in Africa'. In *Feminist Genealogies, Colonial Legacies, Democratic Futures*, edited by M.J. Alexander and C.T. Mohanty. New York: Routledge.

————. 2004. 'Editorial'. *Feminist Africa: National Politricks* 3: 2–3.

Mathews, S., N. Abrahams, L. Martin, L. Vetten, L. van der Merwe and R. Jewkes. 2004. '"Every Six Hours a Woman Is Killed by Her Intimate Partner": A National Study of Female Homicide in South Africa'. Tygerberg: Medical Research Council.

Meintjes, S., A. Pillay and M. Turshen. 2001. *The Aftermath: Women in Post-conflict Transformation*. London: Zed Books.

Moffett, H. 2002. 'Entering the Labyrinth: Coming to Grips with Gender Warzones, using South Africa as a Case Study'. In *Partners in Change: Working with Men to End Gender-Based Violence*. Santo Domingo: United Nations INSTRAW.

Moland, J. 1996. 'Social Change, Social Inequality, and Intergroup Tensions'. *Social Forces* 75 (2): 403–21.

Morrell, R. 2001. *Changing Men in South Africa*. Pietermaritzburg: University of Natal Press; London: Zed Books.

Niehaus, I. 2003. '"Now Everyone Is Doing It": Towards a Social History of Rape in the Southern African Lowveld'. Paper presented at the WISER Sex and Secrecy Conference at the University of the Witwatersrand.

Ougzgane, L. and R. Morrell, eds. 2005. *African Masculinities*. Pietermaritzburg: University of KwaZulu-Natal Press.

Pillay, A. 2001. 'Violence against Women in the Aftermath'. In *The Aftermath: Women in Post-conflict Transformation*, edited by S. Meintjes, A. Pillay and M. Turshen. London: Zed Books.

Posel, D. 2005. 'The Scandal of Manhood: "Baby Rape" and the Politicization of Sexual Violence in Post-apartheid South Africa'. *Culture, Health and Sexuality* 7 (3): 239–52.

Scully, D. 1994. *Understanding Sexual Violence: A Study of Convicted Rapists*. New York: Routledge.

Smith, C. 2001. *Proud of Me: Speaking Out against Sexual Violence and HIV*. Johannesburg: Penguin.

————. 2005. 'Keeping It in Their Pants: Politicians, Men and Sexual Assault in South Africa'. Harold Wolpe Memorial Lecture, Durban, 17 March.

Schwartz, M. 1997. *Researching Sexual Violence against Women: Methodological and Personal Perspectives*. Thousand Oaks, CA: Sage Publications.

Vetten, L. 1997. 'Roots of a Rape Crisis'. *Crime and Conflict* 8: 9–13.

Vogelman, L. 1990. *The Sexual Face of Violence*. Johannesburg: Ravan.

Wood, K. and R. Jewkes. 1998. ' "Love Is a Dangerous Thing": Micro-dynamics of Violence in Sexual Relationships of Young People in Umtata'. Tygerberg: Medical Research Council.

Wood, K., F. Maforah and R. Jewkes. 1996. 'Sex, Violence and Constructions of Love among Xhosa Adolescents: Putting Violence on the Sexuality Education Agenda'. Tygerberg: Medical Research Council.

Race, Gender and Feminist Practice

Lessons from Rape Crisis Cape Town

BENITA MOOLMAN

RAPE IS A complex construction of power and power relations given meaning through personal and social identities, specifically identities of masculinity and femininity (Moolman 2004). 'Second-wave' feminist analysis of rape as an act of power has often focused on rape as a dynamic of gendered power only (Brownmiller 1975). The scourge of rape in South Africa necessitates an analysis of power as expressed and facilitated through a multiplicity of identities, as Moffett discusses in Chapter 6 of this collection. This implies that an understanding of the dynamics of rape in South Africa must include an analysis of how power is expressed through different race, class, national and sexual identities. Steady (1996) claims that '[a]n African feminism that encompasses freedom from the complex configurations created by multiple oppression is necessary and urgent' (4).

The statistics on rape in South Africa during the past ten years have remained significantly high. South African Police Services (SAPS) statistics[1] indicate that in 1996, 50 481 rapes of women and children by men were reported, as compared to 55 114 rapes reported in 2004–2005. One has only to recall the apartheid period to be reminded of the extreme violence in South African history. Morrell (2001) states that 'masculinity and violence have been yoked together in South African history' (12). Within dominant meanings of manhood in South Africa, a physical display of manhood symbolises values of strength, dominance, power, control, conquest, achievement and bravery. These same values used in the construction of manhood were embedded within apartheid systems and policies and they are also present in the act of

rape. Certainly, the prevalence of violence against women in South Africa can be linked to the valorisation of masculine violence reproduced throughout the militarised history of apartheid (Cock 1991). Without attention to the intersection of gender with other forms of identity, however, the existing high incidence of rape in South Africa contributes to the broader public perception that all South African men are 'bad'. Advocating the importance of contextualising masculinity, Reid and Walker (2005) note that 'men accept where they were situated as part of the problem (the abuser, the oppressor, the patriarch) and were neither the object or the subject of study' (6). In grappling with the complexities of rape, feminism and feminist practice in South Africa, I suggest each at its core has been about gendered identity politics.

This chapter is grounded in the notion of rape as a manifestation of power relations, but it also challenges previous static notions of patriarchy, masculinity and femininity. I take up the conversation of power-laden gender-, race- and class-based politics in post-1994 South Africa through an analysis of the country's longest-standing rape crisis organisation, Rape Crisis Cape Town (RCCT). My analysis of race is based primarily on my own 'lived experience'. As a coloured South African woman living in a country where whiteness has defined 'scientific and theoretical evidence', I struggle with conforming to standard or acceptable academic practice where theories and references are used to provide evidence and legitimise 'truth'. This chapter is an indication of my struggle. While at times I conform and use references to situate my work, at other times I don't.

Feminist practice at the RCCT has been synonymous with women's understanding of feminism and rape activism. Since its inception in 1976, the RCCT has been created, shaped and managed by women for women, and originally men were excluded from membership. In January 2005, the policy that stipulated that '[a] member shall be a woman who has worked in the organisation for six months or volunteers' (RCCT 1998a) was finally dissolved and men became full participants in the RCCT. This dramatic change in policy was the result of months and years of meetings, discussions and emotional debates. The final decision symbolised not only a policy change but also a shifting of deeply held values, theories, identities and power. This chapter will analyse different aspects of this organisational and ideological transformation to explore how gender identity politics played out in the post-1994 context within a central woman's organisation.

What I attempt to demonstrate is how the national transformation of social and political rights enlivened the organisation with a new form of feminism that no longer excluded men and no longer essentialised men as violent perpetrators. Further, I demonstrate that race, as a system of power relations, acts as a catalyst in the transformation of feminist practice within the RCCT. While many of the geographic and economic barriers of apartheid still exist within the organisation, a new form of feminist/womanist practice is also developing, one that seeks a notion of 'combined responsibility' between men and women for fighting gender-based violence.

The analysis of organisations affords an opportunity to explore how civil society contributes to changing social power relations, especially in this recent inclusion of men in rape activism. I suggest that this policy change to include men within the RCCT will have a huge impact in shaping service provision. At the same time, its emergence provides a central case that links the theoretical work on sexual violence and social identity with the applied practices of gender organisation within civil society.

This chapter traces the dynamics between feminism as a collective identity and its influence on organisational identity in the shaping of feminist practice within the RCCT. I explore the assumptions of femininity and masculinity embedded in feminist praxis, specifically rape activism at the RCCT in South Africa. First, I discuss the origin of the organisation, looking at the ideological underpinnings that inform its feminist practice. I then provide an overview of the current situation with regard to organisational politics and service delivery. The methods for this study include content analysis of organisational documents as well as data from participant observations, both of which I acquired throughout my nine years of service within the RCCT. This insider status affords a complexity of perspectives for this analysis and draws on autoethnography as a methodological approach, where the researcher is an integral part of what is being researched. While much of this chapter will be a reflection of general observations, trends and dynamics of the organisation, I am also guided by professional ethics that assure the anonymity of all clients who receive services from the RCCT. Thus, for their protection, I will not reveal the identity of any clients. In addition, while I advocate for a transformative feminism that dissolves fixed dichotomies of sex, I salute the women who initiated this radical organisation in a time when South Africa was brutally violent towards all women. The RCCT was then a beacon of hope. It remains this today, for many women.

Herstory

The herstory of the RCCT is linked to the transnational feminist movement that spread ideas of women's empowerment and their quest for freedom from violence: 'Feminism had become a mobilising force for women in the Western world, and some women in South Africa started speaking about women's oppression . . .' (RCCT 1989). This was the impetus that got a small group of women in South Africa to 'start talking about rape' as a central component of women's organising. The RCCT was started in 1976 by a group of women, some of whom were rape survivors. They met weekly at the Women's Centre in Rondebosch – a geographical area that was then under the Group Areas Act (1950). It was during this period that apartheid was institutionalised through social policies that enacted overt racism between white, black and coloured people.[2] Consequently, Rondebosch was spatially designated for white people, which meant that black and coloured South Africans had limited access into and out of this area. They were allowed to drive through this residential neighbourhood, but they could not buy houses or attend schools in this space reserved for the white minority.

The racial geography of Cape Town therefore shaped the organisation directly, as a result of the relative privilege afforded to founding staff members and the complexities of accessing services. In its infancy – and as a result of the apartheid system – white women initially defined the RCCT, and hence race was part of the organisation's complex dynamics from its inception. The initial volunteer groups were drawn from the women's movement at the University of Cape Town (UCT), which was formed after the well-known feminist Juliet Mitchell delivered a lecture there in 1975. These women had also just withdrawn from the university's Community Commission[3] because they identified reluctance by the men to address women's issues in politics. During these early stages, this theme of male reluctance to deal with 'women's issues' was thus brought into the RCCT organisation. The purpose of the organisation at that time was to provide safe opportunities to talk about rape. Women-only spaces were seen as essential to creating strategies of survival and pathways for social change. This is reminiscent of global second-wave feminist approaches to gender-based violence.

The organisation initially provided counselling services to rape survivors and then expanded by offering public educational talks and workshops for various community groups, churches, student groups, and so on. The RCCT

Constitution (RCCT 1979) stated that 'the aims and objectives of the organisation are to offer advice, moral support and legal advice as a form of social assistance to the rape victim and to any member/members of the family or any other persons who might be involved'. The organisational mandate was to deal with 'crimes of sexual intent involving women, children and men'. In relation to the populations served, the RCCT Constitution stated that 'Rape Crisis renders assistance to any person (irrespective of race, colour, sex or creed)'. The organisation thus provided services to men as rape survivors.

In contrast to this distinct stance on service delivery, the organisation did not clearly define its membership in terms of social identity. Guiding RCCT documents focused on how one became a member, rather than *who* could become a member. For example, to be a member required the payment of an annual subscription. There was nothing in the RCCT Constitution that defined membership in terms of gender, race, class, sexuality or nationality. Organisational records such as the Rape Crisis Herstory Booklet (RCCT 1989) explained that membership was defined through the organisation's feminist ideology: 'After the influx of women from the women's movement, we became much clearer in our idea that what feminism was fighting for was our aim . . . by early 1981 we openly called ourselves feminist.' This ideological linkage to feminist values within the organisation captures the complexities of women's access and identity affiliation, which was centrally shaped by the race and class divisions dominant within the overarching apartheid context at this time. At the same time, this very definite feminist standpoint provided an empowering and affirming social space for women as beneficiaries and members.

Feminism within the RCCT

Feminism in South Africa has always been a contentious issue, sharply divided along racial lines (Salo 1994, 2005; Fester 1998; Hassim 2005). The RCCT was not immune to these complexities. Initially, gender as a construct of difference assumed the central priority in the fight to end gender-based violence, rather than the intersectionality of race, class and gender. The Herstory Booklet (RCCT 1989) describes the RCCT brands of feminism as historical and structural. These brands of feminism defined violence against women as a strategy of patriarchy, which maintains the system of men's domination over women. The RCCT drew on feminist theories, in particular

radical, liberal and socialist feminism, which translated into the various policies and practices that impacted every aspect of the organisation. The overarching structure, for example, remained flat/horizontal rather than vertical/ hierarchical, with decision making taking place at general meetings with the full membership present. In support of women's particular concerns, the RCCT provided childcare at all meetings, and the overall tone of newsletters was affirming of and to women. As an active space of dialogue, the organisation held regular debates, where guest speakers were invited to talk about feminism and feminist concerns. These organisational processes capture the patterns that linked the overarching political and social ideologies of feminism to the daily processes and defining culture within the RCCT. This space provided a 'home', a place to belong, for many women.

By 1982, RCCT members agreed that the organisation should provide a safe haven for women – irrespective of race, religion, class or sexuality. More black and coloured women were recruited as volunteers through the training courses, which resulted in additional course offerings within coloured communities such as Mitchells Plain (RCCT 1983). White women managed the organisation at this time. The intentional 'reaching out' to black and coloured women can be seen as a part of the broader socio-political race relations and liberal ideology in South Africa. Biko (2006) criticised such limited measures by stating:

> White racism in South Africa was expressed through the liberal ideology . . .
> demonstrated so well as the insistence that the problems of the country can
> only be solved by a bilateral approach involving both black and white . . .
> The integration they talk about is first of all artificial in that it is a response to
> conscious manoeuvre . . . (21)

Within the RCCT, the recruitment of black and coloured women did not effectively translate into equality and equity within the organisation, as will be discussed later.

In terms of dealing with sexuality difference, however, the RCCT provided a strong model of integration. The organisation became a space where many lesbians felt safe enough to disclose their sexual status and preferences (RCCT 1989). This was one of the greatest strengths of the RCCT as a defined women-only space, and one which makes the organisation significantly different from

much of the women's movement in South Africa (Hames 2003; Gqola 2006). Sturdy (1987) describes her understanding of working in this progressive women's organisation as follows:

> [W]hether expressed or not . . . its internal structure and culture should reflect or embody the group's feminist values . . . we were to express our feminist perspective not only in what we did as a group, but also in how we did it. (31–2)

The approach to feminism supported within the RCCT similarly modelled this critical theory–practice cleavage, with the intention to create safe spaces for women across socio-economic divides.

In relation to men's participation within the RCCT, the organisation did not specifically exclude men from receiving services. Evidence from workshop reports and discussions,[4] however, illustrates that men were not allowed to become members of the organisation:

> The issues that we deal with are a clear and direct reflection of the oppression of women in society, and we can come to a better understanding of them when men are not present; the nature of our work means that the vast majority of our clients have suffered pain at the hands of man, it would be traumatic for them to have a male counsellor; we know that in many mixed organisations men develop at the expense of women, so here our members can develop confidence in a non-threatening environment; in order to fight the issues of sexism and violence against women, we need to build solidarity amongst women; from our experience in other organisations, we have found that women-only organisations work more democratically. (RCCT 1989)

Thus the organisation maintained a women-only safe space for women to grow and develop, to build solidarity among women and provide safety for female clients. Sturdy (1987) states that 'working collectively could be seen as a safe way for an organisation to be radical in identity . . . [I]t can also obscure real differences of interest within a work group in not very helpful ways' (43). Gender was not problematised within the organisation during the 1970s and 1980s. Furthermore, the assumptions of femininity and masculinity, along with the interconnectedness of personal and social identities, emerged as central and defining moments throughout the development of the RCCT.

Yet the RCCT did not totally resist working with men, as the organisational herstory documents reveal. There were early attempts to engage men, such as through a socialisation workshop held in 1981, where the organisational direction and the issues of gender and rape were discussed with men. A training course in 1981 integrated men in the process, but membership barriers made it necessary to maintain a portion of the organisational process for women only. Conclusions from these sessions indicated that men should start their own rape crisis group because they were 'too defensive', and the group spaces were more productive when men were absent.

In terms of feminist practice, service delivery centred on counselling and public education. The counselling services focused on the individual rape survivor and her experience of rape, irrespective of issues of race and class and the impact of the environment (such as poverty, housing and transport) on that experience. The RCCT states that its services have always been open to all people, but in the early years services were offered in historically white areas, initially Rondebosch and then, when the organisation acquired funding, it set up an office in Observatory. This is a central and recurring theme in the herstory of the organisation: class and race boundaries defined access to space, often reproducing the political geography of apartheid.

This micro-focus on counselling services for rape survivors seems to have been adopted from rape crisis centres in the United Kingdom, where the focus then and now is on counselling around the emotional and psychological impact on the individual rape survivor. Indeed, I argue that feminist practice as seen in the RCCT was largely drawn from the European model, despite the fact that in Europe the experience of rape remains very different from the South African situation. Assumptions based on experiences of mainly white, middle-class and Western women have been used to define rape-crisis service delivery in South Africa. By using a liberal ideology of race, the organisation practised a colour-blind approach to racism, even as it espoused feminist values. The assumptions of this ideology centre white women's experiences as the experiences of all women. This form of internalised dominance is indicative of modern institutionalised forms of racism (ELRU 1997).

At the RCCT, we see these ideological underpinnings in everyday processes. For example, the *then* and *still current* counselling practice is that rape survivors have to make their own appointments, in the name of taking the first steps in their own empowerment. This policy applies regardless of the survivor's

employment status, ability to access (or own) a phone and financial resources base. Intended to empower, this policy in fact places severe and disproportionate disadvantages on the majority of black and coloured women, who often struggle to access these resources. As these realities suggest, by drawing from predominant models of services found in Europe, the counselling services at the RCCT did not take the broader socio-political context into consideration. Rather, the public education work focused only on universal understandings of rape without looking at the particular impact of apartheid and taking the local context into account. Such generalised notions of rape are also evident in the organisation's use of educational materials such as the 'Myth Sheet',[5] which categorised all women as the same. Accordingly, one training document stated that 'women who go into a dangerous area at night are asking to be raped'. Yet the scenario of black and coloured women going into a dangerous area is very different from that of white women going into a dangerous area, as the majority of black and coloured women actually live in 'dangerous areas'. This assumption that women experience a universal threat of danger epitomises what the Early Learning Resource Unit (ELRU 1997) problematises in its work to develop an intersectional appreciation of experience.

Salo (1994) states that defining feminism purely in gendered terms assumes that our consciousness (or identity) of being 'women' has nothing to do with race, class, nation or sexuality, but only with gender. I argue that defining feminist practice in terms of gender only is limited and restricts its potential to be a transformative discourse that advocates for change. Furthermore, such practices support a universalised notion of womanhood, critiqued heavily by Mohanty (1991) in her analysis of the inherent bias of Western feminism as supporting an essentialised woman who occupies a single category with universal experiences and interests and is opposed by an oppressive male figure. In this binary interpretation, women are constructed as victims and men are constructed as the oppressor. African feminists such as Oyewumi have also critiqued Western feminist categorisations of woman, pointing out that many female Africans did not even have access to the concept of 'woman' (Oyewumi 1997). This deconstruction of feminist discourse by post-colonial feminists (Nnaemeka 1998; Mohanty 2004) seriously challenges some of the underlying assumptions on which Western feminism is based.

At the organisational level, this ideological shift in feminism meant that the RCCT's assumption of a polarity between 'victims' and 'survivors' of rape

needed to be challenged at the levels of both theory and practice. Similar universalised definitions of 'woman' and of dominant femininity as caring, empathetic, sensitive, powerless, passive and vulnerable (Funk 1993) serve to limit women in these distinctly defined social constructions, while positioning them as inferior in a patriarchal context. The RCCT struggled with the idea of woman. 'Woman' was constructed as strong, capable and independent, while 'women' were defined, in a distorted manner, as victims. Within the paradigm of dominant femininity, to remain valued as a woman required the ability to realise personal power and safety. As a result of the mutuality of gender constructions, men were thus defined as extremely threatening, powerful, oppressive and potentially rapists.

In the 1970s and 1980s this particular form of feminist ideology was used to mobilise women and the organisation. In an RCCT socialisation workshop in 1981, a participant reflected:

> . . . in retrospect the evening raised for me a whole collection of issues . . . the first was whether Rape Crisis wasn't in fact using rape and the experience of the victim as a powerful mobilising point for women. I had a strong sense both within the small group and the larger group that many people were attempting to resolve private crises by investment in the movement. There is nothing wrong or bad about private crises, but to attempt to resolve them by masking them in the generalised positional politics of a movement is, I think, dangerous for everyone. (RCCT 1981)

On one level, this process of blurring social and personal identities is common. There are numerous socialising agents, such as religion or the media, which exist for exactly this reason, often telling us how to be as women or how to be as men. However, feminism was supposed to be an alternative discourse emphasising choices. Feminism could provide many women and some men with opportunities to define themselves differently with a new value system and way of being.

Sturdy (1987) contends that 'an unwillingness to admit difference seems to be especially pronounced in an all-women's group' (43). However, separating the personal/individual feminist identity from the collective can be very difficult and confusing, particularly in the South African context. At the RCCT during the late 1970s and 1980s, I believe the collective and individual

feminist identities merged, which influenced organisational policy and practice. In addition, the identity of the 'rape' victim and/or survivor as someone who was vulnerable, powerless, helpless, distrustful and angry was absorbed into the identity of the organisation. Based on my assessment from within the RCCT, I contend that the organisation vicariously lived and still lives the life struggles of the rape survivor.

This patriarchal and feminist context defined men as a single, unitary, universalised subject where the values of dominance, control, conquest, competition, sexual performance, achievement and power identified indicators of manhood (Funk 1993). According to this feminist discourse, all men want ownership of women. This context also influenced the RCCT during the 1970s and 1980s, as the organisation assumed a universalised construction of men, without taking the differences of race, class and sexuality and their influence on shaping masculinities into consideration. RCCT ideologies, policies and practices were based on an essentialist assumption of 'man' which reinforced broader constructions of masculinity. The definition of man became blurred with that of rapist. The need to investigate alternative preventative options meant that the RCCT had to review its perception of man and rapist, as I explore later in the chapter.

The criticisms of feminist discourse, with its emphasis on the deconstruction of grand narratives, coupled with the introduction of post-structural and post-colonial discourses have helped make clear that masculinity and femininity are not homogeneous categories. Theorists such as Connell (1995) and Morrell (2001) have challenged the notion of essentialised masculinity and identified the multiplicity of male subjectivity. Morrell (2001) discusses the history of South African masculinities and highlights the interconnectedness of colonialism, capitalism and racism in the shaping of South African masculinities. He identifies the tense relationships between different forms of masculinities during the late nineteenth century among English-speaking white men, Afrikaans-speaking white men and African men. The fact that these relationships were played out in settings such as mines illustrates how violence was regarded as a legitimate means of resolving conflict between these groups of men:

> For white men, the uneven distribution of power gave them privileges but
> also made them defensive about challenges (by women, blacks or/and other

men) to that privilege. For black men the harshness of life on the edge of poverty and the emasculation of political powerlessness gave their masculinity a dangerous edge. Honour and respect were rare for black men, and getting it and retaining it (from white employers, fellow labourers or women) was often a violent process. The release of Nelson Mandela in 1990 heralded a significant shift in constructs of South African masculinity, in that the men who agreed to this landmark shift had earlier been committed to a military defence of white privilege or the armed overthrow of white rule. (Morrell 2001, 14)

Reid and Walker (2005) propose that 'the transition to democracy in South Africa [is] . . . unseating entrenched masculinities'. Some argue that women's increasing power in the political sphere has been threatening to these forms of masculinity (Meintjes, Pillay and Turshen 2001). For example, the 1990s saw huge changes in national policies related to gender, as evidenced by the increase in the number of women parliamentarians to over 32.8 per cent of the total by 2004. In addition, I would argue that the transfer of political power from white men to black men has contributed to this 'unseating' of masculine identities.

Morrell (2001) organises the responses of men experiencing South Africa's democratic transition into three categories: reactive or defensive; accommodating; and responsive or progressive. He identifies the reactive/defensive responses as those shown by men who have attempted to turn back the changes in order to reassert their power. The appalling rise in incidents of rape in South Africa can also be considered as a masculinist response to transition. The accommodating responses, some of which are apparently traditionalist, can in fact be understood as attempts to resuscitate non-violent masculinities. For example, rites-of-passage practices among African youth being initiated into manhood have strong ethnic connotations, yet they also invoke an ideal of manhood that is responsible, respectful and wise. This is distinct from the antisocial masculinities of many of the youth on the street. The responsive or progressive responses are demonstrated by men who attempt to challenge violent masculinities, and in so doing construct new ways of how to be a man. A number of organisations (including GETNET, FAMSA and GAP)[6] are currently working to end violence against women by engaging male responsibility for violence, condemning aggression and working for more equitable gender relations (Britton 2006). As these organisations develop and

increase their ability to shape everyday social relations through civil society, drawing from those theoretical contributions which debunk the myth of a monolithic 'man' and promote an appreciation for many different masculinities (Morrell 2001), they provide valuable tools to increase the potential positive impacts of such gender activism. This understanding of men is very different from the rigid understanding of men that existed at the RCCT during the 1970s, 1980s and early 1990s, and creates opportunities to work with and include certain types of men in challenging and opposing exploitative gender relations.

Second-wave feminist theories viewed power as unitary and rigid. Power is determined through gendering and sexualising practices, and this creates essentialised identities of male and female. Identities have been constructed as static and immutable. Since individuals are unable to challenge, resist or change these identities, the position of the 'victim' as powerless will always be associated with the 'woman', and the position of the perpetrator as powerful with the 'man' (Jackson 1999; Funk 1993). These gender identities of *woman as powerless* and *man as powerful* have been conflated with sexual identities. Power has been and continues to be constructed as meaning the same in both gendered and sexualised identities, such as 'all men want control'. In the case of gender, power has been fixed within male attitudes, emotion and behaviours. In the case of sexuality, power became imprinted on the male body, namely the penis, and historically much of South Africa's rape legislation defined rape exclusively in terms of male penetration. This power has been constructed as 'power over', where power has been synonymous with control (Funk 1993). The understanding of power as control is the definition of power that existed within the RCCT until the 1990s. By arguing that men should be excluded because they would dominate the space in the organisation, the RCCT was in fact essentialising men as power and women as powerlessness.

In addition, the organisation had to facilitate the healing process for rape survivors, particularly in dealing with rape trauma syndrome, which involves issues of anger, power and control. Gibson, Swartz and Sandenbergh (2002) argue that 'human service organisations inevitably end up carrying the distress of their clients'. Sometimes survivors remain at certain stages, and they do not move past being angry with men. Alternatively, they completely remove themselves from 'male' spaces, feeling powerless and out of control. The RCCT as an organisation had experienced vicarious trauma and seemed also to assume this identity of a healing rape survivor struggling with issues of

anger, power and helplessness. Gibson, Swartz and Sandenbergh (2002) go further to say that sometimes organisations find that the feelings their clients bring with them are too difficult to manage at all, and the organisation devises ways of trying to avoid them.

As gender organisations prepared for, and worked within, South Africa's democratic transition, they confronted the pervasively essentialised constructions of femininity, masculinity and power. On a societal level, massive changes around race relations took place, starting in the early transition period. The abolishment of old policies, such as the Group Areas Act, created a sense of displacement and anxiety, which resulted in different forms of resistance. The apartheid state expressed overt resistance through the police, while covert resistance also continued, even by some privileged white South Africans who saw themselves as 'non-racial'. Covert resistance to and anxiety about the changes manifested in many ways within the RCCT, as the organisation absorbed some of these societal tensions of democratisation.

The RCCT: 1991 to 2006

During this transitional period and throughout the first twelve years of democracy, the RCCT reflected the transformative social and cultural processes of the national transition. Shifting power asymmetries in the broader gender movement were evident as early as 1991, when, for example, at the Natal Conference on Women and Gender in Southern Africa, black women walked out because white women were dominating the discussions and agenda. This conference was attended by activists, academics, trade unionists, ANC exiles, youth organisers and international observers from Mozambique, Canada and the United States (Horn 1991). Lewis (1995) contends that white feminists hold a certain power, and it is in their interest to keep black women as passive, victimised, silenced objects. Recognition of black women's own interpretations would lead to white feminists' loss of dominance. Black women in the RCCT had also started speaking out, which resulted in the organising of numerous 'race workshops' (RCCT 1994). Black women entering the organisation were politically conscious and were either members of a political party such as the African National Congress or former participants in political protests against apartheid. The variety of women speaking out about their different ideologies and values both challenged old assumptions and introduced new ideas of woman, gender, identity and feminisms.

The RCCT has experienced rapid change since 1993 as a result of both funding and a new state apparatus (Britton 2006). Pressure from international funders precipitated the employment of the first director in 1996, and the introduction of a board of trustees to replace the steering committee, which meant that the organisation was shifting from the feminist-alternative flat structure to a hierarchical form of leadership and decision making. For the first time, this management committee was not fully involved in any area of service delivery. The board of trustees ultimately held the authority and therefore the decision-making power within the organisation. This shift represents a movement towards hierarchical processes that imposed distance between the recipients of service delivery and the governing bodies of the organisation. Britton (2006) identifies the 'funding debate' as a pivotal space for the reshaping of women's organisations in the post-apartheid era.

The vision statement adopted three years after the national transition to democracy reflected this pivotal change process:

> We the women of RCCT have a feminist political understanding of violence against women. We seek to confront and challenge rape in communities, on the level of the individual as well as on the level of social structures and beliefs. (RCCT 1998a)

Although feminist assumptions always guided the work of the RCCT, this was the first time that the organisation formally stated this in its vision and mission statement. The RCCT also included the word 'political' because black and coloured women were uncomfortable with and could not relate to the word 'feminist'. This vision statement was important for the organisation because it was the first time the women-only space was explicitly stated, and this translated into policies such as the Deed of Trust (RCCT 1998a), which, for the first time in the legal policies of the organisation, defined a member as 'a woman who has been a member of the trust for a minimum period of six months and has undergone a training course run by the trust'.

In the post-apartheid context, race relations within the RCCT changed rapidly as black and coloured women entered the organisation. As a central move to overcome the geographical-access disparities, the RCCT opened what were initially called satellite offices, and then community offices, in Khayelitsha in 1995 and Heideveld in 1997. These new offices represented a means of

making services more accessible to women across race and class divides that continued to define women's day-to-day realities in the post-apartheid context. Many black and coloured women could not access the organisation's services because of the lack of transport and money to get to Observatory. However, the Observatory office remained the head office for the RCCT, representing a distinct complexity in terms of access as well as the organisation's broader function within the new democracy.

The Khayelitsha office opened in 1995 to serve one of the most severely disenfranchised populations within Cape Town, an important moment in the organisation's development. The physical space was substantially smaller than the premises in Observatory. Training volunteers, which is a core RCCT programme, had to take place at venues within the community. In this regard, the RCCT as a civil society organisation transcended geographic lines and moved into the everyday social spaces of residential life. In contrast to this movement to integrate the work of the RCCT in community life, all organisational meetings continued to be held at the Observatory office. Similarly, the opening of the Heideveld office in 1997 reinforced racist/classist assumptions – such as access to/ownership of transport, availability of resources such as photocopying machines and books, and the location of decision making – operating within the RCCT.

Differences among women started surfacing during these post-apartheid years. The category woman was contested as issues of race in the RCCT became more salient. Within the shifting dynamics of this context, women's needs for power and control became clearly evident. Processes that affected the management, control and distribution of resources, for example, exemplified both internal power dynamics as well as a broader struggle to increase access to gender protections – such as services for rape survivors – within the wider women's population in South Africa. These realities of organisational power struggles and limited access to gender rights illustrate how the second-wave assumptions that all women share the same experience of their gendered positions are severely inadequate, particularly in the case of South Africa, where striking race and class divides persist.

Developing an inclusive feminist practice

Entering the RCCT as a public education and training coordinator, I thought working in a women-only organisation would be a form of utopia. Here I could forget about the heterosexual and masculinised norms that continue to

shape everyday social life. We no longer had to deal with conditions where men were always watching women's bodies – where we would have to survey each other and ourselves about how we spoke, sat or dressed. In this organisational space, we would not have to fight with men for power or to be recognised as equals. From this perspective, I loved the freedom that working in an all-women's organisation offered.

However, I soon realised that this 'utopian' organisational context was not without its own dynamics of power and powerlessness. Although we would not fight with men for power, we fought with each other. We were definitely not unified, nor did we have the same experiences within the organisation. In dealing with our differences, race surfaced most clearly as a dividing factor among women working for the RCCT. The need for numerous racism workshops, an affirmative action policy and the distribution of the resources between the three offices were constant, and racially charged, tensions that confronted the organisation. Often in these discussions, black and coloured women would stand together 'against the white women' and we would often refer to the 'Obs-centric' way of doing things, linking the historical white geography of Observatory with the racial power dynamics within the organisation. According to ELRU (1997), because modern racism is more subconscious and racist feelings more submerged, it is often harder to 'prove' racism in this context, and therefore it takes much longer to challenge and eradicate it. The organisational enactment of institutional racism similarly presents challenges in transforming structures of inequality when decisions that limit access, for example, are not linked to a history of severe marginalisation and pervasive barriers to social equality.

Black women have challenged many of the underlying assumptions within the RCCT. For example, they lobbied for the rotation of meeting locations to be more geographically equitable and for the purchase of bigger premises for the Khayelitsha and Heideveld offices. At the same time, however, important organisational structures remain unchanged. At the time of this research,[7] the two most senior/powerful positions in the RCCT continued to be held by two white women. In addition, the economic resources are still managed at the Observatory office. With the appointment of the white director in 2002, the board of trustees told the staff that the reason that they could not appoint a black director was because black women were not interested in earning the salary of R15 000 per month.[8] This was an overt dismissal and devaluation

of black and coloured women, and an explicit form of racism. Such acts of subtle and not-so-subtle racism reinforce positions of power and powerlessness, while reproducing dehumanising systems of practice. This is a concrete parallel to the broader South African transition, where political power has shifted to the hands of black people but economic power still rests in the hands of the white minority.

As an agent of change within the RCCT, my own social location shaped the nature of my experience in the organisation. I draw from these experiences to substantiate the pervasive divide between women based on race and class positions. Because gender was at the top of the hierarchy of identity within this organisation, my race identity as a coloured woman was repeatedly dismissed. In my own process of forming affiliations, I could not identify with white women; as a coloured woman, I related to blackness and experiences of racist oppression. I had similar experiences at UCT during my undergraduate training. The issue of access to resources was always assumed, but because I am a coloured, lower-class woman, this reality was not mine. In South Africa, class positions are extremely racialised, and further reproduced in educational systems (Barnes 2007) as well as civil society organisations. As a means of 'fighting back', my race identity became my primary identity within the organisation. Externally, when I represented the organisation, my gendered identity was primary. This prioritising of one form of oppression over another is something that I was not comfortable with, and I often shifted between these subjectivities, moving between race and gender on a daily basis. I am reminded of Nnaemeka's (1998) statement that African feminism resists prioritising oppressions and identities. Instead, she challenges us to examine the position and context of women to determine their degree of powerlessness and agency.

Feminist practice is most effective when it challenges systems of hierarchy and promotes the value of shared power between people, including the socialising of boy and girl children. This propelled me into exploring prevention strategies locally that were based on the concept of shared power. I realised that historically in South Africa interventions aimed at addressing rape had focused almost exclusively on work with women, with the goals of empowerment, education, support and advocacy. This notion of shared power therefore became central to my work within the organisation in ways that more closely paralleled the guiding values of South Africa's new democracy.

Masculine identities in transformation

It is important to acknowledge that the RCCT has always educated men as community members, police officers, magistrates and teachers, and also as partners, fathers, husbands and brothers of rape survivors. Even though the work of ending gender-based violence has been viewed as the responsibility of both men and women, the application of this guiding perspective continues to challenge the organisation. To date, the RCCT has not yet undertaken a practical strategic analysis of the role men can play within the organisation to address violence against women.

Men fulfil multiple roles in their personal and social identities as fathers, husbands, brothers and lovers, as well as in their professional identities as police officers, magistrates, teachers and other male-dominated occupations. These multiple roles present opportunities for men to challenge and confront sexist attitudes and practices and to assert alternative values that promote non-violent masculinities. Working with masculinities provides opportunities for intervention in addressing and preventing rape. Particularly in South Africa, with the lingering associations of militarised masculinity coupled with the exorbitant levels of gender-based violence, such initiatives are even more pressing.

As part of my experience in South Africa's gender-based anti-violence movement, I worked with young boys on the Cape Flats[9] as part of the RCCT's Birds and Bees programme.[10] From this experience, I have witnessed directly young boys' fragility in their attempts to define their masculinities. They come from severely impoverished homes and communities where family upheaval and social problems are commonplace. Often, the protection that ganging and gang membership offers in such contexts seems attractive and necessary to feel a sense of self-worth or visibility (Moolman 2004). How do we provide these young men with alternatives to violent, sexualised masculinity?

Theoretically, the RCCT's position on prevention strategies has been to advocate for changes in the traditional socialisation practices central to the rearing of boy and girl children, which as an organisation we had drawn from early feminist theories. However, this strategy focused mainly on the *sharing of gender roles* rather than the promotion of *shared power*. In its work on masculinity, the RCCT did not consult contemporary theoretical models and debates that have influenced feminist practice. Rather, the complexity of power has not been analysed, and therefore its multiple locations have yet to

be identified. As a result, preventative programmes have focused on a very narrow understanding of gender, power and rape.

Including men in preventative work meant that the RCCT had to revisit the debate of allowing men as members, considering both the internal and external realities of the newly democratic South Africa. Internally, a pervasive tension existed between the historical culture and the current culture and organisational practices. Morrell (2001) argues that the

> [h]istory of masculinity is not exclusively made by men. Women opposed certain aspects of masculinity and supported others. They did so in ways that reflected the class and race forces. Race and class loyalties and political agendas were often stronger than gender subordination. (16)

Black women entering the RCCT were committed to fighting gender subordination. At the same time, they came from a history of fighting racist oppression with men as their allies, and thus they held the belief that men can also be collaborators in fighting rape because they too experienced different forms of oppression.

Externally, the public space of violence against women in South Africa has changed. The shifting context of democracy in 1994 forced the organisation to review its practice and intervention strategies (Britton 2006). An Interfund report (2002) suggested both positive and negative factors attached to the use of interventions with men. This study concluded that there 'was a need to mainstream men into the interventions in order to address the issue from a preventative aspect, while not neglecting the symptoms'.

RCCT service delivery was confronted with questions about the extent to which the assumptions about the positive impacts of 'women counselling women' hold true for 'men counselling men'. Within the training and development departments, the concept of preventative work and the role of men and boys had to be revisited. The changes in the organisation resulted in changing value systems embedded in personal and collective identities of masculinity and heterosexuality. This case provides yet another example of how the dissonance between theory and practice remains a challenge for the RCCT.

Workshops held with staff and volunteers identified that the RCCT would benefit from including men in the organisation in a number of ways, namely because it would gain insight into men's behaviours and its work would be

intensified through combined responsibility. For example, men's presence within the RCCT could provide role models for boys, increase the number of male clients and reduce the pervasive rate of gender-based violence. At the same time, including men would serve to debunk predominant myths about a monolithic notion of masculinity because it would increase the potential to work with inspiring men who understand the enormous impact of gender-based violence. The negative impacts for the organisation were identified as losing an exclusively female space, along with the freedom and safety it affords for clients and members. For example, particular risks associated with this ideological and applied shift included the chance of attracting offenders into the organisation, the possibility that some members might leave the organisation and the potential to lose focus in terms of advocacy and lobbying around men.

This dramatic change in policy and practice also signified a move away from the European model of dealing with rape. These gains were an indication that a new feminism was emerging, a feminist/womanist practice that was inclusive of men, that did not fix men in the role of violent perpetrator and that sought shared power expressed in the notion of 'combined responsibility'. Nnaemeka (1998) highlights combined responsibility as central to African feminism. These changes also symbolised the letting go of the monolithic identity of woman as powerless victim. Letting go of the homogeneous category of man created spaces for the development of caring masculinities as described by Morrell's 'responsive masculinities' category.

The impetus to make this huge policy shift came from two organisational realities. First, the diverse women within the RCCT brought with them a variety of value systems, challenging the perception of the 'universal woman' that existed within the organisation. Consequently, if women could be different, then men could also be different. So we began to challenge the perception of men as a homogeneous grouping and as always-violent perpetrators. These women injected a set of values that acknowledged all people (including men) as having a caring and nurturing ability. Second, because preventing sexual violence is part of the RCCT mission, the organisation had a responsibility to the broader public to explore all avenues in its fight to prevent rape/sexual violence, which necessitated the broader inclusion of men.

As this autoethnographic analysis depicts, organisations exist within and respond to the overarching national and social contexts in which they operate.

In South Africa, the national transition to democracy, with its focus on gender rights, incited a transformative dialogue within the oldest rape service organisation in South Africa. Just as the national context of transition is characterised by a process of sorting out policies, priorities and ideological commitments, so too is the ongoing work of transitioning the RCCT's organisational position and response to the shifting landscape of South Africa. Throughout the new nation, rape incidences remain extremely high. This mandates a commitment to and focus on the development of rape-prevention strategies. Transformative rape activism must include, first, the concept of ownership and responsibility for dealing with sexual violence and, second, practices of role-modelling the concept of shared power and non-violent hetero-sexualities. Using gender as a form of exclusion reproduces dehumanising relationships, practices and systems. The exploration of men's role in stopping rape and violence against women presents us with opportunities to redefine ourselves as women, men and human beings, while also encouraging the development of healthy non-violent relationships and sexualities.

Conclusions

Feminism is a very powerful collective identity politic that has shaped the story of gender-based violence activism in South Africa. We cannot let go of this legacy and the strengths of the feminist movement. We can, however, transform them and adapt them to our changing needs. Through the process of transforming feminist discourse, we need to uncover its oppressive practices and produce new discourses of power.

The scourge of rape presents us with huge challenges and opportunities for developing a transformative feminist discourse and practice. The RCCT Constitution (1979) states that '[t]he basic premise for any lasting success in our work is therefore a democratic society where resources and power are shared equally among all people. It is towards this broad goal that we direct our energies.' A society of shared power is the goal, but gender is not the only form of power operating in the discourse of rape. Equally important are the issues and intersections of race, class, nationality and sexuality. Power is multi-layered and embedded within social and personal identities. It also changes as the economic and political context changes. Power relations on many levels must be uncovered and transformed. For rape survivors, for women and for the organisation, an understanding of shared power needs to be infused within

the RCCT. There is a need to experiment with different identities or subjectivities of power, without locating them in essentialised social categories. Power as a process rather than a fixed attribute needs to be affirmed throughout organisational efforts to address such pervasive manifestations of gender inequality.

The concept of subjectivity is useful as a starting point from which to develop strategic interventions. Organisations such as the RCCT do not have to attach themselves to any one identity, but they need to be aware that service delivery is influenced by a broader political context that differs in varying locations. The RCCT has to examine the different social, political and geographic spaces in which it operates. Having a rape crisis office in Observatory is very different from having a rape crisis centre in Khayelitsha or Heideveld (historically white, black and coloured areas respectively). Life in Khayelitsha varies enormously from life in Observatory, even though the distance between them is only 80 kilometres. The different political economies have a definite impact on the shaping of masculinities and femininities as well as on the experiences of rape. The RCCT has to hold these many interpretations of rape, in the same way that any one person will inhabit many subjectivities. The challenge for feminist practice, however, is to move beyond an exclusive focus on gendered identity. The goal is not to be restricted by the fear of losing an 'identity' on which feminist theory and practice has been built. Courage to embrace different and changing subjectivities might assist in finding the answers to eradicating rape.

This is the potential contribution that the RCCT can offer South Africa. In many ways mirroring the national transformation, this civil society organisation is replicating the persistent inequalities of apartheid's latent political economy. Yet the RCCT is also championing new visions of feminism/womanism that are inclusive of multiple forms of masculinity. By challenging static, universalising visions of men as oppressors and women as victims, the organisation is in a position to contribute something original to the national discussion of gender and the national quest to end gender-based violence. These new forms of masculinity may also offer encouraging perspectives for men throughout the country to find alternatives to the violence and crime they have experienced on a daily basis, and thus such contemporary models may help to challenge violent sexualised masculinity. What the RCCT may begin to offer the national discourse is the idea of combined/collective

responsibility. Moving the idea of a rainbow nation beyond rhetoric and beyond a focus on race relations, this new vision of shared power through collective responsibility may offer a model for altering power hierarchies and could demonstrate that the survival and well-being of all citizens is enhanced through mutual dependency and cooperation.

Notes

1. Available on the SAPS website: www.saps.gov.za.
2. Apartheid classifications, such as the terms 'black', 'coloured' and 'white', are used in this chapter as a form of analysis and not as essentialised social categories.
3. The Community Commission was a UCT organisation that worked with community groups.
4. Organisational documents of the RCCT Socialisation Workshop, 1981.
5. The 'Myth Sheet' is a printed form with a list of sixteen statements about rape; participants are asked to say whether the statements are true or false.
6. Gender Education and Training (GETNET), Family and Marriage Society of South Africa (FAMSA) and Gender Advocacy Programme (GAP).
7. This was mid-2006. In 2007, the organisation employed a coloured Muslim woman who occupied the position of financial manager.
8. The majority of black women in South Africa earn less than R5 000 per month.
9. The Cape Flats are a group of coloured and black townships, established when coloured and black people were relocated from areas such as District Six and Claremont as part of the Group Areas Act (1950), which stipulated where the different racial groups could live.
10. The Birds and Bees is a youth life-skills educational programme. Its purpose is to educate and empower young people on the Cape Flats about sexuality, relationships and rape. It also has modules on prejudice and HIV/AIDS.

References

Barnes, T. 2007. 'Politics of the Mind and Body: Gender and Institutional Culture in African Universities'. *Feminist Africa*. Issue 8. www.feministafrica.org/index.php/politics. (Accessed on 15 December 2007.)

Biko, S. 2006. *I Write What I Like*. Chicago: University of Chicago Press.

Britton, H.E. 2006. 'Organising against Gender Violence in South Africa'. *Journal of Southern African Studies* 32 (1): 145–63.

Brownmiller, S. 1975. *Against Our Will: Men, Women and Rape*. New York: Simon and Schuster.

Cock, J. 1991. *Colonels and Cadres: War and Gender in South Africa*. Cape Town: Oxford University Press.

Connell, R.W. 1995. *Masculinities*. Oxford: Polity Press.

Early Learning Resource Unit (ELRU). 1997. 'Shifting Paradigms'. Cape Town: ELRU.

Fester, G. 1998. *Merely Motherhood Perpetuating Patriarchy? Women's Organisation in the Western Cape*. Cape Town: University of Cape Town Press.

Funk, R.E. 1993. *Stopping Rape: A Challenge for Men*. Gabriola Island: New Society Publishers.

Gibson, K., L. Swartz and R. Sandenbergh. 2002. *Counselling and Coping*. Cape Town: Oxford University Press.

Gqola, P.D. 2006. 'In Conversation: Pumla Dineo Gqola speaks with Wendy Isaack'. *Feminist Africa*. Issue 6. www.feministafrica.org/index.php/wendy-isaack. (Accessed on 10 December 2007.)

Hames, M. 2003. 'The Women's Movement and Lesbian and Gay Struggles in South Africa'. *Feminist Africa*. Issue 2. www.feministafrica.org/index.php/the-women-s-movement-and-lesbian-and-gay-struggles-in-south-africa. (Accessed on 10 December 2007.)

Hassim, S. 2005. 'Terms of Engagement: South African Challenges'. *Feminist Africa*. Issue 4. www.feministafrica.org/index.php?page=issue_four. (Accessed on 17 December 2007.)

Horn, P. 1991. 'Conference on Women and Gender in Southern Africa: Another View of the Dynamics'. *Transformations* 15: 83–8.

Interfund (International Fundraising Consortium). 2002. 'Violence against Women: Working with Men against the Scourge'. Johannesburg: Interfund.

Jackson, S. 1999. *Heterosexuality in Question*. London: Open University Press.

Lewis, D. 1995. 'The Politics of Feminism in South Africa'. In *South African Feminisms: Writing, Theory, and Criticism: 1990–1994*, edited by M. Daymond. New York: Garland.

Meintjes, S., A. Pillay and M. Turshen. 2001. *The Aftermath: Women in Post-conflict Transformation*. London: Zed Books.

Mohanty, C. 1991. 'Under Western Eyes'. In *Third World Women and the Politics of Feminism*, edited by C. Mohanty, A. Russo and L. Torres. Bloomington: Indiana University Press.

———. 2004. *Feminism without Borders: Decolonizing Theory, Practicing Solidarity*. Durham, NC: Duke University Press.

Moolman, B. 2004. 'Understanding Gang Rape on the Cape Flats: The Reproduction of an "Ideal Masculinity" through Gang Rape on the Cape Flats'. *Agenda* 60: 109–23.

Morrell, R. 2001. *Changing Men in Southern Africa*. Pietermartizburg: University of KwaZulu-Natal Press.

Nnaemeka, O. 1998. *Sisterhood: Feminisms and Power – from Africa to the Diaspora*. Trenton, NJ: Africa World Press.

Oyewumi, O. 1997. *The Invention of Woman: Making an African Sense of Western Gender Discourses*. Minneapolis: University of Minnesota Press.

Rape Crisis Cape Town (RCCT). 1979. Constitution. Cape Town: RCCT.

———. 1981. Socialisation Workshop. Cape Town: RCCT.

———. 1983. Annual Report. Cape Town: RCCT.

———. 1989. Herstory Booklet. Cape Town: RCCT.

———. 1994. General Meeting Minutes, April. Cape Town: RCCT.

———. 1998a. Deed of Trust. Cape Town: RCCT.

———. 1998b. Planning Workshop Report. Cape Town: RCCT.

Reid, G. and L. Walker. 2005. *Men Behaving Differently: South African Men since 1994*. Cape Town: Double Storey Books.

Salo, E. 1994. 'South African Feminism: Whose Struggles, Whose Agenda?' Paper presented at the South African and Contemporary History Seminar, Sociology Department, University of the Western Cape.

———. 2005. 'Multiple Targets, Mixing Strategies: Complicating Feminist Analysis of Contemporary South African Women's Movements'. *Feminist Africa*. Issue 4. www.feminist africa.org/index.php?page=issue_four. (Accessed on 17 December 2007.)

Steady, F. 1996. 'African Feminism: A Worldwide Perspective'. In *Women in Africa and the African Diaspora: A Reader*, 2nd edn, edited by R. Terborg-Penn and A.B. Rushing. Washington, DC: Howard University Press.

Sturdy, C. 1987. 'Questioning the Sphinx: An Experience of Working in a Women's Organisation'. In *Living with the Sphinx: Papers from the Women's Therapy Centre*, edited by S. Ernst and M. Maguire. London: Women's Press.

Activating Children's Citizenship

The Politics of the Girl Child in Democratic South Africa

CHRISTINA NOMDO AND SHAAMELA CASSIEM

As citizenship is increasingly interpreted as involving responsibilities as well as rights, it is important not to lose sight of this element when discussing children's citizenship. Indeed the evidence of responsibilities that many children exercise can be used in support of their claims for more effective rights. (Lister 2007, 695)

THE CHILDREN'S BUDGET UNIT (CBU) of the Institute for Democracy in South Africa (IDASA) initiated the Children Participating in Governance project in 2004 to encourage children's inclusion in public political discourse. Because social and political environments are created on children's behalf for their future adulthood, this project set out to ensure that children are not just governed by adults, but that they take an active role in contributing to governance processes in the present. Recognising South Africa's youth as individuals with democratic rights, this initiative promoted a paradigm shift from the conception of children as passive recipients to the promotion of active young citizens.

In the existing South African context, however, interconnected challenges pose substantial barriers to children's rights on a number of levels: perceptions of children as outside of the political process, inequitable gender relations and prevailing cultural dynamics that often prevent or limit the interactions of children within public political discourse. In this case we see a disjuncture between the ideology of democratic social rights central to South Africa's emerging democracy and the pervasive ways in which children are generally excluded from public spaces where democracy is enacted. In addition, social

constructions of childhood, especially predominant notions of the girl child, structure children's lives and shape their interaction in private and public political discourse. This chapter begins with an overview of the Children Participating in Governance project to elucidate how civil society organisations can provide important spaces to link children with South Africa's democratic process and promote engaged citizenship. Constructions of the girl child as a citizen are then explored to illustrate the central linkages among gender, democratic rights and civil society leadership.

This chapter emerges from our own direct experience with the Children Participating in Governance project. Our methodology includes participant observations of workshops held throughout the project and an analysis of the data acquired through the written narratives of girl participants. Throughout this chapter, we draw on the direct experiences of a small subset of girls involved in the project to expound on these connections and offer perspectives from the voices of girls whose everyday life experiences are continually shaped by South Africa's ongoing transition to democracy.[1]

Children Participating in Governance project

IDASA assumes a central role as a civil society organisation committed to monitoring the progress of democratisation and the provision and protection of social rights in the country. IDASA promotes democracy by building institutional capacity, advocating for social justice and facilitating active citizenship in a number of contexts. The CBU is a unit of IDASA that focuses on advocating for public budgets which promote and protect the rights of children. As one of the CBU's initiatives, the Children Participating in Governance project envisaged a representative group of children that would participate in governance by monitoring budgets for the realisation of their rights in urban and rural contexts on a local government level. The project objectives were:

- to create opportunities for children in South Africa to monitor government budgets;
- to improve children's participation in budget processes and facilitate children's research and monitoring of budgets and rights realisation that ultimately informs the shaping of policy; and
- to contribute to the alignment of government budgeting to rights realisation.

In order to implement this initiative, the CBU partnered with four children's organisations that intended to increase awareness of the central link between resources and rights realisation. The CBU strategically partnered with organisations that would be better positioned to develop the life skills necessary for the empowerment of teenage participants and to facilitate the full implementation of this project. These partner organisations included the Youth Development Programme (YDP) of the city of Cape Town; the national Disabled Children's Action Group (DICAG); It's Your Move, a subsidiary of Molo Songololo (based in Cape Town); and Life Hunters, operating under the auspices of Practical Ministries in Port Shepstone, KwaZulu-Natal province. The YDP, It's Your Move and DICAG (children selected from Western Cape and Gauteng provinces) are proxies for children in the urban areas. Representatives from DICAG (Mpumalanga province) and the Life Hunters representatives living in rural Port Shepstone are proxies for children in rural areas. The central roles of each of the partner organisations are described as follows:

- The city of Cape Town's Junior City Council (JCC) was established during the apartheid era with representatives from white schools only. In the post-apartheid context, the JCC now consists of delegates from across the city. Due to perceptions that the JCC is not fully representative of youth from all socio-economic backgrounds, a new initiative within the city of Cape Town began in 2004: the High Schools Capacity Building project. The YDP comprises delegates from both these organisations. The YDP was established by the local municipality to facilitate the acquisition of leadership skills among school-going youth.
- It's Your Move is an active child rights group under the auspices of Molo Songololo, a well-established child rights organisation in South Africa renowned for its work on child trafficking. It's Your Move works with young people at the local level across South Africa and develops national campaigns that aim to protect, promote and fulfil children's rights.
- DICAG was established in 1993 by the parents of disabled children with the goal of empowering parents to educate their children in an inclusive environment. DICAG is an advocacy organisation that helps to raise the level of awareness of disability by challenging stereotypes and perceptions of people with disabilities in South Africa.

- Life Hunters is supported by Practical Ministries, a development organisation focusing on the needs of those living in the rural areas on the South Coast of KwaZulu-Natal. Practical Ministries provided impetus for the establishment of Life Hunters, a life-skills initiative for children.

For this project these organisations partnered with the CBU facilitation team made up of Shaamela Cassiem and Christina Nomdo (chapter authors), with logistical support provided by Faldielah Khan. A reference group comprising two experienced child-participation experts as well as elected leaders of the children's groups guided the CBU in this process. The Children Participating in Governance project operated on a peer-facilitation model where leaders relay training to their constituency groups.

The configuration of these organisational partnerships, as well the overall implementation of the project, models the role of civil society organisations in building democracy 'from the ground up'. In particular, these organisations aligned with the intent to protect one of the most vulnerable sectors of South Africa's population. In line with the participatory democratic ideals of South Africa's democracy, this project is premised on conceptions of children having the ability and willingness to be active citizens.

Active citizens: children as social agents

The contemporary sociology of childhood's construction of children as social actors with agency and varying degrees of competence opens up possibilities for the recognition of children as active citizens in a way that a construction of them as passive objects of adult policies and practices did not. (Lister 2007, 697)

A contextual prerequisite exists in order to include children as agents in public political discourse. Meaningful participatory citizenship requires a process of 'active engagement in nurturing voice, building critical consciousness, advocating for the inclusion of women, children, illiterate, poor and excluded people, levering open chinks to widen spaces for involvement in decision-making, and building the political capabilities for democratic engagement' (Cornwall 2002, 28). For South Africa, the levels of 'political capabilities for democratic engagement' span civil society and government. Our young democracy that is challenged by the need for skills development for

government officials is at the same time strengthened by a rights-centred Constitution and a civil society with a history located in advocacy for social justice and youth activism. This sets the stage (and expectation) for the central role of civil society in public political discourse and the involvement of wide sectors of the population in the ongoing creation of a human-rights-focused democracy. We suggest that this expanded notion of citizenship stems from the emphasis on human rights within South Africa's emerging nationhood. While the notion of children's status as agents in political processes is debated among scholars and activists, our position stems from a guiding assumption that children play an active role in reconstituting the 'new South Africa'. In this particular context, with its emphasis on the continual building of processes and structures that assure the continuation of the ideals of democracy central to the 1994 transitional period, children play an even more central role as political and social agents in South Africa. This ideological stance is in line with the guiding organisational assumptions that governed this research project.

In the Children Participating in Governance project, the CBU operated from the orientation that active citizenship could be fostered among children by providing a structured skills-development process that builds knowledge and experiential opportunities for learning. This is not to suggest that all children present the same needs in terms of their preparation for active citizenship roles. Lister (2007) alludes to the fact that children are often constructed as a monolithic category, with seemingly unified needs. Such assumptions fail to recognise the complex intersections of identity that children share with adult populations in relation to race, ethnicity, gender, class and ability divides. To counter this homogeneous construction of children, during the selection of participants for this project, we considered the diversity of 'children' and paid particular attention to the needs of girls at each phase. Overall, the group participants were diverse in race, ethnicity, gender and capability; however, almost all were from low-income households.

Our work with children as social and political agents affords the opportunity to examine applied practices that illustrate how the democratic ideologies of South Africa are actively defined and applied in civil society organisations that engage this notion of expanded citizenship. In our case, we utilise a gender perspective to explore how democratic engagement through civil society shapes the protection of girl children – one of the most vulnerable sectors in South African society. Below, we discuss the framework for skills-

development training to illustrate the specific processes taken up by civil society to promote the active engagement of children in South Africa's ongoing process of democratisation.

Overview of the training programmes

The training programme for peer facilitators entailed three one-week training workshops that took place between February 2005 and February 2006. The first workshop, titled 'Linking Budgets and Rights', shared information about the progressive realisation of children's socio-economic rights entrenched in the South African Constitution, the process for the division of revenue and the competencies of the various levels of government. In this workshop, the peer facilitators were also introduced to facilitation and gender-analysis skills.

The second workshop, 'Budget Analysis as a Monitoring Tool', provided information about budget-analysis tools, including gender-responsive budgeting. During this workshop the peer facilitators had an opportunity to discuss governance issues with one of the tribal chiefs (who partner with elected representatives to ensure effective governance at the local level) and to visit community development projects to analyse their budgets and financial management.

The final workshop, 'Developing a Strategic Budget Advocacy Campaign', shared advocacy strategies and strategic planning techniques, which delineated a few preliminary steps in initiating local advocacy campaigns. This workshop was planned to coincide with the 2006 budget speech and civil society advocacy initiatives. At this workshop participants were provided with the opportunity to watch films about anti-apartheid advocacy, participate in a press conference, hand over a petition for the extension of the Child Support Grant (to children 14 to 18 years old) to officials at parliament, take a tour of parliament and visit Robben Island (where political prisoners were held under apartheid). Some workshop participants had the opportunity to observe the budget speech being given in parliament (others watched on television), and two children from the project asked the Minister of Finance questions on live national television. All the workshop participants attended the meeting of the Joint Monitoring Committee on Finance, where they posed further questions to the minister of finance. This workshop succeeded in providing children with direct exposure to the central processes of governance surrounding civil society's participation in policy making and collective action.

A delegation of five peer facilitators also participated in a learning exchange by travelling to the CEDECA Ceara project in Brazil in December 2005. CEDECA Ceara is a child rights organisation that monitors government budgets at local government level to ensure the realisation of children's rights. In addition, the organisation gives effect to the right to child participation by involving children in the monitoring of government budgets. The Brazilian child budget advocacy network, Rede OPA, demonstrated its advocacy strategies and arranged for South African delegates to meet with government officials, who explained their processes for participation. The two groups also shared information about the participation of children in all spheres of society (for example, home and school), and exchanged and evaluated the skills-development methodologies of each project. This international experience provided a valuable opportunity to promote cross-cultural aware-ness and understanding by building linkages among youth agents within both Brazil and South Africa. Participants left this exchange with a much greater understanding of their own processes of democratic governance, as well as the foundation to understand youth activism from a global comparative perspective.

One outcome of the Children Participating in Governance programme was that the participant peer facilitators engaged actively with the programme and, as their knowledge and skills grew, they became more confident about their ability to lobby local government officials. Our hope is that this experience will form the basis from which they will interact with their local government officials as they develop into adulthood, ensuring that the rights of children are realised by monitoring the allocation and spending of public resources. This self-advocacy for appropriate expenditure of public resources for children's rights contributes to participants' growth as 'active citizens'. In the following section, we elaborate on the impact of these developmental initiatives by presenting and analysing the narratives of some of the girl participants in this project.

Girls' perceptions of participation and citizenship

In this section, we explore the issues that emerged from the journals and articles girl participants have written about the project. These documents provide important insights into girls' experiences of the project through their reflections on participation and citizenship in the milieu of their broader social

realities. Although their journals rarely alluded directly to these broader realities, our engagement with the girls over a protracted period gave us insight into the gendered nature of their lived experiences. Thus, we will incorporate our own reflections on the girls' written narratives to add depth to the analysis of the data through use of a methodological form that complements the context of our participant observation research and our relationship to the participants in this project.

First, we explore the context of girls' participation in organisations through their reflection on the circumstances in which they live, their families and their communities and the ways in which these factors have influenced whether and how they became involved in organisations. These insights facilitate an understanding of barriers to participation as well as the positive effect of involvement on personal development. Second, because the project's uniqueness was enhanced by the diversity of the participants, we explore the narratives of children who live in rural and urban areas from four provinces in the country, participants who identify with an array of socio-economic backgrounds (related to experiences of apartheid race labels)[2] and children with disabilities working together with mainstream children. Examining the ways in which girl participants grappled with the challenges they faced – especially when it came to including children with disabilities – provides insight into prejudices and the subsequent reorientation of the attitudes they project. Third, we discuss our experiences with the girls in their roles as facilitators and leaders. With an equitable distribution of girls and boys in the peer-facilitation groups, our analysis attempts to ascertain how the girls experienced leadership within this project. Finally, we consider how girls' aspirations for the future are significant to understanding how the project fits into their strategic life goals. In addition, we explore how the project's peer facilitation and model of children as socio-political agents and decision makers provided various opportunities for empowerment, which girl participants became very aware of as the project progressed.

Factors that facilitate or inhibit participation
In building active citizens, it is necessary to be cognisant of the contexts within which the girl child participates. Cornwall (2002) cautions that 'spaces in which citizens are invited to participate, as well as those they create for themselves, are never neutral. To make sense of participation in any given

space, then, we need also to make sense of the power relations that permeate and produce these and other spaces' (7). Contrasting the participant experiences of two girls of similar age who live two totally different realities provides an opportunity to analyse the contextual factors that determine or inhibit the access of girls to projects intended to create conditions of empowerment. The stories of Zubeida[3] and Khanya are used to illustrate how their communities and families impacted their involvement in organisations that complement their aspirations to change their own lives or those around them.

Zubeida is a 16-year-old, completing her penultimate year of secondary education during 2005 and living in Heideveld,[4] a township outside the city of Cape Town. Her geographic location is characterised by poverty and crises of identity evident in the high levels of drug abuse and gang involvement among the youth in her community. In these residential areas, clear socio-economic distinctions construct divisions between residents able to own their free-standing brick homes and those living in the blocks of flats leased from local government. Zubeida has a great empathy for residents living in the flats, even though she herself lives in a house. She explains passionately:

> I ... started making friends in the flats, where I would experience first-hand the poverty most of the people in the flats put up with ... In the apartheid era not only the black people[5] suffered! Coloureds are [marginalised] and seem as if they do not exist, they too are jobless, they may not live in shacks but they live in two-bedroomed flats, which accommodate more than one family. (Zubeida, 17 June 2005)

Zubeida is clearly distressed by the difficult circumstances of her neighbours and feels that she has a responsibility to help them. She would like to improve the lives of others by being a positive role model to her peers through her involvement with children's organisations.

> I am a step closer to bettering my life and those of my people. I realised that most of the children here do not know their basic rights and feel as if they belong in the gutters. One or two make it out of here, but I need to find a way to show them a better way out rather than drugs and gangsterism ... I find myself visioning a way out for us, my voice being heard in government

... I am just a person that always finds a way to stand up for the rights of those who are being overlooked. (Zubeida, 17 June 2005)

Her mother and schoolteacher are both very supportive of Zubeida's involvement in children's organisations. However, Zubeida herself is mired in a crisis of identity that relates to her sexual orientation, family dynamics and the ever-pervasive drugs which are so integral to the socialisation of youth in her area.

In contrast, Khanya's family and cultural practices played a significant role in delaying her involvement in a formalised children's group. Khanya is a 17-year-old Zulu-speaking girl, completing her final year of secondary education in 2005 and living in the rural African township of Gamalakhe (on the South Coast of KwaZulu-Natal, about two hours' drive from the provincial capital, Durban). She lives with her father, mother, siblings, cousins, aunts and grandmother in a house that her father built. They have electricity in the house, but also use paraffin stoves for cooking. Water is accessible only from a tap outside the house. Khanya is the eldest daughter in the family, with an aunt and a cousin who are near her age. In the household, she is responsible for cooking and cleaning as well as participating in the care of her younger siblings. As is typical with gendered dimensions of household labour, her brothers are responsible for gardening, which takes place in the exterior, whereas female labour is connected to interior family spaces. Similarly, if the family had cows, tending the cattle would be the primary responsibility of the boys.

Khanya learned about the Life Hunters group in February 2001; however, she was permitted to join it only in November 2003. She remembers how difficult it was to convince her family that she wished to belong to a children's group. She sadly recalls:

My parents did not want me to join the group at first because of the fact that there are both boys and girls. Culturally girls do their chores at home [and do] not mix with boys. My parents later saw that I wanted so bad[ly] to join this group. (Khanya, 23 August 2005)

Gender roles are embedded in everyday social life. According to Merrifield (2001), socialisation is the central process whereby 'both mainstream and

(alternative) political cultures are passed on from generation to generation' (9). As central institutions, family and community have a great influence on socialisation processes that foster notions of power, roles and responsibilities. Of particular importance to the gendered component of socialisation, these institutions also instil central values and norms about the individual's 'place' in social systems. Asymmetrical power relations between men and women are, therefore, socialisation models for boys and girls. As a result, these generationally reproduced constructions of gender more often than not distinctly limit the public/visible roles of the girl child. The internalisation of these marginalised roles affects the extent to which women participate in public spaces. Thus, political spaces also become centrally constructed by gender inequalities. This poses serious challenges to generations engaging with the principles of democracy for the first time – particularly for girls' involvement in political spaces. The children's workshops, therefore, focused on debunking socially accepted gender inequalities and demonstrating the importance of women's and girls' engagement in civil society organisations.

It would seem as if every new generation must be won over by the promises of democracy. In South Africa, we can classify a first generation of democratic citizens as black persons who cast their first vote in 1994. However, casting a vote for a democratic dispensation implies subsequent development of democratic principles. However, these principles, such as 'freedom of expression' or 'citizen participation' or 'freedom of movement', sometimes go against the grain of alternative political cultures. The tension between alternative political cultures and dominant political culture can be traced in the history of women's political participation (Merrifield 2001).

A history of discrimination as well as a perceived lack of competence often leads to the exclusion of certain groups of people – namely, women – from democratic processes and institutions. Their exclusion is couched in the perception of incompetence in women's ability to act appropriately as citizens. For the girl child this is a double-edged sword. Girls are perceived to hold a certain place in society (that is, outside public political space) and children are perceived to have no opinions of value (that is, not worthy of interacting with public political space). Given these severe obstacles, we assert that any democratic reform must take cognisance of multiple intersections of identity stemming from cultural, historical and political contexts that continue to shape the experiences of the girl child.

Central to the South African context of identity politics and socio-political change, data from this research also indicate that 'culture' need not always be in conflict with the democratic process. In Khanya's experience, the group participation process actually enhanced her understanding of the complete context of her culture, rather than eroding it, as her parents may have feared. Participation in this political process contributed to her personal development, as Khanya related in a manner that illustrated an enhanced level of self-confidence:

> Being part of [the] group grows on[e] culturally, spiritually, emotionally and even your mind. Because of getting to learn about one's culture, one's emotional reactions and a lot more makes you think widely and wisely. (Khanya, 23 August 2005)

Khanya was, in fact, one of the most fierce defenders and monitors of cultural practices, especially expectations of girls. After completion of her secondary education, at the age of 18, she moved to the city to work and live with friends.

In other instances, rather than being restrained by family norms that limit girls' participation outside of the private sphere, girls conceptualised their roles in public processes as holding the potential to positively impact their communities. Zubeida's empathy for members of her community living in impoverished conditions provides insight into the reason why she chose to belong to a children's organisation. Her motivation for being involved in the project is based on her desire to be a role model for her peers in her community by holding a role in a civil society organisation. As we see in these contrasting cases of Zubeida and Khanya, supporting and inhibiting factors for girls are predicated on their role within families and communities, which ultimately affects their involvement in civil society organisations.

Learning about rights, governance, budgets and advocacy
The CBU has facilitated workshops on budget monitoring from a rights approach for several years. The Children Participating in Governance project, however, launched the first initiative that would build the skills of children to act as budget monitors. As project coordinators, we remained fairly certain that this goal was achievable, as it had been accomplished in a project in

Brazil. The training programme concentrated on four key topics: (1) justiciable socio-economic rights of children entrenched in the South African Constitution; (2) structures, levels and functions of government; (3) budget concepts, processes and analysis tools; and (4) strategic planning and advocacy processes. The recollections of the children provide a broad overview of what interested them about these topics as well as insights into their development process as active citizens. Audrey, Lorraine and Petunia commented about the impact of learning about rights:

> When we started with the rights and the differences between various rights, there was more participation because people seemed to know their rights well. (Audrey, 11 August 2005)

> We spoke about different kinds of rights and how they affect us personally. (Lorraine, 10 July 2005)

> We learnt a lot about steps we should take in order for our rights and needs to be met. (Petunia, 10 July 2005)

Rights discussions were familiar terrain for many participants; however, none had ever before focused on justiciable socio-economic rights, which are the cornerstone for improving conditions and experiences of poverty – especially for children, who have specific protections within the South African Bill of Rights.

Participants' interest peaked during discussions of the operations of government. Even though this topic forms part of the school curriculum in South Africa, we suspect the children were interested to see if we could transform 'dry' classroom lessons into fascinating avenues of discovery. Their enthusiasm for learning was remarkable and allowed for an open, creative process among leaders and participants.

> We went over the three levels of government which is national, provincial and local government. (Audrey, 11 August 2005)

> I jumped at the opportunity to learn about the systems that run our country. (Lorraine, 10 July 2005)

. . . I didn't expect to learn so much about how government operates. (Petunia, 10 July 2005)

These training spaces also provided opportunities for participants to engage with local leaders, thereby broadening their perception of South Africa's government process. During our workshop in KwaZulu-Natal, for example, the CBU facilitators were able to arrange for the peer facilitators to interact with the traditional authorities who work with municipal structures to operationalise governance. Petunia, a 16-year-old Zulu-speaking girl who lives in an area presided over by the chief we visited, had never dreamt of having the opportunity to engage with this leadership figure about his role in democratic South Africa:

> The Amakhosi [chiefs] told us that they have a very good relationship with government and even [though] the country has [modernised], they still practise the culture and tradition. (Petunia, 10 July 2005)

Petunia expressed that meeting the chief personally increased her understanding and appreciation for her rich cultural heritage. Many of the children who lived in the chief's area reported that they had felt too intimidated to engage with the chief before and also did not know that he would be so welcoming of children. Personal engagements with local councillors and budget officials (during the same workshop) not only injected a dose of reality into the programme, but also provided advocacy opportunities that most children used to their advantage.

Even the girls whose chief we visited were not shy to voice their opinions and to ask questions of this male authority figure. In fact, at the very start of the project, the level of confidence the girls from KwaZulu-Natal displayed impressed us as facilitators. At times, this confidence played out with the girl participants challenging their boy counterparts throughout the sessions. For example, during the course of their constituency workshops, the girls became impatient with the boys and often assumed responsibility for activities delegated to the boys. These acts demonstrated empowerment that no doubt resulted partly from the girls' continuous engagement with the Practical Ministries' Life Hunters project. Furthermore, women's leadership as facilitators provides alternative frameworks to traditional gender roles in ways that

socialise girls to access and develop their own leadership capacity. Even though the girls demonstrated enormous capacity in this regard, their development as leaders did not exhibit a universal acceptance of their acquired power and authority. Reflecting on the reversal of gender roles in terms of their dismissive views of the boys' capacities during workshops, the girls reverted to blaming themselves and each other for not allowing the boys to fulfil their respons-ibilities. This caretaking approach represented the power of embedded gender norms and the ongoing need to develop girls' internal sense of their potential as powerful agents of change.

Another area of empowerment centred on girls' skills development in finance and budgeting. All participants were initially most daunted by the prospect of learning about government budgets in the workshops. Many of the girls in the group, however, had not been given the responsibility of handling their own money. As a result, their budget literacy remained very low. This was particularly evident when the girls who formed part of the delegation to Brazil were expected to manage part of their per diem by themselves. Zettie became particularly confused and overwhelmed by this experience, leading to her becoming visibly anxious and stating, 'I am still young in terms of handling money and easily forget . . . the simple truth is that I'm too scared to handle my own money' (16 December 2005). This perceived lack of capacity for budgeting prevailed for Zettie despite the fact that the peer facilitators had been exposed to budgeting from the first workshop in February 2005. The notion of handling real money in a different currency and foreign context posed a serious challenge to Zettie in her process of skills development.

Reflecting on Zettie's experience in Brazil and her comment about her abilities according to her age, we need to consider the kind of responsibilities that are expected from children in the process of developing their capacities of 'active citizenship'. As we see in this case, the application of knowledge gained in the workshop presented one of the most serious challenges to children in our project. In Zettie's home situation, for example, she was not expected to control her own money; this is the responsibility of the adults around her and she is content with this. In fact, Zettie expressed her opinion by stating, 'I am still young' as if she were saying, 'My time will come'. On the one hand, Zettie is involved in youth forums that prepare her for participation in public policy discourse. On the other hand, Zettie was not

ready to take on so-called adult responsibilities such as handling money. This wavering position around responsibility reflects one of the core characteristics of the conception of children as active agents in civil society. Lister (2007) states clearly that there is no argument that 'children should exercise the same responsibilities as adults'; however, 'the responsibilities that they do exercise should be recognised' (716). Drawing from this perspective, our work in training children to take on active roles in civil society underscores the importance of valuing and actively recognising children's willingness to participate in public discourse while at the same time recognising their right to be children.

As children are brought into the political process, these dual roles as developing adults must be taken into consideration consistently. In our own experience with the budgeting workshops, we witnessed moments in which participants exhibited simultaneously their roles as maturing young adults and developing children. For example, many of the girls reported that the budget-analysis training was very challenging. Khanya recalls her bewilderment at the '[m]any different complicated formulas that I sometimes confused' (17 February 2006). However, after this first workshop, Audrey was amazed at how much knowledge she had acquired: 'I learnt so much about government and how it spends its money' (11 August 2005). She even developed the capacity to interpret the national budget speech, screened every year on television. Her sense of accomplishment is evident:

> When we had returned from the workshop, we were back just in time for the national budget speech. We were requested by the [CBU] facilitator to watch the budget speech, and since we now understood everything, it was easy for us to just sit down and listen, but this time we understood what was being said. (Audrey, 11 August 2005)

By the end of the first peer-facilitators' workshop, participants expressed that their abilities in relation to both personal and governmental budgeting exceeded their expectations. Petunia noted confidently, 'When I went there, I didn't expect to learn so much about . . . how the country's budget links with children's rights' (10 July 2005). As this case illustrates, building children's capacity for active citizenship necessitates the ability to focus support in areas which present as exceptionally confusing or overwhelming, in order to allow participants to access their developing critical consciousness as engaged actors in civil society.

For girls, this process is even more critical because of the added barriers they face as a result of socially constructed gender roles, coupled with the limitations they often experience in their own environments. Acquiring budgetary skills holds the potential to empower girls with heightened capacities to manage their financial resources and participate in public processes that inform governmental spending. Furthermore, the empowerment of girls in this sphere debunks myths about girls' capacity in math and economics. To this end, the workshops linked the acquisition of personal skills with girls' long-term potential to contribute in public democratic spaces.

Assessing the impact of this portion of the training on rights, governance, budgeting and advocacy, girl participants reported that they found some of the most empowering experiences in the opportunities to engage with traditional authorities, as well as local and national government officials and politicians. Increasing budget literacy, enhancing knowledge of children's socio-economic rights entrenched in the Constitution and learning about the power of advocacy denoted some of the most important skills acquired by girls. As our analysis of the overall outcomes of girls' participation in workshops and training sessions makes clear, the enhanced confidence, awareness and political understanding acquired among participants powerfully positions girls to take part in democratic processes throughout their future. The foundation of preparation for active citizenship instilled through the training promotes participants' increased likelihood to serve as long-term leaders in civil society and government. Ideally, the roles participants eventually assume will contribute to South Africa's long-term development and encourage greater access to human rights in the ongoing process of democratisation. The following participants' reflections on key experiences capture the enhanced power bases acquired by girls in this project:

> I know how to stand up for my rights and that each right comes with a responsibility. (Petunia, 17 February 2006)

> Getting to know how to behave around politicians or any other superiors in my country . . . [She reported this as a significant feature of her personal growth during the project.] (Rene, 17 February 2006)

> I learnt that children do have a voice and that there are people willing to listen to us . . . I learnt to use my power I have as a child and I've become confident around a lot of people. (Lorraine, 17 February 2006)

... [I]t only developed my self-esteem and it motivated me to have the courage to get more involved in my community. (Fatima, 17 February 2006)

All in all this was a great experience and I would say 'we are really doing it ourselves for ourselves!' (Khanya, 17 February 2006)

Our assessment of the overall impact of these reflections on empowerment must be placed within the context of the serious barriers girls are likely to face when they return to their immediate families and communities, which often reflect the prevailing patriarchal social norms that continue to marginalise women and girls. For example, their confidence acquired in the training workshops along with their engagement with government when mediated by an external development organisation may differ significantly when girls return to their local context, where they may be expected to conform to cultural norms relating to the position of girl children in their communities. In addition, their local organisations will need to be very supportive of their initiative in order to reinforce lessons learnt and give them opportunities to practise new knowledge and skills. As participants re-enter their daily life following the workshops, they face a critical juncture in terms of their ability to retain skills. For example, knowledge of budgeting and budget analysis may be forgotten if it is not reinforced by continual practice of engagement with economics on a personal and public level. Therefore, we assert that civil society organisations must provide mechanisms that assure the ongoing development of children's capacity as political agents. To counteract the dominant gendered social norms, this long-term work is particularly critical for girls. Access to social spaces that encourage the development of girls' leadership capacity and continue the acquisition of knowledge and skills is therefore a critical factor in the long-term success of participants, and in their eventual capacity to hold positions of influence within civil society.

Grappling with the concept of the infamous rainbow nation
A unique feature of this project was its intention to bring together children from diverse socio-economic circumstances and, even more significantly, to integrate children with disabilities into the peer-facilitation group. These training contexts created microcosms of South Africa's diversity, which afforded opportunities for children participants to engage in diverse learning communities and challenge prejudices. These skills are central to long-term

engagement with and leadership within South African society. In many cases, learning to overcome past socialisation around difference became one of the most powerful outcomes of this initiative. Lorraine, a boisterous girl selected especially for her ability to fit into any group – and, incidentally, the only white girl in the entire project of approximately 80 children – remembers how surprised she was to meet her fellow participants from diverse socio-economic backgrounds. She recalled vividly, 'The first time I realised that we were all from different parts of South Africa was when we met up with some of the other participants at the Johannesburg airport [for the first peer-facilitators workshop]' (10 July 2005). However, after a year in the project, she commented, 'My biggest challenge . . . was dealing with racial prejudice. It was a little sad that I struggled so hard to fit in' (25 February 2006). On another occasion she intimated despairingly, 'Even though everyone wanted me to learn their cultures, nobody was interested in learning mine' (17 February 2006). As this reflection illustrates, children's workshops tapped into the core realities that South Africa faces in grappling with its 'rainbow nation' ideology.

Besides living in different provinces and having divergent cultures, the group members also needed to find a common language for communication. Zettie noted sagely: '. . . for almost all of us that were at the workshop, English was not our first language or our mother tongue and we had to [speak] English nearly all the time because it was the only way we could communicate' (10 July 2005). Later, however, language choice became an important indicator of the cohesiveness of the group. Zettie commented that although the workshops used a common language, the various groups continued to rely on their own languages after each workshop's completion as a way to exclude others. The CBU facilitators recognised that in the context of a nation with eleven official languages, language politics can have a significant impact in moulding or destroying a group. When tensions arose among members of the group, their first reaction was to revert to their home languages and retreat to their organisational groups. As a result, language became both a practical and symbolic aspect of dealing with difference in efforts to support increasing understanding and interaction skills that promoted the value of diversity among participants.

For the mainstream children, working with children with disabilities made as much of an impact on them as did the content of the workshops. Zettie,

Lorraine, Rene and Khanya remembered how this direct engagement changed their attitudes about children with disabilities. Lorraine was most impressed by the deaf participants, and felt enthusiastic about learning a new language:

> I learnt a lot about myself and how I react to others. I honestly felt ashamed of how I used to think. Because I had never been exposed to so many different people before, I didn't know exactly how to react, or understand children with disabilities. I am learning now, and trying to find someone in Cape Town to teach me sign language. (Lorraine, 23 August 2005)

In addition to two deaf peer facilitators, the initial peer-facilitation group also included three participants confined to wheelchairs, because of physical disabilities or cerebral palsy. Mainstream children had to find ways to 'reasonably accommodate' their peers who required assistive devices for physical mobility.

> . . . [T]he thing [that] surprised [me] was that the 'disabled' kids were there too because I never thought that there will be 'disabled' kids and what we were told there by the facilitators was that we [were] to include everybody in anything that we do, assist the 'disabled' kids as much as they will tell us . . . I have learnt a lot about myself in this project, even about myself and how I deal with diversity. (Zettie, 10 July 2005)

> I was very excited as I learnt that sign language for the first time. In four days I also learnt a lot in the workshop and outside where we were socialising – about disabled people as I have never spent a lot of time like that with disabled children. I realised that we are all the same no matter if you are in a wheelchair or you use both legs. This training helped me mentally and emotionally, as I used to feel pity for a disabled person and I know that we have lots in common. I shouldn't pity as they need no pity, but fair treatment. (Khanya, 23 August 2005)

> I never worked with disabled people in my life and I always thought that they can't think like we think . . . Now I work with them and we are in one big project. (Rene, 17 February 2006)

It was remarkable to witness attitudes and prejudices of mainstream children towards children with disabilities, particularly given the associated meanings of such dominant perceptions in the context of South Africa's broader commitment to diversity. Children's biases are notably comparable with the attitudes and prejudices that adults have towards children, and with the attitudes of men towards women, such as failing to recognise the ability of the 'other' to participate in civil society and governance. Lister (2007) compares children's participation and citizenship with gender and citizenship. She states that 'lack of recognition implies exclusion and marginalisation from "full participation" in the community' (709). Similar reasons are given for excluding children with disabilities from mainstream activities, women from their full capacity for leadership, and children from adult contexts: their lack of competence, their inability to be rational and their dependency (710). Yet it is questionable whether all adults have the competence to make rational decisions.

During our project, we witnessed how mainstream children positively changed their attitude towards the children with disabilities. The authors intentionally provided situations and experiences that would allow mainstream children to reflect on their own attitudes and prejudices towards children with disabilities. The children had to overcome their prejudices and find ways to interact with everyone in the peer-facilitation group. This experience not only affected their attitudes, but many became advocates for the inclusion of children with disabilities among their peers.

In South Africa, many aggressive policies exist to integrate children with disabilities into the mainstream. One example is the inclusive education white paper published in 2001, which is currently being piloted for implementation (Philpott 2004, 118). An integrated approach to policy development and planning is currently being called for, which dedicates sufficient human and financial resources to the realisation of the rights of children with disabilities. The prevalence of HIV/AIDS and the incidence of poverty place added burdens on an already vulnerable sector of society. Therefore, the participation of children is predicated on the extent to which disabling barriers in their social and physical environment can be removed (Philpott 2004).

The facilitation of workshops represented microcosms of society and prepared participants for the skills needed to eventually lead South Africa in its promotion of diversity as a central component of democracy. Participants'

engagement with children from different backgrounds and places and with different abilities made for significant experiential learning. As South Africa is a very diverse society, projects that seek to foster participation and active citizenship will need to factor in identity issues such as culture and language. We learnt that in order to neutralise these issues and prevent the politics of these factors from sabotaging the primary intention of a project, they must be addressed from the outset. This process heightens our understanding of difference at the vector of multiple identity factors, including gender, race, class, language and ability. Working from this vantage point promotes a more nuanced understanding of the overarching context of South African society, and at the same time provides skills for youth as they prepare for active roles as leaders within civil society and government. This conceptual framework played a particularly important role in the development of girls' awareness of their own location within society and their ability to overcome structural barriers to leadership participation.

Leaders empowering others

In the peer-facilitators group, girl participants especially took their role as leaders or representatives very seriously. This was evident throughout the project, but more notably when two girls were selected to represent the project in Brazil as part of a learning exchange. Zettie and Nandie were very mindful that they were acting as the ambassadors of the project:

> The selection . . . I believe it was quite a difficult decision to make, but when I realised how selectively and importantly we were chosen I started to have my personal checkup to see why I've been chosen. (Nandie, 16 December 2005)

> The only challenge for me was for the whole trip that I have to make everybody proud of me and make them feel I have represented them in a responsible way, but I too have to feel it in my heart that I have tried my best, which may not be good enough. (Zettie, 16 December 2005)

Both girls displayed significant leadership skills in order to be chosen to be part of the delegation. They were selected in a two-phase process that firstly included the peer facilitators themselves, with a final decision made by the

reference group. Even in Brazil, boys in the delegation, as well as members of the host organisation, commended the girls for the skills and capacities they demonstrated throughout the experience. These skills developed gradually from the first workshop, where girls were trained to be facilitators. There is no doubt, however, that a significant contributing factor to the long-term success of these girls will be their innate determination to continue their development as active citizens.

Learning facilitation skills at the first peer workshop enabled the peer facilitators to arrange and present confidently at their constituency workshops. The inclusion of girls in this peer-facilitation role was part of the transformation process central to girls increasingly assuming leadership roles in development initiatives. Khanya shared her opinion of the benefit of being a facilitator, commenting introspectively, 'The project means a lot to me as a peer facilitator as I will learn to facilitate under any circumstances. And it also teaches [me] to have self-respect so that I can respect others' (23 August 2005). Facilitation was a very challenging and nerve-wracking experience for some. Khanya remembered disappointedly: 'I did facilitation, I tried my best but [only a] few "participants" participated fully, which disturbed me' (23 August 2005). The amount of work required to infuse energy into the group surprised facilitors. Audrey, however, wisely judged their performance on the impact of their facilitation on their audience. She was pleased to note that 'we work well with the children and they had a good understanding of what we were trying to bring over' (Audrey, 11 August 2005).

In addition to assuming leadership positions as peer facilitators, one peer facilitator from each group was elected to represent their organisation in the reference group, which provided guidance about the strategic direction of the project. Two boys and two girls were elected to fulfil this leadership role, their first engagement as decision makers with equal power in a forum consisting of adults and children. Khanya was surprised that everyone recognised each other's value: 'We attended a meeting at IDASA offices where I met adults from different organisations who were full of great ideas and also listened to our ideas' (23 August 2005). The child-participation experts in the reference group especially encouraged the children's input. It was also necessary to solicit the children's opinions before those of the adults in order to get the children to realise the value of their opinions. Girl participants assumed leadership positions as peer facilitators, and some also acted as the

representatives who served on the reference group for the project, both nationally and in the international learning exchange. As an important indicator of the power of these initiatives to break down asymmetrical gender relations, the capacity of the girls in the group to assume leadership positions was never questioned by the boys in the group. However, this reticence could be affected by the all-female adult leadership of the children's group, as well as the all-female facilitation team. Nevertheless, boys' attitudes towards girls' leadership illustrates how the microcosmic social spaces created throughout such educational experiences provide critical opportunities to transcend inequitable gender roles. Our intent in the design and long-term impact of this work is to foster the transference of these attitudes to participants' continued engagement in civil society. As the data illustrate, involvement in this project positively shaped the girls' aspirations for the future as a central aspect of their experience.

When I grow up I want to be . . .
In order to carry on the gender victories of women's leadership in South Africa, girl graduates of this training must continue their involvement at the public level to practise and enhance the foundation of skills and perspectives acquired in these children's workshops. Varying motivations to join organisations and projects surfaced for girls in this project. As they were encouraged to envision their roles as future leaders, however, they sometimes had to overcome challenges that threatened their ability to participate in governance initiatives. Girls consistently recognised the value of belonging to their organisations and participating in this project. Many stated that their involvement broadened their perspectives and enabled them to develop enough confidence to realise the strategic value of their participation in governance initiatives for their life goals. As a result, many girl participants now envisage a future in politics, community development or civic education. Lorraine and Zettie dreamed of a career in service to their society:

> . . . I hope to move into politics one day. I jumped at the opportunity to learn about the systems that run our country. It was important for me as youth to see where we as youth fit into the system. I also think it's the responsibility of the youth though, to actively get involved in the governance of our country. By learning today, we can acquire the skills to govern a successful nation, when it is handed down to our generation. (Lorraine, 10 July 2005)

Personally, this workshop means a lot to me because maybe I will end up working for government and it has clarified lots of things for me. (Zettie, 10 July 2005)

The project impressed the young people primarily because of the impact it had on their own development and the doors it opened in government.

We are being trained as tomorrow's leaders, and with the skills and knowledge we learn here, we will make our difference in this world. (Lorraine, 10 July 2005)

Some of our municipal officials are interested [in] this project. This will surely break the concrete I assumed was between children and government. (Khanya, 23 August 2005)

Girl participants were very confident about the possibility of careers within the government of the country, even though they would have to overcome several cultural and economic barriers to fulfilling their aspirations. The project contributed to their personal development and enhanced their capacities to become active citizens. Those who continued to participate in the project increased their skills and knowledge, while developing the capacity to confront deeply embedded gender roles that severely limit the participation of many girls in civil society organisations.

Conclusions

The Children Participating in Governance initiative utilised a rights-based framework to foster children's self-advocacy as a model to support the long-term development of South Africa's democracy. The project intended to facilitate the development of children and youth as civil society participants and advocates of active democratic citizenship. By providing direct exposure to a variety of political contexts, this project fostered the growth of children's meaningful participation in public political spaces in South Africa. As Wyness, Harrison and Buchanan state, '[O]ne of the themes running through the research on young people's political participation is the lack of real opportunity to have a say on social and political matters' (2007, 94). This initiative overcame these common barriers for youth participants by demystifying the

political process, which will ultimately allow them to confront structural barriers to civil society participation stemming from continuing inequitable power structures.

Our focus on the girl child encouraged the long-term advocacy necessary to realise the gender equality promises of South Africa's democratic ideologies. Throughout the workshops, girl children formed an integral part of three major components: (1) the peer-facilitation group that transferred information and skills to a broader constituency group; (2) a reference group that provided strategic direction to the project; and (3) an international exchange with a partner in Brazil. Extracts from the girls' journals illustrate their own perceptions of their participation in these processes, along with the overarching aspirations instilled in girls as a result of their participation.

From the exploration of factors inhibiting or facilitating the participation of girl children in development initiatives, we learnt that culture need not conflict with democratic process. However, the interpretation of gender roles within specific families or cultural groups may inhibit or facilitate participation. Cultural diversity is not the only challenge faced by girls wishing to participate as active citizens. Other identity issues, such as language and race or even disability, may prove to be barriers to full participation. The development of programmes that promote civil society participation in public political discourse must therefore take cognisance of these complex intersections of identity central to both individuals' experiences and the overarching social environments within which participants engage in their day-to-day lives.

In the context of transitional democracies, our findings underscore the need for special attention to be paid to the gender relations in society that undermine equality and limit girls' potential to contribute to civil society. By providing social spaces where traditional gender assumptions may be challenged, this participatory project demonstrated that educating young populations holds great promise in the eventual transcendence of asymmetrical power relations that severely disadvantage women and girls. In our work, the agency of girl children in their ability to deal with issues relating to power emerged as one of the most striking and hopeful observations. Although gender relations permeated all the visible and invisible, planned and unplanned activities of the three peer-facilitators' workshops, girls' interpretation of their roles and responsibilities as representatives (either as peer facilitators, group leaders or project ambassadors) relayed their determination to succeed.

Many of the girl children have also decided that they intend to take up public office or play a significant role in South African civil society. These empowered positions acquired by girls as a result of their participation in the project build the foundation for the future of women's increased engagement in civil society and public governance. At this critical juncture in South Africa's development, we assert that the ongoing empowerment of girls assures that the vision of gender equality as a central component of democracy will remain at the forefront of realising long-term social change at both the public and private levels of society. It is our hope that when participant graduates such as Khanya, Zettie, Petunia and Lorraine assume leadership roles throughout civil society, South Africa may provide an even stronger model of women's empowerment and gender equality.

Notes

1. For the purposes of this research, all participants approved the use of their narratives, reflections and journals as a source of data for this chapter. To protect the identity of our participants, we use pseudonyms for each.
2. The apartheid system classified the South African population into race groups, the primary ones being African (referring to the indigenous peoples from groups such as the Xhosa and the Zulu); coloureds (referring to those of mixed origin); Indians (referring to persons with Indian descent); and whites (referring to descendents of European settlers). These race labels were used to delineate a hierarchy of citizenship and privilege, with whites being the preferred class of citizens; Indians, coloureds and Africans being discriminated against and oppressed in varying degrees; and Africans being the worst off. Although South Africa is no longer segregated according to race labels, one of the residual effects of the apartheid system is the continued existence of racially homogeneous communities (Christopher 1994, 103–16). In this study, the demographics of the group are varied. Only one of the girl children in the peer-facilitators group of this project would have been classified white and she resides in the city of Cape Town. The rest of the group's girls are either coloured (living in Cape Town) or African (living either in Cape Town or Johannesburg or in the more rural area of Port Shepstone in the province of KwaZulu-Natal). These girl children would not normally have the opportunity to interact with girls of other race groups.
3. None of the children's real names have been used.
4. Heideveld is a residential area previously demarcated a coloured township by apartheid policies that created separate residential areas for the designated race groups.
5. Classified African by apartheid laws.

References

Christopher, A.J. 1994. *The Atlas of Apartheid*. London: Routledge; Johannesburg: Witwatersrand University Press.

Cornwall, A. 2002. 'Making Spaces, Changing Places: Situating Participation in Development'. IDS Working Paper No. 170. Brighton: Institute for Development Studies.

Lister, R. 2007. 'Why Citizenship: Where, When and How Children?' *Theoretical Inquiries in Law* 8 (2): 692–718.

Merrifield, J. 2001. 'Learning Citizenship'. IDS Working Paper No. 158. Brighton: Institute for Development Studies.

Philpott, S. 2004. 'Budgeting for Children with Disabilities in South Africa'. Cape Town: IDASA.

Wyness, M., L. Harrison and I. Buchanan, I. 2007. 'Childhood, Politics and Ambiguity: Towards an Agenda for Children's Political Inclusion'. www.soci.sagepub.com/cgi/content/abstract/ 38/1/81. (Accessed on 3 December 2007.)

Crafting Spaces for Women's Voices

The Case of Refugee Women in KwaZulu-Natal

JANINE HICKS

WHILE GREAT PROGRESS has been made in ensuring that women can stake their claim as equals in the new South African society, refugees in the country appear to have taken the place of previously disadvantaged black South Africans, in that they are treated as second-class citizens or inferiors. In the context of the post-apartheid democratic transition, the case of refugee populations illustrates a distinct marginalisation as a result of new constructions of 'others'. At times, this marginalisation comes at the hands of black South Africans, who themselves have been at the receiving end of such treatment, illustrating how asymmetrical power relations are reproduced among newly emergent groups in the post-apartheid context.

An invisible community: Refugee women in KwaZulu-Natal

In South Africa, refugees are permitted safe haven from situations of conflict in their home countries until they have been granted official refugee status, an exceptionally long-winded bureaucratic process that keeps thousands in limbo while temporary documents are processed. In 2004, the number of refugees in KwaZulu-Natal (KZN) was estimated at 14 000 people, but there are no statistics available on how many of these are women (Kanani 2004, 8). Research into the living conditions, survival strategies and acceptance of refugee women in KZN reveals that the majority live with their husbands and children in small, relatively expensive, often shared dwellings. Their average monthly income is less than R300, derived largely from car-guard work, hawking or running hair salons. Almost all reported that they are receiving no

assistance or support from the South African government or local service providers, and that they are discriminated against when trying to access public services at schools and hospitals (Kanani 2004). Their struggle to survive and support their families is 'compounded by the fact that they are dislocated from their homes and families, living in a country with a high level of xenophobia' (Kanani 2004, 1).

Refugee men and women experience great difficulty in securing the all-important asylum status that secures their right to remain in South Africa and should entitle them to constitutional and basic social rights. Yet those who are able to obtain refugee documentation report that this is not understood or accepted by a broad range of stakeholders, such as employers, immigration officials, embassies, banks and landlords. Nevertheless, without such documentation refugees cannot access basic services such as banking, education or housing (Kanani 2004, 11).

In South African society, refugees face overwhelming xenophobic attitudes and unsympathetic responses to their plight from members of local communities, who appear to lack an understanding of refugees' situation:

> In South Africa, xenophobia is one of the biggest challenges faced by refugees and asylum seekers . . . Often termed '*amakwerekwere*' (a derogatory term for black foreigners), non-citizens, especially refugees and asylum seekers, are wrongly held responsible for the hardships facing poor and disadvantaged South Africans in terms of jobs, education, health and other opportunities. (Kanani 2004, 6–7)

Kanani notes that 'language is cited as the primary cause of discrimination', with the inability to speak Zulu identified as 'a major cause of being marginalised'. Refugees have experienced an unwillingness on the part of local South Africans 'to be welcoming and willing to teach their language to these "other" people', unlike the experience of refugees in other African countries such as Malawi (Kanani 2004, 13). In South Africa, refugees encounter at the very least an unsympathetic response to their experiences and the difficulties they face. One refugee woman recounted how, on the death of her husband, she battled to secure the release of his body from the South African Police Services (SAPS). Although she was in possession of her husband's death certificate, local officers insisted on being given a copy of

her marriage certificate, and would not accept that this had been left behind in the couple's flight from their home country.

Many women were forced to cut their studies short because of situations of war in their countries. Some of these women have been refugees for more than six years and have not had the opportunity or support to further or finish their education (Kanani 2004). Bursaries for tertiary studies are limited, with a local agent for the United Nations High Commissioner for Refugees (UNHCR) offering one or two bursaries per year, and tertiary institutions restricting their bursaries to South African students only, despite their being specifically designed to support African students from disadvantaged backgrounds. Women also cite difficulties in having their home-country education certificates recognised by tertiary institutions.

In the current South African context, there is little or no welfare or social support for such vulnerable individuals, who are forced to rely on the generosity of fellow refugees who themselves are in desperate situations. In addition, only limited support is available from service providers designated to assist refugees and from religious and civil society sectors. More generally, well-meaning individuals serve as key sources of support for refugee populations as a result of the limited institutionalisation of refugee services in South Africa.

Women refugees form an especially vulnerable group because of their particular social location at the intersection of marginalised gender, race, class and citizenship positions. Conversations with refugee women reveal abusive treatment at the hands of government and health officials and landlords, which shapes their lived experience in even the most basic processes of life management and negotiation. This treatment ranges from disparaging remarks based on women's physical appearance and grooming, to rough handling during childbirth, to continuous sexual harassment and vicious repercussions for women not willing to grant sexual favours for 'special assistance'. Some women refugees are especially at risk – those who are pregnant, the chronically ill, single mothers, widows, women with disabilities and unaccompanied girls who have no means of earning an income. There are also those women who, like their South African counterparts, have to deal with the effects of domestic violence and the reality of HIV/AIDS. Unlike most South African women, however, refugee women lack a network of support from family, friends and state institutions. Kanani (2004) notes that 'women in such situations have to rely on the kindness of fellow refugees as

South African grants are not available to those who are not citizens' (19). The majority of refugee women surveyed reported that the stress of daily survival and long working hours, together with a sense of being unable to provide adequately for family needs, has a distinct negative impact on their family lives and relationships.

Against this backdrop of the day-to-day realities of refugees in South Africa, I explore in this chapter the extent to which the voices of these marginalised women find their way into South African policy and programming processes. This enquiry is rooted in the perspective and experience of refugee women in KZN, through an organised membership-based civil society body, the Union of Refugee Women (URW). The URW was established by an informal network of refugee women based in Durban to provide support to women refugees and address their social grievances. Research for this chapter is informed by my long-term work within this organisation. In particular, my findings are based on a series of discussion groups among refugee women associated with the URW and NGOs that work with refugee rights. In this context, I conducted a series of semi-structured interviews with URW leadership, refugee service providers, the Lawyers for Human Rights (LHR) Refugee Rights Project, agents of the UNHCR and the Mennonite Central Committee (MCC). I also conducted extensive semi-structured interviews with South African institutions forming part of the gender machinery in KZN, including the Commission for Gender Equality (CGE) and the Office on the Status of Women (OSW) in the office of the KZN premier. In addition, I reviewed all legislation pertaining to the status of refugees since 1994. Throughout this chapter, I draw on data from these multiple sources to locate refugees within South Africa's political transition. This broad enquiry into refugee women's participation in policy processes may be compared with the concept of inclusion of marginalised communities generally in governance – a topic that has received considerable attention in the literature.

The democratic deficit

Many authors have written about the idea of a 'democracy deficit' – the failure of established, liberal notions of representative or participatory democracy to link citizens with the institutions and processes of the state, which impacts on the quality and vibrancy of democracy and results in reduced accountability (Gaventa 2004; Luckham, Goetz and Kaldor 2000). Many democracies are

consequently characterised by a disappointing sense that free elections have done little to improve government accountability and performance. Carothers (2005) notes that typically, with growth in poverty, inequality and corruption, and as citizens become increasingly sceptical and distrustful of political parties and institutions, there is declining political participation. This widening gap between citizens and state institutions results in a 'diminished democracy' (Skocpol 2003, 11). With the focus of political parties characteristically being on electoral processes to the detriment of effective representation, links between citizens and the state remain weak or non-existent. Carothers (2005) states that the result is an underdeveloped democracy with limited representation.

Around the world, governance actors, analysts and activists are grappling with this issue and exploring how best to engage citizens in government decision-making processes. However, citizen participation is often reduced to participation by elite, organised civil society, predominantly in the form of NGOs, business and other interest groups with access to resources. Participation mechanisms that are established to channel citizen input are not accessible to the majority population in societies characterised by inequality, with marginalised communities and sectors in particular being excluded, and typically do not 'automatically benefit poor people and groups that have long faced social exclusion' (Manor 2004, 5).

Developing avenues to overcome the 'democracy deficit' through the active participation of civil society organisations is particularly important in the South African context, where pervasive inequalities persist and new forms of social exclusion replace apartheid divisions. The question that emerges is: how can we develop mechanisms that enable the poor and unorganised, and vulnerable groups such as refugee women, to influence policy making, thereby building 'democratisation with inclusion' (Manor 2004, 6)? The case being examined in this chapter – namely, the prospects for refugee women to engage with governance processes – highlights sharply the deficiencies in a system that serves to keep marginalised groups firmly on the periphery of decision making.

When asked what advantage they saw in being drawn into policy processes, URW leadership representatives stated that this would ensure that when government makes policy relating to refugees, it does so from a position of being aware of refugees' needs, 'instead of just guessing'. They stated that

this would ensure that refugees get what they really need, prevent having to address problems arising from the implementation of costly and inappropriate services and assist in integrating refugees into the local communities. In the existing South African context, however, access to protective policies is mediated by constrained notions of citizenship because refugee populations remain unprotected from a policy standpoint and, at the same time, are socially marginalised in ways that limit full participation in democratic processes.

Refugee status, rights and services
The United Nations Convention relating to the Status of Refugees (UN 1951) defines a refugee as a person with a 'well-founded fear of persecution on account of race, religion, nationality, membership in a particular social group or political opinion'. This definition forms the basis for South African legislation pertaining to refugees. The LHR Refugee Rights Project staff stated that the definition of refugees discriminates against women, in that the emphasis tends to be on political distinction and political discrimination, and that women tend to fall outside of this category. Kanani (2004) supports this notion, pointing out that the 'traditional focus on the word "persecution" . . . has made it difficult for women or others who cannot claim to be directly politically persecuted to claim asylum status' (4).

The UNHCR has endorsed the notion that gender constitutes a social group or subset, affirming that states are 'free to adopt the interpretation that women asylum-seekers who face harsh or inhumane treatment . . . may be considered as a "particular social group" within the meaning of the 1951 UN Refugee Convention' (UN 1986, at conclusion, para. k). Despite gender having been recognised as a marker of vulnerability, and states encouraged to adopt measures necessary to address the needs of this vulnerable group, nothing has been put in place in South African legislation, policy or practice to ensure that women refugees do not endure ongoing persecution on the basis of gender. This suggests that the gender rights framework central to South Africa's democratisation has not yet been expanded to include women in refugee populations.

South African refugee legislation permits asylum-seekers to remain temporarily in the country. Those with official status as refugees – that is, those who have been granted asylum – are entitled to 'full legal protection, which includes the rights set out in Chapter 2 of the Constitution and the

right to remain in the Republic' (RSA 1998, clause 27b). The Act goes on to state that refugees are entitled to seek employment (clause 27f) and 'to the same basic health services and basic primary education' as South Africans (clause 27g). Kanani (2004), however, points out that there is 'no coherent government policy dealing with health and welfare service provision for refugees and asylum seekers', and that as a result 'it is not known which services refugee households are entitled to' (6). Despite the legal guarantee of access to constitutional and basic rights, which should entitle refugees to child-support grants and other social support, Kanani notes that this has 'failed to materialise in any significant way. At present, refugees are not being accorded the same rights as South African citizens' (12).

It is clear from the experiences described by refugee women that they do not enjoy treatment equal to that of South African citizens, and that they continue to experience persecution and discrimination as a result of xenophobic attitudes on the part of government officials and ordinary citizens. The fact that there are no official programmes in place to address this, or to provide support to refugee women, heightens this experience of social exclusion and severe marginalisation. The question that arises, then, is, what opportunities or spaces are created for refugee women to raise these anomalies and bring these issues to the attention of policy makers to ensure that appropriate policies and programmes are developed and effectively implemented?

The role of support and gender institutions

At this juncture it is critical to assess the role played by service provider agencies and gender institutions in addressing the needs and concerns of refugee women, and their ability to take these up at policy levels. South Africa may be distinguished from other African countries that receive refugees in that it does not have refugee camps that provide social and material assistance to refugees. In South Africa, the UNHCR is essentially responsible for ensuring that refugees entering the country are able to access their constitutional rights by encouraging 'government, the public and private sectors to understand and implement these basic rights' (Kanani 2004, 5).

In KZN there are three primary support institutions to assist refugees: (1) the MCC, the UNHCR's only implementing partner for refugee social needs in KZN, as it does not have an office there; (2) the LHR Refugee Rights Project; and (3) Refugee Pastoral Care, which offers basic welfare services to Catholic

refugees only (Kanani 2004, 17). The MCC provides subsidies towards school fees, uniforms and stationery for vulnerable and unaccompanied minors, and a scholarship to pursue tertiary education for one or two refugees annually. It also provides assistance for social needs for refugees falling into the categories of the chronically ill, the aged and unaccompanied minors, as well as limited, time-bound support to new arrivals and 'crisis cases'. Further, it provides job placement services through micro-loans and subsidies towards vocational skills training. The LHR Refugee Rights Project primarily provides legal assistance to refugees and asylum-seekers in accessing documentation and asylum status. It interacts with the Department of Home Affairs on these issues and reports to the UNHCR. It also addresses issues related to refugee housing and police brutality. Neither the MCC nor the LHR Refugee Rights Project has programmes specifically addressing the needs of women, although both recognise them as a particularly vulnerable group.

While both the MCC and the LHR Refugee Rights Project interact with government officials on refugee issues, both groups acknowledge that more focused policy advocacy interventions would be of great benefit, in terms of addressing certain procedures that are not properly implemented by the authorities and responding more effectively to capacity problems and lack of awareness in relation to the case of refugees on the part of Home Affairs staff. Both the MCC and the Refugee Rights Project do seek to create spaces for refugees to engage with government stakeholders through workshops for refugees on their rights, to facilitate forums for refugee service providers and representative structures and to convene events at which government representatives interact with these bodies.

From the perspective of gender rights, two government institutions form part of South Africa's gender machinery active in KZN: the Office on the Status of Women (OSW) in the office of the KZN premier, and the Commission on Gender Equality (CGE). The OSW does not have any programmes specifically focused on addressing the particular needs of refugee women. In terms of its implementation strategy, it has two key programme areas: violence against women and children, and women's economic empowerment. However, OSW office manager, Queeneth Mkhabela, states that she sees refugee women fitting into the category of women with 'special needs', and expressed great interest in interacting with representative groups, such as the URW, to draw them into OSW programme areas.

Thabisa Dumisa, a CGE commissioner at the time of this research, acknowledged that if black South African women are triple-oppressed, refugee women are in an even worse situation with regard to the vulnerability of their status. The CGE does not have any official programme responding to the needs of refugee women, and has not yet tackled this issue. Dumisa reported that refugee women could be drawn into CGE provincial initiatives, depending on the stakeholders and networks active at provincial level. The CGE would be limited to intervening where discrimination on the basis of gender is experienced.

These findings reveal huge gaps at both policy intervention and service delivery levels. Institutions mandated to address issues relating to refugees, and those addressing issues impacting specifically on women, do not have information or programmes focused on the needs of this particularly vulnerable group. While refugee women consulted in this research identified themselves firstly as women and secondly as refugees by virtue of their situations, neither gender nor refugee service providers are positioned to engage in advocacy on or provide support in response to the violations and discriminations experienced. Furthermore, at the time of this research, neither the CGE nor the OSW was positioned to take up the particular needs of this population at policy levels.

Spaces and mechanisms for public participation

In examining what opportunities exist for refugee women to engage with the policy machinery in South Africa, it is essential first of all to assess the broader context of spaces and mechanisms for public engagement with policy processes in the new democracy. South Africa has clear constitutional and legislative provisions for community participation in governance, leaving no doubt as to the existence of extraordinary political commitment to notions of participatory governance (RSA 1996, 2000). However, some significant barriers to participation in policy processes present distinct challenges to the implementation of democratic governance. These include design, capacity shortcomings and resource gaps impacting the effectiveness of measures put in place, as revealed in the research findings within this sector.

Another challenge faced is that of the political system of proportional representation. The selection of representatives from party electoral lists undermines the notion of citizen representation, with representatives allocated

to constituency areas that they must then service. This system is not sufficient to ensure that citizens' needs and interests are incorporated in policy making, with many arguing that elected representatives owe greater allegiance to the political parties who include them in party lists than to the electorate, who can only vote for parties and not individuals.

Interrogation of existing opportunities, spaces and mechanisms at the levels of the provincial legislature, executive and local government through desk-top analysis (Ngwenya and Ngema 2005), focus-group discussions and interviews with policy makers (Hicks 2005) reveals further inadequacies. Public participation within processes of the provincial legislature is under-mined by inadequate time for members to consult with communities and few opportunities for public comment. Insufficient political will to implement broader participatory processes, lack of clarity on where responsibility for this lies, as well as lack of guidelines, resources and capacity to facilitate this objective further weaken participation. Poor information dissemination and lack of summarised, plain-language versions of policy and legislation under scrutiny further prevent marginalised groups from participating effectively.

Policy discussion sessions and interviews with policy makers on par-ticipation at the executive level (Hicks 2005) reveal that departmental initiatives are in the main limited to the *izimbizo* (public gatherings) of the office of the premier. These gatherings draw together thousands of community members to raise issues of concern in the presence of the premier and departmental representatives, who have to respond to and address issues and problems raised to the satisfaction of the premier. While this innovation has been welcomed, limitations of this forum have been noted, such as the sheer size of the gatherings, which makes the forum unsuitable for deliberation on issues and possible solutions. They are also often unfocused, resulting in a catch-all process for all community problems.

In the local government sphere, discussion sessions and interviews with policy makers (Hicks 2005) reveal that municipalities have initiated numerous mechanisms to facilitate public input into their decision-making processes. In the main, integrated development planning processes are regarded as central to engaging community groups in decision making. These include integrated development planning forums, ward committee meetings, roadshows and budget processes, each of which is supplemented by stakeholder meetings,

media work and dissemination of information through traditional leadership structures.

Opinions of policy makers

Discussion sessions and interviews with policy makers reveal a heartening approach to public participation in policy making. Interviewees were unanimous in their view that engaging citizens in joint decision making brings benefit to all. As a positive spin-off, interviewees noted that participation enables the crafting of innovative solutions to policy challenges, and that engaging citizens in policy making contributes to the empowerment of communities, with people learning more about governance and policy processes by getting involved in them.

However, analysis of existing mechanisms reveals that policy makers tend to seek communities' input into *already formulated policy responses*, or to disseminate information on existing government programmes. When asked whether it would be possible to engage communities at the early stages of problem identification and policy drafting, the response was that communities lack sufficient understanding of these processes to do so, and that such consultation would require innovative approaches.

Civil society experiences of policy processes

Some critics might argue that there are existing spaces for engaging with policy processes, as highlighted above, and that civil society needs to be better informed, positioned and active to engage with these. A counter-argument to this is that only a privileged few have *access* to these spaces, which are not sufficiently advertised or accessible, particularly to marginalised groups such as refugee women. Attempts to facilitate community input are largely superficial, and do not tap into the real power base where decisions are made. Most processes present predetermined positions and programmes for limited feedback or the sharing of information, or create opportunities for communities to raise concerns, and therefore make very little substantive difference to policy decisions. This thinking appears to be supported by civil society experiences of the policy process, and by refugee women in particular, as shared in policy discussion forums (Hicks 2005).

Groups at these forums spoke of mixed experiences of the policy process. Feelings of being sidelined, marginalised, excluded and disempowered

overwhelmingly dominated. These feelings were occasioned by not receiving feedback on inputs made in processes; not seeing any recommendations being taken up or any impact from having participated and made input; being co-opted into participating in a process with a predetermined outcome; being excluded from an 'inner circle' enjoying privileged access to decision makers and information; and not being recognised as worthy of participating.

Concerns were raised at government's tendency to call for community input for political buy-in and implementation at advanced stages of policy formulation, rather than at the outset, when problems are being identified and solutions are being developed. In this regard, participants from the children and women's group noted that

> [m]eaningful, participatory spaces are closing up – the really consultative processes or spaces where decisions are made are not in the public arena. There is not meaningful engagement with civil society – decisions are taken elsewhere. (Hicks 2005, 16–17)

They also commented that the use of primarily print media in government communication and information dissemination excludes certain groups and communities. Representatives from the discussion group for community-based organisations (CBOs) noted further that the language used in these processes further alienates communities, and that notices of opportunities to make submissions tend to 'come late'. As a result, CBOs are excluded from decision making. They stated that CBOs need to be involved from the outset of the policy process.

Impact on refugee women
Refugee women reported a particular set of experiences at the hands of government representatives with whom they attempted to interact to obtain information and services. In the main, the treatment meted out by government officials can only be described as abusive. Refugee women are typically treated with contempt. Officials often refuse to speak in English and insult and swear at refugee women, giving instructions in Zulu, knowing full well that they are not conversant in this local language. Officials have refused to provide information, receive documentation or accept legitimate refugee documentation. Refugees are forced to queue in poorly maintained facilities, set aside from

those used by South African citizens. Refugee women are sexually harassed on a routine basis by male officials and other men in countless other situations. Women report distinct acts of harassment and discrimination, ranging from being propositioned regularly, receiving aggressive responses when they spurn advances, to being denied assistance from public officials and receiving threatening messages about eviction from landlords.

Attitudes reveal deep xenophobia and prejudice, with women being told that they stink, that they have too many children and that they are taking away resources from South Africans. Findings from this research reveal little or no interest in, or empathy with, the trauma experienced by many women in standard institutional processes, with women continuing to be harangued by officials even in desperate circumstances, such as during childbirth or upon the death of a husband. When asked about making attempts to interact with more senior government officials to raise awareness about their plight, a woman at the discussion forum convened for refugee women retorted: 'We are invisible. They do not know us – we don't ever meet them. They know us on papers only.'

Power in the policy process

Discussion forum participants (Hicks 2005) were particularly struck by power relationships at play in the policy process, both among policy makers themselves and between policy makers and civil society. Groups reflected on how these power relationships impact on the process, resulting in the kinds of experiences they shared. These were typified by unequal power relationships between politicians and bureaucrats and between government and civil society representatives, between those with access to information and resources and those without, between those who belong to organised structures and those who do not, between those who are viewed as educated and those who are not, between urban and rural residents, between men and women, and between people with different abilities.

Refugee women in particular noted further discrepancies, stating that power inequities are deepened on the basis of both gender and citizenship, with women constantly experiencing distinct forms of sexual harassment. Language is also used as a means to further alienate women attempting to engage with government officials, with the inability to understand Zulu resulting in verbal abuse and poor service at the hands of officials. Perceptions

of women's standards of education and income – denoted by aspects of women's physical appearance such as grooming, dress and skin tone – also influenced how they were received by officials.

Finally, refugee women identified information and knowledge as key influences. Those who possess a better understanding of government systems and processes, as well as their rights within that process, fared better at the hands of officials than those who are ignorant and who do not have support. Similarly, those who received support from organised structures such as the URW were better able to receive proper services. However, women reported that they had to be careful to appear humble and inferior so as not to anger officials. They noted that officials seem to lack information on or an understanding of how refugees come to be in South Africa. The misinformed perception that refugees are illegal aliens fuelling crime rates, HIV infection, unemployment and drug dealing only serves to deepen the xenophobic response typically received. Therefore, as long as women acted in ways that upheld these xenophobic notions of 'outsiders', they were less likely to receive proper services. Although women's survival may hinge on socially reproducing embedded stereotypes about the 'other' in the presence of public officials, such social encounters reinforce a broader system of severe inequality that is gradually recreating the forms of treatment that were so vehemently resisted during the apartheid era.

Discussion forum participants in this research reflected that these unequal power relationships play themselves out in the policy arena, resulting in some issues not making it onto the agenda, the exclusion of some stakeholders, the rendering invisible of others, and the isolation of many from that critical juncture where decisions are made. Participants noted that unless these power issues are surfaced and addressed through careful planning, collaboration and facilitation, they will continue to undermine participatory initiatives seeking to gain civil society input and buy-in.

Participants from the children and women's group discussion noted that, as a starting point, power resides with political parties. There is power in the process of setting the agenda for discussion itself, and participants questioned how issues get on to the political agenda and attract sufficient support and attention. When it comes to the implementation of policies and programmes, power is devolved to government agencies, and this is not monitored by or made accountable to civil society – illustrating that although the country's

democratic process is noted for open participation, South Africa too is characterised by a 'democracy deficit'.

Participants from the HIV/AIDS discussion group picked up on this concept, and they thought it important to distinguish between the power base of political and bureaucratic actors and national government actors as opposed to provincial and local actors. While politicians deliberate ideas and make decisions, bureaucrats have the final power of implementation. Likewise, most policy processes are formulated at national level, which is perceived as being far removed from communities and difficult to access, with provincial and local governments then tasked with implementing these policies.

These experiences and reflections from civil society stakeholders indicate that although South Africa has in place legislative provision for participatory mechanisms, it is not enabling civil society to participate meaningfully. Policy makers acknowledge the limitations of these mechanisms, and civil society experience leaves no doubt that these are inadequate, inaccessible and disempowering, and that new approaches to participatory policy making are required.

Preconditions for civil society engagement

A further issue for consideration is how marginalised groups such as refugee women can enter the policy arena motivated, empowered and equipped to engage with a greater sense of equity with government and other civil society actors. The literature on agency and citizenship identifies a notable challenge in how individuals develop the ability to act when they experience a sense of internalised powerlessness that keeps them from the discussions at the centre (Kabeer 2005; Gaventa 2005). In discussions of access to democratic rights in South Africa, civil society stakeholders repeatedly focused on issues of the agency of poor people, the development of political attitudes and opinions among the marginalised, and whether these groups can be motivated to engage with policy debates in ongoing processes of nation building. Discussion forum participants felt strongly that the satisfaction of basic needs has a central impact on people's ability to engage with policy processes. Furthermore, those lacking in basic service delivery experience a particular sense of alienation from government. Participants in the children and women's discussion forum stated how difficult it is to engage 'hungry' people on policy issues.

Yet the government's prioritising process needs to be consultative and participatory, so that a people-driven national agenda is developed. For refugee women, the biggest challenge centres on *how* people can engage in South Africa's democratic processes:

> People's lives are stressed – how do you sustain processes and draw in groups, when the benefit or impact is not immediately apparent? The challenge is sustaining public participation at community level, and finding a balance for this, acknowledging that it comes at personal cost. Processes need to be managed in a way that helps people's lives. (Hicks 2005, 22)

Comments made by refugee women in their deliberations confirmed these sentiments, with one discussion forum participant noting: 'People are not ready to claim their rights, because of the cost of life.' While the challenges to participation in governance and the ability to directly influence policy change may well be shared by other civil society groupings in South Africa, the additional factors of discrimination and vulnerability, xenophobic and unsympathetic responses from officials, lack of established support networks and the overwhelming struggle for survival set refugee women apart.

Several authors refer to basic resources and capacities required by participants to make full use of government participatory processes. Cornwall (2004) speaks of the need to assess what work is required with groups prior to their participation in a process to ensure that they engage with greater equity. This includes, as a starting point, capacity building to develop an understanding of the policy framework and process, and enhanced technical and planning abilities (Logolink 2002). Also required are improved advocacy skills to mobilise and organise outside of the policy arena in order to challenge any barriers to participation, as well as essential consciousness-raising (Gaventa 2003b; Kabeer 2005). The important role played by NGOs in providing support to participatory initiatives is highlighted, including providing marginalised groups with access to information and material support, as well as establishing 'vertical lines' of communication that link grassroots issues and structures with national processes (Stiefel and Wolfe 1994, 207).

In the South African context, the Human Sciences Research Council (HSRC) conducted a survey into citizens' knowledge of government processes, their willingness to participate in these and what actual participation resulted.

Their findings indicate that citizens' knowledge of government processes is insufficient, which impacts on their ability to engage with them (Roefs and Liebenberg 1999). Issues raised by civil society groups in their discussion forums support these findings. The CBO group (Hicks 2005) noted particularly that CBOs tend to lack information on how to work with government and how to get involved in policy making, stating that they are often unable simply to find the appropriate contact point. In the case of marginalised group members' engagement, these obstacles tend to be even more daunting as a result of educational inequalities and institutional barriers.

Refugee women display a great lack of understanding of South African government processes and opportunities to engage, with one discussion group participant asking, 'What is a municipality?' They identified the need for basic training and information on their rights as refugees in relation to international conventions, South African legislation and government services and pro-grammes. They specifically identified the need for greater understanding of South African governance processes, including where to go for information, how to engage with policy processes, who is responsible for delivery of particular services and how to advocate effectively on their rights and issues. Refugee women identified a range of support interventions that would be required to enable them to engage with policy processes on a more equitable basis, including having access to relevant documents and information about processes. Refugee women also called for preparatory processes among themselves to enhance their efforts to participate in policy deliberations, consider the policy issues and proposals put forward by government, deliberate alternative options and reach broad agreement on their priorities. The particular needs of refugee populations highlight the importance of an evaluation of assumptions underlying individuals' as well as marginalised groups' abilities to engage in civil society. In the South African case, while the democratic model is one of open participation, overlapping barriers for refugees create asymmetrical power relations that mandate particular considerations for the involvement of this growing population in civil society processes. Furthermore, refugee women's ability to mobilise and demand greater protections is severely challenged by two predominant obstacles: barriers to understanding the system of governmental participation and prevailing xenophobic assumptions that place extreme disadvantages on women.

Crafting new democratic spaces

From the critiques and findings reported above, it is clear that careful attention needs to be paid both to the institutional design of new democratic spaces and to the facilitation of spaces themselves, in order to address challenges of representation, power and voice, and to ensure more equitable participation of marginalised groups, such as refugee women, in policy processes. Fung and Wright (2003, 15) note that the institutional design of empowered participatory governance is based on three principles: a focus on specific, tangible problems; involvement of ordinary people affected by these problems and officials close to them; and the deliberative development of solutions to these problems. In addition, Fung (2003) has developed 'recipes for public spheres', and sets out a range of 'institutional design choices' facing policy makers in creating deliberative forums or 'mini-publics' (339). The creation of these mini-public spaces affords opportunities for citizens to engage in political processes and, in the South African case, in the ongoing process of democratic nation building.

In order to understand how the design of these spaces is connected to social power asymmetries, it is critical to consider where these spaces are located. Gaventa (2005) stresses that the process of creating democratic spaces must take place where people naturally act. In creating new democratic spaces, we must consider how the framing of civil society spaces impacts on the quality and value of the participatory process. Issues such as who creates the space for participation (thereby setting the agenda) and who invites certain groups to participate (thereby excluding others), what knowledge is valued and what is disregarded, and how the 'rules' for engagement are determined substantially influence the nature of the deliberation and decisions that are made within that space. Forms of participation are clearly determined by who creates the space (Gaventa 2003a; Brock, Cornwall and Gaventa 2001; Cornwall 2004; Sisk 2001). In the case of refugee populations, such spaces are often exclusionary, presenting substantial barriers that impede the full participation of this sector.

In understanding the case of refugee women, it is also critical to keep in mind that no political or civil society space is 'neutral'. When participatory spaces are created, they are 'infused with existing relations of power', which 'reproduce rather than challenge hierarchies and inequalities' (Cornwall 2004, 81). This means that established patterns of behaviour, perceptions and

stereotypes that exist between groups and classes of people will 'follow' these people into a participatory space, and subtly influence the decision-making process underway. These spaces need to be transformed by introducing new rules, techniques and processes to avoid reproducing the status quo. This can be done through the choice of language used, seating arrangements, rules for engagement and decision making, and by building on existing spaces where people are already engaging (Cornwall 2004).

In CBO discussion forums, recommendations were put forward on choices of community spaces to use in convening participatory processes. Participants spoke of the need to create a greater sense of equity among government and civil society representatives by seating them alongside each other at round tables, or making use of horseshoe seating arrangements and removing tables. Leaders gave careful attention to the facilitation of processes, and to the preparatory work that should be undertaken in the form of disseminating information in plain and local languages on the process and policy options under consideration. Participants also called for consultative sessions to enable community members to come to grips with policy options and develop their positions and inputs.

While echoing many of these recommendations, refugee women made specific additional inputs on how such spaces could best be facilitated to ensure their engagement with policy processes. They identified the need for ordinary refugee women to form the majority at any policy discussion related to their issues of concern, and for an understanding of who they are, why they have come to be in South Africa and their interest in the policy issue to be established upfront, as a context for the discussion. Refugee participants emphasised the need to exercise the right to express themselves, and not be spoken for by service providers or groups claiming to represent their interests. Women stressed the need for government representatives to listen to what they have to say, and felt strongly that the venue for discussions should be located where refugee women would feel confident to talk 'in our own place', as one discussion session participant noted.

Clearly, if notions of power, space and voice are not addressed, the mere opening up of public spaces for participation in government decision making will result in these being filled by those who already have power and access to resources (Gaventa 2003a). Of greater concern is the need to ensure that new spaces work to the advantage of the poor and unorganised, and not to

that of bureaucrats. Friedman (2004) speaks of the danger of creating 'forums which are most convenient for officials and politicians because they are structured . . . neat and easily manageable [yet] least convenient for the poor who may well be far better off using the less structured methods of expression which are allowed by a democratic constitution' (25). Refugee women in this research identified how such processes could enhance their participation in civil society. For example, participants noted that service providers, Chapter 9 institutions and parliamentary committees could strengthen deliberative policy processes that engage refugees by networking with refugee structures and drawing them into their events and processes; providing support to their campaigns and lobbying government on their behalf; and assisting in raising awareness among local communities on refugee issues.

Conclusions

Returning to the original question of whether new democratic spaces can be crafted that enable marginalised groups such as refugee women to engage with policy processes from an empowered position, findings from this research suggest a way in which this may be done. In the case of South Africa, although barriers imposed by xenophobic attitudes and limited access to democratic processes continue to shape the experiences of refugees, civil society engagement also provides a space where this population has been able to participate in the democratic process, thereby accessing collective agency and establishing the foundation for further levels of organisation. A distinct dialectic emerged throughout my work with refugee women in KZN, who were both constrained by and actively resisting the social exclusion of 'outsiders'. Civil society organisations provided a space where refugee women could unite in their voice and link to other CBOs, as they enacted both individual and collective agency. Much like the policy reform initiatives among domestic workers discussed in Chapter 5 of this collection, the ability to align with other civil society organisations to assert a collective and powerful voice is particularly important when women are severely marginalised at the vector of several forms of inequality.

The legislative framework for public participation in South Africa – in the form of constitutional and local government provisions for the voices of civil society – provides an important context for examining opportunities for refugee populations to improve their day-to-day living conditions. Furthermore,

the gender rights imperative of South Africa's democracy widens access for women in these political processes. In this case, women are better positioned to establish processes that meet the specific needs of female refugees.

What is missing is the establishment of stronger links between state institutions and civil society stakeholders such as the URW as a basis for participatory policy making. For stakeholders such as refugee women to participate with confidence and capability in policy processes, there is a need to provide capacity building to enable them to engage with these processes and build a sense of agency over time. Such capacity building would address information needs and include programmes that deal with understanding policy making, policy research and analysis; monitoring support; and advocacy training and planning. Finally, the design ideas recommended on how best to plan, conceptualise and facilitate new democratic spaces need to be taken up, so that joint policy deliberation between government and civil society representatives are accessible, equitable and transformative. With these initiatives, South Africa's democratic processes may be expanded such that marginalised refugee women are able to take a central role in participatory governance with a greater sense of equity and alignment with the country's overarching commitment to gender rights through engagement with civil society organisations.

References

Brock, K., A. Cornwall and J. Gaventa. 2001. 'Power, Knowledge and Political Spaces in the Framing of Poverty Policy'. IDS Working Paper 143. University of Sussex: Institute of Development Studies.

Carothers, T. 2005. 'What Really Lies behind Challenges of Deepening Democracy and Establishing the Rule of Law?' Presentation at Centre for the Future State conference 'New Challenges in State Building', London, 21 June.

Cornwall, A. 2004. 'Spaces for Transformation? Reflections on Issues of Power and Difference in Participation and Development'. In *Participation: From Tyranny to Transformation*, edited by S. Hickey and G. Mohan. London: Zed Books.

Friedman, S. 2004. 'A Voice for All: Democracy and Public Participation'. *Critical Dialogue: Public Participation in Review* 1 (1): 22–6.

Fung, A. 2003. 'Survey Article: Recipes for Public Spheres: Eight Institutional Design Choices and Their Consequences'. *Journal of Political Philosophy* 11 (3): 338–67.

Fung, A. and E. Wright. 2003. 'Thinking about Empowered Participatory Governance'. In *Deepening Democracy: Institutional Innovations in Empowered Participatory Governance*, edited by A. Fung and E. Wright. London: Verso.

Gaventa, J. 2003a. 'Perspectives on Participation'. Paper presented at symposium 'Developing Participation: Challenges for Policy and Practice', Stockholm.

———. 2003b. 'Towards Participatory Local Governance: Assessing the Transformative Possibilities'. Paper presented at conference 'Participation: From Tyranny to Transformation', Manchester, 27–8 February.

———. 2004. 'Deepening the Deepening Democracy Debate'. Background paper prepared for Ford Foundation seminar, Rio de Janeiro, 3 December.

———. 2005. Institute of Development Studies class presentation, University of Sussex, 13 June.

Hicks, J. 2005. 'Crafting New Democratic Spaces: Participatory Policy-making in KwaZulu-Natal, South Africa'. Paper compiled in partial fulfilment of MA in Participation, Development and Social Change, Institute of Development Studies, University of Sussex.

Kabeer, N. 2005. '"Growing" Citizenship from the Grassroots: Nijera Kori and Social Mobilization in Bangladesh'. In *Inclusive Citizenship: Meanings and Expressions*, edited by N. Kabeer. London: Zed Books.

Kanani, E. 2004. 'Investigation into the Living Conditions, Survival Strategies and Acceptance of Refugee Women in KwaZulu-Natal'. Forthcoming, Centre for Civil Society, University of KwaZulu-Natal.

Logolink. 2002. The International Workshop on Participatory Planning Approaches for Local Governance. Bandung, Indonesia, 20–7 January.

Luckham, R., A. Goetz and M. Kaldor. 2000. 'Democratic Institutions and Politics in Contexts of Inequality, Poverty and Conflict: A Conceptual Framework'. IDS Working Paper 104. University of Sussex: Institute of Development Studies.

Manor, J. 2004. 'Democratisation with Inclusion: Political Reforms and People's Empowerment at the Grassroots'. *Journal of Human Development* 5 (1): 5–29.

Ngwenya, T. and S. Ngema. 2005. 'Desktop Analysis on Current Public Policy Mechanisms and Spaces in Provincial and Local Government with Particular Reference to Best Practices'. Research paper prepared for KZN task team.

Republic of South Africa (RSA). 1996. Constitution of the Republic of South Africa (Act No. 108 of 1996).

———. 1998. Refugees Act (No. 130 of 1998).

———. 2000. Municipal Systems Act (No. 32 of 2000).

Roefs, M. and I. Liebenberg. 1999. 'Public Participation in South Africa as we Enter the 21st Century'. In *Democracy and Governance Review*, edited by Y.G. Muthien, M.M. Khosa and B.M. Magubane. Cape Town: HSRC Press.

Sisk, T. 2001. 'Expanding Participatory Democracy'. In *Democracy at the Local Level: The International IDEA Handbook on Participation, Representation, Conflict Management and Governance*, edited by T. Sisk. Stockholm: International Institute for Democracy and Electoral Assistance.

Skocpol, T. 2003. *Diminished Democracy: From Membership to Management in American Civic Life*. Norman: University of Oklahoma Press.

Stiefel, M. and M. Wolfe. 1994. 'Participation in the 1990s'. In *A Voice for the Excluded: Popular Participation in Development: Utopia or Necessity?* Geneva/London: UNRISD/Zed Books.

United Nations (UN). 1951. United Nations Convention relating to the Status of Refugees.

———. 1986. United Nations Doc. HCR/IP/2/Rev. 1986, No. 39 (XXXV1). 8 July.

CHAPTER TEN

Transgressive African Feminism
The Possibilities of Global Organisation

M. BAHATI KUUMBA

The transnational feminist challenge to global inequality

Feminist cross-border and transnational activism has been a particularly vibrant and growing opposition to market-driven globalisation and its detrimental impact on women's lives over the last few decades. These transnational movement networks and structures mirror the increasingly integrated and coordinated system of global dominance and inequality against which they struggle (Keck and Sikkink 1998; Kriesberg 1997; Moghadam 2000). They are testimony to the fact that the borders of the nation state have become just as permeable to social justice activism as they are to the flow of deepening inequalities and oppressions that characterise the current era of globalisation. Contemporary scholars and activists recognise the proliferation of transnational networks, organisations and strategies as a counter-hegemonic process of 'globalisation from below' that links the grassroots/local and the global/ international levels of collective resistance in an emergent *global civil society*.

At this moment, the overarching context within which the widening disparities and social oppressions that differentially, yet globally, affect women is the increasingly integrated and coordinated system of multiple hegemonies generally referred to as 'globalisation' (Basu 2000; Moghadam 2000; Naples and Desai 2002; Sassen 2000). With this growth of global interconnectedness and restructuring, we see a simultaneous resistance movement that aligns women from diverse social locations through civil society organisations. However, in contrast to earlier attempts to forge international solidarity and unity among women on the basis of a presumed universalised women's

oppression or 'global sisterhood', today's transnational activism is defined by the recognition of women's particular experiences and social locations within a common struggle increasingly shaped by systemic patterns of global inequalities. As Mohanty (2003) describes it:

> What seems to constitute 'women of color' or 'Third World women' as a viable oppositional alliance is a common context of struggle rather than color or racial identifications. Similarly, it is Third World women's oppositional political relations to sexist, racist, and imperialist structures that constitutes our potential commonality. This is the common context of struggles against specific exploitative structures and systems that determines our potential political alliances. (49)

This 'common context of struggle' posited by Mohanty is taken up in civil society organisations where women both align and actively resist the dominant patterns of gender inequality central to global restructuring. Through data collected within women's civil society organisational research sites in both the United States and South Africa, I illustrate how African women's transnational activism engages Mohanty's (2003) concept of solidarity based on African women's diverse experiences of related and common contexts of struggle against global inequalities and hierarchies.

From many activist and scholarly perspectives, transnational social movements and justice activism is linking grassroots/local and global/international opposition into a global civil society with immense potential for challenging and transforming both local and global systems of domination and inequality. In the midst of diverse experiences among African and African diasporan women, their relational and commonly contextualised positioning within the globalised system of multiple inequalities has provided particular historical and contemporary opportunities for transnational feminist activism. African women's international mobilisation is just one form of resistance created in opposition to the global system of inequality and domination that increases its expanse and concentration of power. Yet within these processes of resistance, civil society emerges as a particularly powerful space that holds the potential for transnational African women's/feminist organising to build an international movement that contests the multiple layers of global inequality.

Despite its dynamism, the transnational feminist activism that has flourished in the last few decades has received insufficient attention in the

dominant scholarly research and from contemporary activist strategists. Sociologist and women's studies scholar Moghadam (2000) recently observed that 'neither the globalisation literature nor the social movement literature examines feminism as . . . transnational organisations linking women in developing and developed regions and addressing social, economic and foreign policy issues in supra-national terms' (59). Within this broader area of scholarly and activist neglect, the transnational feminist alliances forged by African and African diasporan women have been doubly, if not triply, ignored and marginalised.

This chapter, as well as the ongoing research on which it is based, contributes to the literature on transnational women's social justice activism and civil society organisation by exploring two African/African diasporan cases that have built critical linkages between the geographic contexts of South Africa and the United States and within the African continent. I combine the strengths of two theoretical paradigms in my methodological approach and comparative analysis: global African feminisms and radical social movement theories. Because of the distinct geographical and political diversity of African feminisms, I draw broadly from the liberatory themes that connect African and African diasporan women's diverse historical and contemporary liberatory thought and action.

I apply these theoretical perspectives to the cases of the All African Women's Conference (AAWC) and the Women's HIV/AIDS Resources Project (WHARP), examples of historical and contemporary cases of transnational African feminist organising, respectively. The AAWC was founded in 1962 in Dar es Salaam, Tanzania, as a coalition of women's organisations associated with African national liberation struggles. The secondary analysis of this organisation was based on archival research conducted at the African Studies Department Library at the University of Cape Town (UCT) in South Africa in 2002. I relied mainly on primary AAWC organisational documents, transcriptions of conference speeches and meetings, and reports from member organisations. The contemporary example I examine is WHARP, a three-year transnational partnership that linked two HIV/AIDS advocacy and education organisations (SisterLove, Inc., and the National Center for Human Rights Education (NCHRE)) founded by black women in the United States to three similarly focused organisations in South Africa (Positive Women's Network (PWN), Township AIDS Project (TAP) and the Society for Women and AIDS in

Africa (SWAA)). The partnership, which began in 1999 and ended in 2002, engaged the organisations in mutual learning and information exchange, collaborative organisational development, and joint HIV/AIDS education and advocacy projects based on transnational commonalities with respect to the impact of the pandemic.

The research methodologies employed for the WHARP analysis consisted of the examination of official partnership and individual organisational documents, face-to-face interviews with key partnership players and intermittent periods of participant observation over a two-year period (2000–2002). As in the case of the AAWC, my engagement in these research processes was transnational in that it was conducted in multiple global locations: Cape Town, South Africa; Johannesburg, South Africa; Witbank, South Africa; and Atlanta, Georgia, United States. Throughout my analysis I employ feminist reflexive practices that connect my own social location as an African feminist activist scholar with my observer/participant position within these organisational sites. For example, my scholar-activist position affords additional insider knowledge in my analysis of the US-based WHARP partners (SisterLove and the NCHRE), on the basis of my engagement with these organisations and their social justice work in a scholarly-activist capacity since my arrival in Atlanta in 2000. As a result, my position as a feminist activist researcher is integrally connected to my own participation within civil society organisations in both Africa and the US. On an institutional level, the Women's Research and Resource Center at Spelman College, with which I am professionally affiliated, has partnered with SisterLove and NCHRE in order to transcend the pervasive historical divides that separate organisational activism from hierarchical educational institutions centred on knowledge production. My own relationship to this project therefore mirrors the transcending of boundaries central to the development of a strengthened global civil society.

Historical contexts for transnational activism

In order to situate African women's activism within today's growing global civil society movement, we must first explore pivotal moments in the history of international organising and transnational mobilisation. According to Sperling, Ferree and Risman (2001), 'women's transnational advocacy networks organized around the principles of challenging gender hierarchy and improving the conditions of women's lives have been among the earliest and most

influential of such global mobilizations' (157). Early well-known examples of transnational women's organising were directed towards women's suffrage and peace. For example, the International Women's Suffrage Association, founded in 1904, linked European and North American women and their organisations across nation states through conferences and correspondence towards the objective of citizenship and voting rights for women. Likewise, the Women's International League for Peace and Freedom, which was formed in 1915 in The Hague, Netherlands, engaged women from around the world in opposition to the First World War.

While oppositional to patriarchal inequality, these early expressions of transnational women's activism were inherently embedded with, and reflective of, other systems of inequality and oppression characteristic of world societies of that era. These movements, which reflected racial, national, class and cultural exclusivity, lacked input and participation from the majority of the world's women, who were largely subjected to patriarchies within the contexts of slavery, colonialism and fascism. Not only were the participants in these international women's social justice campaigns predominantly of European and European diasporan origin, they were also representative of relatively privileged class origins. Additionally, they advocated rights for a narrow group of the world's women – namely, those of European descent – essentially ignoring but reinforcing the relationship between a particular expression of gender inequality and other systems of domination including colonialism, racism and class exploitation. These embedded inequalities are reflective of the racist, colonialist patriarchy that characterised the period.

Indeed, the legacy of internationalised gender activism among women of African descent is equally tied to the enduring nature of globalised stratification on multiple levels, such as gender/sexuality, race/ethnicity, national origin, cultural background and class positioning. In other words, while 'globalisation' is relatively recent terminology, the inequitable distribution of globalised power, resources and opportunities to which it refers is not. According to African feminist and scholar McFadden (2005), globalisation is not simply a particular moment in time, but 'an ongoing context made up of historically recognizable forces that are once again attempting to restructure the world in order to maintain hegemonic systems of exploitation and privilege' (1). As the global system of inequality has moved through particular historical moments, or 'strategic instantiations', patriarchy and gendered power relations

have consistently served as a crucial nexus in the constellation of intersecting systems of inequality (Sassen 1998, 2000).

Transnational activism among African women and other women from previously colonised nations has its basis in the struggle against the gender, race and class inequalities of European colonial domination and anti-colonial resistance. While gendered divisions and inequalities certainly existed in pre-colonial African societies to varying extents, the colonial superimposition of Western patriarchy and capitalism widened the gender gaps and increasingly oppressed indigenous women. According to Seidman (1994), in reference to the indigenous and colonial patriarchies of the colonial era in southern Africa, the competing gender ideologies intersected and consistently disadvantaged women. African women, consistent with women in other colonised societies, experienced the combined loss of traditional sources of economic and political power, access to communal lands and resources and control over their productive and reproductive labour. African-descendant women in the Americas, Caribbean and United Kingdom were similarly positioned at the apex of multiple marginalities within the nations through which they were dispersed as property and forced into labour during the transatlantic slave trade. Their marginalised and exploited positions within the global political economy persist today.

Paradoxically, the male-dominated struggles for nation-state autonomy that swept across Africa, Asia and Latin America during the mid- to late twentieth century provided the early context for a more indigenous women's activism that transcended the nation state. In particular, African women's transnational feminist activism was incubated in the context of the gendered opportunities and constraints embedded within national liberation and social justices movements. Recent research into these movements consistently validates the crucial nature of women's participation in these struggles as well as the varying degrees of exclusion and marginalisation that they experienced (Kuumba 2001).

The women's wings and other ancillary bodies established within most national liberation organisations in Africa, and through which women's anti-colonial activism was funnelled, were structural expressions of this marginalisation. According to Molyneux (2001), these bodies can be described as 'directed mobilizations': that is, overarching and autonomous structures directed at the mobilisation of women's organisations and movements that

were 'subjected to a higher (institutional) authority and [are] typically under the control of political organisations and/or governments' (149). Often, these women's organisations were so closely aligned with the national liberation organisation or political party with which they were affiliated that they essentially served as vehicles through which the politics of the larger male-dominated liberation organisations and parties were played out on women.

The tensions associated with these layered and multiple oppressions led African women activists and their collectives to embark on more autonomous actions through transnational networks of communication, support and action. A significant expression of this autonomous and transnational impulse was the formation of the AAWC in July 1962 in Dar es Salaam. This coalition linked the women's wings and organisations associated with national liberation struggles throughout the continent with the stated purpose of 'creat[ing] an international African organisation to allow exchange of opinion and to undertake common actions' (AAWC 1968). Represented organisations included the Women's Brigade of Zambia, the National Union of Algerian Women, the Organisation of the Women of Mali, the Sudanese Women's Union, the Union of Women of Tanzania, the Women's National Movement of Mauritania, the Uganda Women's Organisation, the Union of Moroccan Women, the Front for the Liberation of Mozambique (FRELIMO) Women's Section, the Union of Burundian Women and the African National Congress Women's League. The AAWC unified African women and their organisations of different national, ethnic, class and ideological origins and positions, whether inside the country or in exile. This transnational activist network linked individual women with women's organisations on the basis of broadly defined principles and policies, which included the following collective desires established in 1968:

1) to accelerate the movement of emancipation of African women and promote their total rehabilitation so that they may take part in all the creative activities in the social, political and economic fields in their countries;

2) to support the great trend of political, economic and social liberation of the African continent and contribute, through a conscious, real and constant action, to the advancement of its peoples; and

3) to set up relations of friendship and co-operation and effective unity
 between the African women and the other women of the world with a
 view to promoting progress, justice and peace in the world. (AAWC 1968)

As its stated policies indicate, the AAWC was both anti-patriarchal and
transnational, combining the objectives of gender and national liberation from
its inception. Importantly, the AAWC's transnational bridge-building strategy
extended beyond the confines of the African continent through its global
outreach to other 'colonised' women and their activist structures. A 1972
speech delivered by the delegation of the FRELIMO Women's Section, for
example, paid 'honour to the women from Indo-China to Tanzania, from Angola
to Cuba, from Guinea to Portugal, in the Arab countries and in all the world,
who are engaged in the same combat for their emancipation, for the liberation
of their countries, and for the liquidation of all forms of oppression and
exploitation' (AAWC 1972). While scholars generally situate transnational
activism within the contemporary era, the cross-border activism of the AAWC
exemplifies an earlier precedent of globalised struggle against multiple forms
of inequality. As the AAWC developed in numbers and strength, it encapsulated
the early foundations of a transnational civil society movement built on the
central commitment to women's rights across race, class and national bound-
aries. The contemporary expression of African women's transnational activism
represents a continuation of this tradition. I suggest that the current context
of anti-globalisation activism among women is strengthened through the
material and ongoing ideological networks established within the pivotal
AAWC.

From global to transnational sisterhood and feminist activism
The existing configuration of global power relations, although an outgrowth
of the earlier relationships of dominance and exploitation, is characterised
by central dimensions of reinforced inequality that particularly impact African
women, in both their daily lived experiences and their collective activism
within civil society organisations. In the post-colonial global political economy,
African and other previously colonised woman around the world have
experienced increasing disadvantage and marginalisation. The process of
market-driven globalisation that has restructured and recolonised the world
through the imposition of neo-liberal economic policies and neocolonial

politics has deepened world poverty, increased power differentials and reinvigorated traditional and contemporary patriarchies. According to Sassen (2000), the impact of globalisation on women in the 'global south' (or 'underdeveloped' world) is widespread and dominantly detrimental:

> There is considerable research showing the detrimental effects of debt on government programs for women and children, notably education and health care, which clearly are investments necessary to ensure a better future. Further, the increased unemployment typically associated with the austerity and adjustment programs demanded by international agencies to address government debt has also been found to have adverse effects on women. (511)

As a result of trends that include cutbacks in needed services, rising unemployment and scarce resources, 'households and whole communities are increasingly dependent on women for their survival' (Sassen 2000, 506).

The contemporary global civil society resistance movement is characterised by a challenging of the world's neo-liberal ideologies that continually reproduce structural inequalities. Predominant economic trends and political policies of the post-colonial era have created challenges and hardships of a similar type for communities around the world – thus imposing a disproportionate burden on women's lives. Throughout Africa, these trends have been met with a groundswell of women-led grassroots and indigenous structures, mostly focused on meeting basic human and community needs. Simultaneously, the infrastructure of the contemporary global system allows for greater contact and collaboration between these grassroots women's movements without the intermediating role of indigenous elites or altruistic colonisers. Thus, contemporary transnational feminist networking and activism are driven more by local and indigenous actors, as opposed to external and dominating catalysts, than in the past.

This common context of gendered exploitation and oppression, expressed differently in particular locations and sites, has created unique opportunities for counter-hegemonic opposition through interaction on a global level. In Moghadam's (1999) view: 'the emergence of transnational feminism – notwithstanding cultural, class, and ideological differences among the women

of the world – is the logical result of the existence of a capitalist world-economy in an era of globalisation, and the universal fact of gender inequality' (381).

The growing consciousness among women of the interconnectedness of their lives and struggles across national borders as a result of the levelling impact of neo-liberal economic policy has been matched structurally by the development of transnational civil society networks and movements that have become major antagonists in the global struggle for power and resources.

The proliferation of transnational feminist organisational structures has been assisted by the adoption of the human rights framework outlined in the UN Declaration of Human Rights, which articulates the rights that should be guaranteed to all humans regardless of their societal location. Using this framework, issues such as violence against women, sexual abuse, reproductive rights and the feminisation of poverty can be understood as human rights abuses on a par with torture and genocide. Not only is the human rights framework useful in contextualising and validating women's demands, it also travels easily between geographic and situational sites. Through application of the human rights framework, women from diverse backgrounds and locations can forge collective alliances and strategies despite their 'common differences'.

Basu (2000) historicises the development of women's transnational feminist/activist networks into two broad phases: (1) contested global feminism (1975–1985) and (2) local–global connections (1985–1995).

> The first phase, between 1975 and 1985, was marked by bitter contestation over the meaning of feminism and over the relationship between the local and the global. The second decade-long phase, which began with the Nairobi conference in 1985 and culminated in the Beijing conference in 1995, was marked by a growth of networks linking women's activism at the local and global levels. (70)

In Basu's view, the UN Decade on Women (1985–1995) and subsequent international women's meetings, gatherings and collective actions were important catalysts in the development of global networks of communication and transnational structures among women activists. At many of the international meetings and gatherings that took place during Basu's first phase,

women from the 'global south' challenged the narrow and restrictive notions of liberation and feminist struggle being promoted by their counterparts from the 'global north'. Many scholars cite the mid-1980s as a watershed period for transnational networking and the emergence of a global civil society movement centred on gender rights. The 1985 Nairobi conference in particular has been identified as a turning point in international women's organising because of the leadership of local and grassroots women's collectives and NGOs.

This historical moment is also important to our understanding of contemporary global civil society activism among women because it marked a pivotal ideological shift that centralised the multiple diversities in women's experiences. As opposed to being grounded in a universalised notion of gender oppression as articulated in Morgan's (1984) *Sisterhood is Global*, the relationships and networks of feminist struggle that characterise this era of women's transnational activism were based on the dual appreciation of the particularities of women's localised experiences within a common 'context of struggle' (Mohanty 2003, 49). As we examine women's roles in civil society within the contemporary period, these intersecting components continue to strengthen gender organisations within the AAWC and the continuation of women's transnational networking through the UN conferences on women. To elucidate the contemporary installations of similar models of global activism within the context of neo-liberal globalisation, I now turn to a focused analysis of diasporan African women's civil society organisations that have successfully mobilised for social change across multiple boundaries. My focus on women's HIV/AIDS activism within civil society organisations provides a contemporary case that encapsulates the intersections of inequality central to this global pandemic and its particular gender impact.

WHARP: The Women's HIV/AIDS Resources Project

Although they have received scant attention in the chronology of transnational feminist activism, African and African diasporan women's collectives and organisations have also been active players in the development of cross-cultural networks of activism. These networks are based on the historical commonalities of African diasporan women as they confront the particular placement of black women as cheap and exploited labour pools in the global economy. This material reality connects African women to broader ideological

struggles central to global feminism, which problematises the severe marginal-isation of women of colour throughout processes of global restructuring. Similarly, within African feminism, one of the most consistent and salient themes is a repeated analysis of the multiple and intersecting nature of oppression and resistance for African diasporan women. According to anthropologist Steady (1993), the spectrum of African feminisms has been deeply connected to mutual forms of oppression, such as slavery, colonialism, neocolonialism, racism, poverty, illiteracy and disease. Here again we see parallels to the issues emerging in the AAWC beginning in 1962.

Opportunities for cross-border activism have developed even from the most lethal manifestations of capitalist-driven globalisation. The impact of the HIV/AIDS pandemic on African-descendant women globally is a case in point. Throughout the world, women of African descent are disproportionately infected with the virus. This enhanced vulnerability to the virus can be directly linked to the compounded economic, sexual, health-care and political disadvantages that African women experience in these locations. For instance, according to the global report of the Joint United Nations Programme on HIV/AIDS (UN 2006), sub-Saharan Africa is home to 64 per cent of all people living with HIV/AIDS. When we analyse these data from a gender perspective, we see that the pandemic impacts women most severely in this region, where three women are infected with HIV/AIDS for every two men. In the United States, although African American women make up less than 25 per cent of all US women, the National Institutes of Health (NIH) reports that they account for 79 per cent of AIDS cases among women (NIH 2006). As these data suggest, the interlocking systems of poverty, race and gender structure this global pandemic in ways that manifest a particular structural violence on women of colour throughout the world. At the same time, these transnational commonal-ities between women of African descent underlie their efforts to work across borders within organisations connected by common goals and objectives.

WHARP is a transnational African feminist network that emerged out of these common experiences and the political opportunities for cross-border activism on macro-, meso- and micro-levels. It was initiated in 1999 by SisterLove, Inc., an HIV/AIDS and reproductive rights education and advocacy organisation founded by and focused on African American woman based in Atlanta, Georgia. Initially an informal, unfunded relationship between like-minded activists and organisations, the partnership became 'official' in 1999

when SisterLove received a grant from the Centers for Disease Control (CDC) to collaborate with three South African HIV/AIDS organisations that were founded by, comprised primarily of and focused on, women of African descent: PWN, SWAA and TAP.

These three South African NGOs were focused on HIV/AIDS education and advocacy. The PWN, based in the province of Gauteng, was established in 1996 by women infected with HIV; the SWAA was founded in 1989, representing 30 countries in efforts to raise consciousness about HIV/AIDS; and TAP was established in 1989 by medical professionals concerned about the lack of HIV/AIDS education in Soweto and other areas in Gauteng. WHARP is illustrative of the opportunities that currently exist for transnational organising through the engagement of civil society organisations. Not only is it emergent from the underbelly of globalisation – the rise of HIV/AIDS among African and African diasporan women – it is built on the opportunities provided from the structural and ideological globalisation of women's activism through the dissolving of national boundaries and building on the 'common context of struggle' (Mohanty 2003) through civil society organisations.

The foundation of these partnered civil society organisations emerges from the history of activism shared by women throughout the African diaspora. Like other transnational feminist networks and campaigns, WHARP is directly linked to the international meetings of women that followed the UN Decade on Women. By utilising the global infrastructure facilitated in international meetings and communication technologies, women's engagement with this collective civil society initiative contributed to favourable political opportunities for transnational HIV/AIDS activism and advocacy. Most of the founders and/or directors of the organisations involved in the partnerships were in attendance at the UN-sponsored conference on women in 1995 in Nairobi, Kenya. As an organisation, SisterLove began its international activities in 1993 at the International Women's Health Meeting in Uganda. The organisation continued to forge global linkages through participation in the preparatory committee (Prep-Com) meeting that preceded the International Conference on Population and Development in 1994; the Fourth World Conference on Women (NGO forum) in Beijing, China, in 1995; and the 8th International Women and Health meeting in Rio de Janeiro, Brazil, in 1995.

These sites of transnational organisation strengthened the growth of a global civil society, where women from the African diaspora collectively

aligned in their shared experience of disproportionate HIV/AIDS infection. Seseni Nu, director of international programmes for SisterLove, described the common political opportunities for activism by drawing on the linkages between women in South Africa and the United States:

> We, in the US, one of the 'richest' countries in terms of material resources and financial resources, we as a people do not have access to health care. I was a student of public health and I didn't even have access – I didn't have health care. And so, just dealing with those issues that our governments do not see health care, they see health care in terms of a commodity, you know. So we don't end up having access to health care, so we can't deal with these issues effectively. And in the same sense in South Africa, they have limited access to health care because, although they have a government which may be, the face may be all black or may be indigenous, the resources are controlled by other people who are not investing in the human development of the country. Health care is a commodity. So just those kinds of issues, those kinds of similarities help to strengthen the connection and the ties and we have to keep this partnership afloat. (Interview by the author, September 2001)

On the organisational level, the WHARP project was a major source of resource, information and activist exchange, indicative of the potential to draw from civil society organisations in the promotion of women's rights across social location divides. The project attempted to undermine the inherent power and resource differentials of the partnership through strategic decisions and communication processes. For example, in the case of the WHARP project, the fact that SisterLove received funding for the project from the CDC based in the United States created the potential for unequal control and power with respect to its partners. The question of how to forge transnational alliances without reinscribing power and resource differentials between partners remained of critical concern throughout the organisational alliance processes. Nu alluded to this dilemma in the following statement:

> In essence, the WHARP project is about sharing knowledge in a horizontal manner rather than a vertical manner. You have to be careful when you are a primary grantee, or you are the primary receiver of funds, that you don't take on the donor mentality of dictating what the sub-grantees, or even that term

'sub-grantees' . . . that's a technical term, but it's a partnership. So you have to be careful and be mindful of your own inherent contradictions. You have to be mindful of your own tendencies to impose your American values that you're not even consciously aware of . . . or just assumptions that you may make in terms of what capacities or what capabilities our sisters have in South Africa. And, so, that's always a fine line. (Interview by the author, September 2001)

As exemplified in Nu's discussion of funding resource allocation, the global women's movement at times manifests circumstances where institutions have the potential to contravene important transnational alliances through creating linkages that reinforce power asymmetries. Such inequalities burden the notion of a global civil society because organisational relationships can mirror broader circumstances of inequality within women's groups. In the WHARP project, awareness of this potential divisive power relationship facilitated a series of strategic operational standards to minimise this global north/global south divide among women's networking processes. For example, the use of unilateral decision-making and consensus-building processes (rather than the kind of vertical format often seen in the donor–grantee relationship) mirrors the ideological commitments of alignment among women with a common struggle, while acknowledging power differences embedded in the global system of skewed capital and social resource distribution.

However, as the literature across a number of contexts suggests, with the growth of a global civil society, forging transnational identities can be a complicated and power-laden process. This general difficulty is exacerbated by the historical divisions among African and African diasporan women that were strategically created and manipulated as part of the colonial/capitalist 'divide and rule' strategy. In the case of WHARP, transnational African feminist identities were complicated by differences in social location according to class, nation, ethnicity and sexuality. SisterLove's founding director, Dazon Dixon Diallo, discussed the particularly fraught nature of these multiple identities and power differentials:

There's this issue of having to deal with perceptions of who you are as an American . . . that is, there's a disconnect between my blackness and my citizenship. I'm seen as a white person in the US because I bear that citizenship.

We were the imperialist dictators, it was a natural perception because of where we were coming from. No matter how good we are, we are carrying the face of the imperialist. (Interview by the author, March 2002)

As this narrative illustrates, individuals within civil society organisations embody larger macro-inequalities as a result of their histories of colonial imperialism and structural domination. Therefore, civil society organisations must actively resist the tendency to become microcosms of the broader structural inequalities that they confront within the process of global restructuring.

Since its inception, WHARP has directed its emphasis towards fostering transnational linkages through the use of civil society organisations as sites of resistance to broader global inequalities. My research identified key organisational processes that embodied broader ideologies committed both to aligning women's activism and redressing former structures of social location inequalities. For example, the project has engaged in cross-training through 'train the trainer' workshops in South Africa and the United States on grant writing, community programme development and care and support for caregivers. The linkage has also resulted in increasing the resource base and financial strength of the organisations by securing funds for local efforts as well as international conference attendance. As a result, during the first year of the partnership, the PWN was able to open a new site in KwaZulu-Natal. Three years after the initiation of the partnership, SisterLove opened its first office in Witbank to serve as a resource for the more than 50 organisations in the province doing HIV/AIDS work. In addition, SisterLove partnered with SWAA and the Treatment Action Campaign (TAC) to pressure the South African government to make antiretroviral drugs available to pregnant women. These tangible organisational successes provide a perfect example of the 'boomerang effect' of transnational advocacy in which global linkages can strengthen the positioning of local organisations in pressuring their own governmental policies.

Transnationality and the future of the struggle
Today, women of African descent globally occupy a particular point of convergence for the socially constructed hierarchies and systems of race, nation, class, gender and sexuality. While African women's experiences are

varied and divergent on ethnic, cultural, geographic and class levels, there are key aspects of their historical and contemporary realities that underlie and facilitate transnational advocacy and networking. While the deleterious effects of top-down, market-driven globalisation on African and African diasporan women are well documented, the potential for transnational African feminist networks are vastly underexplored. Despite their differences, the activist and collective agency we see among women as a result of their ability to build on connective historical and contemporary threads in African and African diasporan women's experiences illustrates the potential of transnational activism. This creative and militant energy has the potential to become a transformative force within resistance struggles on the African continent and throughout the diaspora. Transnational linkages are complicated and contested zones which offer fresh chances to navigate the opportunities and constraints of the globalised system of relationships, organisational resources and subjective and oppositional identities. Yet, even as we better understand African women's diasporan mobilisation, I suggest that we must continually revisit the grounding forums, such as the AAWC, which built the foundation for both strategic and ideological practices that continue to undergird the strength of the ongoing struggle to resist neocolonial practices in the context of globalisation. Such historical frameworks illustrate that many of the struggles in this current context are not new; rather, they are taking distinct shape within the rapid changes central to global restructuring.

Although women have varied experiences in diverse locations, they commonly experience the repercussions of market-driven globalisation, the resurgence of fundamentalisms and traditional patriarchies and the rise of militarisation and political destabilisation (Brenner 2003; Moghadam 1999). Social movement, globalisation and women's studies theorists have only just begun to explore the increasingly coordinated global and transnational challenges to hegemonic power relations. Social movement theory has been criticised on the basis of '(1) a Western bias and a tendency to focus research on movements in Western countries; (2) a gender bias and a tendency to ignore women's participation in social movements or theorise the gender dynamics of collective action; and (3) a national bias and a tendency to ignore global or world-systemic developments' (Moghadam 2000, 57). As a partial response to Moghadam's concerns, I contend that the political process model, if taken together with feminist thought and globalisation theory, can be

stretched beyond its original theoretical contours in order to accommodate a gendered and globalised analysis of social movements. The most useful aspect of the political process framework is its acknowledgement that the emergence of resistance movements is contingent on levels of multiple structural and subjective factors that must work in tandem: the larger political opportunity structure, the organisational strength and resources of the insurgents, and participants' consciousness and subjectivities (Costain 1992; McAdam 1982). More recently, social movement scholars have been challenged to take into account the global and gendered dimensions of political opportunities, mobilising structures and collective identities (Abdulhadi 1998; McCarthy 1997).

Drawing from historical and contemporary examples, this chapter focused on transnational African feminist networks, an emerging form of collective activism among and between women in different geographic locations that are engaged in struggles for social justices and equality. I contend that the current era of globalised capitalism has created particular opportunities and imperatives for cross-border activism and transnational resistance through civil society organisations. According to Wichterich (1998), this is the foundation for new forms of women's international politics that both counter and act within processes of globalisation.

These divergences and differential power and resource dynamics between women based on all aspects of their identities and structural relationships to the state and economy have often made working across borders conflictual, and in many instances have served to reproduce hierarchies of power. Despite these divergences, feminists and gender activists continue to create linkages across geographic, ideological, sexual preference, class and race/ethnic boundaries through their networking within civil society. While these alliances have not been without conflicts and contestations, they have been a force for social change and against the systemic inequalities that have the most deleterious impact on women's lives.

In this chapter, examples of transnational African women's activism were explored on multiple levels through the lens of an African feminist and political process model. Although African-descendant women's experiences differ on the basis of culture and custom, class and status, socio-economic level, political and economic context and historical period, they are simultaneously linked through commonalities in the source, expressions and persistence of

multiple struggles against multiple oppressions (Collins 2000; Kuumba 2001). My research suggests that transnational African women's activism has been, and continues to be, an intrinsic and significant site of resistance to worldwide inequality that holds the potential for transformation on both local and global levels. As women continue to take up struggles within organisations, a simultaneous movement emerges through the enhanced burgeoning of a global civil society, where transgressing boundaries reshapes central social power differentials through new patterns of collective resistance and interconnected campaigns for justice and equality. While the forms of transnational activism vary, the combined effect of these African feminist global networks – working simultaneously towards particular and universal forms of social justice – has remapped and broadened the terrain of counter-hegemonic struggle and social movements.

References

Abdulhadi, R. 1998. 'The Palestinian Women's Autonomous Movement: Emergence, Dynamics, and Challenges'. *Gender and Society* 12 (6): 649–73.

All African Women's Conference (AAWC). 1968. 'Statutes of the All African Women's Conference, Algiers, 27–31 July 1968'. Helen Joseph Simonson Collection, African Studies Archives, University of Cape Town.

———. 1972. Organisational Document. Record of speech delivered by the delegation of the FRELIMO Women's Section at national conference.

Basu, A. 2000. 'Globalizing of the Local/Localization of the Global: Mapping Transnational Women's Movements'. *Meridians: Feminism, Race, Transnationlism* 1 (1): 68–84.

Brenner, J. 2003. 'Transnational Feminism and the Struggle for Global Justice'. *New Politics* 9 (2): 25–34.

Collins, P.H. 2000. *Black Feminist Thought: Knowledge, Consciousness, and the Politics of Empowerment*, 2nd edition. New York: Routledge.

Costain, A.N. 1992. *Inviting Women's Rebellion: A Political Process Interpretation of the Women's Movement.* Baltimore: Johns Hopkins University Press.

Keck, M.E. and K. Sikkink. 1998. *Activists beyond Borders: Advocacy Networks in International Politics.* Ithaca, NY: Cornell University Press.

Kriesberg, L. 1997. 'Social Movements and Global Transformation'. In *Transnational Social Movements and Global Politics: Solidarity beyond the State,* edited by J. Smith, C. Chatfield and R. Pagnucco. Syracuse, NY: Syracuse University Press.

Kuumba, M.B. 2001. *Gender and Social Movements.* Walnut Creek, CA: AltaMira Press.

McAdam, D. 1982. *Political Process and the Development of Black Insurgency.* Chicago: University of Chicago Press.

McCarthy, J.D. 1997. 'The Globalization of Social Movement Theory'. In *Transnational Social Movements and Global Politics: Solidarity beyond the State*, edited by J. Smith, C. Chatfield and R. Pagnucco. Syracuse, NY: Syracuse University Press.

McFadden, P. 2005. 'Becoming Postcolonial: African Women Changing the Meaning of Citizenship'. *Meridians: Feminism, Race, Transnationalism* 6 (1): 1–18.

Moghadam, V.M. 1999. 'Gender and Globalization: Female Labor and Women's Mobilization'. *Journal of World-Systems Research* (2): 367–88.

———. 2000. 'Transnational Feminist Networks: Collective Action in an Era of Globalisation'. *International Sociology* 15 (1): 57–85.

Mohanty, C.T. 2003. *Feminism beyond Borders: Decolonizing Theory, Practicing Solidarity*. Durham, NC: Duke University Press.

Molyneux, M. 2001. *Women's Movements in International Perspective: Latin America and Beyond*. New York: Palgrave.

Morgan, R. 1984. *Sisterhood is Global*. New York: Feminist Press.

Naples, N. and M. Desai. 2002. *Women's Activism and Globalisation: Linking Local Struggles and Transnational Politics*. New York: Routledge.

National Institutes of Health (NIH). 2006. 'HIV Infection in Women'. Washington, DC: US Department of Health and Human Services. www.niaid.nih.gov/factsheets/womenhiv.htm

Sassen, S. 1998. *Globalisation and Its Discontents: Essays on the Mobility of People and Money*. New York: New Press.

———. 2000. 'Women's Burden: Counter-geographies of Globalisation and the Feminisation of Survival'. *Journal of International Affairs* 53 (2): 503–24.

Seidman, G. 1994. *Manufacturing Militance: Workers' Movements in Brazil and South Africa, 1970–1985*. Berkeley: University of California Press.

Sperling, V., M.M. Ferree and B. Risman. 2001. 'Constructing Global Feminism: Transnational Advocacy Networks and Russian Women's Activism'. *Signs: Journal of Women in Culture and Society* 26 (4): 1155–87.

Steady, F.C. 1993. 'Women and Collective Action: Female Models in Transition'. In *Theorizing Black Feminisms: The Visionary Pragmatism of Black Women*, edited by S.M. James and A.P.A. Busia. London: Routledge.

United Nations (UN). 2006. 'Report on the Global AIDS Epidemic'. Joint United Nations Programme on HIV/AIDS. Geneva. www.unaids.org:80/en/KnowledgeCentre/HIVData/GlobalReport/Default.asp

Wichterich, C. 1998. *The Globalized Woman: Reports from a Future of Inequality*. London: Zed Books.

Contributors

Hannah Britton is Associate Professor of Political Science and Women, Gender and Sexuality Studies at the University of Kansas. She received her Ph.D. in Political Science from Syracuse University in 1999. Her research and teaching interests include African politics, gender politics, institutions, civil society–state relations and transnational movements. Her first book, *Women in the South African Parliament: From Resistance to Governance* (University of Illinois Press: 2005), focuses on women and governance in South Africa. In this book, Britton explores the methods used by South African women to change the Constitution, electoral laws and institutional frameworks to increase women's position in national office as well as to foster improvement in the status of women. In addition, a co-edited collection with Dr Gretchen Bauer, *Women in African Parliaments* (Lynne Rienner Publishers: 2006), examines the growing momentum for women's political participation across the continent. Britton's current research centres on state mechanisms and civil society strategies for ending gender-based violence in southern Africa.

Shaamela Cassiem is Programme Manager of Training and Technical Assistance at the International Budget Partnership (IBP). She is responsible for developing the IBP's international training and technical support aimed at enhancing civil society's budget work and advocacy as a tool to improve effective governance and reduce poverty. Cassiem is a trustee of the Women's Legal Centre in South Africa. Prior to joining the IBP, she was the head of the Children's Budget Unit at IDASA in South Africa, where, together with her colleagues, she was instrumental in pioneering a rights-based approach to budgeting monitoring. She has partnered with Christina Nomdo on projects aimed at improving children's participation in the budget process at local government level in four provinces in South Africa. Cassiem has a background

in adult education and training, children's rights activism and applied budget work. Cassiem is a Nelson Mandela Scholar; she holds a postgraduate qualification in Adult Education from the University of Cape Town and an M.Phil. in Development Studies from the Institute of Development Studies, University of Sussex.

Jennifer Fish is an Associate Professor of Women's Studies and an affiliated faculty member in the Graduate Program in International Studies at Old Dominion University. She completed her Ph.D. in Sociology from American University in 2003, with a focus on the intersections of gender and post-conflict reconciliation, reconstruction and social development. From 1995 to 2008, Dr Fish has worked as a scholar-activist with a number of South African universities and organisations, including the University of Cape Town, Nelson Mandela Metropolitan University, the South African Domestic Service and Allied Workers Union and the Simelela Centre. Her first book, *Domestic Democracy: At Home in South Africa* (Routledge: 2006), situates the institution of paid household labour as a site of ongoing race, class and gender inequality within the context of South Africa's public commitment to gender rights. Dr Fish also works in Rwanda to support girls' and women's education in the aftermath of severe conflict. She teaches courses in the areas of social inequality, globalisation, feminist research methodologies and international development, with a focused expertise in service-learning approaches to global education.

Janine Hicks is a Commissioner with the Commission on Gender Equality. She has an MA in Participation, Development and Social Change from the Institute of Development Studies at Sussex University, and an LLB from the University of Cape Town. Hicks has a long background in the human rights and non-profit sector, having led for ten years the Centre for Public Participation, an NGO focusing on strengthening citizen participation in governance. Prior to that, she worked for the Community Law Centre, a rural paralegal and human rights NGO dealing with access to justice. Hicks serves on the boards of several non-profit organisations, including the Valley Trust, the Community Law and Rural Development Centre, the Non-profit Consortium, and Agenda Feminist Media.

M. Bahati Kuumba, Ph.D., is Associate Professor of Women's Studies/ Associate Director of the Women's Research and Resource Centre at Spelman College and the 2005 recipient of the Fannie Lou Hamer Award. Her scholarly research, activism and public presentations focus on African women trans- nationally in the areas of social resistance movements, population policy, and global African/black feminist theory and praxis. Her research and activism have led to collaborations with women and women's organisations in the United States, Canada, Cuba, Zimbabwe and South Africa. Dr Kuumba is a prolific scholar who has published widely in scholarly journals and activist publications such as *Sociological Forum, Mobilization: International Journal of Social and Political Movements* and *Agenda*. She has also authored several book chapters as well as a book, *Gender and Social Movements* (AltaMira Press: 2001), which focuses comparatively on women in the US civil rights/black power and South African anti-apartheid movements. Her co-edited interdisciplinary anthology, *Transnational Transgressions: African Women and Transformational Struggle in Global Perspectives*, is forthcoming from Africa World Press.

Sheila Meintjes is Associate Professor and Head of the Political Studies Department at the University of the Witwatersrand. She teaches African politics and feminist and gender studies and is engaged in research on women in electoral politics and gender-based violence. Professor Meintjes is the Chairperson of Tshwaranang Legal Advocacy Centre Against Violence Against Women and of Women'sNet, both NGOs that promote gender equality in South Africa. She has co-edited *Women Writing Africa: The Southern Region* (Feminist Press: 2003) and *One Woman, One Vote: The Gender Politics of Elections* (Electoral Institute of Southern Africa: 2003). Her recent co-edited book, *The Aftermath: Women in Post-Conflict Transformation* (Zed Books: 2001), has been widely utilised in classrooms and acclaimed by international audiences. As a former Commissioner with the Commission on Gender Equality, she has rich sources of knowledge about the inner processes of gender and national transformation at the public level.

Helen Moffett is a freelance academic, writer, editor and researcher. She received her Ph.D. from the English Department at the University of Cape Town, and has taught there and internationally. She has held fellowships at Princeton University, Mount Holyoke College and Emory University in the

US, and was an Honorary Research Fellow at UCT's African Gender Institute for five years. She also worked as Oxford University Press South Africa's academic editor for several years. Her academic writings include journal articles and monograph chapters on sexual violence in the post-apartheid context, gender and refugees and race and masculinity. She has also authored a university textbook on poetry and a collection on South African landscape writing, co-authored a work on cricket and is a published poet.

Benita Moolman is a doctoral student at the University of California, Davis, and a social worker with established expertise in the violence against women sector for the past ten years. In South Africa, she has worked extensively with issues of domestic violence at the National Institute for Crime Prevention and Reintegration of Offenders (NICRO). She later focused her work on issues of rape and sexual violence at Rape Crisis Cape Town, where she partnered with communities in the Cape Flats to facilitate training and educational workshops among different groups in youth associations, churches and volunteer organisations. In 2003 she completed her Master's degree in Women and Gender Studies at the University of the Western Cape.

Christina Nomdo holds an MA from the University of Cape Town, where she explored gendered social networks as her dissertation topic. Christina has worked as a trainer, researcher, programme coordinator, advocacy facilitator, youth project coordinator and children's librarian during her fifteen-year professional career. She has worked in the areas of children's rights and government budgets with IDASA, disaster mitigation with a research unit at the University of Cape Town, and youth development at a community learning site for health faculty students with the University of the Western Cape. Nomdo has published an article from her thesis and has presented her work at global forums. She has also published on topics including urban vulnerability, children's participation in governance as well as government education programmes. With Shaamela Cassiem she produced a manual for children's participation in governance based on the South African initiative. Nomdo is currently a managing member of a social development consultancy – On Par Development – which specialises in research, training and materials development as well as monitoring and evaluation.

Cynthia Fabrizio Pelak is Assistant Professor of Sociology at the University of Memphis. She received her Ph.D. from Ohio State University in 2002. Her primary research interests include feminist theory, intersections of race/class/ gender inequalities, social movements and social change and sociology of sport. She has published articles and book chapters on women's movements in the United States, international gender movements, feminism and women of colour, gender/race and education, US AIDS policy and gender/race and sports. Her most recent publication examines sexist naming practices at southern universities and colleges in the United States and the role that race plays in maintaining gender inequalities in education. Professor Pelak is currently working on a research project that examines collective memories, race and neo-liberalism in the southern United States. She teaches courses on the sociology of gender; gender, race and social inequality; race and ethnic relations; and social research methodology.

Denise Walsh is Assistant Professor of Politics and Studies in Women and Gender at the University of Virginia. She received her Ph.D. from the New School for Social Research. Walsh was a co-winner of the Journal of Southern African Studies 2006 Best Article Prize and won the 2007 Best Dissertation Prize for the Women in Politics Research Section of the American Political Science Association. Walsh will be a fellow at the Dickey Center for International Understanding at Dartmouth College for the 2008–2009 academic year. She is completing a book on public debate and gender justice in South Africa.

Index